Invisible Colors

Leonardo

Roger F. Malina, Executive Editor

Sean Cubitt, Editor-in-Chief

Invisible Colors

The Arts of the Atomic Age

Gabrielle Decamous

The MIT Press
Cambridge, Massachusetts
London, England

This book was set in ITC Stone Serif Std by Toppan Best-set Premedia Limited. Printed and bound in the United States of America.

Library of Congress Cataloging-in-Publication Data

Names: Decamous, Gabrielle, author.
Title: Invisible colors : the arts of the atomic age /
 Gabrielle Decamous.
Description: Cambridge, MA : The MIT Press, 2018. | Series: Leonardo book
 series | Includes bibliographical references and index.
Identifiers: LCCN 2018005124 | ISBN 9780262038546 (hardcover : alk. paper)
Subjects: LCSH: Art and technology. | Technology in art. | History, Modern,
 in art. | Art and society--History--20th century. | Art and
 society--History--21st century.
Classification: LCC N72.T4 D43 2018 | DDC 700.1/05--dc23 LC record available at
 https://lccn.loc.gov/2018005124

10 9 8 7 6 5 4 3 2 1

Contents

IV Fukushima and Other Clouds of Suspicion

Toward a Conclusion: More Artistic Hotspots 335

Series Foreword

Leonardo/International Society for the Arts, Sciences, and Technology (ISAST)

Leonardo, the International Society for the Arts, Sciences, and Technology, and the affiliated French organization Association Leonardo, have some very simple goals:

1. To advocate, document, and make known the work of artists, researchers, and scholars developing the new ways in which the contemporary arts interact with science, technology, and society.
2. To create a forum and meeting places where artists, scientists, and engineers can meet, exchange ideas, and, when appropriate, collaborate.
3. To contribute, through the interaction of the arts and sciences, to the creation of the new culture that will be needed to transition to a sustainable planetary society.

When the journal *Leonardo* was started some fifty years ago, these creative disciplines usually existed in segregated institutional and social networks, a situation dramatized at that time by the "Two Cultures" debates initiated by C. P. Snow. Today we live in a different time of cross-disciplinary ferment, collaboration, and intellectual confrontation enabled by new hybrid organizations, new funding sponsors, and the shared tools of computers and the Internet. Sometimes captured in the "STEM to STEAM" movement, new forms of collaboration seem to integrate the arts, humanities, and design with science and engineering practices. Above all, new generations of artist-researchers and researcher-artists are now at work individually and collaboratively bridging the art, science, and technology disciplines. For some of the hard problems in our society, we have no choice but to find new ways to couple the arts and sciences. Perhaps in our lifetime we will see the emergence of "new Leonardos," hybrid creative individuals or teams

that will not only develop a meaningful art for our times but also drive new agendas in science and stimulate technological innovation that addresses today's human needs.

For more information on the activities of the Leonardo organizations and networks, please visit our Web sites at http://www.leonardo.info/ and http://www.olats.org/. Leonardo Books and journals are also available on our ARTECA art science technology aggregator: http://arteca.mit.edu/.

Roger F. Malina
Executive Editor, Leonardo Publications

ISAST Governing Board of Directors: Nina Czegledy, Greg Harper, Marc Hebert (Chair), Gordon Knox, Roger Malina, Tami Spector, J. D. Talasek, Darlene Tong, Joel Slayton, John Weber

Leonardo Book Series Editor-in-Chief: Sean Cubitt

Advisory Board: Annick Bureaud, Steve Dietz, Machiko Kusahara, José-Carlos Mariategui, Laura U. Marks, Anna Munster, Monica Narula, Michael Punt, Sundar Sarukkai, Joel Slayton, Mitchell Whitelaw, Zhang Ga

Preface

The idea to research the connection between art and nuclear technology came to me while I was a Hilla Rebay International Fellow at the Guggenheim family of museums. During my time in Venice, I came across a book on the postwar Italian group of artists, the Movimento Nucleare, whose artworks focused on depicting the atomic age. The book was just there, somewhere in a dusty corner of a large library in the city, and I had come across it by accident while looking for something else. This was years before Fukushima, and back then I was already struck by the idea that responses in the arts to nuclear and atomic realities had been somewhat overlooked. I started research on the topic. Years later in Japan, and in particular after visiting the peace museums in Nagasaki and Hiroshima, I could not help but notice all these powerful yet neglected artworks that are still largely unknown in the West, even after Fukushima. I observed the same phenomenon regarding Marie Curie—her statements as much as the atomic-related artworks of her time. The nuclear age is usually understood to start after Hiroshima and Nagasaki, thereby excluding valuable works of art and scholarship created in the wake of Curie's discovery of radium; that urged me to continue mining for artistic ores in many other forgotten places and archives.

By the time I was nearly finished with the writing, the political climate had become very tense between the US and North Korea. Even though I live three hours from South Korea, and the anxiety surrounding the potential for further nuclear incidents was very strong then, I have tried not to let these factors color my text. By the time I was working on the final version of the book, the tension seems to have been resolved, but I hope there is no need to add another chapter to this book, about another incident, in the future.

Around that time, too, another unnoticed but crucial event happened: AREVA, the French nuclear corporation and the leader on the global market

of nuclear reactor and uranium mining, changed its name to Orano. While this seems insignificant, the revamping of its entire website meant that most of the company's past data on AREVA were erased, in particular about their art patronage. Most of my references on the company evaporated, but traces are still available on the Internet though not always via Orano's official website to date so I kept both references (old and new). (I had researched their activities for nearly a decade before the company transmuted to Orano.)

The present book is thus the result of more than ten years of research about forgotten artworks in many parts of the world and in many languages. My starting point is grounded in the arts, and, in that sense, my book is neither pro- nor antinuclear. It tells of the artistic responses to the atomic age. The book is also the result of relentless "excavation" and the search for rare artworks, as well as for out-of-print (and at times) overpriced books discussing artistic traces that were themselves atomized in the many dusty corners of collective memories, museums, and libraries—even for the more contemporary pieces.

Many valuable encounters contributed to the creation of this book as well, and I could not have completed it without the help of a great many people. I wish to thank my colleagues Andy Painter, Kurakata Kensaku, Shimojo Keiko, Christophe Thouny, and Shimizu Toshihiro for their insight and assistance with my manuscript. I am particularly in debt to Douglas Sery, Sean Cubitt, and Roger Malina for making this publication possible and for understanding my work so well. I would also like to thank Mary Bagg for editing the manuscript and Marcy Ross for helping me with the entire process. Hanako Ayada has been instrumental in helping me with a wide range of Japanese writings of all sorts over the years. I am also immensely grateful to Laura Luse for her precious assistance with the perilous process of copyright clearance and to Wang Qi for helping me in transitioning from one referencing system to another. I also wish to thank my entire family, in particular my parents and my husband Yūta, for their constant support and encouragement from the beginning to the end of this nuclear journey. This project would never have been possible without each and every one of them.

Introduction

This book aims to bring visibility to the atomic age from the neglected vantage point of the arts. Countless books, reports, and conferences have already analyzed the atomic age in pivotal ways, so it might seem that this approach has nothing to contribute to a rich, existing set of multidisciplinary investigations. And yet, by exploring atomic-related artworks, a different picture of the atomic age emerges and goes beyond familiar narratives of key Western nuclear scientists, militaries, and politicians of the nuclear age, and takes us beyond the discussions of technological power and geopolitical stakes.

In 1984, Jacques Derrida notoriously argued that those in the humanities were entitled to be concerned with nuclear weaponry because the bomb's existence exposed a reversal of competencies—between the multitudes of non-experts (i.e., "incompetents") on the one hand; and on the other, the few "experts" entrusted to make a "final decision" to deploy a nuclear weapon as if "in a game of dice." As he declared: "Nowhere has the dissociation between the place where competence is exercised and the place where stakes are located ever seemed more rigorous, more dangerous, more catastrophic."[1] For Derrida, the field of humanities—given its own experts in discourse and in texts—is as competent to engage in a dialog as any other field, particularly when analyzing the nuclear rhetoric of the Cold War.

In the atomic age at large, the iconic mushroom cloud, Godzilla, and the exploding power plant have become persistent images, if not imageries. They pertain to the textuality described by Derrida, and to the structures of information and language (including non-vocalizable language) that inform the way we think about the nuclear age and the threat of nuclear war. But it is now time to look behind these pictorial tropes.

It is time to look at what lies behind them, historically and globally, starting from the time of Marie Curie to the events of Fukushima: How did literature and the performing arts at the time of radium's discovery relate to

later visual depictions of the atomic age? How did Hiroshima and Nagasaki artists represent the bombings? What is the art of the radioactive Bikini and Moruroa Atolls? What is the art of irradiated Three Mile Island, Chernobyl, and Fukushima? What realities do artists depict? Are these the same in the East and in the West? Why are they still relevant today? How do they help us to understand the atomic age differently?

The aim is not to replace one collective memory by another. But by exploring the answers to these questions, and by examining others that relate to artistic visualization in response to the nuclear age, *Invisible Colors* aims to provide the missing pieces of a puzzle that has too quickly become global and has lost historical context in the process. In fact, this piecing together is an overdue task: after the accident at the Fukushima power plant, the philosopher Nishitani Osamu explained that the accident had consequences not just for the city of Fukushima, but also for the rest of the world.[2] The same applies to each nuclear "event." Analyzing the cultural production of the atomic age is one way of reassembling the global pieces of the puzzle, and one way to give visibility to particularly rich pieces.

Representing the "Invisible" and "Unthinkable"

Radioactivity is invisible, cannot be smelled, felt, or tasted. From an artistic point of view, it would seem that this intangibility is first and foremost the most challenging to evoke—the Geiger counter being a scarce artistic instrument. But in truth, it can no longer be said that the atomic age or atomic bombings are "the unthinkable": a multitude of artists have depicted the atomic age for more than a century in myriad ways and in myriad nuclearized nations.

The contributors to this body of work can hardly be reduced to one movement or one group. They include visual artists such as Pablo Picasso, Nancy Spero, and Nam June Paik, as well as filmmakers like Stanley Kubrick and Akira Kurosawa, photographers such as Yamahata Yōsuke and sculptors like Henry Moore; *hibakusha* (bomb survivor) writers such as Ōta Yōko and Hara Tamiki, as well as the poet Tōge Sankichi; fiction writers like Maurice Leblanc, Agatha Christie, and H. G. Wells; and musicians and pop-culture recording artists such as Sun Ra and David Bowie. These works speak many artistic languages expressed through mainstream and alternative media, also including comic books or science fiction, drama and a genre of documentary film and writing blending fictional and historical narratives.

Significantly, as Catherine Jolivette has pointed out, "art makes tangible and visible the 'nuclear,' from atomic formation ... to atomic war."[3] This

is so because the radioactive fallouts are sociopolitical as much as technological. Thus the pertinence of these works in today's world, and their potential to affect our thinking about the future, is also great; their somber radiance, particularly in the historical pieces, still glows. They possess an ability (we might say an *infinite* ability) to remind us of the lasting effect of radioactivity.

Radioactivity's intangibility may not be particularly challenging for an artist to portray, but other challenges exist beyond the creation of the work, such as making the work itself visible. Most of the pieces discussed in *Invisible Colors* are still broadly unknown (and not just in the West), even those from Hiroshima or the many affected parts of Oceania. In this book I argue that by understanding the ways in which artists have been and still are challenged to make these works *seen*, we can grasp a better awareness of the global impact of the atomic age.

In an October 1945 newspaper article titled "You and the Atomic Bomb," George Orwell proclaimed that in spite of its might, "the atomic bomb has not roused so much discussion as might have been expected."[4] More than seven decades later, atomic-related artworks are still largely underexplored, and efforts to analyze them are fairly recent.

For a long time, the field of art history counted only three major books on the topic: Lynn Gamwell's *Exploring the Invisible: Art, Science and the Spiritual* (yet only in the twelfth chapter); Catherine Jolivette's *British Art in the Nuclear Age*, which also solely focuses on Western modern artworks; and the Arts Catalyst's exhibition catalog titled *Atomic*, with a focus on three Western contemporary artists.[5] (The Arts Catalyst is a UK art organization that regularly plans events on the topic.)

After Fukushima, a few more publications emerged. Two exhibition catalogs are notable for giving more visibility to the atomic age and for including at least a few Japanese artists: John O'Brian's *Camera Atomica* and Ele Carpenter's *The Nuclear Culture Textbook*.[6] But they focus on a particular medium or time frame—*Camera Atomica* on the photographic medium and *The Nuclear Culture Textbook* primarily on contemporary visual artists (with few rare exceptions). In Japan, Yamamoto Akihiro's *Kaku to Nihonjin—Hiroshima, Gojira, Fukushima* (Nuclear and the Japanese—Hiroshima, Godzilla, Fukushima) has a broader historical span but surveys popular culture of Japan with no link to Western or non-Japanese nuclear cultures.[7]

Yet today it is crucial to consider modern and contemporary art altogether: from the East and the West, and from the time of Marie Curie to the present. Nuclear culture is a global and historical culture—or rather, a culture made global by force—extending beyond Japan and the Pacific

and spreading to many nuclearized ethnicities and landscapes, some African nations among them. Most investigations about the nuclear age do not consider the uranium mine in the same category as a nuclear device of the atomic age, and consequently leave many atomized communities and voices in the shadow of the mushroom cloud and the exploded power plant.

The Priorities, Focus, and Structure of This Book

Although in *Invisible Colors* my goal is to make many and diverse atomized artistic productions visible to a larger audience, I cannot claim to provide an all-inclusive survey. I focus on artists who directly refer to nuclear realities in their artworks or statements and, most importantly and with few exceptions, I give *priority to the artists working at the time of these many nuclear events and in the places where they occurred*. I put particular emphasis on artists who also are *hibakusha*, the Japanese term for "bomb survivors" that also means "the people exposed to the bomb." I extend the use of that term, as the photographer Toyosaki Hiromitsu, who is part of the Atomic Photographers Guild started by Robert Del Tredici (after he photographed Three Mile Island), has already done, to cover the many atomic victims and witnesses—not only of radium and A-bomb, but also of uranium mining and nuclear accidents—who exist outside Japan.[8] Although I give priority to the global *hibakusha*, I include discussions of how other artists created visualizations of the atom, and thus attempt to link the many nuclearized nations, in the East and in the West, through their artistic language.

In order to encompass such a diversity of responses, there are at least five main epistemological frameworks—referred to here as "compounds"—that must be acknowledged in regard to these artworks: the good/evil use of the atom; the civilian/military use (which differs slightly from the good/evil use); and the East and West, in art and science, and in political and apolitical arenas. Calling these frameworks "compounds" (in reference to molecular compounds) instead of "binaries" gives an emphasis on the "intra-actions" rather than "opposition" between the two elements, to draw on the physicist and feminist scholar Karen Barad's notion of "intra-action." They interact, both elements are intertwined, cannot be disentangled, and their interactions affect both of them.[9]

I've analyzed the artworks chronologically except in part I, where I provide a broad overview of the art of the atomic age from Marie Curie to Fukushima: I survey the artworks inspired by the discovery of radioactivity but also examine the theoretical frameworks that are useful to analyze such

a large spatiotemporal frame. Initially, part I was a shorter introduction, but the sections on pre-Hiroshima artworks kept growing and I had to split the introduction into two chapters. In part II, I analyze the *hibakusha* arts of Hiroshima and Nagasaki in tandem with critical Western responses to the bombings. In part III, I focus on the Cold War in the Pacific, the US, and other irradiated landscapes, such as uranium mines. And in part IV, I discuss nuclear accidents in Fukushima, Chernobyl, and Three Mile Island. Finally. I conclude with an exploration of artistic expressions of the atom that do not fit neatly into a nuclear taxonomy of radioactive traumas, even though these apolitical works have catalyzed the smallest number of artworks. Although the arts of the atomic age are first and foremost depictions of suffering, other alternative explorations of the atom exist, and the ethics of their representations must be equally discussed. As a whole, however, I analyze the ethics and politics of these representations of the atomic age in order to give visibility to their "dark radiance" (to paraphrase the use of the term by Maurice Blanchot in the context of post-war literature).[10]

I An Overview of the Arts of the Atomic Age from Marie Curie to Fukushima

1 From Marie Curie to Hiroshima

Although discoveries made by Wilhelm Röntgen (X-rays) and Henri Becquerel (the SI-derived unit of radioactivity) occurred more or less in tandem with those of Pierre and Marie Curie, the cultural production that emerged in the West in response to atomic research in the early part of the century drew on Marie Curie's work with radium. In terms of medium, artworks in the visual genres were rare at the time of the Curies—only a small hotspot in the annals of art history—and few scholars touched upon them as explored further in the next section.

Instead, literature became the nest of creativity in response to the atomic age. The number of novels produced in the pre-Hiroshima days is large enough to group as a genre that I will call "radium literature" in reference to the Japanese genre of "A-bomb literature" (detailed in part II). But even there, very few scholarly works included pre-Hiroshima fictional stories. Two works, both by US scholars, help in finding a few of these narratives: David Dowling's *Fictions of Nuclear Disaster* and Paul Brians's *Nuclear Holocausts: Atomic War in Fiction*.[1] Their research, however, has mainly focused on postwar narratives and sheds light on Western depictions of atomic weapons, accidents, and impending doom rather than any other plots. In a study analyzing works produced in Japan, Nakao Maika also focuses primarily on short storys that depict pre-Hiroshima fictional atomic bombings. She includes, however, one work by science fiction writer Unno Jūza, "Sennen-go no sekai" [The World after One Thousand Years, 1939], that relates to the smashing of matter for endless energy in a futuristic world and a work by Miyazawa Kenji, a poet who referred to radium a "fossilized phosphorescence" in a 1920 poem "Radium no Kari" [Radium's Wild Goose, 1920], broadly inspired by Japan's radium *onsen* (hot-springs).[2]

As Dowling and Brians underscored, a large number of the narratives are depictions of atomic weapons or doomsdays. Robert Cromie's *The Crack of Doom* (1895) is said to be the first novel to offer an atomic-related plot

and to describe an atomic explosion. And one of the most notorious pre-Hiroshima novels is H. G. Wells's *The World Set Free* (1914), celebrated for foreseeing the atomic bomb. Wells has even been credited for inspiring Leo Szilard—the physicist who conceived of the nuclear chain reactor and later helped to endorse work on the Manhattan Project—to think about conceiving an actual bomb.

However, because their books focused on doomsday narratives, Dowling and Brians did not cover other scenarios that still emerged in consistent ways: the value of radium (for multiple purposes) prompted several tales of what can be called "radium bandits," whereas the dangers of radium—especially as seen in the historical case studies of the Radium Girls, who suffered from radioactive poisoning in the 1920s in Orange, New Jersey, and Ottawa, Illinois—inspired plotlines in fiction, film, and drama. These works, which appeared between the two world wars and some of which continue to be produced today, are equally interesting to map because they underscore an epistemological shift in the humanities regarding the understanding of the atom at that time.

Overall, works produced before the 1945 bombings of Hiroshima and Nagasaki predominantly responded to the good/evil and military/civilian use of the atom. (Responses to other compounds were present to some extent, and we'll explore them in chapter 2.) And the visual properties of radium, as well as the perpetual movement of the atom in a void, inspired those in the performing arts. Their work deserves to be explored in the next section, before we return to literature.

Radioluminescence and the Dance of the Atoms

At the onset of the atomic age, the performing arts rose to the challenge of conveying the imperceptible nature of radioactivity, specifically in the design of luminescent costumes. In two theatrical productions, for example, the costuming sparked interest onstage and evoked the "good" rather than the "evil" use of the atom. The overall effect reflected the hopes that radium inspired at the time, far removed from thoughts of weapon making or evil use of the atom.

In the first production, *Piff! Paff! Pouf!*, a 1904 Broadway musical by Jean Schwartz, chorus girls wore glow-in-the-dark clown suits as they performed during a song called "Radium Dance" (figure 1.1). The show's comedic plot, which had nothing "scientific" about it, concerned a man whose wife set up complicated conditions in her will to be fulfilled before he inherited her fortune. The score, however, was upbeat, with the song "The Ghost That

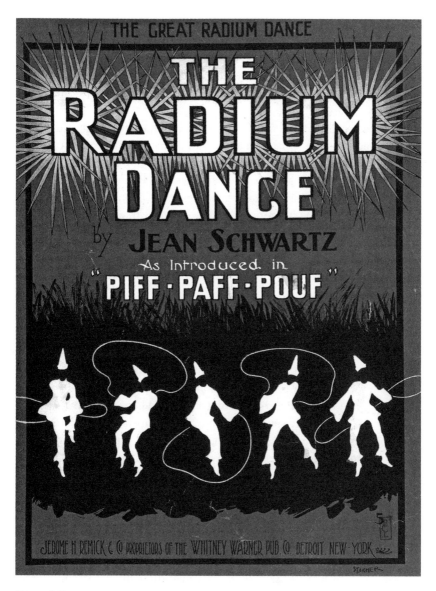

Figure 1.1
"The Great Radium Dance." Sheet music cover, published in 1904, Jerome H. Remick & Co. and Whitney Warner Publishing Co., Starmer (illustrator), chromolithograph. From the Bella C. Landauer Collection of Business and Advertising Ephemera (PR031), Series I Box 125, f: 1. New-York Historical Society.

Never Walked" rivaling "Radium Dance" in popularity. A reviewer for the *New York Times* noted the special glow-in-the-dark effects that enhanced the performance of "Radium Dance" and described the action: "the pony ballet dons Pierrot costumes with great disks of phosphorescent substance sewed in them, and on a darkened stage skips rope with phosphorescent clothesline."[4]

The second theatrical piece, staged a few days later by the American dancer Loïe Fuller, was also titled "Radium Dance." The luminescent costumes for this dance, unlike those in the musical, were directly inspired by the work of Pierre and Marie Curie. Fuller even had the chance to discuss the piece with them prior to staging and performing it in her studio.[5]

Fuller is considered a forerunner of modern dance and theatrical lighting; she became famous in the Parisian art scene and befriended Mallarmé, Rodin, and Toulouse-Lautrec among many others.[6] Rodin credited her for "opening the pathway for an art of the future."[7] Her "Serpentine Dance" of the 1890s, in which she swirled her arms and body to manipulate voluminous folds of white silk—prompted her reputation as the embodiment of Art Nouveau, and her notoriety only increased when she performed in Paris at the Folies Bergère and the Exposition Universelle of 1900.

A *Los Angeles Herald* critic at the time described the "Radium Dance" as "weird and fantastic": visitors were "marshaled" at the end of a gallery in complete darkness to distinguish vague and ghostly green figures appearing and disappearing. The figures resembled "hundreds of tiny glow worms," and a "tissue of twinkly stars" that were finally superseded by a "monster glowing moth, with a shining antennae a foot long, eyes which are globes of light, and wings six feet high, glittering with numerous scrolls in all colors."[8] The studio lights were then relit when the number of "insects" dwindled and finished fluttering around.

Fuller's dance was splendid in many regards. Her initial intention had been to use actual radium, and she would have gone ahead with that plan if the Curies had not dissuaded her.[9] According to the *Herald* critic's report, the Curies saw and approved of Fuller's alternate choice: she made costumes out of fabric soaked with salts that were extracted from "pitchblende," the substance from which the Curies had extracted radium; the chemical makeup of the salts was akin to radium, and their fluorescence was believed to be activated by radium's residue.[10] The dance itself was marvelous because it exemplified Fuller's lifelong interest in technological and scientific advances: she had a laboratory in her basement in which she experimented and made new discoveries.[11] Although she referred to the 1904 "Radium Dance" as her "newest scientific creation,"[12] as early as 1893

she had obtained several patents for her "Serpentine Dance" costumes in Europe and the United States.[13] She also experimented with other media, and made a film produced by Pathé in 1905 using a then new technique of stencil coloring that re-created lightning effects she had designed for "Serpentine Dance."[14] Given interest in new techniques and technologies, her fascination with radioluminescence is no surprise.

The unique staging of Fuller's "Radium Dance" influenced several other dances and dance-related performances as time went on. In 1938, for instance, Fuller's partner Gab Sorère produced an evening of glowing dances with costumes under black light, the "Ballets et Lumières" [Ballets and Lights].[15] Pierre Huyghe, a contemporary artist, displayed a glow-in-the-dark costume in *Dance for Radium* (2014) at The Artist's Institute in New York in 2014 (see figure 1.2). The piece, in homage to Fuller, combined elements of her "Radium Dance" and "Serpentine Dance."[16] In Japan Erika Kobayashi referred to it and included depictions of the "Serpentine Dance" dance in the first volume of *Hikari no kodomo* [Luminous: Child of the Light, 2013], a manga that retraces the history of radioactivity through archival material and drawings.[17]

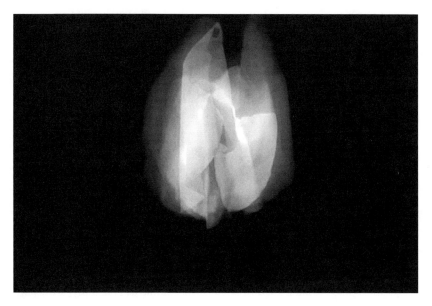

Figure 1.2
Dance for Radium for Pierre Huyghe's season at The Artist's Institute, 2015. Photograph by Mae Fatto. Image courtesy of The Artist's Institute.

Just one year after the two 1904 radium dances, radioluminescence was also used in another rare occurrence: *The Radium Book* (1905), a story for children written by William Rose, instructed its readers to hold their books to the light for a few moments to activate the luminescent material that made the cover and pages glow in the dark. The plot, however, similar to *Alice's Adventures in Wonderland* (1865) and *The Wizard of Oz* (1939), had nothing to do with radium; it follows a young girl named Dorothy who encounters strange creatures on her travels to the Land of Noo.[18] The book's special effects gave the story a magical appeal, conjuring an awareness of radium as harmless and reflecting the excitement surrounding the work of Pierre and Marie Curie.

At that time, the understanding of the atom shifted away from the traditional philosophical understanding of it, as viewed by ancient Greco-Roman philosophers and the philosopher Acharya Kanada in India who had discussed the existence of elementary particles in the past.

The association between dance and the new concept of radioluminescence brings to mind the Roman poet Lucretius, who portrayed "dancing" atoms in his six-book poem *De rerum natura* [The Nature of Things, 50 BCE]. The following excerpt from the poem's second book focuses on the nature and properties of atomic compounds, most importantly their perpetual motion at high speed (II. 89–118). Lucretius portrays the dancing movement and alludes as well to the assumptions and principles of the atom: atoms strike one another other, rebound, and intermingle in an infinite void.

All bodies of matter are in motion. To understand this best,
Remember that the atoms do not have a place to rest (...)
After colliding, some will leap
Great intervals apart, while others harried by blows will keep
In narrow space. Those atoms that are bound together tight (...)
There's a model, you should realize,
A paradigm of this that's dancing right before your eyes—
For look well when you let the sun peep in a shuttered room
And you'll see myriads of motes all moving many ways
Throughout the void and intermingling in the golden rays (...).[19]

Lucretius reinvestigates the doctrine of the Greek philosopher Epicurus, who himself expanded on the pre-Socratic atomism of Leucippus and Democritus. For them, living things (and all material) are the result of combinations of atoms and nature has her own sets of law removed from the Gods. Lucretius stated:

What can things be fashioned from? And how is it, without
The machinations of the gods, all things can come about?
For if things were created out of nothing, any breed
Could be born from any other; nothing would require a seed.
People could pop out of the sea, the scaly tribes arise
Out of the earth, the winged birds could hatch right from the skies
(I. 157–160).[20]

One characteristic of atomism and of the poem is that Lucretius's rebuttal of anything supernatural is particularly strong. There is no determinism or fate other than the ones deriving from the proprieties of the atoms. Moreover, there is indeterminacy and thus free will, or what he calls "to swerve" or *clinamen* in Latin: while all atoms fall in the void, at "*random time and place. / They swerve a little …*" (II. 218–219),[21] and since some are heavier than others, they fall faster. One can divert from its path and is at the origin of a disturbance, a fertile motion, the creation of a world of differences. Without this, nature could not create and creatures would be mere engines. For him, *clinamen* thus "… shatters the law of fate" which explains that "freewill … exists in every creature" (II. 255–256).[22]

Another specificity of ancient atomism worth noting today, Lucretius thus states: "But by observing Nature and her laws … *that nothing's brought / Forth by any supernatural power out of naught / … Nothing can be made from nothing*," "*… Add that Nature does not render anything to naught*"[23] (I. 148–150, 214). His statement thus precedes Lavoisier's discovery of the law of conservation of mass: nothing is lost, nothing is created, everything is transformed.

The materialist views were shared in part by some philosophers of the eighteenth century. But by the nineteenth century the approach to atomism began to shift: the nature of material reality became a matter of science (or modern science), not just philosophy or the humanities. By the time of radioactivity's discovery, heated discussion on the opposing views of determinism (determined by God) and free will related to the atom started to get less attention.

As the twentieth century began, and radium's properties were a hot topic of scientific study, the public became increasingly aware of radium's harmful effects. Technologies of the atomic age were soon under scrutiny. At stake was less the atom itself than the technology of its use. In artistic production the dual use of the atom—or the sense of the atom as a good/evil compound—was notably expressed in fiction.

Good/Evil Plots: "Lady Clanbevan's Baby," *The Deadly Tube*, and the Real-Life Radium Girls

In literature, truly positive narratives on radium are scarce and usually describe a dual use of applications. One such example is Richard Dehan's "Lady Clanbevan's Baby" (1915). (Richard Dehan was the pen name of Clotilde Graves, an Anglo-Irish writer.) In this stort story, a professor claims to have discovered the properties of the Röntgen rays twenty years earlier than Röntgen. As a proof, he points to the radiant beauty of Lady Clanbevan, to the "glow of her gorgeous hair, the liquid sapphire of her eyes," and to the fact that she had been a widow with a one-year-old child for twenty years! He explained to the surprised narrator that, out of love (and not because of a craving for fame), he maintained the mother's and child's youth through a complex apparatus using radium so that she could keep her inheritance (since when her child became an adult, he would inherit the estate). Although the professor could stop their bodies from aging, their hair and nails would continue to age. Wildly intrigued, the narrator waits for an opportunity to sneak a look at the twenty-year-old baby whose face is constantly covered to see for himself: "The child had a mustache!"[24] The monstrosity of the baby and of the greedy mother echoes the good/evil use of the technology.

Another early example of a plot that turned on the good/evil use of atomic-age technology, specifically the dual effects of radioactivity and X-rays, appears in *The Deadly Tube* (1912) by Arthur Benjamin Reeve. Reeve was an American writer and screenwriter. His best-known character, Professor Craig Kennedy, a scientific detective, is often referred to as the American Sherlock Holmes. In this mystery, Kennedy sets out to uncover the reason behind the terrible disfigurement of Mrs. Huntington Close, "one of the famous beauties of the city."[25]

Mrs. Close had undergone X-ray treatments to cure a mild case of dermatitis, but Kennedy's scientific sleuthing quickly led him to conclude that the burns she suffered did not occur in the doctor's office. He vacuumed up dust in her bedroom, collected it in a tube that glowed "with a dazzling point of light,"[26] and identified the noxious substance the dust contained with the help of a chemist. As he further reported: "The fact is, that in their physiological effects the X-ray and radium are quite the same. Radium possesses this advantage, however, that no elaborate apparatus is necessary for its use."[27] Kennedy suspected foul play and, thanks to his detective's perspicacity, discovered the real culprits: criminals, posing as diamond merchants, brought the radium pretending they would use it in order to polish

and thereby improve the appearance of flawed diamonds. After a series of twists and turns that determined the motive and means for releasing the poison on Mrs. Close, Kennedy uttered the following pronouncement: "No infernal machine was ever more subtle ... than the tube which I hold in my hand. ... I hold the price of a woman's beauty."[28]

When examining these fictional narratives of the early atomic age today, it may seem as if they predicted the potential for real-life events to occur, if not the events themselves—as if fiction anticipated science. In the 1920s, just few years after Reeve's narrative, there was the historical case of the young women, known as the Radium Girls, who suffered from radium poisoning in the United States. In reality, however, they lost more than mere beauty: they lost their health and their lives.

The Radium Girls were employees of the United States Radium Corporation in Orange, New Jersey, and of other companies whose facilities were located in Ottawa, Illinois, and in France, among others.[29] These girls, most of them still in (or just out of) high school, were hired to paint watch dials and clock faces with radioluminescent paint; they were instructed to keep the points of their brushes sharp by moistening the bristles in their mouths. The effect was quick and irreversible. Some died in just two years, others developed radiation sickness, necrosis of the jaw, the need for an arm or leg amputation, and other terrible physical conditions.

Many of the women filed lawsuits against their employers: during 1925–1928 in New Jersey, and in Illinois during 1937–1938.[30] The trials have become important parts of historical case studies used by advocates of women rights and labor safety. Despite the favorable final verdicts in these cases, the plaintiffs can hardly be said to have won: Quinta McDonald (of New Jersey) doubted that the initial payoff and yearly stipends would be sufficient to help her care for her two children, ages five and eight, while Catherine Donohue (of Illinois) died shortly after winning the case, leaving her children behind (one of which died prematurely).[31] Their struggles made the headlines; the press nicknamed them the "Living Dead."[32] One cartoonist portrayed them working with skeletons as factory assistants (figure 1.3). When Marie Curie read about their condition she said: "I would be only too happy to give any aid that I could. [However], there is absolutely no means of destroying the substance once it enters the human body."[33] In the 1936 German novel *Radium: Roman eines Elements* [Radium: A Novel], Rudolf Brunngraber, devoted a slim but sympathetic chapter to the Radium Girls.[34] In the media, however, opinions about their diagnoses wavered. Although a number of medical experts presented hard evidence of radium's poisonous effects, other "experts" were

Figure 1.3
"Radium Girls Cartoon," 1926. The cartoon was first published in *American Weekly* on February 28, 1926.

biased by their vested interest or unfounded judgment. Corporate-funded researchers, for instance, sometimes claimed the girls had not been affected by radium, or they placed the blame for their symptoms on syphilis.[35] Similarly, artistic representations of Radium Girls could send mixed messages.

In 1937, a popular US movie in the genre known as "screwball comedy" created a fictional Radium Girl to enhance its plotline. The film, aptly titled *Nothing Sacred*, focuses on a beautiful young woman named Hazel (played by Carole Lombard), recently diagnosed with radium poisoning; when the news of her plight reaches a New York City newspaper reporter (played by Fredric March), he goes to the Vermont town where she lives, hoping to cover her story. But Hazel's doctor has reversed the diagnosis, and despite several thwarted attempts to tell the reporter the truth, Hazel plays along with his intentions to capitalize on her tragedy. When the film opened in November 1937, film critics commended *Nothing Sacred* for its wit, humor, and its cynical view of the dishonesty and corruption endemic in the press. But the *New York Times* reviewer mentioned nothing objectionable in the characterization of a Radium Girl as an opportunist. When the film was restored and issued on DVD, however, a reviewer in 2011 commented that the director and screenwriter "wring laughs from the way the public is titillated by tragedy" and asked, "Is 'Nothing Sacred' the most heartless of great American comedies?"[36]

The ordeals of the Radium Girls continued to unfold because radium contamination made them objects of scientific experiments that extended even beyond the grave, and those experiments were documented and eventually made available to the public. The stories have inspired countless responses in literature, theater, poetry, and film even to this day, as we will see later in the section. Thus the relevance of artistic works of the atomic age, even of the modernist period, cannot be taken out of their historical, political, and finally scientific contexts. We need to open the framework through which we examine them, and to examine realities other than artistic ones. For that reason we now turn to nonfiction and the documentary film.

Case File 05–215 and Glowing Girls in the LaSalle Bar

The Radium Girls found an ideal medium for their voice in the documentary film genre. One such film is *Radium City* (1987, directed and produced by Carole Langer). It describes how in 1948 the Argonne National Laboratory (built two years earlier in Lemont, Illinois, by the US Atomic Energy Commission), began to conduct experiments on the women who had been

(or were currently) working at the Radium Dial factory in nearby Ottawa, Illinois—the point was not to treat them or search for a cure but solely to run tests. In one of the film's more chilling moments, Langer shows the manner in which the deceased were buried in armored coffins because the radioactivity of their corpses was still detectable deep in the ground. Langer also explains how the Radium Dial corporation eluded lawsuits brought against it, in part by demolishing its original factory in 1968 and reopening a new one, called Luminous Processes, only few blocks away, with little regard for new employees and local residents.

Radium City documents the far-reaching effects on the workers, their families, and the community by addressing ongoing dangers concerning radioactive waste.[37] Not the least of the issues concerns culpability. One view holds that the Argonne National Laboratory is not entirely to be blamed for conducting the research almost entirely in secret, especially as the Cold War loomed and escalated. Officials insisted that ongoing research on radioactive materials was vital because it contributed to the establishment of safety measures and permissible levels of radioactivity in the United States.[38] The research was considered seminal, even considering lapses in reporting that occurred as other agencies and institutions contributed their own research, because, as one of the last Argonne reports in the 1980s stated in its foreword, "radium continues to work its insidious effects."[39]

From another point of view, however, as Langer quite strikingly underscores, nothing was done to decontaminate the Radium Dial plant when it closed, despite proof of the dangers confirmed by Argonne's research, until the state of Illinois voted to approve funds to tear down Luminous Processes in 1984. Moreover, despite the purported value of the research to those who conducted it, none of the Radium Girls were compensated for participating in the tests at Argonne. One worker, Charlotte Purcell, wrote a heartbreaking letter to Argonne requesting financial help for her hospital bills—which the laboratory did grant.[40]

Coming back for a moment to Reeve's *The Deadly Tube*, it's worth underscoring that his "scientific detective" Craig Kennedy stated: "The imagination of the most sensational writer of fiction might well be thrilled with the mysteries of this fatal tube and its powers to work fearful deeds."[41] Despite the seemingly predictive plot of his book, Reeve unwittingly distanced his readers from the extent to which the physical effects and future ramifications of radium would spread.

Indeed, it is painful to read the detailed patient files gathered and studied by Argonne, as well as research conducted by Robley Evans at the Massachusetts Institute of Technology's Radioactivity Center. Most of the cases

go by numbers instead of people's names, justified as a way to ensure ano-
nymity, but nonetheless dehumanizing. Among the many subjects tested,
Case 05–215, who was born in 1887, is paradigmatic; her files document a
litany of horrific side effects, both physical and mental.[42]

In disturbing contrast, some reports include rare moments in which
radium was portrayed as a literal bright spot in the sufferers' lives: one
recounts the use of black light in a bar on LaSalle Street, which allowed
the girls to glow.[43] Some of the girls were also filmed for Pathé's *Dawn of a
Miracle* (circa 1920). The images from the film in figures 1.4a–e indicate that
it also heralded radium's "new light" as the way of the future, as a novelty
and a business opportunity. The disconnect between the visual represen-
tations of the time and the actual lives and trauma of radium victims is
striking.

Stories of the Radium Girls remain deeply rooted in our current-day con-
sciousness and contemporary representations are less disconnected. They
surface in the arts and popular culture, inspiring for example the subplot of
a 1994 American comic book *Wolverine: Evilution*, in which two young boys
make headlines after they find a can of glowing green paint near a nuclear
plant, cover their faces with it, have fun glowing in the dark, and die
shortly thereafter. Erika Kobayashi not only mentions the Radium Girls in
her manga *Luminous*, in which she also represents Fuller's "Radium Dance,"
but she also called her post-Fukushima nuclear disaster album *Radium Girls*
(2011), made in collaboration with the legendary Japanese singer Phew and
the German electronic music composer Dieter Moebius. In literature, Kurt
Vonnegut mentions the radium dial industry in his novel *Jailbird* (1979),
noting cynically yet bluntly that the women employed "had died or were
about to die most horribly with their bones crumbling or their heads rot-
ting off." In her novel *Radium Halos* (2009), Shelley Stout creates a compel-
ling narrator in a sixty-five-year-old woman, residing in a mental hospital,
who worked alongside her now-deceased sisters and aunt in the Ottawa
factory in 1923. Among the large number of contemporary dramas paying
tribute to their stories today is *Radium Girls* (2000, by D. W. Gregory), which
raises issues concerning the commercialization of science and the respon-
sibility for health and safety in the workplace. The play titled *These Shining
Lives* (2008, by Melanie Marnich) focuses on Catherine Donohue's judicial
struggle. And Eleanor Swanson, in her poem "Radium Girls" (2002), force-
fully asks, "Would you die for science?"[44]

It comes as no surprise that most of these artists are female. Claudia
Clark has underscored the imbalance of power that existed for the working-
class teenage girls and the few women scientists in a corporate radium

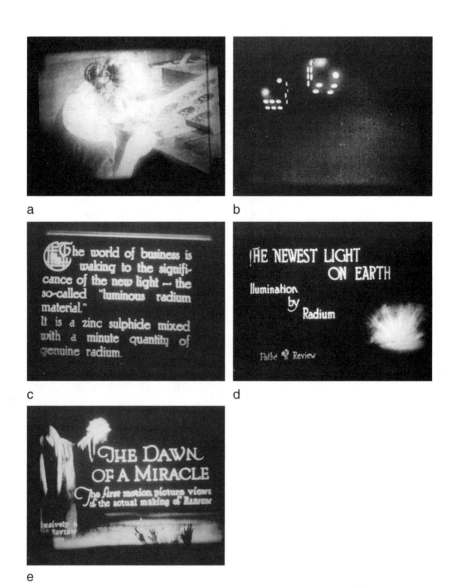

Figures 1.4a–e
Stills from *Dawn of a Miracle*, Pathé film (circa 1920).

industry dominated by male-owned corporations and male scientists.[45] The patriarchal exploitation of women is, in this case, beyond argument. As we analyze and take in the cultural production of the atomic age, before the Hiroshima and Nagasaki bombings and into our post-Fukushima context, we see a great number of female artists and scholars playing a central role in giving visibility to that age and its arts.

As I demonstrate in chapter 2, the artworks inspired by stories of the Radium Girls are only a drop in the radioactive ocean compared to those spurred by the experiences of global *hibakusha* after Hiroshima and Nagasaki and other irradiations until Fukushima. But the girls (who can be called radium *hibakushka*), the radium that poisoned them, and the historical events documented in case studies remain central in works leading up to and after the use of atomic weapons. In radium literature of the pre-Hiroshima era, a particularly compelling pattern of stories involved radium bandits that are, here again, not weapon-related.

Radium Bandits: Dick Fann and Arsène Lupin on the Case

Several novels, published mostly in Europe and especially in France, incorporated Sherlock Holmes–like characters into Jules Verne–like adventure stories in which the search for radium thieves takes readers on vicarious voyages across the world. One of the first of this kind was Paul d'Ivoi's *La course au radium* [The Race for the Radium, 1908] (figures 1.5a–d), later republished as *Le radium qui tue* [The Radium That Kills]. The novel centers on Dick Fann, a skilled but amateur British detective. A Canadian woman named Fleuriane, with family ties to a world association of precious stones traders, hires him to stop greedy villains from using radium to pass off ordinary specimens of the mineral corundum as expensive gemstones.

For the villain to achieve his goal, he and his gang must procure all of the corundum existing on the planet and, more importantly, remove all the radium from the great laboratories worldwide, among them Marie Curie's, "where this bizarre and enchanting body called radium was studied." All the radium amounted to "23,718 grams," which once stolen could not be replenished for twenty years.[46] Dick and Fleuriane conduct an undercover investigation while participating in a car race looping from Paris to Le Havre, then from New York to San Francisco, across Alaska to Siberia, Russia, Germany, and back to Paris. Myriad adventures ensue.

Other fictional narratives in the same vein similarly avoid mention of atomic destruction. Henry de Graffigny, in *La caverne au radium* [The Radium Cave, 1927] (figure 1.6), tells the story of French travelers shipwrecked on

Vous allez entreprendre un autre voyage. (Page 23.)

Figure 1.5a
Book cover for *La course au radium* [The Race for Radium] by Paul d'Ivoi, collections "Voyages excentriques," Boivin et Cie Editeurs, 1909. Courtesy of the Curie Museum.

Figure 1.5b
"You will undertake a journey," illustration from *Le radium qui tue* [The Radium that Kills] by Paul d'Ivoi, Tallandier Edition, illustration by Maurice Toussaint, 1948.

the shores of South America, encounters with violent Toba (Qom) Indians, and a race for gold and precious metal. On one expedition the members of the French group accidentally stumble into a radium cave, and thus bring the financial and scientific fortune home to their family.[47] In *Le désert du froid qui tue* [The Desert of the Killing Cold, 1922], by Christian Brulls—later republished as *Le yatch fantôme* [The Ghost Yacht], two scientists travel the world in search of a cave large enough to hold a wealth of uranium so they can continue their research in medicine.

During the interwar years and into World War II, the nationalities of the evil-bandit characters in radium literature reflect the changing dynamics among nations. A short novel also titled *La course au radium* [The Race for the Radium, 1936] by the French author Michel Darry, follows a French journalist who investigates radium mining in Canada during the "radium

L'anglais s'était agenouillé sur le tapis. (Page 58.) *Cachez cela !* (Page 102.)

Figure 1.5c
"The Englishman was kneeling on the carpet," illustration from *Le radium qui tue* [The Radium that Kills] by Paul d'Ivoi, Tallandier Edition, illustration by Maurice Toussaint, 1948.

Figure 1.5d
"Hide this!," illustration from *Le radium qui tue* [The Radium that Kills] by Paul d'Ivoi, Tallandier Edition, illustration by Maurice Toussaint, Pierre Lafitte Edition, 1922.

rush."[48] (Although several radium and uranium mines did exist in Canada at that time, the mention of them in novels of this period are rare; I come back to the topic of mining in chapter 2 and 7.) The journalist, helped by a British counterpart and a Canadian Indian, succeeds in stopping the evil German journalist from mishandling radium.

Maurice Leblanc, the renowned author of the series *Aventures extraordinaires d'Arsène Lupin* [The Extraordinary Adventures of Arsène Lupin], also cast a German as the evil thief in *La pierre miraculeuse* [The Miraculous Stone, 1922] (figures 1.7a–d). This novella is the second part of a longer work titled *L'Île aux trente cercueils* [The Island of the Thirty Coffins, 1920]. The complex plot (set after World War I) follows the German thief, who hopes to fulfill a prophecy that would see him crowned as the "chosen

Figure 1.6
Book cover for *La caverne au radium* [The Radium Cave] by Henry de Graffigny, J. Ferenczi et Fils editions, 1927. Courtesy of the Curie Museum.

Figure 1.7a

L'Île aux trente cerceuils, 2eme partie: La pierre miraculeuse [The Island of the Thirty Coffins, Part 2: The Miraculous Stone] by Maurice Leblanc, illustration by Maurice Toussaint, Pierre Lafitte Edition, 1922.

CONTENT DE SON PRÉAMBULE, IL SE REMIT A MARCHER DE LONG EN LARGE (p. 6).

Figure 1.7b
"Happy of his preamble, he began to walk up and down," illustration of *L'Île aux trente cerceuils, 2eme partie: La pierre miraculeuse* (The Island of the Thirty Coffins, Part 2: The Miraculous Stone) by Maurice Leblanc, illustration by Maurice Toussaint, Pierre Lafitte Edition, 1922.

one." He performs cruel sacrificial rituals and crucifixions (particularly of women), hoping to obtain the precious God-Stone, described as dating from the time of pre-Christian cults in Bohemia.

In a long passage, as several characters try to decipher the powers of this miraculous stone, one explains that it contains properties characteristic of radium. "You've said it, my boy: radium," he proclaims. "Phenomena of radioactivity occur more or less everywhere, and we may say that they are manifested throughout nature, as in the healing actions of thermal springs."[49] Leblanc significantly locates the God-Stone in Joachimsthal, which is the German name for the Bohemian spa town Jáchymov, now part of the Czech Republic. Most radium mining before World War I took place in Jáchymov. The Curies obtained their radium from the pitchblende deposits in mines there, and visited spas in the town itself.

In *The Big Four* (1927) the renowned British mystery writer Agatha Christie leads her most famous character, the Belgian detective Hercule Poirot, to

TOUT EN MAINTENANT LA VICTIME DEBOUT, ILS TIRÈRENT SUR LA CORDE. VORSKI REÇUT LA
MALHEUREUSE, ET L'ATTACHA SUR LE FUT DE L'ARBRE (p. 24.)

Figure 1.7c
"While holding the victim upright, they pulled the rope. Vorski received the poor
woman and tied her to the tree's bole," illustration of *L'Île aux trente cerceuils, 2eme
partie: La pierre miraculeuse* (The Island of the Thirty Coffins, Part 2: The Miraculous
Stone) by Maurice Leblanc, illustration by Maurice Toussaint, Pierre Lafitte Edition,
1922.

ET DEPUIS UNE HEURE QU'ILS SONT AU JARDIN, L'ENFANT NE CESSE DE POSER
DES QUESTIONS A SON SAUVEUR (p. 70.)

Figure 1.7d
"And for the hour in which they are in the garden, the child cannot cease posing questions to his saviour," illustration of *L'Île aux trente cerceuils, 2eme partie: La pierre miraculeuse* (The Island of the Thirty Coffins, Part 2: The Miraculous Stone) by Maurice Leblanc, illustration by Maurice Toussaint, Pierre Lafitte Edition, 1922.

a French scientist, Madame Olivier, who claimed she was victim of radium thieves. Madame Olivier had a "wonderful power … with her long nun's face and burning eyes" and was the "brilliant successor of Becquerel and the Curies."[50] Poirot eventually discovers that Madam Olivier and a group of three other distinguished characters (from America, Britain, and China) were plotting to dominate the world—an omen of the Cold War's nuclear arms race.

In *The Radium Terrors* (1911) by the British-Australian writer Albert Dorrington, the bandits were not from Germany, France, America or China but—noting that this novel dates to pre–World War I—from Japan (figures 1.8a–c). The plot is rife with racist and orientalist overtones, including a description of the Japanese as "Asiatic ruffians" who train a house rat to carry out their dirty work.[51]

In this early narrative, even though no precursors to atomic weapons are involved, anxieties provoked by their harmful use in science or by their potential use in the military lie under the surface. The main character, Gifford Renwich, is employed by an international inquiry bureau in London to track down the radium bandits. He identifies them as a Japanese doctor / nerve specialist, Teroni Tsarka, and his sidekick, Horubu, a boorish former military man, who have hatched an elaborate plan to extort money from wealthy, distinguished art patrons: during an exhibition they trick a Japanese artist into poisoning the viewers with a sponge infused with radium as they watch his microscopic painting, called the "Haunted Pagoda," with a stereoscope. The point was to bring the patrons to the Radium Institute, which the evil pair controlled, so they would spend their fortunes to be cured. Motivated by more than profit, however, the doctor hoped to entice a young, talented female scientist from America, Beatrice Messonier, a character modeled on Marie Curie, to work at the institute; she had been rejected by male doctors in Britain because she was both a woman and a foreigner. Ironically, the novel could have been noted for its pre-feminist plotline, except that the Western women in the book are empowered at the expense of the non-Western people.

The injuries these art patrons suffered range from effects of radium poisoning were mostly imaginary: painful blindness, a skin "covered with a multitude of dark spots" and a "fixed purple moustache."[52] But the references to scientific and military cooperation and to the frenzy around the rarity of radioactive ore in this 1911 novel seem chillingly prescient. As the doctor says to his trained house rat, "What do you think of the radium blood-trail, my little magic worker? Men have died for gold, but this year

"THE DUCHESS OF MARISTER WAS CONDUCTED TO THE
SCARLET ROOM AND STOOD GAZING AT THE PICTURE CALLED
'THE HAUNTED PAGODA'"

Figure 1.8a
Illustration for *The Radium Terrors, A Mystery Story* by Albert Dorrington, W.R.
Caldwell & Co Editions, 1911.

"HE LOOKED ONCE AT PEPIO AND THEN AT THE YOUNG
DETECTIVE. 'YOU MAKE GREAT INTRUSION,' HE GROWLED"

Figure 1.8b
Illustration for *The Radium Terrors, A Mystery Story* by Albert Dorrington, W.R.
Caldwell & Co Editions, 1912.

"'DRAG THE BEAST OUT! TIE HIM TO THE CAR WITH HIS OWN ROPE!' STICKS AND UMBRELLAS SMOTE AND STABBED IN HORUBU'S DIRECTION"

Figure 1.8c
Illustration for *The Radium Terrors, A Mystery Story* by Albert Dorrington, W.R. Caldwell & Co Editions, 1913.

they will slay and poison each other for the god in the pitchblende!" Similarly, he proclaims: "Men who handle radium constantly become possessed of two devils—one good, one full of malice toward humankind."[53]

Other works of pre-Hiroshima radium literature imagine the atom used in ways other than good/evil compound we've already explored. Picking up on a theme in the subplot involving the young female scientist in *The Radium Terrors*, we move on to the next section, in which I examine not only feminist plots and authors, but also the potential for new energy and aircraft technologies that anticipate a discussion of the civil/military use of the atom at the chapter's end.

The Red Star, Women's "Secret Power," and Mighty Atomism

In an era in which women's suffrage, female scientists, hot-air balloons, transatlantic air races, and female pilots and combat pilots were making headlines, issues of gender equality and political systems in opposition were beginning to surface in radium literature; meanwhile the various uses for the imaginary radium-powered aircraft that appeared in its pages explored the possibility of travel in outer space.

In Russia, one such imaginary aircraft fueled the elaborate and fascinating story of Earthlings, Martians, and a social (communist) revolution, as told by Alexander Bogdanov in *Red Star: The First Bolshevik Utopia* (1908). Bogdanov, himself a Bolshevik, was also a science fiction writer, philosopher, and a physician; this book borrows from the latest in scientific advances as well as from Marxist doctrine and feminist thinking. The plot features several highly accomplished female Martian scientists, progressive ideas about sexual freedom, and other surprisingly elaborate feminist turns in the narrative.[54]

Leonid, the story's narrator and protagonist, meets a Martian disguised as an Earthling, who convinces him to embark on a journey to Mars. He discovers that Martians have built an aircraft powered by "a certain radioactive substance ... [and] have discovered a method of accelerating its decay by hundreds of thousands of times." They have also created a unified planet and an, efficient society in which people are equally qualified to succeed in many professions, and to fulfill job assignments based on societal need. Their grasp of science was so grand that, as one Martian explained, they "knew about radioactive elements and their decay long before Curie and Ramsay, and our analysis of the structure of matter has come much further than theirs."[55]

Another fascinating atomic aircraft is the one imagined by Marie Corelli. Known for melodramatic plots and mystical undertones, Corelli was a prolific, best-selling author from the late Victorian to the Edwardian age whose readers ranged from shop girls to Queen Victoria and the Prince of Wales.[56] Even though the literary style of Corelli's novels is tedious because her characters' emotions are overblown and overemphasized, her expressions of the gender, scientific, and political components of the atomic age are particularly well stressed.

The Secret Power (1921) is paradigmatic in its interlacing of many components. The historical contexts of Marie Curie's discovery and female pilots of the period are central to the story Corelli constructs: the main character is a female scientist (and also a kindhearted heiress) named Morgana Royal, who has discovered a secret "wrapped up like the minutest speck of a kernel in the nut of an electron."[57] From this secret she designs and pilots an atomic-powered vessel and a healing potion. The plane, called the "White Eagle," operated as follows:

Morgana set one of the tubes she held upright in the socket made to receive it, and as she did this, fine sharp, needle-like flashes of light broke from it in a complete circle, filling the whole receptacle with vibrating rays which instantly ran round each disc, and glittered in and out among them like a stream of quicksilver.[58]

In opposition to Morgana Royal, Corelli depicts her fellow scientist in the novel, Roger Seaton, as an egocentric, heartless misogynist whose experiments in New York on the "condensation of radioactivity startled America." He had also fashioned a bomb that "glittered like gold" and had tried to sell it to the United States and Great Britain in vain. In a fit of frustrated rage, he set off the bomb in California, proclaiming: "There shall be no more wars! There can be none! I say it!—My great secret! I am master of the world!"[59] Everyone attributed the ensuing destruction to an earthquake, and therefore to an act of God—an ironic assumption given Seaton's megalomania. Seaton somehow survived the disaster, although he never regained his mental faculties.

In radium literature, even before Hiroshima, many novels thus deal with the duality of the atom itself, or rather, with the duality of the technology of its use. There is an evident epistemological shift from previous philosophical atomist views. Corelli's novels are symptomatic of this shift: *The Secret Power* relates to scientific uses of the atom, but her previous novel, *The Mighty Atom* (1896) still uses the atom to discuss the opposition between determinism and free will or at least non-theological explanations of the world.

In *The Mighty Atom*, Corelli rails against secular education developed in France at the time. Her main character, an eleven-year-old boy named Lionel, has been subject to rigorous secular studies from a succession of professor-tutors and a cold authoritarian father. When he asks what one tutor thinks to be impudent questions, such as "Where is the Atom?" and "Are you quite sure the First Cause [of everything] is the Atom?," a long debate begins.[60] The tutor swings "a heavy battering-ram of explicit fact against the child's argument" giving no answer to the meaning of life other than:

As a matter of positive truth and certainty, atoms *do* rule us! ... The atoms of disease which breed death,—the atmospheric atoms which work storm and earthquake,—the atoms which penetrate the brain-cells and produce thought,... the development of worlds and the progress of man,—good heavens!—... but you are too young to understand,—you could never grasp the advanced scientific doctrines of the day.[61]

In contrast, the sexton of the village church, who is also the father of Lionel's playmate Jessamine, has tried to provide Lionel with heartfelt, joyous, *religious* life lessons. When Jessamine dies of diphtheria, the sexton's assurance that God's way is the best way sends Lionel into despair who finally hangs himself in his schoolroom to find out by himself if God exists.[62]

The chilling end to Corelli's *Mighty Atom* reflects the trend of her times in relation to secular education all the while parting from the ancient Greek philosophical positions while in her 1921 work *The Secret Power*, only scientific uses of the atom are narrated. The epistemological atomist tradition of discussing free will and determinism in connection with atomic particles, however, continued to some extent with the divergence between Heisenberg's uncertainty principle (and the Copenhagen interpretation) and Einstein's theory of relativity. Against the Copenhagen interpretation, is Einstein's famously stated words that "God does not play dice with the universe"[63]—even though his statement related more to predictability in the laws of nature than to an interventionist God. In *The Evolution of Physics*, Einstein referred to Democritus, even though he found that the materialist theories were a figment of the imagination. And Heisenberg, in a conference that took place in Geneva in the late 1950s titled "Man and the Atom," thought modern physics renewed the problem of idealism in Plato. (Plato defined the atom as having variable geometrical shapes, which is further explored in the next chapter.)[64]

Marie Curie's "Secret Power" in World War I

In the many tales of radium bandits and atomic-powered aircraft before Hiroshima, the threat of war lurked, even if not in explicit ways, which led to themes involving the military use of the atom not only in radium literature, or at least of mad scientists crafting atomic or radium bombs.

Both David Dowling and Paul Brians refer to *The Crack of Doom* (1895) by Robert Cromie as the first work in which nuclear devices are described. It tells the story of a mad scientist crafting an atomic bomb (better analyzed in the next section). For Dowling, who only mentions Cromie's short novel in passing, such stories can be explained because "there was a drawing sense that technology would soon give man Faustian destructive powers."[65] Similarly, Brians only lists it with other doomsday narratives such as George Griffith's *The Lord of Labour* (written in 1906, published in 1911) and Well's 1914 novel *The World Set Free* and its emphasis on deterrence. For Brians, the several plots anticipating nuclear deterrence or "muscular disbarment" were in fact "repetition of the hopes expressed upon the invention of weapons such as TNT."[66] In addition, World War I also later contributed to the feeling of impending doom. In reality, and not just in literary fictions, the military/civilian use of the atom is a compound that also was prevalent before Hiroshima together with the involvement of scientists (albeit in a different way than for the Manhattan Project). The writings of Marie Curie during World War I provide an important historical and alternative view of the scientist's involvement in war efforts.

In Curie's 1921 *La radiologie et la guerre* [Radiology and War], which greatly contributed to my own thinking about writing *Invisible Colors*, she detailed the latest scientific and material developments and their impact on French civilians, medicine, and hospitals, ultimately stating: "Human suffering asks urgently to be relieved, and medical science, for a great part still condemned to empiricism, never fails to try an attempt that offers new hope." With a medical team, Curie had developed a mobile radiology unit that could fit into a car, and could therefore go wherever it was the most needed during World War I to help track broken bones and bullets beneath the skin. Her radiotherapy unit depended primarily on X-rays, since medicinal applications of radioactivity were still being developed. In her book she documented not only what she observed during the war but also her hopes for such technology in the future.[67]

Postwar, in 1921 therefore, her hope was to use what she then called "radiumtherapy." The treatment depended on the penetrating proprieties of radium's rays, which are stronger than X-rays. She intended it for cauterizing

wounds but also for its "energizing" properties. She recommended it as a treatment for arthritis, and, most importantly, to cure cancer—which she called "one of the most terrible wounds of humanity." Such applications were at a very early stage; she mentioned some experiments conducted on "small animals" and how quickly the doses can become deadly.[68]

As Curie explained it, the extensive use of radiology techniques on military personnel resulted in hospitals being permanently equipped with enhanced and efficient equipment for civilians. Her statement relates to an ongoing argument still debated today: that war is one precondition for scientific development—thus justifying (if not giving meaning to) ghastly war casualties.[69] But she concluded her book with these words: "The great catastrophe that unleashed onto humanity, accumulating victims in dreadful numbers, provoked the ardent desire to save everything that can be saved by reaction, to deeply exploit all the means by which human lives can be spared and protected." She further stated the role she envisioned for future scientists and research: "Such new source of light, fruit of the patient efforts of the savant in his laboratory, one day will spread its glare onto humanity."[70] Curie saw the power of the mind "unlimited," yet at no point does she mentions its possible usage for military purposes.

On the contrary, in 1939, Einstein had sent several letters to President Franklin Roosevelt explaining the advances of nuclear technology and its possible military use by Nazi Germany (and further analyzed in the next chapter). Although he never contributed to the Manhattan Project scientifically, Einstein always regretted his involvement in advocating it, and signed the Russell-Einstein Manifesto (against the further development of weapons of mass destruction) on July 9, 1955, at the height of the Cold War. Of course President Dwight Eisenhower's 1953 "Atom for Peace" speech made to the United Nations also greatly contributed to broadcast the idea of the dual aspect of nuclear technology—even though this dual aspect already existed, considering that the good/evil use of science (and technology) is not solely characteristic of nuclear power. In any case, the "peaceful" use of the atom existed before Hiroshima, through the Curie's search for medical applications of radioactivity.

Atomic Doomsdays and Penguins in Radium Literature

As previously mentioned, one of the first novels to explore the civilian use of the atom, and at the same time to anticipate future military use, is *The Crack of Doom* (1895) by Robert Cromie, an Irish novelist and journalist. The story focuses on the Englishman Arthur Marcel, "doctor in all but the

degree," and Herbert Brande, a wealthy, fanatic scientist.[71] Having fallen in love with Brande's beautiful sister Natalie, Marcel joins his secret scientific society to stay close to her but soon discovers that he is entangled in its diabolical plan to blow up the earth. Brande has concocted an atomic weapon for that purpose, and Marcel is determined to foil Brande's plan.

Brande believes the "indestructibility of the atom" to be a fallacy, "a creed of cruelty writ large, ... [which] makes the whole scheme of what is called creation fall to pieces. ... As the atom was the first etheric blunder, so the material Universe is the grand etheric mistake."[72] In order to restore the universe's elemental ether, Brande asserts that the earth must be destroyed.

Toward the end of the novel, Marcel accompanies Brande, Natalie, her friend Edith Metford and several society members to an island near Java. En route Metford and Marcel drug Brande and alters the formula of the bomb. What is destroyed is not the earth but an island near Java, from which the Western heroes (except Brande) escape, leaving behind the natives to face their lethal fate—a terrible omen to the Cold War. Natalie unfortunately dies on the boat even before the bomb goes off, a sign of her symbiotic relationship with her brother.

Despite its depiction of the bomb and the machinations of the secret society, the book does more than tell the tale of a murderous lunatic. It explores other contemporary realities, such as socialist leanings in politics and the emergence of feminism, especially regarding women's rights and their fight for the vote. One scene indicative of the many differences in worldview between Marcel and Brande occurs when Marcel discovers Natalie and her friend dressed like men, smoking cigarettes, and behaving in otherwise assertive ways; images of the "New Woman" they conjure repulse Marcel, women wearing "knickerbockers" being particularly repellent.[73] The mad scientist Brande, however, seems unfazed by feminism and gender confusion; in fact, Cromie's characterization of Brande as a fanatic male proto-feminist seems to play off Marcel's fears that unmanly men are capable of destroying the world if left unchecked. Edith Metford had initiated the plan to stop Brande and survives, though she wears knickerbockers, but she is of no romantic interest for Marcel: the "nuclear couple" (the heterosexual nuclear family) has been split wide open like the atom, never to be reconciled (in the novel). It is worth noting the difference between Cromie's Brande, a male with feminist leanings capable of ending the world, and Corelli's Seaton, a male scientist who was ultimately rendered powerless by his ambition and incapacity to love.

The description of the exploding bomb is vivid and suggests the power of an earthquake as well as a spontaneous combustion of fire. It thus evokes a terrible image of atomic bomb tests to come:

A reverberation thundered out which shook the solid earth and a roaring hell-breath of flame and smoke belched up so awful in its dread magnificence that every man who saw it and lived to tell his story might justly have claimed to have seen perdition. In that hurricane of incandescent matter the island was blotted out forever from the map of this world.[74]

Other pre-Hiroshima descriptions of atomic bombs could be found in the background of plots with other societal preoccupations of the time. The French writer Anatole France's *L'Île des pingouins* (Penguin Island, 1908) is a hilarious atheist novel playing off the aspirations of secular France and the use of bombs by its anarchist and anti-bourgeois groups of the 1890s.

The storyline follows a society of penguins mistakenly baptized by a deaf monk with bad eyesight. In an effort to cover up the monk's faux pas, God transformed them into beings that were half-human and half-penguin. Anatole France thus draws a satiric portrayal of human (i.e., Christian) societies from the Dark and Middle Ages through the Renaissance and into the future.

The novel is full of ironic juxtapositions. For instance, toward the end of the novel, in the midst of people discussing happiness, a group of anarchists plant a radium bomb in front of a hotel.

The experts chosen by the courts discovered nothing that enabled them to determine the engine employed in the work of destruction. According to their conjectures the new explosion emanated from a gas which radium evolves, and it was supposed that electric waves, produced by a special type of oscillator, were propagated through space and thus caused the explosion. ... At last two policemen, who were passing in front of the Hotel Meyer, found on the pavement, close to a ventilator, an egg made of white metal and provided with a capsule at each end. ... Scarcely had the experts assembled to examine it, than the egg burst and blew up the amphitheatre and the dome. All the experts perished, and with them Collin, the General of Artillery, and the famous Professor Tigre.[75]

The novel also conveys its cynicism in ways that were meant at the time to be entertaining and lighthearted, but that resonate grimly today:

During the three weeks that followed no outrage was committed. There was a rumour that bombs had been found in the Opera House, in the cellars of the Town Hall, and beside one of the pillars of the Stock Exchange. But it was soon known that these were boxes of sweets that had been put in those places by practical jokers or lunatics.[76]

Thus, in these novels by Robert Cromie and Anatole France, the crafting of bombs is not directly related to military influences but rather to large-scale destructive forces. On the other hand, only a thin line separates them from fictional narratives in which scientific and governmental (and at times military) forces are more clearly identified.

H. G. Wells crafted bombs in his fictional plots with both authority and authenticity. Wells referred to the chemist William Ramsay, and to Ernest Rutherford and Frederick Soddy, crucial scientists in study of radioactivity, in the first sentence of *The World Set Free* (1914), a novel that addressed the atom in terms of energy and as a means of destruction (a war to end all wars). According to Richard Rhodes, Wells had read Soddy's 1909 book *Interpretation of Radium*, in which the possibility of harnessing energy and weapons was mentioned even though Soddy himself thought it could not be done.[77]

Atomic bombs, war, weapons, or doomsday holocausts were also explored more or less directly in works such as "The Last Unscientific War" (1919), an article published in the *English Review* by Civis Milesque, and *The Millennium: A Comedy of the Year 2000* (1924) by the American writer Upton Sinclair. Sinclair's plot centers on a group of wealthy elite who escape a radium doomsday caused by a "purplish gas" called "X-radiumite." Finely dressed and adored with glittering jewels, they try to prevent a scientist to continue his research on X-radiumite after reading about it in the press. Not wanting to stop his studies, the scientist then uses the "highest achievement of military art in the year 2000": some weapons "which could be carried in a man's vest-pocket" and could kill "by means of radium emanations." Everybody on the planet dies except for eleven people who escaped by flying on a high-speed airplane going at a thousand miles an hour. The scientist's act is interpreted as a form of rebellion by one of the members of the elite: "Merciful providence, will there never be an end to my troubles? First the labour unions rebel! Then the engineers rebel! Then the women! Rebels, all rebels! And they want to kill me!"[78]

Another compelling narrative of atomic doomsday is by the Czech writer Karel Čapek, who imagined the "Karburator," a device that had the capability to annihilate matter in order to generate an endless source of cheap energy, for his novel *The Absolute at Large* (1922).[79] As a by-product of this energy, however, he envisioned "the absolute," an essence he portrayed as capable of causing global war. Such godlike power exacerbated nationalist and religious feelings among the characters, as in the following passage, which also gives an example of Čapek's humorist tone: "The German Monist Association laid in Leipzig, with great pomp and ceremony,

the foundation-stone of the future Cathedral of the Atomic God. There was some disturbance, in which sixteen persons were injured and Luttgen, the famous physicist, had his spectacles smashed."[80]

In Japan, among the few Japanese pre-Hiroshima bomb stories, a scientific accident leads to the development of a uranium 235 bomb dropped on San Francisco in "San Furanshisuko Fukitobu" [The Obliteration of San Francisco, 1944]. According to Nakao Maika, these stories were evidently responses to the Pearl Harbor bombing in 1941, but also to the fact that a scientist died from an experiment wrongly attributed to nuclear military research, referred to as "the Odan Incident."[81]

The destructive use of the atom was explored in a 1916 French film, *Les effluves funestes* (The Dire Emanations, 1916) by Camille de Morlhon, in which an engineer, who spent his life and all his money building an explosive device, powered by a combination of radium and rays, dies while trying to trigger the device.[82] An American play that Brians noted, *Wings over Europe: A Dramatic Extravaganza on a Pressing Theme* (1928), by Robert Nichols and Maurice Browne, involves a British scientist who has learned to harness atomic energy but is repulsed by his government's militarism and its insistence on keeping the knowledge secret rather than release it to the world.

Paul d'Ivoi imagined a radium-powered ray-gun in *Millionaire malgré lui* [A Millionaire in Spite of Himself, 1905].[83] Radium bullets were mentioned in George Griffith's *The Lord of Labour* (1911) and Edgar Rice Burroughs's *Under the Moons of Mars* (1912). And the British philosopher and writer Olaf Stapledon concocted an atom gun in *Last and First Men: A Story of the Near and Far Future* (1930), a novel that looks ahead two billion years and examines civilizations of eighteen different human species. The gun was designed and operated by a young Mongol and was "like the old-fashion rifle," but by using the positive and negative forces of the atom it could annihilate the planet. To demonstrate its might, he fired it with an antidote, destroying an island in a "gigantic mushroom of steam and debris." The book also narrates a doomsday explosion caused by the mining of minerals, and depicts several other technologies such as "ethereal radiation," which would help the human brain become telepathic.[84] Finally, the science fiction writer Unno Jūza mentioned a nuclear submarine and an atomic bullet weapon in "Chikyū Yōsai" [Fortress Earth, 1940–1941] (inspired by the cyclotron that Japan possessed that was second only to its American counterpart).[85]

Because most of the bombs created in radium literature explode like earthquakes (or erupting volcanoes followed by floods for Wells), the casualties are therefore far removed from those of atomic bombs as described

by *hibakusha* writers after Hiroshima. It might be rare to find atomic bombs as we know them now manifest in the imaginations of authors of pre-Hiroshima literature, but those bombs were in fact understandable in the context of World War I and the interwar (and even as far back as the anarchist movements of late nineteenth-century France).

In this chapter's exploration of the pre-Hiroshima and Nagasaki days we've seen the good/evil references to the atom give way to early responses to its civilian/military use. Those dualities surfaced in artworks ranging from radium dances, literature based on stories of the Radium Girls, and tales of radium bandits to early imaginaries of atom-powered aircraft, weapons dreamed up by mad scientists, and societies subject to change for better or worse. But it is after Hiroshima and the Atom for Peace speech, as we will see in chapter 2, when the good/evil compound that inspired artistic responses dissolved into full-fledged responses to the atom's civilian/military use. Although that civilian/military use of atomic technology is historical and central to both science and the arts or humanities, another central and tenacious compound that is equally vital to consider—the East/West —will lead us also to examine political/apolitical responses to cultural production from post–atomic bombings to Fukushima.

2 From Hiroshima to Fukushima

Prior to Hiroshima and Nagasaki, the framework of artistic responses to the atomic age—and, notably, to the depictions of imagined atomic weaponry that existed in Western and Japanese literature—ranged from good/ evil to military/civilian uses of the atom. After World War II and the bombings, however, responses shifted to envelope viewpoints based on other compounds—Eastern/Western being predominant among others, including those with artistic/scientific and political/apolitical origins—even though these had been present in earlier responses.

The East/West compound or non-Western/Western is the most prevalent. Unarguably, it is a reductive one. Myriad cultures and ethnicities have been irradiated that can hardly be separated into two poles. But when it comes to depicting the actual bombings, profound differences between postwar Eastern and Western artworks are evident for reasons other than the differences in culture, the first being that Japan experienced the bombings directly, as did other affected populations, including Oceania and the many mining *hibakusha* in African nations, as well as native territories in the US and Canada. Their histories must become visible. The East/West is thus a central but nuanced epistemological compound to address.

Admittedly, when we talk about East/West responses, this includes but goes beyond the power imbalance created because the West bombed the East or the ensuing competitiveness that emerged between the East and West during the Cold War. The combined political and scientific power held by the West postwar and post-Hiroshima, however, is not unique to Western culture, as Amira Bennison has shown in her 2010 study *The Great Caliphs*.[1] In the eighth-century translation movement of the 'Abbasid Empire (or caliphate), ancient sciences and knowledge were translated in one single language, Arabic, and thus played an important role in the further development of scientific knowledge. The ensuing analyses resulted for example in the triad of algebra, alchemy, and algorithm.[2] Surpassing its

reputation as "the saviour of European science," the translation movement also contributed to philosophy and medicine, and it ultimately helped to reverse the isolation imposed on Europe by the Christian emperor Justinian, who in 529 closed down the nine-centuries-old Academy of Plato in Athens and set in motion the five-century-long period known as the Dark Ages.[3] The main difference between the two uses of combined powers, apart from a difference in places and time frames, is the lasting pervasiveness and contaminating ways in which the postwar West used its power.

As centuries passed, East/West history became enmeshed in colonial enterprises. Colonization in the recent past—say, up to the end of the nineteenth century—may seem an irrelevant factor in the response to current techno-nuclear activities simply because it preceded the discovery of radioactivity itself, but its heritage of land and resource appropriation, industrial practices, and art patronage is at the crux of the problem we must deal with in our post-Fukushima context because it still interferes with contemporary politics and energy policies.

At the time of World War II, the aspect of colonization was crucial. In the letter that led to the Manhattan Project, Einstein felt compelled to write to President Roosevelt not only because of advances in nuclear science but also because "Germany [had] actually stopped the sale of uranium from the Czechoslovakian mines which she has taken over."[4] To secure resources, he then suggested "some good ore in Canada … while the most important source of uranium is Belgian Congo."[5]

Uranium mining is generally not considered a part of the nuclear landscape. Richard Rhodes underscored the importance of the mines strategically and geopolitically during World War II but devoted only in a few lines to them in *The Making of the Atomic Bomb* (although he did give the mines a bit more space in *Dark Sun: The Making of the Hydrogen Bomb*). Spencer Weart, in *Nuclear Fear: A History of Images*, only mentioned uranium mining in the US in passing.[6] While it is true that coal mining too had its toll of hazards, exploitation, and pollution, which Emile Zola efficiently portrayed in *Germinal* (1885), the Western mining of ores in Native Indian territories in the US and Canada, in addition to many African countries, makes a postcolonial approach to art of the atomic age even more important to consider, especially as uranium mines were pivotal to the Cold War and to contemporary nuclear devices.

Artistic Nuclear Fallouts in the East and the West: Hiroshima

From the Japanese bombings, to the irradiated Pacific Islanders, and to Native Indians and many other African nations—the terrain of the global

hibakusha is wide, and its representation thus exceeds to that of Western cultural production.

The US bombing of Japan dominates the literature of the atomic age for decades. Although the Japanese representations of Hiroshima and Nagasaki certainly differ from those in the West, we'll see them converge and develop similarities in several cases discussed in part II. As I noted in the introduction, however, due to the focus of their research none of the very few books focusing on the art of the atomic age (by Lynn Gamwell and John O'Brian, for example) consider the historical art and literature of Hiroshima and Nagasaki. Thus very little is known in the West about art by *hibakusha* artists and the voices of the A-bomb victims themselves. In Japan, this genre of writing is known *Genbaku bungaku* (A-bomb literature).

In the West, US journalists were the first to cover the news of the bombings (as well as the metaphorical fallout resulting from them). Key reports written for the *New York Times* by William L. Laurence, who was a special consultant to the Manhattan Project and who also witnessed the bombing of Nagasaki from a B-29 Superfortress, were released to the US War Department. One report that became the basis for President Truman's address to the country (and the world) included these words: "It is an atomic bomb. It is a harnessing of the basic power of the universe."[7] Laurence quickly published his numerous *Times* reports, adding statistics and commentary, in the volume titles *Dawn over Zero: The Story of the Atomic Bomb* (1946). John Hersey's seminal "Hiroshima" (1946), first published in *The New Yorker* (as an article that filled the entire issue), included accounts of *hibakusha* and influenced other writers to take up their pens.

Leonard Engel and Emanuel S. Pillar's novel *The World Aflame: The Russian-American War of 1950* (1947), set just three years into the future from the time of writing, grew out that journalistic influence. The authors drew on Hersey's work, and the narrator they create, a reporter named Ed Craig, even directly references Hersey by name: "'Entire sections of Chicago appeared to be evaporating into pillars of dust which were rising into the atom cloud overhead. Behind these pillars, the sky was red with flame. ... This was Hersey's Hiroshima—ten times worse—in my own country.'"[8]

On the one hand, Hersey's *Hiroshima* was instrumental in offering a window onto the horror of the bombs and for giving a human dimension to the calamity very early on for US and other Western audiences; Hersey used novelistic techniques to build suspense in the intertwined lives of the six survivors whose lives he detailed. (The narrative takes place during the hours and weeks after the attack). Because he included the ordeal of Father Kleinsorge, a German Jesuit priest, the suffering of a foreigner was also given visibility (among the few other priests mentioned). Even though

the priest was German (and thus from an Axis-power country), this still gave attention to the plight of non-Japanese *hibakusha*—an issue that was very political in Japan after the war, as Lisa Yoneyama has underscored. She has explained, for example, the weight of the colonial heritage in the struggle for official commemoration, and the erection of a 1970 memorial for Korean victims of the bomb (and its relocation closer to the Peace Park amid debates in the 1990s), which finally inscribed "their presence onto Hiroshima's and Japan's history and society."[9] In addition, the death of American POWs (prisoners of war) in Hiroshima has also little visibility, even in the US. (These and other political and nationalist issues surrounding the memory of Hiroshima are further explored in part II.) On the other hand, although its effect should not be undermined given the enormous demand for reprints after its first publication, the testimonies from the six victims were mediated via Hersey's narration and edited to fit publication requirements.[10]

Stories that come directly from the victims themselves and from *hibakusha* in general are in fact still invisible, even if their voices were present from the start in Japanese A-bomb literature and in many other mediums: photography, painting, drawing, theater, sculpture, and certainly poetry (including tanka and haiku). Strangely, just enough novels and literary works were translated into English so as to be "accessible," but these accounts continued (for a time) to hide in plain sight. John Dower, who also greatly participated in countering their invisibility, once noticed that "episodically, almost in a cyclical manner ... the American public has shown interest and sensitivity concerning what really took place beneath the mushroom cloud."[11] The same can be said of Western audiences at large. It is true that a great number of the translations were published, a few in the 1960s, but most in the 1990s. Still, in spite of this, the genre of A-bomb literature is still broadly unknown if not unrecognized in the West.

Instead, the images of a razed empty city, the ones taken by the US military (about a month after the bombings) and a few Japanese ones of razed landscapes too, dominate the consciousness. In the artistic landscape, several artworks stand out: The Alain Resnais film *Hiroshima mon amour* (1959), with a screenplay by Marguerite Duras that she later published in a book form, is perhaps the ultimate reference in the West, not only for the harrowing newsreel and documentary footage Resnais incorporated into this story of two lovers—a French actress and a Japanese architect—but also for the intense exchange between the two about the atrocities of the bombing, the futility of war, and their measure of personal suffering. The Japanese film *Kuroi Ame* (Black Rain, 1989)—based on the 1965 novel by Ibuse Masuji

are at times referenced in the West too. The film begins with a graphic depiction of the bombing, and follows one female survivor five years into the future, as the so-far invisible effects of radioactivity continue to tick inside her like a time bomb. There also is Kenzaburō Ōe's *Hiroshima Notes* (1965), a series of essays recently republished on the fiftieth anniversary of the bombing, which addresses moral and political implications of the attack, the survivors' suffering and their dignity, and the Japanese movement to ban nuclear weapons. Ōe has relentlessly tried to give visibility to the victims. Finally, there is Edita Morris's *The Flowers of Hiroshima* (1959). Morris's book was inspired by her son's experience as an intelligence officer in Hiroshima after the bombings.

These works are essential in bringing awareness to the plight of the *hibakusha*, but the words and images of the bombing victims themselves must be given the attention they deserve. Again, the aim in exploring the literature of *hibakusha* writers is not to replace one collective image by another but to complement the visualization of the atomic age and to understand the reasons for its absence as a topic of study in Western scholarship.

To return to a point I proposed at the start of this book, the invisibility of radioactivity does not in itself pose the greatest challenge to the artist. Thus we begin to explore the compound of East/West responses by turning to the arts of Oceania and of the mining Hibakusha.

Barren Landscapes and Bikini Lines

The Cold War and the nuclear arms race had a significant effect on other parts of the world besides the Pacific Islands, notably Russia and China, and especially considering the many nuclear tests entangled with colonization. In these contexts the arts met new challenges from diverse sources.

Responses to the Russian nuclear programs have not been easily accessible in the West (in part perhaps because of the language barrier, and in part because the programs themselves were, wherever located and by design, meant to remain invisible). The works of Toyosaki Hiromitsu, Julian Charrière, and Nadav Kander have brought into view the landscapes where these programs were conducted (even though works on the nuclear disaster in 1986 at Chernobyl have more visibility than works on the military programs). Kander, for instance, photographed restricted military zones along the Aral Sea between Kazakhstan and Russia, where hundreds of bombs were detonated in a remote but lightly populated area until 1989, and where studies were conducted in secret to determine the effects of radioactivity on unsuspecting victims (figures 2.1a–d).[12] Artistic representations like these

Figure 2.1a
Nadav Kander, "Priozersk XIV (I Was Told She Once Held An Oar), Kazakhstan, 2011." © Nadav Kander, Courtesy Flowers Gallery.

are few in number and yet they still outnumber the scant visual accounts of the French tests in Algeria and of the Chinese tests of the time.[13]

On the contrary, the art produced in response to the tests at Bikini and Moruroa Atolls is more accessible. But, just as with the Japanese *hibakusha*, the literary and visual artworks are broadly unknown in the West in spite of having been translated by (or discussed in the translated work of) scholars. No John Hersey–like writer appeared in the middle of the Pacific to collect testimonies. Nevertheless, the Oceanian artistic accounts still glow across time.

The New Zealand literature scholar Michelle Keown inserted a map of nuclear test sites of the Pacific into her book *Pacific Islands Writings*, thus supplementing the visibility given to the Western tests by particularly vivid "indigenous literary responses" (a topic explored further in part III).[14] It is also telling that she included a historical timeline, starting with the settlement of Oceanian ancestors in the area, but also retracing other Western involvements in the Pacific: the British, French, Spanish, Germany, and

Figure 2.1b
Nadav Kander, "Priozersk XII (Theatre Props), Kazakhstan, 2011." © Nadav Kander,
Courtesy Flowers Gallery.

US colonies and annexations, and finally the nuclear tests and contamina-
tions. (She also included a few non-Western involvements in the area by
Japan and Chile.) The Marshallese poet Kathy Jetñil-Kijiner recently and
indirectly completed the timeline in her own book by noting that global
warming is threatening the existence of many Pacific Islands as the sea level
rises, which added to her pivotal 2014 speech at the United Nations.[15]

The impact of Western colonization and its link to the bombings is made
clear in *L'Île des rêves écrasés* (Island of Shattered Dreams, 1991), a novel by
the Mā'aohi and French Polynesian writer Chantal Spitz. In a song from
the people of the island where the story takes place, Tematua, voice of the
eternal Land, sings:

They will come on a boat without with no outrigger, these children, these branches
of the same tree that gave us life. Their bodies will be different from ours, but will
be our brothers, branches of the same tree. They will take our Land for themselves,
they will overturn our established order, and the sacred birds land of sea will gather
to mourn.[16]

Figure 2.1c
Nadav Kander, "Priozersk II (Tulip in Bloom), Kazakhstan, 2011." © Nadav Kander,
Courtesy Flowers Gallery.

In the midst of the Pacific *hibakusha* struggling to be heard, visualizations meant to evoke the tests dominate in the West, such as post-card-like atomic mushrooms rising from once-calm lagoons or hovering over coconut trees. Cold War pictorial tropes of the Pacific, such as those intended to accompany newspaper editorials, are still persistent, and so are other tropes such as the problem of the two-piece swimsuit called the "bikini."

Louis Réard debuted his design in 1946, just five days after the Bikini Atoll nuclear testing began and right on the heels of a less-skimpy version from another Frenchman, Jacques Heim, who called his swimsuit the "Atome." Réard, in his marketing campaign, intended to play off the public's "explosive" reaction. Whatever his intent, giving the name "bikini" to a scandalous new fashion not only pointed ironically to but also sent mixed messages about a form of social control practiced by European Christian missionaries since the nineteenth century: to cover island women's exposed skin with modest clothing deemed appropriate by "men of the cloth."

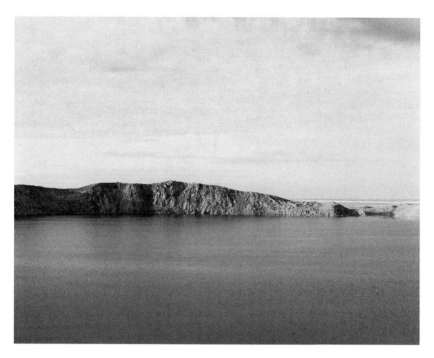

Figure 2.1d
Nadav Kander, "The Polygon Nuclear Test Site X, (Atomic Lake), Kazakhstan, 2011."
© Nadav Kander, Courtesy Flowers Gallery.

As the I-Kiribati and American scholar-poet Teresia Teaiwa sees it: "The sexist dynamic the bikini performs—objectification through excessive visibility—inverts the colonial dynamics that have occurred during nuclear testing in the Pacific, objectification by rendering invisible." The living history of the Pacific Islanders was thus erased. When we think of "bikini," Teaiwa asks, do we think of women whose skin is tanned by the sun's rays or do images of "Bikini Islanders cancer-ridden from nuclear radiation" come to mind? By being encouraged to shave their "bikini line," Teaiwa posits, women have been objectified further, as "the fetishistic aversion for real female genitals extends to female body hair."[17]

Western pictorial tropes of the Bikini Atolls permeate pop culture of the twenty-first century, as Jetñil-Kijiner suggests in her poetry: SpongeBob SquarePants lives in Bikini Bottom. Add to that the imagery and narrative of Disney's blockbuster film *Moana*. Both fantasized views suppress the history of nuclear testing in the atolls and the fact that radioactivity makes the

atoll uninhabitable today—of which the target audience for both, a genera-
tion of parents and their children, may be unaware.

Undeniably, the art of the nuclear islands cannot be approached without
considering the doomsday effect of Western involvement in the Pacific,
beginning more than a century ago with the first missionaries and colonists
and continuing even today given the ecological impacts. But the postco-
lonial angle we adopt must extend beyond the Pacific. Colonial heritages
of other populations were compromised and abused in another invisible
technoscientific device: the uranium mine.

West and East: It's a Corporate World

Mining was already "big business" in a number of countries more than a
decade before Einstein brought uranium to Roosevelt's attention in the let-
ter supporting the Manhattan Project. Early representations are very scarce.
As underscored in the previous chapter, the 1936 adventure novel *The Race
for Radium*, by Michel Darry, is one example and is also paradigmatic of the
concerns of the time regarding the mines and how strategic they were: the
plot follows French and British journalists as they track down Herr Doktor
Wilhelm Von Krieg, a German journalist responsible for kidnapping Betty,
the daughter of a man who owns a radium-mining franchise in Canada.
In the novel, "Betty" symbolizes radium ore (or uranium ore); her predica-
ment is an allegory for the disasters that could ensue if "she" is left in the
wrong hands. In reality, and historically, Nazi Germany had closed the sales
of the European uranium mine in Czechoslovakia; hence the concerns of
Leo Szilard and Einstein, that Germany intended to use "Betty" for military
purposes.[18] The hands of science are presumably the right hands, according
to the 1937 British Pathé short film *Mining for Radium*, which opens with
a photo of Marie Curie, gives way to footage of the mines, and returns to
clips that show radium treatments administered at the hospital and spa at
Jáchymov, where Marie Curie (or her daughter) was filmed (figures 2.2a–c).

Another rare visualization of ore mining is a British Pathé short film
from 1933 called *Radium!* (figures 2.3a–c), which documents radium min-
ing in the US before the Manhattan Project; it opens with the following
message—"Precious beyond all other earthly substances. A lot of it comes
from Colorado pitch-blende ore"—and continues to show men in a mine
shaft shoveling rock onto a huge dolly.

Mines in several locales were pivotal in providing uranium for bombs.
Einstein, as we've seen, mentioned the uranium mines of the Belgian Congo
as viable alternatives to potentially contested ones in Czechoslovakia, along

Figure 2.2a
French scientist Madame Marie Curie—or possibly her daughter Irène Joliot Curie, *Mining for Radium*, British Pathé short film, 1937.

with mines in Canada, and those, as well as mines in the US, played an important role during at the start of the Cold War. But in both the US and Canada, these mines were located on land leased from Native Indian tribes. Interestingly, Darry's novel includes a Native Indian named Hitschawk, who helps the French and British journalists to rescue Betty. The mining processes in these territories fueled the production of bombs at the expense of natural and human resources: land, bodies, and memories of native cultures were contaminated. Thus nuclear activities must also be investigated from the standpoint of postcolonial theories because the industry still currently mines uranium ores in a neocolonialist fashion.

Currently the Rössing Uranium Mine, located in Namibia, is one of largest in the world, but it is exploited by the vast British-Australian multinational corporation Rio Tinto—even though a portion of the mine is owned by Iran (and even though Namibia does not provide Iran with uranium).[19] In the former French colony of Niger there is a uranium mine in Arlit, near

Figure 2.2b
Patients undergoing treatments at the Jáchymov Institute (hospital), *Mining for Radium*, British Pathé short film, 1937.

Akokan (the Akouta mine) and the future Imouraren mine might also be developed in the future. Both are operated by the French public nuclear company AREVA—the leader in the market of nuclear reactors—renamed Orano in January 2018. The shareholders of COMINAK, a uranium mining company and an affiliate of AREVA in Niger, are companies in France, Niger, Japan, and Spain.[20]

In these business enterprises, art is not left out of the equation. In 2011, the British-Australian multinational corporation Rio Tinto Group launched a $1.8 million "partnership"[21] with the Art Gallery of Western Australia that intends to promote aboriginal art at annual exhibits, as well as through other cultural and educational events and institutions. In the catalog for the tenth exhibit, the director of the gallery, Stefano Carboni, thanked Rio Tinto for its part in providing "evocative insights into the landscape, stories and culture of the Pilbara through the visual arts of the Traditional Owners of this region."[22] In 2017, Rio Tinto's twelfth annual art exhibition, in the

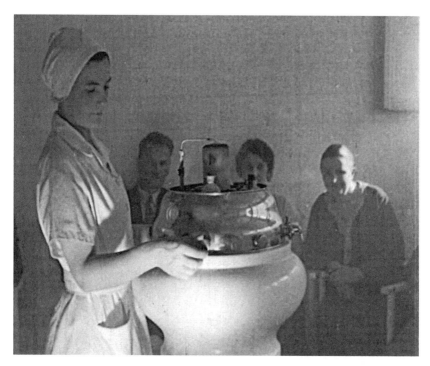

Figure 2.2c
Patients undergoing treatments at the Jáchymov Institute (hospital), *Mining for Radium*, British Pathé short film, 1937.

foyer of one of Perth's skyscrapers, the Central Park, commemorated the corporation's collaboration with the gallery by showing a collection of more than 310 artworks by 30 Pilbara-based Aboriginal artists. Since its launch, more than 2,115 artworks have been sold via these exhibitions, generating almost $2.2 million for artists, their art groups, and their communities.[23] Strangely enough, the multinational corporation seems to contribute very little to the African Namibian communities around the Rössing mine itself.[24] And yet, as great wealth is being extracted from the country, the health of mine workers has been criticized and put under the spotlight.[25]

Rio Tinto's annual art exhibitions bear the title "Colours of Our Country." The colorful paintings on view in 2017 by Aboriginal artists such as Kimitha Coppin, Clifton Mack, and Allery Sandy portray a particularly vibrant landscape with wildflowers, waterholes, rock formations, and creatures of the land and sea often painted in intense colors. But despite the visibility these works bring to the region and its people, they simultaneously

Figure 2.3a
A trolley full of rocks is wheeled out of the mine, *Radium!*, British Pathé short film, 1933.

bear the invisible imprint of a decades-long history of uranium mining in Australia—from its direct engagement with the land and health of the Aboriginals but also, indirectly, from the double standards the company seems to create regarding other populations its mines have contaminated across the globe. We are left here to interpret this and other corporate mixed messages that seem geared to celebrate the very people they continue to exploit.

The use of artworks (in general and in many genres) to support the agenda of established powers—whether political, scientific, commercial, or even religious—reaches far back in history. Edward Said, with *Orientalism* (1978), his groundbreaking study of the cultural misrepresentation of the Orient in Western artworks, has been acclaimed for his role in making postcolonial studies an independent field of scholarship that at the same time promotes an interdisciplinary approach. *Orientalism* strikingly demonstrates the key role played by European scholars and artists in the

Figure 2.3b
Male and female workers extracting radium, *Radium!*, British Pathé short film, 1933.

colonization of the East, and the West's subsequent control, via orientalist views and academic "studies" pairing territorial and economical control. But, using an example Said cites from nineteenth century, we can see that the collision of art, science, and corporate interests were slightly different than those of today.

As Said and other historians have noted, the prospects for digging the Suez Canal in Egypt to connect the Mediterranean and Red Seas had a contentious multinational history. Eventually, Ferdinand de Lesseps received an Act of Concession from the viceroy of Egypt and created an investment company in 1856, called the Companie universelle (or Suez Canal Company—which transmuted into the electric company GDF Suez and now is known as ENGIE), to oversee its construction. The Académie Française sponsored a poetry contest in 1862 to bolster support for the canal project among the French citizens.[26]

The winning poem, Henri de Bornier's "L'Isthme de Suez" (Isthmus of Suez, 1861) is a long mixture of nationalist, orientalist, racist, and

Figure 2.3c
"Then, looking strangely like table salt, the radium is extracted and placed in small tubes—infinite power for good or ill," *Radium!*, British Pathé short film, 1933.

religiously dubious verses that take the moral high ground, such as when targeting "half-naked" Indians.[27] Ironically, a poem celebrating a canal that was intended to bring two worlds closer together seemed to do nothing but widen the East/West gap.

In addition to such types of corporate sponsorship of the arts, the Exposition universelle in the late nineteenth century upheld the Western (orientalist) narrative of modernity by using both scientific and artistic artifacts: the latest Western achievements in architecture, art, and science juxtaposed with other cultures exhibited primarily as archaic, no more than relics of the past, and sometimes with natives caged in human zoos. Abigail Solomon-Godeau referred to the sum of these displays as a "colonial Disneyland."[28] The World's Columbian Exposition of 1893 in Chicago, for example, created an "Orient that was meant to be perceived as the real thing": from the "Moorish Palace" and the "Turkish Village" to the "Streets of Cairo" extending along a main promenade, much like the later Disney Epcot sites that

would reconstruct "authentic" scenes from Mexico, Japan, and Morocco, among others.[29]

At the turn of the twentieth century, many exhibitions presented works that combined artistic and scientific elements. For example, Loïe Fuller performed her US-patented "Serpentine Dance," with its special luminescence light show, at the Paris Exposition Universelle of 1900. The 1904 World's Fair in St. Louis, Missouri, not only showcased displays of radium in the form of a "dirty-looking little powder," but it also offered lectures describing this new substance as "a radiant energy so great as to be virtually incalculable," thus making radium the fair's most popular attracton.[30] Radium was predicted to be useful in the arts as much as in science.

Thus we can relate one instance of historical context, in which the arts played a role in marketing Marie Curie's discovery of radioactivity as a boon for the future, to a current instance in which a corporation relies on the arts to promote its uranium mining industry.

Today's uranium mines and their radioactive burdens, however directly inherited from the Cold War, have also inherited former colonial approaches to managing entrepreneurial ventures in which art played a role, as with the Académie Française poetry contest to celebrate the building of the Suez Canal. Undeniably, the problem our current generation must face is first and foremost technological: we have to deal with the heavy burden of the storage and treatment of nuclear waste that will be radioactive for thousands of years. The problem of nuclear waste must undeniably be solved in order to change the gloomy future ahead of us, as the philosophers Jean-Luc Nancy and Nishitani Osamu argue.[31]

But in addition to finding a technological solution for the future, we must also consider the present situation from the point of view of past activities, and essentially from a postcolonial angle because the colonial legacy endures into our evermore complex and globalized world.

Art/Science: Il Movimento Nucleare and the Festival Pattern Group

The atomic age must also be considered through the lens of another important epistemological compound: the interaction between art and science (or the humanities and modern sciences)—an aspect I discuss in every chapter of this book. We've already seen this unavoidable and vital interaction between scientists and artists of the atomic age, as exemplified by Marie Curie and Loïe Fuller for Fuller's *Radium Dance* in 1904, and this interaction continues until now, in the post-Fukushima example of the musician Ōtomo Yoshihide, who consulted a scientist about ways to avoid

contamination during the music festival Project FUKUSHIMA! in Fuku-shima city itself.

The interaction is multilayered. Artists partner with scientists, as in the cases mentioned above. There are cases in which artists are being scientists, such as with Alexander Bogdanov, a physician himself, who imagined radium-powered airplanes in *Red Star: The First Bolshevik Utopia*. Scientists often refer to the humanities and to writings about art, as did the physicist Werner Heisenberg. In the 1950s, Heisenberg stated that modernism operated by drastically abandoning previous forms of representation, which can be explained by the fact that modern science radically changed the perception of nature.[32] He also stated that modern physics and quantum physics had renewed the idealism of Plato, and that art should therefore take science as its basis.[33]

Finally, the connection between Leo Szilard and H. G. Wells has become a recurrent topic in nuclear-related investigations. According to Richard Rhodes, Szilard counted Wells as one among his circle of influential friends and colleagues, and traveled to meet him in London. Szilard had read *The World Set Free* with its plot of atomic energy and atomic war, but recalled not being completely influenced by it. He later stated: "This book made a very great impression on me, but I didn't regard it as anything but fiction. It didn't start me thinking of whether or not such things could in fact happen. I had not been working in nuclear physics up to that time." Instead, according to Rhodes, Wells's *The Open Conspiracy* (1928) piqued Szilard's interest because it envisioned the establishment of a world republic in which science-minded industrialists could save the world.[34]

The compound relating to art and science has deeper roots, however. Given the extreme complexity of the nuclear/atomic sciences and the vastness of the discipline, atom-related artworks collided at the crossroad of what C. P. Snow notoriously called "the two cultures." In a 1959 Cambridge lecture, Snow observed how expert academics would be exceptionally versed in their own fields but ignorant of other disciplines. He first underscored the scarce literary knowledge of some scientists, and even told an anecdote about a scientist who would use his books as "tools." To that remark Snow added: "It was very hard not to let the mind wander—what sort of tool would a book make? Perhaps a hammer? A primitive digging instrument?" He then pointed to a similar lack of the most basic scientific knowledge in erudite circles.[35] And yet for Snow, most importantly, the separation between the arts and the sciences was more profound: anthropologically speaking the humanities and sciences literally belong to two different "cultures." He firmly maintained this assertion four years later

when he stated that the educated "can no longer communicate with each other on the plane of their major intellectual concerns."[36] The issue of this modern epistemological shift can be traced further back in time. F. R. Leavis strongly opposed Snow's views, but there also was the 1882 opposition between the poet Matthew Arnold in his "Literature and Science" to the biologist T. H. Huxley in Britain.[37] There also was Goethe's resentment of Newtonian theories in *Theory of Colors* (1810) versus their appreciation by Émilie du Châtelet (who translated Newton in French) and Voltaire. The two even conducted experiments together in the marquise's laboratory in her country house.

For the arts, interfering with nuclear science's great complexity is inevitably challenging. In a few instances the separation between art and science has been strident if not volatile. The conference organized in the 1950s by the modern postwar Italian group the Movimento Nucleare—the only artistic movement to have devoted its practice entirely to the representation of the atomic age—was somewhat unsuccessful in bridging the gap. As the Italian art critic Tristan Sauvage recalled of the event: "Present in the room was the holder of the Chair of Physics at Milan University, Professor Polvani, who at a certain point fled in horror, dismayed by the 'scientific' theories of the painters. The meeting continued in uproar and insult."[38] The movement, however, offered compelling representations of the atomic age with nuclear clouds, dripping paint, and portrays of disintegrating figures that appear to be melting under an intense heat (figures 2.4a–c). The American art historian Stephen Petersen saw the Italian paintings as influenced by the drippings in the work of Jackson Pollock, whom he suggests was also reacting to the atomic bombings.[39]

The modern specialization of the fields of art and science can often isolate one field from the other, and thus pose a particular challenge. But the impulse to create a smooth fusion between "the two cultures" (as Snow would say) was equally inevitable and its success not impossible. Contemporary to the Movimento Nucleare were the British designers called the Festival Pattern Group.

In the 1950s, fascinated by the pattern of matter she was discovering on an atomic scale, the crystallographic scientist Helen Megaw at Birkbeck College, London, contacted her colleagues from the design department with the following request: "I should like to ask designers of wallpapers and fabrics to look at the patterns made available by X-ray crystallography. I am constantly being impressed by the beauty of the design which crop up … without any attempt of the worker to secure anything more than clarity and accuracy." One colleague, Marcus Brumwell, enthusiastically replied, "I

Figure 2.4a
Enrico Baj, *Manifesto Bum*, oil on canvas, 1952. Courtesy of Archivo Baj, Vergiate, Italy.

have always thought that art and science can help each other and should co-operate."[40] This unique collaboration resulted in a series of wallpaper, lace, ties, plates, and upholstery based on atomic structures such as hemoglobin or insulin (figures 2.5a,b). The art/science alliance was so successful that the Festival Pattern Group's design was remembered in 2008 as being a "peculiar success as a cross-disciplinary venture."[41]

In the UK, Catherine Jolivette analyzed other artistic examples. Crystallography also inspired London's Institute of Contemporary Arts in 1951 to host *Growth and Form* as part of the Festival of Britain. This exhibition, curated by the English painter and collage artist Richard Hamilton, drew from the latest discoveries in science and technology together with visual arts and architectural design, with the explicit intent to boost postwar spirits. One of the pavilions at the Festival of Britain was titled the "Physical World," and its art/science fusion was manifest in a model of the British Experimental Atomic Pile (BEPO) that was displayed near a mural by

Figure 2.4b

Enrico Baj, *Forme cranique nucléaire*, oil on canvas, 1952. Courtesy of Archivo Baj, Vergiate, Italy.

Laurence Scarfe "based on [watercolor] studies he had made from 1950 to 1951 at the site."[42] Aside from the difference in medium, the murals have a similar feel to the series of photographs taken in France by Robert Doisneau of experiments conducted by Irène and Frédéric Joliot-Curie from 1942 to the late 1970s.[43]

Art and science, therefore, did not necessarily behave as repellent forces, and they were even defined by some as complementary. A few years before C. P. Snow's lecture, Martin Heidegger had envisioned a meeting point or even a common origin between the two fields. Heidegger had an interest in science and technoscience: in one of his lectures he offered his own view on the commonly cited statement by the theoretical physicist Max Planck: "That is real which can be measured."[44] Heidegger also brought up topics related to nuclear technology, the bomb, and the nuclear age in other instances.[45] In 1954, in *The Question Concerning Technology*, he viewed science, or rather technology, as a revealing (of nature and truth) but also as a challenge he calls "Gestell" (enframing), which "puts nature to unreasonable demands that can be extracted and stored" and in which

Figure 2.4c
Enrico Baj, *Figura atomica*, oil on canvas, 1951. Courtesy of Archivo Baj, Vergiate, Italy.

Figure 2.5a
Insulin 8.25, wallpaper, 1951. Crystallographer: Dorothy Hodgkin. Designer: Robert Sevant. Commissioned for The Festival Pattern Group, Festival of Britain, 1951. Copyright Victoria and Albert Museum, London.

human beings are challenged by themselves more than they are challenged by nature: "Agriculture is now the mechanized food industry. Air is now set upon to yield nitrogen, the earth to yield ore, ore to yield uranium, for example; uranium is set upon to yield atomic energy, which can be unleashed either for destructive or for peaceful purposes." On the other hand, art for Heidegger can be a revealing but also a "saving power" against the technological enframing as long as it acknowledges the technological enframing.[46]

We've seen that interactions between art and science can work to enmesh the "two cultures" as well as set them apart. Finally, after the civilian/military (good/evil), East/West, and art/science compounds, a last compound must be acknowledged.

Political and Apolitical Art

The particular evolution of the arts into the "political" and "apolitical" categories is of importance in the context of the atomic age. The examples of the Movimento Nucleare and the Festival Pattern Group work well to

Figure 2.5b
Printed bone china plate based on the crystal structure of beryl, 1950–51. Crystallographer: Sir Lawrence Bragg. Designer: Peter Wall. Commissioned for The Festival Pattern Group, Festival of Britain, 1951. Copyright Victoria and Albert Museum, London.

illustrate the categories. While the Movimento Nucleare had a clear political, antinuclear message, the Festival Pattern Group, although active during the Cold War, focused rather on the apolitical creation of aesthetically pleasing objects. In the arts, the two categories have been the focus of much philosophical discussion.

Theodor Adorno described and qualified them to be "falsely at peace"[47]: on the one hand, there are the "committed" (or politically committed) artworks, and on the other, the "autonomous" (apolitical) practices that adhere to the doctrine *l'art pour l'art* (art for art's sake). The apolitical category was further formulated and crystallized in the postwar era by the art critic Clement Greenberg as a specific trait of modernism and the politically committed category by Jean-Paul Sartre (even if the two terms were already at work in the past).[48] This particular compound, involving the political/apolitical uses of art, is important to acknowledge because it opens the larger discussion of issues in which the art and science of the nuclear age are indisputably entangled in Western modernity: the tension between the modern call for specialization of the fields and the postmodern appeal for the interdisciplinary exchange of knowledge.

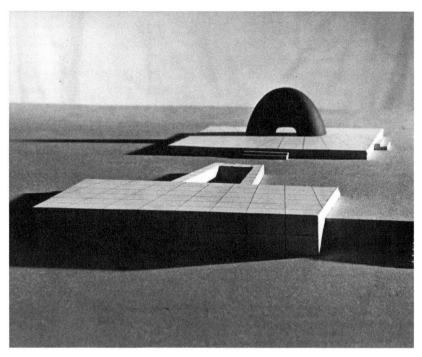

Figure 2.6
Isamu Noguchi, *Memorial to the Dead, Hiroshima*, 1952, plaster, unrealized model. ©The Isamu Noguchi Foundation and Garden Museum, New York / ARS—JASPAR, Tokyo, 2017 C1466.

When it comes to the atom, many modernist artists deviated from their apolitical position to take a political stand. A notorious example is Andy Warhol, whose *Atomic Bomb* (1965), in the words of Susan Sontag, is "the only photograph Warhol silk-screened that refers to the violence of war."[49] Two other paradigmatic examples are Isamu Noguchi's unrealized Hiroshima cenotaph and Henry Moore's twin nuclear sculptures.

Noguchi's works are usually apolitical but after the bombings he returned to Japan, where he had spent his childhood. But because he spent most of his life in the US—in the very country that dropped the bomb—the Committee for the Construction of the Peace Memorial City rejected his proposal as inappropriate (figure 2.6). Noguchi reacted to the rejection with the following words:

I was opposed by the people of Hiroshima because I am an American. Certainly, I am an American, but my heart is that of a Japanese and how it ached in the days of the B29 air raids. ... My feeling was unbearable when Tokyo was burning and the

nuclear bomb was falling on Hiroshima. Therefore, I felt guilty for the people who lost their lives all at once.[50]

The many compounds are also particularly at work in Henry Moore's pieces. To commemorate the twenty-fifth anniversary of the first self-sustaining controlled nuclear reaction conducted by Enrico Fermi, a committee from the University of Chicago asked several sculptors if they would consider creating a monument to be installed on the site of Fermi's former laboratory at the university. Henry Moore accepted even though he was a trustee of the Campaign for Nuclear Disarmament (CND). Moore began work in 1963, and by 1965, the group overseeing the budget viewed a photograph of the work-in-progress. They were concerned by the "mushroom cloud" shape before the media took up those the concerns.[51]

In a letter, Moore addressed some of the problematic images it evoked: "As a general principle I prefer to let my work speak for itself, but sometimes it is possible to give a hint of what was in one's mind in making the sculpture. In this, the upper part is very much connected with the mushroom cloud of an atomic explosion, but also it has the shape and eye sockets of a skull."[52] The committee supported the work, and the finished piece, titled *Nuclear Energy* (figure 2.7), was installed in December 1967.

Moore offered an additional interpretation of his sculpture in a 1972 *Arts Journal* interview: "'One might think of the lower part of it being a protective form and constructed for human beings and the top being more like the idea of the destructive side of the atom. So between the two it might express to people in a symbolic way the whole event.'"[53]

Moore's worked brought similar controversy in Japan, but not for the same reasons. In 1987, the newly built Hiroshima City Museum of Contemporary Art (MOCA) purchased *Atom Piece* (1964–65) (figure 2.8), one of seven casts made for *Nuclear Energy* prior to its installation in Chicago. If at the time *Atom Piece* was considered by the media to be the "jewel in the crown"[54] among the various recently purchased artworks, by 1991 the appropriateness of the piece was reexamined considering the significance of its installation at the Chicago site.[55] The debate was followed by an intense media coverage, and the piece was swiftly moved into storage.

Initially, the museum intended to obtain only one artwork from Moore, *The Arch* (1963–69): a monumental sculpture (6.1 meters high and weighing 4 tons) that Moore first envisioned as "a male torso with tensed shoulder-girdle bones forming a sort of arch."[56] It was installed at MOCA, overlooking "ground zero," with the hope that it would become a "Hiroshima gate" to pair with the red Shinto gate of the Itsukushima shrine. The two "gates" were then thought to become "an abstract depiction of a pair of joined

Figure 2.7
Henry Moore, *Nuclear Energy*, 1964–66 (LH 526). Reproduced by permission of The Henry Moore Foundation. Photo: Ann Harezlak.

Figure 2.8
Henry Moore, *Atom Piece (Working Model for Nuclear Energy)*, 1964–65 (LH 525). Reproduced by permission of The Henry Moore Foundation.

hands, representing peace by embracing landscape."[57] The museum only purchased *Atom Piece* (1964–65) in a second round of acquisitions, which temporarily derailed the city's call for peace through the arts.

In the United Kingdom, art historians still discuss what may have been in Moore's mind when he created the sculpture.[58] In Japan, the issue was finally reinvestigated and perhaps even resolved through MOCA's exhibition of the contemporary artist Simon Starling's *Project for a Masquerade (Hiroshima)* in 2011. Starling's work also scrutinizes Moore's sculptures in the context of Cold War politics through a reenactment of Japanese medieval Noh theater piece: *Eboshi-ori* (figures 2.9 a–d), for which he created masks of Moore and other figures such as James Bond, Joseph Hirshhorn, Anthony Blunt, and even Enrico Fermi.[59]

MOCA's chief curator at the time of Starling's exhibition, Kamiya Yukie, commented on Moore's intention: "The sculptor, who just three months before his death demonstrated obvious determination and delight at the idea of *Atom Piece* coming to Hiroshima, surely wanted to stamp a single

Figure 2.9a
Simon Starling, *Project for a Masquerade (Hiroshima): The Mirror Room*, 6 carved wooden masks, 2 cast bronze masks and bowler hat, stands, suspended mirror, masks from 18–28 cm high, stands from 150–170 cm high, 2010. In collaboration with Yasuo Miichi, Osaka. Photo credit: Keith Hunter. Site-specific installation realized at The Modern Institute, Glasgow, in 2010.

meaning—hope for peace—on two works of the same form in the two locations of totally different significance."[60]

More examples similar to Warhol, Noguchi, and Moore appear in later chapters, but here the interlacing and the molecular nature of the many compounds is clear: they assemble in several configurations not only in such artworks but also in the agendas of institutions that give art public visibility (academic, curatorial, and even publishing houses, as well as the museums).

Artistic Chain Reactions until Fukushima

In 2008 the Wellcome Trust Gallery in London hosted a retrospective exhibition of the Festival Pattern Group titled *From Atoms to Patterns* of the works initially displayed in 1951.

Without a doubt, the exhibition opened a fantastic window onto this particular art/science collaboration, which was also the product of

Figure 2.9b
Simon Starling, *Project for a Meeting (Chicago)*, chryso-uranotype print. Print size
40.6×50.8 cm; framed size 84.5×95, 2010. Photo Jens Ziehe. Courtesy of The Modern
Institute / Toby Webster Ltd., Glasgow.

tremendous art historical research. But at the same time, for an exhibition
relating to atoms, and in spite of the gallery's postmodern mission promot-
ing interdisciplinary exhibitions, its "autonomous" (apolitical) curatorial
stance evaded the importance of the context of the Cold War for the origi-
nal exhibition.

The Festival Pattern Group's exhibition at the Festival of Britain in 1951
was a huge-scale event intended to showcase the inventiveness of British
scientists and their potential contribution to new technologies. In 1950,
however, Britain's nuclear program and experiments had started, and by
October 1952, "Operation Hurricane"—the first British atomic weapon
test, was detonated at the Montebello Islands in Western Australia. The
2008 Welcome Trust exhibition avoided mentioning the military context
and, similarly, the context of Britain's construction of a new generation of
nuclear power stations that clouded the reception of the exhibition. The
government had declared, few years earlier, that nuclear energy was "back

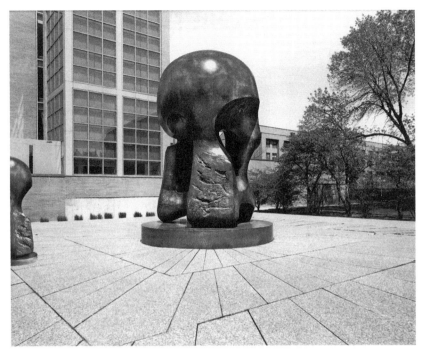

Figure 2.9c
Simon Starling, *Project for a Meeting (Chicago)*, chryso-uranotype print. Print size 40.6×50.8 cm; framed size 84.5×95, 2010. Photo Jens Ziehe. Courtesy of The Modern Institute / Toby Webster Ltd., Glasgow.

on the agenda with a vengeance."[61] Although the governmental agenda for energy resources and the timing of the gallery's exhibitions is most likely pure coincidence, the many compounds of artistic response woven into today's contemporary practices is unavoidable and the institution's own agenda also becomes important.[62]

The art program organized at the Large Hadron Collider (LHC) at CERN (Conseil européen pour la recherche nucléaire, Organization for Nuclear Research) is another good example. "Arts at CERN" offers various awards and residency programs for artists to explore, create, and be inspired by particle physics, with the idea that "particle physics and the arts are inextricably linked: both are ways to explore our existence—what it is to be human and our place in the universe."[63] The "autonomous" nature of the program allows the production of artworks that respect modernist tradition by avoiding direct political statements—even though, by using or being inspired by technoscientific devices, such work transgresses the Greenbergian call for

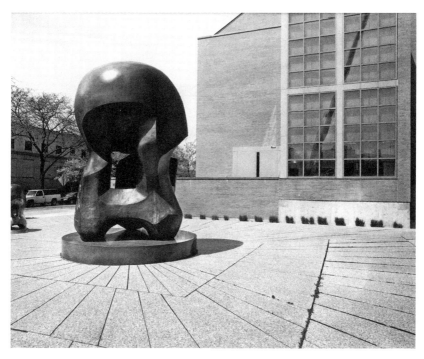

Figure 2.9d
Simon Starling, *Project for a Meeting (Chicago)*, chryso-uranotype print. Print size 40.6×50.8 cm; framed size 84.5×95, 2010, Photo Jens Ziehe. Courtesy of The Modern Institute / Toby Webster Ltd., Glasgow.

an art purely concerned with itself. In addition, the international collaboration among participants from diverse countries and scientists from different subfields of physics encourages artistic responses that engage not only some of the individual epistemological compounds we've explored but also the ways in which they are interlaced. This unique "crossword" therefore allows for an approach that diverges from ethical concerns about the use of the scientific technology that arise in the midst of power plant accidents (at all levels) and the ever-multiplying number of nuclear warheads developed by countries engaged in a nuclear arms race.

The arts of the nuclear age have to deal not only with the military/ civilian and the art/science compounds, but also with modernity and modernism's heritage—together with its link to the colonial empires—and the way art has evolved in our postmodern times within the entanglement of "committed" and "autonomous" practices. In that sense, giving historical

perspective to current artistic and scientific nuclear activities is crucial and complementary to finding solutions for a hypothetical post-nuclear age. The challenge for the arts in this sense, therefore, is not in the invisibility of radioactivity but invisibility in other areas.

A historical perspective is critical because of the repetition of the "events." In 2014 the Museum of Contemporary Art Tokyo (MOT) curated a two-part exhibit of its permanent collection under the title *Our 90 Years: 1923-2013*. It took as temporal markers the 1923 Great Kanto Earthquake, which had dreadful repercussions and more than 100,000 deaths, and of course included the 2011 Great East Japan Earthquake. The introductory wall text explained the curators' hope to take "a different perspective from 'history' *per se*," with their desire to "probe the meaning of what artists saw and created in the years between major events affecting society."[64] One of the first pieces viewers saw as they entered the museum gallery was the 1924 work of Kanokogi Takeshirō titled *September 1, 1923* (1924); it depicts a sadly familiar scene of forced exodus from a ravaged city landscape, broken electricity poles, and steaming emergency fire hydrants. Also featured was the work of Yoshida Hiroshi (1896–1950), who was forced to search through the rubble for the woodcuts and prints he could salvage after the 1924 earthquake.

In response to all the meaningful curatorial choices, the feeling of déjà vu is perhaps most shocking. The Great East Japan Earthquake was not the first, and will not be the last. In his philosophical essay on the Fukushima nuclear accident, Jean-Luc Nancy also recalled a few previous earthquakes such as the one in Iran in 1990 and, inevitably, the 1755 earthquake in Lisbon that triggered, amidst the sorrow, the burning desire of Rousseau and Voltaire to make sense of it in their ongoing written dialogue.[65] Not only did the disaster appear in Voltaire's novella *Candide*, but he wrote a poetic treatise in the aftermath the earthquake in opposition to Leibnitz's optimistic and religious views that our world is the best of all possible worlds God could have chosen. In "Poème sur le désastre de Lisbonne" (Poem on the Lisbon Disaster, 1755–56), he was opposed to the idea of an interventionist God and even criticized Plato and Epicurus, whose atomist theories centuries earlier had put God at a distance by observing nature's own set of laws independent of divine forces, as the following stanza reveals:

Man is a stranger to his own research;
He knows not whence he comes, nor whither goes.
Tormented atoms in a bed of mud,
Devoured by death, a mockery of fate.[66]

Some two centuries later, Adorno expressed his philosophical views concerning the impact of Auschwitz on the significance (or insignificance) of past and future cultural production, as well as, overall, how Auschwitz would weigh on the consciousness of society. His direct reference to Voltaire's poem—"the earthquake of Lisbon sufficed to cure Voltaire of the Leibnizean theodicy"—brings to the surface the problems of comparing a natural disaster with a disaster so strongly attributed to human responsibility. The "visible catastrophe" of the earthquake was "insignificant," according to Adorno, compared to "the one which defies the human imagination by preparing a real hell out of human evil."[67] Such debates will continue to address the good/evil binary just as assuredly as Adorno predicted the potential for future genocide, and earth scientists the certainty of natural calamities.

But, as Nancy clearly explained after the accident at Fukushima, earthquakes in general must be distinguished from those that hit a nuclear power plant. For Nancy, a tsunami that seriously damaged such a site is not comparable to any other tsunami, because "the atomic catastrophe—whether of a military or civilian origin, keeping in mind their differences—remains essentially an irreversible catastrophe. ..."[68] The residual calamity of nuclear disasters, together with the difficulty to clearly delimitate their fallouts, make them specific—specific and yet familiar.

At the same time of the MOT's exhibition *Our 90 Years: 1923–2013*, the Tokyo Museum of Modern Art (MOMAT) hosted a retrospective of works by the modern Japanese artist Tetsumi Kudō. Included were his series on chain reactions, such as *Proliferous Chain Reaction in Plane Circulation Substance* (1958) (figure 2.10) and on radioactivity, with *Cultivation by Radioactivity* (1967–68), which confronts the viewer with a disturbing engineered world of mutated crops and deformed body parts growing in sprayed-painted pink and green incubators. The Osaka curator Shima Atsuhiko described the series of dystopian landscapes as "an omen of the disaster that occurred some 50 years later."[69] The decision to host this exhibit and the curator's choice of what to include was no accident.

On the one hand, the art museum's commitment to offer a reflection on Japan's radioactive past and present subtly contrasts with the governmental insistence to continue using nuclear energy in Japan, while on the other, it reminds us of the familiarity of the radioactive threat even though the curator finds the pieces exclusive. He explained: "Unlike the anxiety and fear that we feel in regard to radiation, which is invisible to the eye, Kudo's works have a unique appearance in which a contemporary Pop sensibility coexists with a humorous sense of the grotesque."[70] The context of Kudō's

Figure 2.10
Testumi Kudō, *Proliferous Chain Reaction in Plane Circulation Substance*, 1958. Hara Museum, ©ADAGP, Paris & JASPAR, Tokyo, 2017, C1492.

work derives from the May 1968 student uprisings but also the Cold War and the atomic age. Kudō's radioactive "cultures," which also encompass *culture as civilization*, as the curator underscored, resonate as in a familiar threatening oracle.

Natural disasters, accidents, and even weaponry will not vanish, but when the radioactive landscapes multiply and successfully implant themselves in our daily lives, approaching what we perceive as normality, then there is an urgency to understand, rethink, and prevent such invisibility, such cultivation of the "everyday radioactivity."

II Hiroshima and the Colorless Paintings

3 A-bomb Literature's Dark Radiance and Modernism

In the faint light of the three-mat dining room next to the kitchen, the unnamed narrator of Ōta Yōko's autobiographical novella *Zanshū tenten* [translated as Residues of Squalor, or sometimes Pockets of Ugliness, 1954] peers at her relatives in the adjacent room, where they huddle, scrunched under an old pale green mosquito net. She notices the countless slugs beginning to crawl over the net and invade the room. She explains her reluctance to kill the slugs using her sister Teiko's method: by removing the mollusks with chopsticks and dropping them in a can filled with salt water. She could not think of obliterating the slug infestation in such a way:

I looked in the can. They were half melting, but not completely melted. Thick and muddy, there was no sign of their having put up resistance to this sole primitive measure. After once eyeing this sight, I had begun to suffer from association. It was about human beings heaped up in a mound of death, half burnt but not completely melted, with no energy to show any sign of resistance. They were so alike.[1]

In *Residues of Squalor* Ōta recounts her life as a survivor of the bombings: she chronicles her visits to the hospital, surveys the debris of her past love life in the ruins of the city that had started to rebuild itself, and shares haunting memories. The sight of the dying slugs reminds her of the uncountable deaths she had witnessed in Hiroshima; she thinks of the slugs as ghosts of the many soldiers who had died on the parade ground. Besides, to consider the "slugs as mere slugs" is not acceptable, she believes: "Heartless mollusks to me seemed personifications with hearts."[2] The association of slugs to dead soldiers is one of many moving details in *Residues of Squalor*. In *Hotaru* [Fireflies, 1953] Ōta similarly likens the souls of the soldiers to fireflies trapped between earth and heaven.

Ōta Yōko is known as *the* A-bomb writer—a label she herself endorsed—because she was the only *hibakusha* writer to have survived long enough to write an entire body of work on the bombings.[3] The most well-known

of her books is *Shikabane no machi* [City of Corpses, 1948], which directly recounts the horrors of the bombings. Other works include the novels *Ningen ranru* [Human Tatters, sometimes translated as Human Rags, 1951] and *Han-ningen* [Half Human, 1954], the latter portraying radiation sickness, overmedication, and possible mental illness of a woman much like herself.[4] Undoubtedly, the authenticity of her experience is what makes her accounts so memorable. Before the art of the atomic bomb opened to include other mediums, literature was its primary form of expression—so much so that *Genbaku bungaku* (A-bomb literature) became a genre of its own in Japan. The genre encompasses work ranging from the most important testimonials about the effects of radioactivity to equally powerful writings that immerse readers in symbolism and imagery, as with Ōta's use of slugs and fireflies. In the 1970s, the Japanese A-bomb specialist Nagaoka Hiroyoshi, who singlehandedly uncovered the powerful radiance of the genre, brought some two decades worth of works to light in his seminal *Genbaku bungaku shi* [History of A-bomb Literature, 1973]. According to Nagaoka, A-bomb literature evolved into four different phases that changed every five years or so.[5] Each of the phases includes numerous writers and poets who were mainly *hibakusha*—the first period being the most important historically, with novelists such as Ōta Yōko and Hara Tamiki, as well as the poet Tōge Sankichi, being direct witnesses.

Most scholars refer primarily to Hara when it comes to writing about A-bomb literature, or even to Kenzaburō Ōe who definitely played an important role in the genre, but less often to Ōta.[6] This might be because Ōta produced nationalist novels during the war, and Japan had aligned itself with Nazi Germany. But, surprisingly, Nagai Takashi's *Nagasaki no kane* [The Bells of Nagasaki, 1949] is more celebrated than any of Ōta's novels. Although Nagai was a nationalist army physician, he took an antiwar stance after the bombings, as did Ōta. Perhaps Ōta's gender explains such disregard for her prolific body of atomic age work.

In any case, A-bomb literature is densely populated with authors. The genre defies rigid artistic taxonomy since it embraces the many testimonies of nonprofessional writers, and yet these testimonies lack neither poetry nor moving literary style. The genre embraces contributors of all ages: there is the collection of poems Tōge wrote and edited with children, for instance, *Genshigumo no shita yori* (From Beneath the Atomic Cloud, 1952), and *Genbaku no Ko* (A-bomb Children, 1951), a collection of testimonies of *hibakusha* children. John Whittier Treat, an American scholar who has written substantially about A-bomb literature, praised a collection of testimonies titled *Genbaku taikenki* [Personal Accounts of

the Atomic Bomb, 1965]. He was particularly touched by the words of Mutsu Katsutoshi, a middle school teacher who wrote about the bomb this way:

As others, startled by the brilliant moment of light and the explosion like that of distant thunder, raised their heads to gaze their eyes of awe at the beauty of a strange mushroom cloud silently billowing high in the far blue skies, in another small corner of Hiroshima I was a traveler wandering somewhere betwixt the land of the living and the land of the dead.[7]

Together with testimonials of Auschwitz, and of any human massacre, the genre of "documentary literature" or "docu-fiction" expanded after the war because, as Treat stated: "No one could have imagined anything as inhuman, a-human, as the German programs of genocide, or as total and efficient as a nuclear device."[8]

Scientists and physicians also wrote critical testimonies of their own. As I mentioned above, the best known of the genre is *The Bells of Nagasaki* by Nagai Takashi, which became so prominent in Japanese culture that it inspired a long list of songs and films. Nagai's work is pivotal in that he was a radiology expert who had worked with the army and who began writing compulsively after the bomb—even while bedridden. In his book, a particular moment stands out: two of his students were discussing within the blasted hospital whether to save the contents of the X-ray room to later treat patients or help the wounded. Nagai decided in favor of helping the wounded. The powerful life-based metaphor is a sad reminder that Marie Curie's efforts and hope for the future of radioactivity were in vain.[9]

The 1945 diary of Hachiya Michihiko—a hospital director in Hiroshima—is also paradigmatic. As John W. Dower pointed out, although Hachiya's bomb-related injuries left him with about 150 facial and body scars, he worked in his ruined, overcrowded, and foul-smelling hospital (the place reeked from the cremation of the bodies) "with composure [and] compassion."[10] Nagai's and Hachiya's writings, together with nurse Fumitsuki Junko's literary account of the death of Ōta Yōko, as well as Ōta's discussion of Japanese scientific reports of the bomb and radioactivity in *City of Corpses*, demonstrate that the art/science compound is unarguably present in postwar Japan too.[11]

But most surprisingly, despite the many works that were anthologized in the 1980s in two editions amounting to dozens of volumes in Japan, Japanese A-bomb literature remains largely unknown to the West and only partially translated. The *hibakusha* poet Kurihara Sadako accurately pointed out how the literature of the Holocaust is widespread compared to A-bomb

literature. Ōta, Hara, and Tōge were partially referred to or quoted in at least two early Western works, one that took a psychoanalytic approach to the literature and the other by a journalist more focused on the making of the bomb than its aftermath.[12] They were finally acknowledged by literary circles in the 1990s due to John Whittier Treat's brilliant analyses. Although the interest in A-bomb works is cyclical, commentary on the bomb's consequences for the mostly civilian population receives less attention than the military power and use of the bomb, as Dower has noted. But with a death toll of at least 200,000 people in both cities (and without counting the deaths caused by radiation sickness and other injuries), it is surprising that even today, the genre is still unknown, even sometimes in Japan.

This is precisely where the power imbalance of the atomic age resides. The invisibility of radioactivity is not the challenge. Instead, the challenge comes from the intricate politics that have made invisible radioactivity's calamitous consequences by obliterating the voice of the victims. This is true not only of Japanese literature but also of painting, sculpture, photography, and poetry. As a result, there are clear differences in the ways in which the bombings were represented in Japan and in the West. Investigating these differences, as well as the reasons for these disparities (but also their similarities) is an absolute necessity—even decades later—especially because A-bomb literature kept its "dark radiance," as philosopher Maurice Blanchot has said of the literature of the Holocaust.[13]

The Japanese philosopher Kazashi Nobuo wrote a poetic account revisiting the significance of the Hiroshima A-bomb dome, the monument that is left standing in the heart of the city. Even during the reconstruction with "super modern building"[14] lining up around it, and sometimes gloomily engulfed by the architectural fashion of the moment, the A-bomb dome still stands, floating in the center, from dawn to dusk, in the illuminations of the city.

In *Tetsugaku no 21 seiki: Hiroshima kara no daiippo* (Philosophy of the 21st Century, First Steps from Hiroshima, 1999), Kazashi explains that this "A-bomb dome city" still holds a specific power. He alludes to a theme in Thomas Mann's *Magic Mountain* (1924) by saying that one gets used to saying that one can never get used to things. The contrasting figure of the A-bomb landscape, the origin of the nuclear age, "so to speak, has a power to re-ask [questions] about the meaning of the human civilization, about life itself and its foundation."[15]

Hiroshima's A-bomb literature also stands as a glowing nuclear archive—a metaphoric monument as real as the dome in the city—and a significant part of that archive includes Hiroshima testimonials. Unfortunately as

Nagaoka underscores, no equivalent of the A-bomb dome exists in Nagasaki; perhaps because of that, Nagasaki literature is less extensive and attracts less attention. Yet Nagasaki deserves more of a spotlight since the city was bombed after Hiroshima not to win the war—but to make a statement. It was a postwar exercise of military capacity and power, as Treat stated in *Writing Ground Zero*.

Although it is commonly thought that the artistic representation of something as inconceivable and incomprehensible as the atomic bombings is impossible, uncountable works exist whose dark radiance shows that Hiroshima and Nagasaki are not the "unthinkable." The more we expose ourselves to the prose of the victims, the more visibility we give them.

The City of Blue Rivers and Ash-Colored Skin

It may be unsettling at first to discover the powerful beauty in writings and poems of A-bomb literature. The metaphor for the bomb in Hara's title, *Summer Flowers*, is one example. John Whittier Treat described Hara's bombs-cum-flowers as "brilliant, yellow, an explosion of color at the height of the summer heat," and Treat credited such imagery with the ability to "shift our attention to the inverse: life, beauty, nostalgia."[16]

After World War II, Theodor Adorno made an influential statement, that "to write poetry after Auschwitz is barbaric." The original declaration stemmed from his challenge to what he called cultural criticism's "self-satisfied contemplation" and in no way intended to declare poetry (or art) obsolete. Later defending and qualifying his statement, in "Commitment," he stated "writing lyric poetry is barbaric" when analyzing the representation of suffering within the categories of political and apolitical art. He then pointed to the problem of "the aesthetic stylistic principle" that could elicit enjoyment, even in commemorative works (of any medium), and that would "make the unthinkable appear to have had some meaning; it becomes transfigured and something of its horror is removed."[17] However, in 1966, in *Negative Dialectics*, he retracting the much misinterpreted original statement having decided in effect, as Rolf Tiedermann explains: "The only poems possible are those that are concerned with commemorating that suffering, that have absorbed it and have thereby transcended the aesthetic."[18]

Throughout the lines of the many *hibakusha* writers, images of beauty are surprising but aesthetical enjoyment is of no concern. In *City of Corpses*, Ōta describes Hiroshima before the bomb in stunning ways. She explains how Hiroshima, which means "large island," was first called Ashihara,

"red plain." Its rivers were "uniformly blue" and possessed of "unchanging beauty." For her the city was the most beautiful when heavy winter snow turned it into a "silent and uniformly silver world." But the poetical depictions are instantly brushed away if not totally absorbed by the cruel images that detail the bomb's devastation. The contrast is all the more striking when she describes in the following chapter the raging fire, the destruction, and neighborhoods laying in "pitiful ruins."[19]

Hara also uses the same contrasting literary effect, but in reverse. First he plunges the reader into the horror of the atomic blast before describing some relief from it during his ride on an outbound train with his family: "The wagon proceeded along the road through the endless destruction. Even when we went to the suburbs, there were rows of collapsed houses; when we passed Kusatsu, things finally were green, liberated from the color of calamity. The sight of a swarm of dragonflies flying lightly and swiftly above green fields engraved itself on my eyes."[20]

The contrast is even more pronounced when portraying the inhabitants. After fleeing with her mother, sister, and her sister's eight-month-old baby after the blast, Ōta explains that the outpouring of blood on the victims was such that she did not realize they were burnt. These burns were unusual, all alike, "as if the men who bake *sembei* had roasted them all in those iron ovens. Normal burns are part red and part white, but these burns were ash-colored. It was as if the skin had been broiled rather than burned." Their faces were swollen, enormously fat, and their eyes "crinkly and pink." Their arms were swollen, too, and "bent at the elbows, in front of them, much like crabs with their claws. And hanging down from both arms like rags was gray-colored skin."[21]

Just as she paints a verbal picture of Hiroshima's beautiful landscape before the blast, Ōta portrays Hiroshima's women, with their dark hair and white teeth, tall and spirited, who "brim with youth."[22] Her depiction of afflicted women after the blast distances the reader from any possible aesthetic enjoyment:

The women were an ugly sight. A girl was walking about naked, with nothing on her feet. A young girl had not one strand of hair. An old woman had both shoulders dislocated, and her arms hung limply. … People were no longer vomiting up everything, as had been the case yesterday; but there were people whose bodies were covered with broil-like burns—skin hanging off, bleeding, exuding an oil-like secretion. They had all slept naked on the sand, so sand and blades of grass and bits of straw and the like were pasted onto the putrid-looking flesh of their burns.[23]

She had tried to calm down a badly injured high school boy lying next to her, who was groaning: "I'm dying. I think I'm dying. It's horrible."[24] The boy died during the night.

Even a decade later, the calamity of the bomb had not faded away, as Hara on the outbound train might have hoped. *In Residues of Squalor*, Ōta likens a disfigured *hibakusha* whose appearance was "half-human" to her cousin Tsuyako, who had returned a widow from colonial Seoul, visibly safe but terribly sick. "At heart, I involuntarily compared Tsuyako with the young woman who was still groaning in a ward almost straight above this one, whose entire body had been burnt by atomic bomb radiation. … While looking at Tsuyako and listening to her story, I could not help noticing that here, too, the war disaster pierced the abdominal walls of life in general."[25]

The literary testimonies also spread across generations together with this contrast of the beautiful and the dreadful. The *hibakusha* who were children in 1945 later felt compelled to write about its horror, even decades later. Recalling the bombing of Nagasaki, the opening of Hayashi Kyōko's *Futari no bohyō* (Two Grave Markers, 1975) also remains one of the most indelible radioactive traces, leaving a strong imprint onto the reader's mind:

Clusters of pale yellow acacia flowers sway in the early summer breeze. The wisteria-like clusters call to mind flocks of butterflies.

Wakako sits in the roots of the trees. Her hair is in braids. By her side is a baby. The baby wears a rose-colored baby dress and her small hands are open: she is dead.

Just like a doll—so sweet, Tsune thought.

Ants swarm around her lips, and maggots crawl in and out of her tear ducts.

(…) Grease runs from the baby who has started to melt, making just that part of the earth glisten, dark with moisture. The clusters of flowers shine lustrously, absorbing juice from the baby's flesh.

The wind blows. The baby's fine hair trembles.[26]

Hayashi also describes how the remains of her school girlfriends were found, like "several brittle pieces of bone which crumbled easily like dry sugar cakes when they were picked up."[27] Such disturbing similes and references to childhood loss resonate deep in the hearts of the readers. Hayashi's story is a gut-wrenching testimony of her "lucky" escape with her best friend who progressively gets covered by maggots, becoming a living corpse before dying. The survival is a betrayal, transmuting into guilt, nothing a teenager should ever have to live through.

Whether written directly after the bombings or years later, all of these descriptions—whether from novels or testimonials—are so vivid and graphic that we can no more talk about deriving enjoyment from them than we can deny the power in the beauty of their prose. Even today, their

a

b

Figures 3.1a–c
Hisashi Akutagawa, *Monument of the A-bombed Teachers and Students of National Schools*, 1971. Courtesy of Hiroshima Peace Memorial Museum.

c

Figures 3.1a–c (continued)

dark radiance still glows across time, engraved in time. A monument dedicated to the A-bomb teachers of a national elementary school in Hiroshima (figure 3.1a, b, and c) bears a stone plaque on which appears one of Shōda Shinoe's tanka (short Japanese poem) from her book *Sange* (Penitence, or also "death" in Buddhism, 1947):

The heavy bones
Must be the teacher
And alongside
Small skulls
Are gathered.

From the standpoint of the arts, radioactivity—the atomic age—is not invisible. It has a color, and this color can be "ash-colored," like charred corpses, and "crinkly-pink," like the burns described by Ōta: it has the "color of calamity," to paraphrase Hara.

The atomic age also becomes visible through other colors. Maruki Iri and Maruki Toshi's *Hiroshima Panels* (figures 3.2a–3.3d) are predominantly black-and-white motifs of traditional Japanese ink drawings. The first of many panels that were produced over a span of thirty-two years, *Yūrei* (Ghosts, 1950) (figure 3.2a) depicts "a procession of ghosts—ghosts wearing

Figure 3.2a
Maruki Iri, Maruki Toshi, The Hiroshima Panels I, *Ghost*, ink, Japanese paper, 1950.
Courtesy of Maruki Gallery for the Hiroshima Panels.

Figure 3.2b
Maruki Iri, Maruki Toshi, The Hiroshima Panels VI, *Atomic Desert*, ink, Japanese paper, 1952. Courtesy of Maruki Gallery for the Hiroshima Panels.

Figure 3.2c
Maruki Iri, Maruki Toshi, The Hiroshima Panels, *Death of the American Prisoners of War*, ink, Japanese paper, 1971. Courtesy of Maruki Gallery for the Hiroshima Panels.

Figure 3.2d
Maruki Iri, Maruki Toshi, The Hiroshima Panels, *The Rape of Nanking*, ink, Japanese paper, 1975. Courtesy of Maruki Gallery for the Hiroshima Panels.

shreds of burnt clothes, ghosts with swollen hands, faces and breasts. Purple blisters broke—and skin hung from bodies like tattered dresses."[28] Red also creates a burst of atomic flame in another black-and-white panel. Nagaoka considered the Marukis' murals to be part of A-bomb literature; the couple added short prose poems to their panels because they found drawing too limiting.[29] First, the people they depicted in the murals were Japanese, but they also included American prisoners of war (POWs) and Korean victims about whom they had no prior knowledge (3.2c). In the interview with Nagaoka, the Marukis also explained their surprise to hear about American POWs dying in Hiroshima, citing the twenty-three who died and wondering how many Koreans died as well. After a trip to the United States, the couple also created a mural devoted to the terrible Japanese wartime and colonial atrocities of the Nanking Massacre (1937–38, also called the Rape of Nanking) during the Second Sino-Japanese War (3.2d).[30] But the panels respond mostly to the atomic bombings' aftermath, which the Marukis witnessed when they came to Hiroshima.

The many works of the A-bomb literature burn the mind and skin of history in other ways, because they have more distinctive characteristics and because the descriptions we've seen so far have served as only a preview to the vastness of the disaster.

The City of Blue Rivers and the Blue Flash

In A-bomb literature, the testimonial genre distances any question of the reader's aesthetic enjoyment in the text or the writer's intent to provide it. Most of the survivors, as John Whittier Treat points out, write in the first-person, and the narrative "I" is what distinguishes testimonial from documentary writing. Both forms share a concern for facts, and historical veracity is a definitive feature of both, Treat explains. In documentary, however, the information is presented "objectively," detached from an explicit interpreter. In the testimonial, "a very specific narrating subject," likely to be the survivor's own voice, presents, relates, and mediates the facts with "a nearly palpable urgency. ... In testimony the involvement of the narrator is not eschewed, it is paramount: we do not read of events, we are told of them."[31]

At times, however, the immediacy of the writings can appear surprising. It is unsettling to read in *City of Corpses* that right after the blast Ōta experienced the fleeting thought that perhaps she was a ghost. She had been sleeping when the bomb fell: "I dreamed I was enveloped by a blue flash, like lightning at the bottom of the sea. Immediately thereafter came a terrible sound, loud enough to shake the earth." She then recounted being "dazed, in a cloud of dust." And yet, "I was alive. How could I still be alive? That seemed strange. I looked about me dazedly, half expecting to see my dead body stretched out somewhere."[32]

She recalled other post-blast behaviors that can appear strange to the reader: when she started listing the missing or damaged material belongings shredded around her, for example, or as she laughed, even for an instant, after fleeing to the riverbed, because her sister mistook the sun for another "firebomb." Such an account might seem superficial if not disrespectful when thinking about the hundreds of thousands of lives lost to the deadliest weapons used on earth. But when she adds her brother-in-law's library and its three thousand volumes to the list of evaporated belongings, the metaphor of knowledge eradicated by war gives a profound weight to her loss. In addition, the "superficial" details also indicate her shocked state of mind at the time as well as the ignorance of the type of the bomb being used here for the first time.

Hara's testimony in *Summer Flowers* often reflects a different tone of voice than Ōta's. In the first few lines of the book he explain how three days before the blast he had brought flowers to lay at his wife's grave (she had died the year before). Then he abruptly begins his account of post-bomb events: "I owe my life to the fact that I was in the privy."[33] The unemotional

and semi-comical tone continues as he relies completely on his sister to fix his problems. (Hara had always been a bit withdrawn and was also feeling unwell since the death of his wife):

Beyond the dense cloud of dust, there appeared patches of blue, and then the patches grew in number. ... As I took a few tentative steps on the floorboards, from which the tatami had been sent flying, Sister flew towards me from across the way. "No hurt? Not hurt? You're all right?" she cried. Then: "Your eye is bleeding; go wash it off right away," and she told me the water was running in the kitchen sink.

Realizing that I was utterly naked, I said, looking back at Sister, "Isn't there something for me to put on?" She produced some underpants from a closet that had survived the destruction."[34]

Another incongruous vision Hara shares (and that Treat also noticed in his analysis of the book) appears in the portrayal of his eldest brother, whom he had discovered on the riverbank several hours after the blast: he was wearing only a shirt and was clinging to his beer bottle. Hara tell us that he looked "to be alright," but goes no further to approach him. Instead, Hara focuses on what it means to have survived.[35] Unlike Ōta, who suspected for a moment that she was a ghost, Hara knew he was alive "right from the start," but he oddly segued to his next immediate thought: what "an enormous inconvenience this all was."[36] Then, like Ōta, he resumed his description of material destruction and loss around him.

It is equally disconcerting to read in *The Bells of Nagasaki* that Nagai, a radiologist, still had enough strength to make fun of and patronize the two female teenage students he had nicknamed "Little Barrel" and "Little Bean" (due to their body shapes). While watching the two girls run up and down the hill to carry and save patients from the flames of the hospital, he congratulated himself on how well he had trained them.[37] A-bomb literature is soaked in death, but it also is an implacable account of life, in its entirety and complexity.

Ōta once described the badly burned victims as "pathetic and pitiable."[38] In several other troubling descriptions of survivors, the authors make incongruous but evocative comparisons to staples of their diet. Hara described his first encounter with a victim, writing that a huge "grotesque face seemed to me made entirely of black beans," and Nagai described a body "swollen like a pumpkin." The physicist Hachiya Michihiko took time to write in one of his diary entries on August 21, 1945, that a visitor compared the victims he saw to "octopuses": "The first-aid station the Labor Service set up at Hijiyama ... was in turmoil. There were so many burned that the odor was like drying squid. They looked like boiled octopuses. I have never seen so pathetic a spectacle."[39]

Between the lines of the *hibakusha* writers, the dehumanizing effect of the bombings is laid bare and becomes more tangible. Hachiya treated so many patients and saw so many corpses that he had become numb to their plight. His diary entry in fact starts with these words, "A clear day. Visitors increased daily and all had something to tell of what they had seen, heard, or thought. By now, I was bored listening to stories they insisted on telling from morning until night."[40] In one of his prior comments regarding the representation of disasters, Adorno had found lyricism inappropriate before changing his mind. But doesn't humor appear even more disrespectful? In the many examples from A-bomb literature, cynicism, and it accompanying disaffection, is perhaps one possible remedy against oblivion.

In his "History of A-bomb Literature," Nagaoka mentions a short writing depicting a person that sarcastically says to another, after cremating seven bodies: "This potato field will become very big. Because the ashes of the corpses will be a good fertilizer," to which the other replied while smoking, "a cheap fertilizer."[41]

Page after page, little by little, the genre of A-bomb literature becomes filled with uncountable corpses, clogging the Hiroshima river, the parade ground, and the roads to the central hospital—hence Ōta's title: *City of Corpses*: "The corpses were all headed in the same directions of the hospital ... Eyes and mouths all swollen shut and limbs, too, as swollen as they could possibly be ..."; "... they had died with arms stretched out ... the bodies of people who had come tottering toward this hospital only to die before reaching a doctor"[42] The description of the injured in the hospital impoverished by the strike and years of war is as hellish as is the scene outside. Quickly, in the city and in the midst of anxieties over another air strike looming onto the city, flies appear and maggots proliferate under the heat of the summer sun in such an oppressive number that Ōta registers surprise so many could have survived. Only then does Ōta try to understand, talking with her sister, what sort of bomb this could have been—perhaps mustard gas, or poison gas, combined with conventional bombs? Similarly, in the *Bells of Nagasaki*, Nagai recounts the confusion of the experts at his hospital: "Atomic Specialist and doctor of physics though he was, Seiki did not realize that this was an atomic bomb." Nagai also later wonders who could have made the bomb: the Joliot-Curies? Einstein? Bohr? Fermi? "The curtain was rising on a new age: the atomic age" writes Nagai, as he recalls the enemy planes dropping bundles of leaflets warning about possible future atomic bombs.[43]

In a moment of despair, Nagai once refused to help an injured person but then changed his mind: "To ignore these patients would not only be an act of cruelty toward individual persons, it would be an unforgivable crime

against science, a neglect of precious research material for the future."[44] Just like the Radium Girls before them, the victims became human lab-mice, whose invisibility still persists, even for a unique research area that Susan Lindee called "colonial science" when referring to the Atomic Bomb Causality Commission.[45]

For the humanities, the bombs clearly added another twist to the epistemological turn that began in the earlier part of the century—when discussions of the atom departed from determinism and free will (or non-theological understanding of the world) in atomist Greek philosophy to secularism in Marie Corelli's *Mighty Atom*—and moved toward the representation of suffering in atomized lives. In A-bomb literature an evident disconnect of firsthand knowledge exists between writers (of novels and of testimonials) and their contemporary readers; thus a feeling of uneasiness prevents us from seeing the prose develop in a stylized pattern for literary contemplation. The A-bomb literature is not a literature of enjoyment, nor the basis of a discussion of determinism, but like any testimony, it is inherently political.

In the end, even Adorno underscored the vital role of "resisting, solely through artistic form, the course of the world, which permanently puts a pistol to men's head."[46] And this is true in Japan and in the West too, since artists in the West also reacted to the atomic bombs, in ways that are at times similar, and at times much different.

Modernism and the Bomb: Newman, Pollock, and the Movimento Nucleare

Western representations of the bombings in the visual arts are equally important to consider, although initially they bear little resemblance to the Japanese depictions. To paraphrase Nagaoka: the A-bomb genre must become international, so that it can reach the minds of those who are still unaware of the dreadful effects of the bombs.[47]

It would be an overstatement to say that the atomic bombings spurred a clear-cut movement in the visual arts of the West. An analogy to literature seems appropriate here: World War II might not have directly influenced new movements already in progress in literature, as Maurice Blanchot suggested, inasmuch that "war is always present and, in some ways, pursued." But the war marked "the change of an era that we do not yet know how to measure for lack of a language." World War II was an "*absolute*"—a term Blanchot used to mark the "political and racist inhumanity represented by Nazism"—that accelerated any process or change.[48] The bombings also belong to that era, and the analogy applies to all the arts.

As Lynn Gamwell has noted, the American Abstract Expressionists Barnett Newman, Mark Rothko, and Jackson Pollock responded to the bombings "and within a few years, driven by themes associated with atomic energy, they each moved into total abstraction and achieved their mature styles."[49] Newman began to use his signature motif, a vertical band connecting the top and bottom margins of his paintings (known as a "zip") in 1948, Rothko his rectangles of color in 1947, and Pollock his drippings in 1947.

Both Newman and Pollock directly referred to the atomic bombings when clarifying the reasons for their new styles. In *The New Sense of Fate* (1948), Newman explained that in the past Egyptian and Greek art had their own understanding of fate, tragedy, and death, and that "the war the surrealists predicted has robbed us of our hidden terror, as terror can exist only if the forces of tragedy are unknown. We now know the terror to expect. Hiroshima showed it to us. ... The terror has indeed become as real as life." Newman therefore asks: "Shall we artists make the same error as the Greek sculptors and play with an art of overrefinement, an art of quality, of sensibility, of beauty? Let us rather, like the Greek writers, tear the tragedy to shreds."[50]

In the 1950s, Pollock advocated for new styles after the war in these terms:

My opinion is that new needs need new techniques. And the modern artists have found new ways and new means of making their statements. It seems to me that the modern painter cannot express this age, the airplane, the atom bomb, the radio, in the old forms of the Renaissance or of any other past culture. Each age finds its own technique.[51]

Pollock's drippings can be read as explosive forms, and they have come to exemplify the freedom of American Abstract Expressionism. In his drawing *War* (1947), however, he departs from that style by using graphic images in part obscured by thick lines in black, yellow, and red. But none of his paintings, and very few by other immediately postwar American modernist painters, offer recognizable representations of the bombings compared to those in sci-fi novels and film, and even compared to imagery of an atom's structure as adapted for industrial and home design.[52] Only Richard Pousette-Dart made a direct reference in *The Atom. One World* (1947–48), which represents a mushroom-like explosion. Instead, American Abstract Expressionism was rather apolitical. Newman advocated for more autonomy in *The Sublime Is Now*, written in 1948.

On the other hand, modernism in Europe counts few more radioactive hotspots of response post-Hiroshima. In the 1950s, the Italian group the

Movimento Nucleare (introduced in chapter 2), through the choice of their name, clearly began to broach the realities of a new age rather than stay safely ensconced in the artistic sphere (art for art's shake). Enrico Baj, one of the main protagonists of the group, explained this choice as follows: "The term 'nuclear' had for us at the start many justifications. Above all, we felt ourselves to be artists of a period in which atomic and nuclear research opened up for man new and infinite horizons; artists, therefore, rather than nuclear, of a nuclear age." Sergio Dangelo, another Nuclearist, recalled Baj as explaining, "With these pictures we shall have an exhibition that will be really actual. And I'll tell you what these pictures shall be called: they shall be called Nuclear."[53]

The Movimento Nucleare formed in 1951, first showing their canvases in basements of Milanese bars. The group held its first large-scale exhibition in Brussels in March 1952 at the Apollo Gallery. Some of Baj and Dangelo's artworks in the exhibition quite directly responded to the "committed" concerns expressed in their manifesto: *Paysage atomisé* [Atomised Landscape, *Paysage ultrasonique* [Ultrasonic Landscape], *Conception immaculée* [Conception Immaculate], *Déflagration* [Deflagration], *Remembering Klee*, *Homme explosant* [Exploding Man], and *Forma cranice nucleare* [Nuclear Skull Shape] (see figure 1.11a–c).[54] As a group they opposed geometric abstraction, and when depicting devastated landscapes or other images suggestive of nuclear clouds or fallout, their techniques were aligned with those of the gestural artists. Yves Klein, who signed some of their manifestos, also produced later pieces responding to atomic bombs, in particular *Hiroshima (ANT 72)* (1961) (figure 3.3). In 1958, Klein announced his intention to use a specific tint of blue in his bomb-related works as a symbolic statement to oppose nuclear testing (see chapter 6).

In between the two polarized positions of autonomous (art for art's shake) and politically committed art, hybrid responses to the bomb also appeared. Lázló Moholy-Nagy is paradigmatic of the individual artist's specific relationship with atomic science for two reasons. First, as early as 1945, Moholy-Nagy produced *Color Explosion* (1945) (figure 3.4), *Nuclear I, CH* (1945), and *Nuclear II* (1946) (figure 3.5), and he continued to produce several other paintings and drawings with links to nuclear themes until his death in 1946.[55] Whereas these works clearly refer to nuclear technology, none make any political statement, perhaps because Moholy-Nagy was aware of early conflicting responses to nuclear power: at the time of the bombings he was in Chicago, where Fermi, working in his laboratory at the University of Chicago, had played a major role in the building of the first nuclear weapons. The city was half celebratory and half prophetical.

Figure 3.3
Yves Klein, *Hiroshima, (ANT 72)*, Private Collection, 1960. © Succession Yves Klein
c/o Adagp, Paris, 2017. Cliché: Adagp Images.

The *Chicago Daily News*, for example, praised the importance of "Chicago's
part" in the bombings, while a *Chicago Tribune* cartoon questioned if these
bombings would lead to the "End of Warfare or End of Civilization?"[56]

Second, Moholy-Nagy was diagnosed in 1945 with leukemia, and had
to undergo a series of radiation treatments. According to the American art
historian Timothy J. Garvey, this experience with radiation "gave Moholy-
Nagy a unique appreciation for the avalanche of new reports about both
the promises of nuclear science and special dangers of the atomic bomb."[57]

Figure 3.4
László Moholy-Nagy, *Colour Explosion*, colored pencils on circular cut paper, mounted on blue plastic foil, 1945, 20.5 × 25.5 cm. Photo: Atelier Schneider. Courtesy of Bauhaus-Archiv Berlin.

In addition, as Garvey disclosed, the artist also read during his treatment a report detailing the development of the atomic bombs written by Henry DeWolf Smyth. The report was published at the request of the director of the Manhattan Project, Major General Leslie R. Groves.[58]

Moholy-Nagy's understanding of nuclear science was therefore dual. But just like Newman and Pollock, the Bauhaus protagonist had specific views on the arts in 1946. For him, art was "biological" because it "sensitizes man to the best that is immanent in him through an intensified expression involving many layers of experience." Departing from the views of the American painters, however, he stated: "The so-called 'unpolitical' approach is a fallacy" since "the conscious but also the subconscious mind absorbs social ideas which are then expressed in the specific media of the arts."[59] Just like Isamu Noguchi and Henry Moore, the words of Pollock, the Nucleare, and Moholy-Nagy are clear example of the difficulty

Figure 3.5
László Moholy-Nagy, *Nuclear II*, 1946. Oil on canvas. 49¾ × 49¾ in. (126.37 × 126.37 cm) framed: 50¼ × 50⁷⁄₁₆ × 2¾ in. (127.64 × 128.11 × 6.99 cm). Gift of Kenneth Parker. M1970.110. © Artists Rights Society (ARS), New York. Courtesy of Milwaukee Art Museum.

in disentangling the many compounds: art/science, civilian/military, East/ West, and apolitical/political responses in postwar modernism.

Surrealism and the Bomb

Salvador Dalí is another European modernist who breached the "art for art's sake" doctrine. Dalí painted very early on at least three works directly relating to the atomic age: *Melancholy, Atomic, Uranic Idyll* (1945), *Dematerialization Near the Nose of Nero* (1947), and *Atomic Leda* (1949). The earliest—the *Idyll* (for short)—was clearly the most politically motivated work. Among the numerous images free-floating on the canvas, he superimposed an image of a military plane dropping bombs onto a faceless human head, thereby creating its desolate if not suffering expression. The whole host of Dalí's signature motives are there in the *Idyll*—the melting clocks, the melting bodies, and the swarms of ants—with the addition of an atomic explosion on the right lower corner, with its rays of light and fire.

Freud and his theories on the interpretation of dreams had inspired Surrealism, but, in December 1958, Dalí released an exhibition leaflet titled "Anti-Matter Manifesto" that signaled his departure from the Surrealist doctrine. Dalí's new thinking was inspired by Heisenberg's quantum theories, which, unlike the arts, still debated the differences between determinism and free will. Thus the manifesto included the following statement: "In the surrealist period I wanted to create the iconography of the interior world—the world of the marvelous, of my father Freud. I succeeded in doing it. Today the exterior world—that of physics—has transcended the one of psychology. My father is Dr. Heisenberg." Dalí explained how he intended to fulfill this goal: "It is with pi-mesons and the most gelatinous and indeterminate neutrinos that I want to paint the beauty of the angles and of reality."[60] In the modernist tradition, he also called for a renewal of traditional ways of painting.

Surrealism had already crossed paths with a representation of the bomb in Hara's *Summer Flowers*. He wrote that the desolated landscape of melted corpses resembled a depiction of "the dreadfully gloomy faint green light of the medieval Buddhist hell," as well as surrealist paintings.[61] Riding in a wagon with surviving members of his family he surveyed the ruined landscape:

In the expanse of silvery emptiness stretching out under the glaring hot sun, there were roads, there were rivers, there were bridges. And corpses, flesh swollen and raw, lay here and there. This was without doubt a new hell, brought to pass by precision craftsmanship. Here everything human had been obliterated—for example, the expression on the faces of the corpses had been replaced by something model-like, automaton-like. ... But seeing the streetcars, overturned and burned apparently in an instant, and the horse with enormous swollen bellies lying on their sides, one might have thought one was in the world of surrealist paintings.[62]

Remembering these moments, Hara composed his own Surrealist verses in *katakana*, the alphabet used for the transcription of foreign words (and which is often printed in capital letters in English translations of Hara's *Summer Flowers*):

BROKEN PIECES, GLITTERING,
AND GRAY-WHITE CINDERS,
A VAST PANORAMA—
THE STRANGE RHYTHM OF HUMAN CORPSES BURNED RED.
WAS ALL THIS REAL? COULD IT BE REAL?
THE UNVERSE HENCEFORTH, STRIPPED IN A FLASH OF EVERYTHING.
THE WHEELS OF OVERTURNED STREECARDS,
THE BELLIES OF THE HORSES, DISTENDED,
THE SMELL OF ELECTRIC WIRES, SMOLDERING AND SIZZLING.[63]

Hara's portrayal of Hiroshima before the bomb also included a reference to an "impressionist painting," showing another meeting point between Eastern and Western representations of the bombings.[64]

Nevertheless, and despite Hara's own clear reference to Surrealism, using imagery from Dalí's paintings to describe or allude to the disaster of the atomic bomb is limiting if not demeaning to the victims. The nude in Dalí's *Atomic Leda*, for instance, unarguably exemplifies the sexual objectification of women characteristic not only of his work and of many Surrealists, but also of Yves Klein. The nakedness of the men and women Ōta described (whose clothes had been burned off during the bombings) the nakedness of Hara (who'd been in the privy when the bomb went off) cannot be likened to the nudity of the human form represented in a work of art (whether idealized or objectified.) Neither Ōta nor Hara used nakedness as an artistic motif, or for the purposes an artist would choose to paint a nude.

The work of the Marukis bears mentioning here. Dower wrote of their "great fondness for the abstractness found in both Nihonga [Japanese painting] and Surrealism."[65] Having incorporated some elements of each in their work, Dower explained that they were sometimes criticized for depicting ways in which the victims' clothes had been ripped from their bodies. The Marukis themselves recounted being criticized at times because their rendering of the victims' naked bodies in the panels was seen as "unrealistic."[66]

The influence of Surrealism (together with Cubism and abstraction) and its fusion with Nihonga and Japanese painting is evident in several Japanese works depicting the direct aftermath of the bombings. An image from one painting is the mushroom cloud of *Henreki* [Itinerary, 1945] (figure 3.6) by Mashima Kenzo, who had seen the cloud firsthand. Burning shades of red appear in his *Hiroshima no yūyake* [Hiroshima's Sunset, 1945]; the title as represented in kanjis (the iconographic Han Chinese characters used in Japanese writing) can also mean "Hiroshima's evening burns." Other works include the *Guernica*-like painting *Hiroshima* (1948) by Yamamoto Keisuke (figure 3.7); the abstract black and white of *Gunzō* (Group, 1946) by Yoshihara Jiro, the co-founder of the Gutai Group; and the many devastated landscapes that Takamasu Keisō depicted right after the bombing (these are only a few examples among the many exhibited in *1945 nen +/– 5nen* (1945 +/– 5) by the Hiroshima City Museum of Contemporary art. (figure 3.8 and 3.9).[67]

One could spend a lifetime looking into the ways in which the styles of representation coincide between Japan and the West. But, undeniably, the urge for *hibakusha* such as Ōta and Hara in Japan to bear witness is not the underlying motive for Newman, Dalí, or the Nucleare artists in the

Figure 3.6
Majima Kenzo, *Itinerary*, oil on canvas, 1945. Courtesy of the Collection of Nagoya City Art Museum.

West—even though the urgency to resist and speak against atomic weapons and human suffering should be universal.

Reliving the Unthinkable: Writing with a Mission

In fact, there are more parallels between A-bomb literature and the writings on the Holocaust, as Tsukui Nobuko has underscored with examples from the literature of Charlotte Delbo and Nelly Sachs.[68] The testimonial style there too is derived from a sense of urgency. Ōta's need to record the Hiroshima bombing and its aftermath was so strong, as she explained in *City of Corpses*, that she wrote on pieces of peeled paper from *Shōji* (paper sliding doors) and toilet paper: she had lost everything in the atomic blast.[69]

Figure 3.7
Yamamoto Keisuke, *Hiroshima*, oil on canvas, 1948. Photo credit: Hyogo Prefectural Museum of Art. Courtesy of Hyogo Prefectural Museum of Art.

Her sense of urgency was also heightened by the fact that radioactivity was still working insidiously within her body. She prefaced the 1950 version of *City of Corpses* with an acknowledgment of her "thinking … that every moment might be [her] last" because she had to face the "gruesomeness" of radiation sickness: "a vast and profound force that destroys the human body even while the body is alive."[70] That realization is a terrible and possible omen to her rapid decline and death in 1963, in the city of Fukushima, coincidentally, while working on a new book.[71] She had previously written about the effects on the health and on the minds of the survivors through her and her mother's experience, in particular in the novels *Hachijussai* [Eighty Years Old, 1961] and "Haha no shi" [Mother's Death, 1959].[72]

Yet not all *hibakusha* writers were taken by radiation sickness. Hara committed suicide in 1951 by laying down on train tracks.[73] Previously, he too had scribbled on pieces of paper after the bombings, writing, "miraculously unhurt; must be Heaven's will that I survive and report what happened."[74] He wondered why his life was spared in such essays as *Heiwa e no ishi* [Will

Figure 3.8
Takamasu Keisō, *Untitled, Sketches Drawn Right after the A-bomb*, September 9–10, 1945. Donated by Takamasu Fumio, Collection of the Hiroshima Peace Memorial Museum.

Figure 3.9
Takamasu Keisō, *The Burnt Ruins That Became of Hiroshima*, September 9–10, 1945. Donated by Takamasu Fumio, Collection of the Hiroshima Peace Memorial Museum.

to Peace, circa 1948] and *Chinkonka* [Requiem, 1949]. In *Summer Flowers*, he also put into perspective his previous suicide attempts following circumstances involving communist militancy and a prostitute, as detailed by Richard H. Minear in *Hiroshima, Three Witnesses*.[75] His sense of mission did not last long, however, and the reasons for his suicide, at the age of forty-seven, are subject to speculation and debate.[76]

The death of the *hibakusha* poet Tōge Sankichi is also worth noting. A different kind of urgency prompted him to write *Poems of the Atomic Bomb* (1951) within a very short time. After a lifelong history of strange medical conditions that could be the subject of its own book (also explained by Minear), Tōge felt himself on the brink of death. Thus he felt compelled to create or finish the poems in his hospital room while waiting for surgery; he stayed up at night and hid from medical personnel to accomplish the task.[77] He survived for five years after exposure to the most lethal type of weapon on earth, but he did not die specifically from radiation sickness. Ironically, a record of the last moments of his life comes from the log of an X-ray technician who acknowledged reading "Prelude" (1951), from *Poems of the Atomic Bomb*, when Tōge was in critical condition, an hour before his death.[78] "Prelude" is Tōge's most well-known poem; the first four lines follow:

Bring back the fathers! Bring back the mothers!
Bring back the old people!
Bring back the children!
Bring me back![79]

In a 1985 interview the Marukis spoke about their reasons for deciding to create the Hiroshima Panels: "We don't paint these subjects because we enjoy painting them. It's not out of some desire to do something for humanity or to make a point. We painted the bomb because we had seen Hiroshima, and we thought there had to be some record of what had happened." The Marukis were in Tokyo when they learned of the bombings. Having close relatives there they traveled to Hiroshima and witnessed the tragedy. Some of Iri's family members were already dead; his father died after six months. While there, they helped the injured and, as they recalled, "cremated the dead, searched for food, made roofs of scorched tin sheets, wandered about just like those who had experienced the bomb, in the midst of flies and maggots and in the stench of death."[80]

Without a doubt, these works are inherently political. As Maruki Iri disclosed: "We had opposed the war, we were socialists, and we were not satisfied only painting pretty pictures. That's the kind of people we were."[81] The

ultimate necessity to testify and remember was therefore urgent, and as seen from examples of other artists and writers, expressed in many forms. Within his "History of A-bomb Literature," Nagaoka included the art of the Marukis, but in that compendium he also summarized several films, such as *Black Rain* (and even mentioned, in passing and without comment, *Dr. Strangelove* by Stanley Kubrick). Although Nagaoka acknowledged visual "literature" to belong to the genre of A-bomb literature, he did not extend it to manga, though the art form also plays an important role.

The Particular Case of Manga and A-bomb Literature

The celebrated *Hadashi no Gen* [Barefoot Gen, 1973–85] by the *hibakusha* manga artist Nakazawa Keiji cannot be forgotten. The manga plays a crucial role in Japanese popular culture and is now an integral part of any school library in Japan; film versions of these comics have been released as well.

Although the comic strips are rendered in black and white, the colors of nuclear calamity are quite clear, as when Nakazawa depicts the horrors he witnessed as a child: the death of so many of his family members, the decomposing human bodies that, like the slugs melting in a pot of salty water as described by Ōta, become "half-human" (figures 3.10a and b). One strip reveals a disturbingly cruel scene: a man covered in bandages from head to toe being mocked by passing children—so many of the *hibakusha* writers described this kind of shameful discrimination against survivors after the bomb. Another chronicles the terrible plight of a teenage girl, Natsue, whose daily life was marked by trips to the hospital before her premature death.[82] Nakazawa's more recent *Kuroi ame ni utarete* [Struck by Black Rain, 2005] is an equally strong candidate to help establish the manga's place among other strong visualizations from *hibakusha* artists, some of which convey the feelings of occupied Japan and its resentment toward Americans.

Several other manga artists have couched their grief in their comic strips. *Jigoku* [Hell, 1971] by Tatsumi Yoshihiro and *Black Jack, yarinokoshi no ie* [Black Jack, the Things Left to Do at Home, 1971] by Tezuka Osamu—known otherwise for his manga character AstroBoy—are worth noting for their uncompromising depiction of the bombings and the victims.[83] Most famously and recently, Kōno Fumiyo's *Yūnagi no machi, Sakura no kuni* [The City of the Evening Breeze, the Country of Cherry Blossom, 2003–2004] also offers a poignant depiction, with voices of the dying children and victims that haunt a young woman from Hiroshima. This manga was directly inspired by Ōta's novels (which has a similar title) and by others writers

Figures 3.10a–b
Pages from *Barefoot Gen*, by Nakazawa Keiji. ©Nakazawa Keiji. All rights reserved.
Reprinted by permission of the publisher, Last Gasp.

Figures 3.10a–b (continued)

of A-bomb literature. Kōno created her manga when she realized that few around her in Tokyo had accurate knowledge about the bombings. Her manga was later adapted for the screen.

A-bomb literature, in any medium, still glows like a humanitarian lighthouse, invoking the philosopher Kazashi Nobuo's description of Hiroshima's A-bomb dome: it re-asks questions about the meaning of human civilization, about life itself and its foundation. But strikingly, as Kōno realized even in Tokyo, A-bomb literature is a genre quite unknown. On the other hand, John Whittier Treat has emphasized that A-bomb literature was sometimes criticized, unlike Holocaust literature, for being "non-literary."[84]

The reason for this invisibility includes but goes beyond any discussion of literary style, as both Treat and Nagaoka explain. A-bomb literature, however, cannot be mentioned without considering the greater historical context of occupied Japan: due to the Press Code instituted by the Allied Occupation Powers under US General Douglas Macarthur, A-bomb literature was affected by censorship just like any other journalistic reportage on the bombings.

In addition, and acknowledging that Nagaoka barely referred to it (just as he did not refer to A-bomb manga), photography also holds a special place in the history of art of the atomic age. Styles range from the documentary photographs of Hayashi Shigeo, who witnessed the aftermath of the incinerated Hiroshima, to the soul-burning pictures of Nagasaki taken by Yamahata Yōsuke.

For photographs, too, the documentary genre in fact defies any rigorous artistic category. The photos of the atomic mushroom taken by Fukuda Toshio are considered to be the closest representation of the radioactive cloud. Fukuda was only sixteen years old at the time and could hardly be called a professional artist.[85] Most importantly, exploring this medium together with literature, as I do in chapter 4, also helps to explain the actual differences between A-bomb art in Japan and in bomb-related representations in the West.

4 Censorship in A-bomb Literature and Photography—
or the Story of Oiwa

In *Residues of Squalor*, Ōta Yōko offers another life-based metaphor for the horrific power of the nuclear age: her attempt at solving the slug infestation in the shabby rain-soaked house where her unnamed narrator (Ōta) lives with her relatives in June 1951, nearly six years after the bombing of Hiroshima.

On the night Ōta observes her relatives huddling under protective mosquito netting in the next room, she decides to wait until everyone has fallen asleep, and then sprinkle DTT, hoping that the slugs would run away. The insecticide DTT, in white powder form, was used to stop infestations and epidemics during World War II, and extensively used by the American forces and Occupation forces in Japan, sometimes in humiliating ways.[1] But Ōta's plan backfires. The slugs melt in the same awful fashion as the human beings did in Hiroshima. There is no escape: "This was what I feared the most. One day the pale white radioactive flash burned H City as though to toast it, I was in that city, and I saw how human beings were burnt and melted not by flames of fire but by the rays of the homicidal weapon that had fallen from the sky."[2]

Ōta mentions the torrential rains and typhoons that, after the war, came with foreign women's names in Japan (unlike the West, Japan does not ascribe genders or names to typhoons but rather numbers), and the moisture brought on the slugs in droves. Now, unable to cope with the sight of the melting slugs and the ghosts of the bombs, she covers them with a newspaper to get them out of sight. Within the first few pages of her novel, Ōta summarizes her killing of the slugs in an analogous way to the use of atomic bombs: the intention to "save lives" or reduce pain via technology, and its backlash; then the intention to cover it up and look away. The analogy goes on.

To stop the nausea she feels after the "accident," Ōta invites her sister to drink sake with her, to "finish turning the corner of [her] heart that was

filled with dark depression."[3] The two women exchange comments about the bones of the soldiers resurfacing now and then, whether it rains or not on the parade ground. Their brother, Tetsuji, was killed there too by the instant flash, at the place where housing units for the survivors were now located. His bones were never identified. The x-shaped keloid scar on her sister's lips, along with other scars caused by glass slinters, starts to itch. Ōta offers the antihistamine she herself usually uses to sleep, before adding: "Control poison with poison. I can't live straight, can I?"[4] As she speaks, the slugs crawl back to visibility.

Residues of Squalor is paradigmatic of the impossible cover-up of the nuclear age: turning a blind eye is impossible because the slugs and fireflies of yesterday always continue to contaminate today's lives. One of the pivotal characteristics of A-bomb art in Japan is censorship. In other words: the intent to put the atrocities out of sight by covering them with a newspaper.

Newspapers were the primary target when General Douglas Macarthur and the General Headquarters (GHQ) of the Supreme Commander of the Allied Powers officially released the Press Code, with ten items primarily geared to the Japanese news media, on September 21, 1945.[5] In October a related unit operating as the Civil Censorship Detachment (CCD) assumed the responsibility "to collect and scrutinize *everything* published or performed in Japan—newspaper, books, magazines, radio and theatrical scripts, movie scenarios, even pamphlets of clubs and professional societies." Whereas the point of the Press Code for news media was to avoid disturbing the tranquility of the pubic, to "promote prewar orthodoxy, or deter the spread of democracy," and to make sure that news steered clear of editorial opinion and adhered to the "truth," the CCD determined that literature in all its form should be assessed for factual or opinionated content. Under the GHQ, the censorship period and its aftereffects on those creating, publishing, or otherwise showcasing various art forms lingered until 1951 and even into 1952.[6]

In fact, only a handful of A-bomb artworks emerged at the time, whether visual or textual. The work of Nagai Takashi and Hara Tamiki, as well as Ōta Yōko's main nonfiction and novels, were published during the censorship period, as were the photographs of incinerated Nagasaki that Yamahata Yōsuke took—the only extensive photographic record of either of the bombings. Notably, the second chapter of Ōta's *City of Corpses* was censored. Ōta, just like Hara, recalled hearing on the radio that because of the censorship law "only scientific accounts of the atomic bomb could be published."[7] Paradoxically, the one chapter of Ōta's novel that was censored was entirely filled with scientific reports, from Japanese physics professors,

X-ray experts, and anatomical experts such as Dr. Fujiwara from Hiroshima University, Dr. Tsuzuki from Tokyo University, and Dr. Sawada from Kyushu University.

Writers continued their work of bearing witness to the bombings and the suffering they ensued in spite of the censorship. But not until more than three decades later did an A-bomb anthology appear. Dedicated to multiple genres of literary response to the bombings, *Nihon no genbaku bungaku* [Japanese A-bomb Literature] published by Holp Editions in 1985 comprises at least thirteen thick volumes of writings, poems, and songs.[8] Similarly, the visual arts found venues willing to bring bomb-related works to large audiences. For instance, the Hiroshima City Museum of Contemporary Art regularly curates commemorative exhibitions with a flurry of artists from all around the world. These shows feature painting and sculpture in all possible styles ranging from abstract, to minimalist, surrealist, and photorealist, including artworks by pivotal twentieth-century artists such as Nam June Paik (*Hiroshima Matrix*, 1988), Willem de Kooning (*Woman in Landscape VI*, 1968), and Kusama Yayoi, who in *Yomigaeru tamashī* (Revived Souls, 1995) commemorates the victims using black and white dots instead of her usual colorful explosions of dots. For the special exhibition *Contemporary Art of "Hiroshima"* the museum included Yves Klein's *ANT 170* (1960), a painting from his Anthropometry series, now part of its permanent collection, instead of his *Hiroshima (ANT 72)* (1961), but the technique and color of both works are similar, and reflective of Klein's stance against nuclear testing (see chapter 6).[9]

The contrast between content permitted during the Press Code period and content today is no less striking when it comes to commemorative events. By 2015, for the seventieth anniversary of the bombings, NHK (Nihon Hōsō Kyōkai [Japan Broadcasting Corporation]) launched a special set of programs, including music, memorial concerts, letters from *hibakusha*, and two drama series: "Red-Brick" and "The Tram Is Running Again in Hiroshima." The latter is based on the true story of teenage girls who ran the tramways (while regular drivers were mobilized by the military) to provide transportation for families looking for relatives across town.[10] In the 1970s, NHK had requested that survivors send their drawings as testaments of their suffering—and these were finally exhibited outside of Japan in 2014 in Manchester Art Gallery alongside the work of Otto Dix, Nancy Spero, and Omer Fast, pushing further the boundaries of what we consider as "art."[11]

Yet the obvious contrast between the years before and after the Press Code must not necessarily be attributed to the cessation of the censorship.

In fact, as the sociologist Saito Hiro explained, Hiroshima and Nagasaki's testimonies were caught between the Press Code and a disinterest from the politics centralized in Tokyo, before being caught up in nationalist enterprises to make Hiroshima a unifying national symbol.[12] Whether or not the Press Code or the CCD directly influenced the production of A-bomb works by survivors, and therefore influenced the Western works, is still a topic for debate, as I explain in the next section. But in discussions of censorship we are dealing with the visibility not only of the bombings but also of the victims. Here again, for the arts, it is not radioactivity that is challenging, but its political cover up.

Artistic Radiation Sickness: The Censorship of A-bomb Literature

Almost all of the A-bomb *hibakusha* writers faced censorship and wrote about it. On the one hand, it is true, as Jay Rubin claims, that there was an increase in publications after the war (in literature at large), that can be distinguished from previous increases in that it occurred "while the entire publishing industry was under control of a censorship apparatus initiated and maintained by those alien troops." In his article on censorship, Rubin examined the views of Etō Jun and Nakamura Mitsuo, two prominent Japanese critics. Etō was convinced that "the Japan psyche was recast into an American mold," whereas Nakamura had little to say about censorship, remarking that the occupation made Japanese literature "unnaturally free," and warned that the end of Occupation would bring the end of what he called a "hothouse" liberty. Nakamura's ultimate objection was that writers during the Occupation had focused monotonously and too profitably on sex.[13]

Rubin comes to a different conclusion than Etō, however, and argues that Occupation censorship did not impose an alien system on writers but rather it liberated them from prewar censorship and the constraints of writing to glorify the state. According to Rubin, the censorship was loose and sometimes oddly implemented.[14]

When examining how censorship affected writing about the nuclear bombings, it is true, as Hara claimed, that his *Summer Flowers* was published in 1947, seemingly uncensored, as was Agawa Hiroyuki's *Hachigatsu muika* (August 6, 1947). It is also true that Agawa's *Nen nen sai sai* (translated as Years upon Years, 1946) had only one passage removed—the one recounting the rumored genetic effects of radiation that resulted in deformities, such as being born three-legged or one-eyed—because it was deemed "untrue— disturbs public tranquility."[15] Ōta's *City of Corpses* was also published in full in 1950 (the second chapter was censored in the 1948 edition), and the

deleted chapter was not the one including a gruesome depiction of ash-burned victims and corpses, but rather a chapter referring to Japanese radiation experts. Even in the case of the Hiroshima Panels, the Marukis decided to change the title *Atomic Bomb* to *Ghosts* to avoid censorship.[16] Occupation censorship seems, on the surface, mild.

On the other hand, censorship in Japanese A-bomb literature was still pervasive. Nagai's *The Bells of Nagasaki* was first censored in 1946 in the context of the Military Tribunal of the Far East in Tokyo.[17] But the X-ray specialist had friends who pleaded his cause in Washington, DC. Permission was granted on the condition that the Japanese atrocities in the Philippines also be detailed with the publication.[18] Even Hersey's *Hiroshima* was censored in Japan, and he was asked to add details of atrocities perpetrated by the Japanese army.[19] Later on, Hara also had to manage his way through the net of pre- and post-censorship.[20] Therefore the first part of *Summer Flowers* was published in 1947 and the three parts together in 1949. Like Nagai, Hara had contemplated publishing in English to shortcut the censors, but the project proved difficult to achieve. In photography, the few pictures that Matsushige Yoshito took of Hiroshima after the blast were confiscated (but he managed to keep some negatives).

Most importantly, as Rubin suggests, the level of censorship that survivors imposed upon their own writing must be given visibility even though its impact is difficult to evaluate. One seminal example is Shōda Shinoe's decision to publish her tanka poetry secretly. She explained her defiance as follows:

I composed my *tanka* collection *Sange* (Penitence) with the intention of mourning those victims who were killed instantly and those who died later and of comforting those survivors who are grieved and suffering.

In those days the GHQ censorship was strict; and I was told that if my secret publication of *tanka* collection was found out, I would certainly be sentenced to die. I made up my mind that I would face the death penalty if I must; and despite my family's objection, I published the book secretly because I felt compelled to do so.

Like one in delirium, I personally handed copies of my book to the people who were crying in their hearts.[21]

As Rubin points out, however, no one was tortured or killed because of the Press Code, but the pressure was evident. Of course censorship laws of various kinds existed in most countries for centuries, and the Japanese laws were in the hands of the imperial system before being taken over by the military.[22] The 1933 police torture and subsequent death of the proletarian writer Kobayashi Takiji was one terrible example. The Occupation brought at once freedom and restrictions.

Ōta's sarcastic recollection of her encounter with censorship officers is also worth noting. It shows how fast the finely geared mechanics of the nuclear age worked in covering the melting slugs of the atomic age. After Ōta sent her manuscript for clearance, an Occupation intelligence officer and an American Japanese translator soon showed up on her doorstep, repeatedly asking if she knew any atomic bomb secrets, if any foreigners had read her manuscript, and if she had any contact with foreigners. The intelligence officer also pressed her to forget about the bomb because "America won't use the atomic bomb again," and only answered her questions about the Press Code with an evasive explanation: "It's not my job to answer that, either, so I can't answer. I want you to forget the atomic bomb."[23] She finally stressed that if she could not publish it in Japan, she would send the manuscript to the United States—just like Hara and Nagai had planned on doing.

The pervasive effect of censorship, even if sometimes odd and inconsistent, cannot be denied. In fact, it even contaminated cultural events. Tōge wrote a poem titled August 6, 1950, referring to the peace ceremony, because the ceremony itself was banned. An excerpt from the poem follows:

(…) August 6, 1950:
the Peace Ceremony has been banned;
on street corners at night, on bridge approaches at dawn,
the police standing guard are restive.
(…)
workers, merchants, students, girls,
old people and children from outlying villages—
a throng of residents representing all Hiroshima
for whom August 6 is the anniversary of a death—and the police:
pushing, shoving. Angry cries.
The urgent appeal
of the peace handbills they reach for,
the antiwar handbills they will not be denied.
(…)[24]

The GHQ's pressure resulted in the cancellation of the 1950 Peace Memorial Ceremony because some groups wanted to protest against the Korean War. As the sociologist Saito Hiro underscored, this pushed these local groups to use universalistic terms: making Hiroshima a transnational symbol of peace for humankind.[25]

Consequently, to return to the differences in the depiction of the bombings in Japan and in the West, censorship had an effect—even though the Press Code and the CCD lasted only a few years—that extended even

beyond the language barrier and the difficulty in translating A-bomb litera-
ture. In addition to that, photographs of the disasters were censored too.
And their invisibility lasts as well, like lingering radioactivity.

The Black and White but Invisible Pictures of Yamahata Yōsuke

As Rubin pointed out, the Press Code was intended primarily for the press—
which actually was the most direct and efficient way to circulate informa-
tion and knowledge about the bombings. Yamahata Yōsuke's photographs,
in fact—because they are not easily classifiable as journalistic, artistic, or
military (even though Yamahata was a military photographer)—are also
paradigmatic of the post-mushroom obliteration of the victims through
the ways in which censorship manifested in both Japan and in the United
States.

Uncompromising, crude, and frontal, without any literary or photo-
graphic filter, some of the pictures were published before and after the Press
Code.[26] Yamahata's photographic records were also jointly published with
a very detailed scientific report of the disaster, together with drawings by a
war artist and comments by an intelligence officer who had accompanied
him in incinerated Nagasaki. The quality of the developed and reproduced
images has been affected by several factors, such as problems obtaining
photographic materials during the period, a camera with a defective mech-
anism, and fogging on the surface of the photographs possibly resulting
from radiation.[27] The many compounds—art and science, civilian and
military—are symptomatically entangled.

In "Genbaku satsuei memo" [Notes on A-bomb Photography], Yamahata
explained having had a narrow escape, traveling via Hiroshima on August
5, 1945 (only one day before the bomb), before arriving safely in Hakata (in
Fukuoka) where he was assigned. He was then sent to report about what was
called a "new type bomb" and about which details were still unknown.[28]

The photographs are unequivocal about human cruelty: ash-burnt "bod-
ies" or, more accurately, remains (figure 4.1b); burnt, stunned, and crying
babies; a close-up of a dead child naked and deeply burnt whose head is
indistinguishable among the rubble; a swollen horse pinned under piles of
debris; a disfigured couple (the private parts of the man seem blinded by
a white flash or scratch); an elderly person crawling in the rubble (figure
4.1c). Among the many pictures are those of a destroyed church and few
healthy looking Caucasian and Asian monks in prayer. The bombing of
Nagasaki destroyed the Urakami cathedral. Here is the cruel reality that
Western artists of the time had no access to.

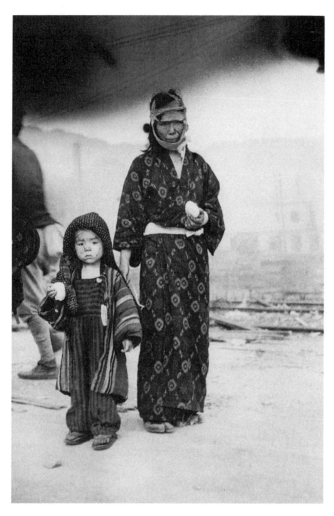

Figure 4.1a

Yamahata Yōsuke, *Photograph of Escape in Nagasaki A-13-2*, August 10, 1945, owned by the Tokyo Photographic Art Museum. Courtesy of Tokyo Metropolitan Foundation for History and Culture Image Archives.

Figure 4.1b
Yamahata Yōsuke, *The Burned Body of Boy Near Ground Zero*, August 10, 1945, owned by the Tokyo Photographic Art Museum. Courtesy of Tokyo Metropolitan Foundation for History and Culture Image Archives.

Figure 4.1c
Yamahata Yōsuke, *An Old Woman Crawling (Mori-machi)*, August 10, 1945, owned by the Tokyo Photographic Art Museum. Courtesy of Tokyo Metropolitan Foundation for History and Culture Image Archives.

Just like the Marukis decided to add captions to their Hiroshima murals because drawing was not sufficient to express their feelings, Yamahata also added notes to his photographs that sink the viewer into deeper layers of the horrors portrayed by the camera. Among the captions: "Wounded persons were in an abstract state of mind ..."; "A mother and her child lay dead on the platform of Nagasaki Station. The black spots on their bodies on this picture were red burns of the atomic bomb. ..."; "We could not help averting our eyes from the miserable figures of infants. They were already so weak that they could not cry under first-aid treatment." Among the pictures of the survivors, a set of two photos stand out with the caption "An old woman was paralyzed with terror, and she crept about with her knees"[29] (figure 4.1c). Just like the writings of the A-bomb *hibakusha*, they do away with magnifying photographic style and aesthetic embellishment, and his description of the scene is as heart piercing as those by Hara, Ōta, and Nagai. They too can be added to the history of A-bomb literature. Strangely, Nagaoka does not refer to Yamahata's photographs, but to post-censorship photographers and their work, such as Domon Ken's *Hiroshima* (1958) and Fukushima Kikujirō's *Pikadon* (1961), the latter having followed a *hibakusha* family for nine years (*Pikadon* and sometimes *pika* refer to the way the bomb was called in Hiroshima).[30] Even though Yamahata was a military photographer, his stance is far from nationalistic or celebratory of war, and his photographs provide a direct visual account complementary of the textual accounts of Ōta and Hara.

Yamahata's pictures have the immediacy and authority that Susan Sontag praised in the photographic medium. In *Regarding the Pain of Others*, Sontag stated: "Ever since cameras were invented in 1839, photography has kept company with death." Sontag further explained how the camera, freed from the tripod and equipped with lenses permitting "feats of close observation," also had an "immediacy and authority greater than any verbal account in covering the horror of mass-produced death," the ones of Bergen-Belsen, Buchenwald, Dachau, "and those taken by Japanese witnesses such as Yōsuke Yamahata."[31]

In 1952, Yamahata similarly commented on his visual testimony of the bombing of Nagasaki: "Humans' memory, because of the changes in life and circumstances, softens its criticism and can fail, but the camera captures everything of that time, the grim truth now does not change, and what happened seven years ago can serenely be reported to everybody."[32]

The reason for censorship of these photos is precisely their "immediacy" and "authority." But like the dying and melted slugs that were sprinkled with DTT, covering them with a censored newspaper like Ōta had done is not a solution. They will get back in sight. After the San Francisco Peace

Treaty (signed in September 1951 and enforced in April 1952), and as Saito observed, literary and photographic testimonials of Hiroshima and Nagasaki "were rushed into publication"[33] in Japan: *A-bomb Children* (1951) and Tōge's *Poems of the Atomic Bomb* (1952) in words, and *Hiroshima: sensō to toshi* (Hiroshima: War and City, 1952) in pictures.[34] In film, *Genbaku no ko* (Children of the Bomb, but translated as Children of Hiroshima, 1952) by Shindō Kaneto was released (figure 4.2); the film follows a young woman who returns to her hometown four years after the bombings, where she finds, in the midst of sickness and desperation, some sense of hope and recovery. The documentary *The Effects of the Atomic Bomb on Hiroshima and Nagasaki* (1946) would only be released in the late 1960s. The filming of

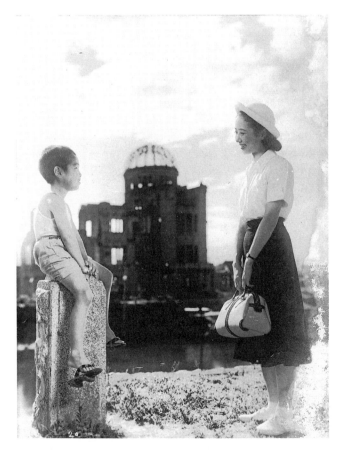

Figure 4.2
Children of Hiroshima, film clip, by Shindō Kaneto, 1952. © Kindai Eiga Kyokai Co., Ltd.

the documentary had been ceased by the Occupation forces toward the end of shooting in Nagasaki, and it had been assessed by the GHQ. The final editing is detrimental to the film—particularly the clinical shots of the *hibakusha* and the music—and the film was not translated into Japanese until the 1990s. The list of post-censorship works goes on, and Yamahata's 1952 album picture can evidently be added to the flurry. Most notably, pictures of the two cities were published in the August 6, 1954, special issue of *Asahi Graph*, which sold 520, 000 copies in a single day (and 700,000 in total).[35] The number of catalogs published in Japan with pictures of Hiroshima and Nagasaki are by now countless. Yet, while the slugs and fireflies hide in plain sight in Japan, they still barely have reached the Western audience. Their invisibility cannot be blamed on the language barrier since just enough of A-bomb works have already been translated and photographs use a non-verbal language. The nuclear machinery is still at work.

Yamahata Yōsuke's Photographs and Postwar US

War censorship was not implemented solely in Japan. Through the history of war photography Sontag recounted in *Regarding the Pain of Others*, she strikingly demonstrated the recurrent issue of state or military censorship, noting that "if the governments had their way, war photography, like most war poetry, would drum up support for soldier's sacrifice" and not for portraying the cruelty and reality of war.[36] In the US, after Pearl Harbor, the Office of Censorship had forbidden public viewing of any images of dead American soldiers—except a few with the bodies and/or faces obscured. In spite of the fact that, as Sontag underscored, pictures of calamity and causalities from faraway lands are more easily circulated, the photographs of destruction in Hiroshima and Nagasaki only sporadically reached the general public outside of Japan.

In the US, the magazine *Life* published some of Yamahata's pictures of Nagasaki along with a few by Matsushige of Hiroshima on September 29, 1952, in an issue titled "When Atom Bomb Struck—Uncensored."[37] Compared to John Hersey's 1946 article "Hiroshima" in *The New Yorker*, which only had one picture of a man seen from behind walking toward a razed area, *Life*'s article seemed as close as possible to its claim of being "uncensored." The pictures selected show survivors in rags, few barely distinguishable corpses in a ditch, a child in a wheelchair with his/her face completely covered in bandage. The short article ends, however, in stark contrast to other images of devastation, with a picture of a young beautiful woman smiling as she pops out of the shelter that saved her life (see figure 4.3).

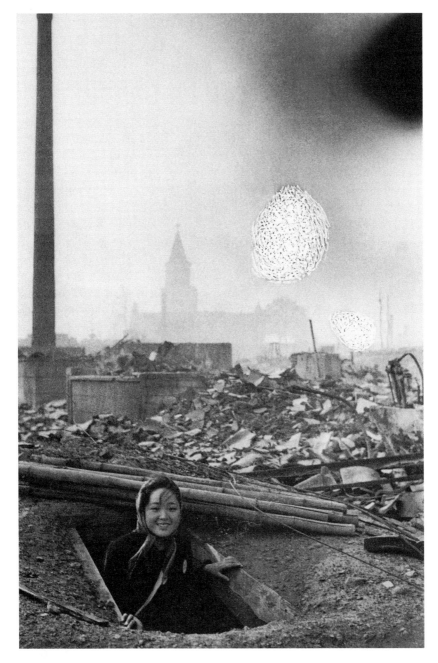

Figure 4.3
Yamahata Yōsuke, *Girl Who Escaped*, August 10, 1945, owned by the Tokyo Photographic Art Museum. Courtesy of Tokyo Metropolitan Foundation for History and Culture Image Archives.

The image is particularly unsettling because—given the photographic record of corpses amid rubble, and the survivors in rags and wheelchairs and bandages—it's hard to imagine a person so seemingly unscathed (physically and emotionally) upon witnessing what happened on August 6. The choice of this image is troubling. It counteracts the devastation in the others and thus erase the visibility the magazine hoped to convey.

In addition, while the *Life* issue claimed on its cover "First pictures—Atom Blasts, Through Eyes of Victims," the short article accompanying them revealed nothing comparable to the scale of suffering expressed in the written and photographic records of Yamahata and of the *Asahi Graph*, or any of the A-bomb *hibakusha* writers. The images were carefully selected and Yamahata was quoted as saying "the dead, those who died with the bomb, [had] no suffering written on their faces. They had died instantaneously and many resembled shop window mannequins." Without a doubt, *Life* selected the pictures very carefully. But overall, as a group, these pictures clearly indicated the opposite of a peaceful, painless demise. And the only atrocities the magazine referred to came through the voice of Yamahata, quoted further as saying "people walked aimlessly, some with flesh gone from their legs."[38]

We cannot but agree with Sontag that we usually expect photographs to be authentic, but that even before the era of digital photography and Photoshop, misrepresentation was possible, since "to frame is to exclude."[39]

The first monograph of Yamahata's photographs in the US was published in 1995, but the Museum of Modern Art in New York City had exhibited a couple of his (less shocking) photographs in the groundbreaking 1955 exhibition *The Family of Man*.[40] The Marukis' murals are exhibited from time to time, with cyclical interest, to paraphrase John Dower again.[41] But when it comes to the photographic testimonies of the bombings, unarguably the pictures by Tōmatsu Shōmei and perhaps Domon Ken are given greater exposure, for they were taken more than ten years after the bombings, once the wounds of the ruins and victims of Hiroshima and Nagasaki have been visibly, and only visibly, healed. In fact, Tōmatsu's *Nagasaki, 11:01, 1945/ 8/9* (1995) includes the photographs he took in 1961 (figures 4.4a–d). More than a direct testimony of the atrocities of the bombings, the photographs should be seen rather as a testimony of their lasting effect. They may have been taken through a more "artistic" filter than Yamahata's military photos, but Yamahata's undeniably belong with the many testimonials in the large category of artistic response to the A-bomb.

Figure 4.4a
Tōmatsu Shōmei, *Ms Tsuyo Kataoka 1. Motohara-machi*, 1961. Courtesy of Tōmatsu Shōmei—INTERFACE and Nagasaki Prefectural Art Museum.

Contemporary US and the Invisibility of Yamahata Yōsuke's Photographs

Still, even today some museums are taking bold steps, such as the International Center of Photography (ICP) in New York City. Erin Barnett, who curated the 2011 exhibition *Hiroshima Ground Zero 1945* at ICP, stated with Philomena Mariani, the director of publications, in their short yet incisive catalog introduction that for decades, "Americans were spared the most unsettling images of the destruction visited on Hiroshima and Nagasaki." They underscored the "sanitized" and "tightly managed" version of the bombings resulting from the US government's anxiety "to contain criticism—at home and abroad."[42] The museum had acquired the declassified military photographs taken by the United States Strategic Bombing Survey's Physical Damage Division in order to, as ICP director Willis E. Hartshorn said, "provide an opportunity to reflect on the limits and consequences of military engagement."[43] The catalog even selected two of Yamahata's pictures of Nagasaki (even if these were among the least shocking of his work).

Furthermore, the museum deserves credit given that the 1994 exhibition at the Smithsonian National Air and Space Museum commemorating the sixtieth anniversary of the bombing had been notoriously challenged as anti-American by conservative groups such as the American Legion and the Air Force Association.[44] In spite of the controversial move, the exhibition

Figure 4.4b
Tōmatsu Shōmei, *Mr. Yamaguchi Senji 2. Nakasono-machi*, 1962. Courtesy of Tōmatsu Shōmei—INTERFACE and Nagasaki Prefectural Art Museum.

Figure 4.4c
Tōmatsu Shōmei, *Bottle Melted by Heat Rays and Fire*, 1961. Courtesy of Tōmatsu Shōmei—INTERFACE and Nagasaki Prefectural Art Museum.

of declassified pictures taken by the US military of Hiroshima, whether a month or many months after the bombings, only portrays the calamity without victims, without bodies—another "sanitized" version. The sanitized images influenced cultural productions instead of the photographs that were first censored. The film *On the Beach* (1959) is paradigmatic. It is a Hollywood adaptation of the post-apocalyptic science fiction novel by Nevil Shute, in which the last humans surviving nuclear fallout await death by slow poisoning. In the film, when the characters reach irradiated San

Figure 4.4d
Tōmatsu Shōmei, *Statues of Angels at Urakami Tenshudo Catholic Cathedral Which Was Destroyed by the Blast. Motoo-Machi*, 1961. Courtesy of Tōmatsu Shōmei—INTERFACE and Nagasaki Prefectural Art Museum.

Diego, the depiction of a nuclear war-stricken city is one that has not one body or victim in sight.

Such attempts at cleanup also explain the rift in representation of the bombings in Japan and in the West: the textual and visual testimonies of the victims were made invisible by the nuclear machinery—a process directly inherited from the already highly refined and effective military censorship. Here is the artificial and mythical power of the nuclear age.

The contrast is therefore sharp between the American and Japanese depictions. One of the most visually detailed Japanese publications is *Shashin-shū*

genbaku o mitsumeru: 1945-Nen Hiroshima Nagasaki (Staring at the Collection of Photographs: 1945, Hiroshima and Nagasaki, 1981), which includes the work of more than twenty photographers (professional or not).[45] The publication shows the destroyed city as well as an almost unbearable number of pictures of corpses and *hibakusha* about which Ōta's description of "half-human" cannot but come to mind. In one extremely soul-burning photograph a nurse cradles an agonized human figure. Only the caption helps in understanding that she was a fourteen-year-old girl. Her entire body had been burned, her breasts had become two open wounds. Yet the fact that she had no clothes on seems not even shocking. The melting of her flesh stole her human dignity: "half-human," there is no other word. Another gut-wrenching account of the bombings from Japan is *Hiroshima: sensō to toshi* (Hiroshima: War and City, 1952), which inevitably also contains some of the pictures from Nagasaki by Yamahata. The horrifying graphic details of photographs push the limit of what a viewer can absorb and comprehend.[46]

Western viewers' responses to these photographs understandably depended upon the venue and the selection on display. The reactions of readers following the 1952 *Life* article were quite strong, sometimes indicative of the outrage citizens feel when they learn after the fact how the their nation's military power has affected civilians elsewhere, especially as nationalist feelings of fear and aggression that linger between enemies gradually recede postwar. As the ICP curator Erin Barnett pointed out, such reactions reveal guilt and ignorance regarding the effects of the bomb. Men and women wrote of being "hardened to shock" at the "horror against innocent victims." A man belonging to a 1945 combat engineering battalion—and who had cheered with "hysterical joy" when the bomb was dropped because he had feared invading Japan—finally commented: "I have studied your picture series in terms of people I know and I cringe."[47] One wonders what reactions would have resulted in response to the pictures of the half-human *hibakusha*, the pictures of suffering victims, the slugs and the fireflies of the atomic bomb, if only they had been published in the West.

Since the bombings of Hiroshima and Nagasaki, censorship and nuclear activities have existed side by side. For instance, Saito detailed the difficulties for the *hibakusha* to gain national recognition in Japan until the *Dai go fukuryū maru* (Lucky Dragon 5) incident in 1954, in which a Japanese fishing boat encountered fallout from a US nuclear test conducted in the Bikini Atoll. Because the tuna had been distributed to markets before the discovery of their contamination, the entire nation realized the tests were threatening food supplies.[48] Exhibits like those of the ICP and the English translations of few A-bomb works—which gave visibility to the bombings must

continue. While these look few in number, no other known monograph of Yamahata's photographs or substantial translations of Ōta, Hara or Tōge's literature exist in French, Spanish, or Italian, for example. Most *hibakusha* writers, except perhaps Hara and Nagai Takashi, have never been published other than in collections that include the works of other survivors.

In *Two Grave Markers*, Hayashi Kyōko mentioned that during her escape with her badly injured friend after the bombing of Nagasaki, the fingers of a corpse next to her touched her cheek as she leaned over to drink from the river. "When she brushed it away the man with crew cut hair flipped upside down as simply as the shutter carrying the poisoned Oiwa in the kabuki story, and fell into the water."[49] Given the countless disfigured *hibakusha*, the sixteenth century kabuki play titled *The Story of Oiwa* is a striking echo of the nuclear age. In the play, the ghost of the poisoned and now disfigured Oiwa remains to haunt the characters who caused her demise.

Just like the ghost of Oiwa, the textual and visual testimonies of the *hibakusha* will haunt us back, perhaps in cyclical ways as they already have. How long will they be put out of sight? The voices of the victims are central to the art of the atomic age, without a doubt, but other representations of the bombings should not be overlooked. The Western portrayal of the military men and scientists of the nuclear age are also equally important to the visualization of the atomic age.

5 The Mainly Dramatic Art of Representing the Military Men and Scientists

The drama that unfolds in John Adams's opera *Doctor Atomic* (2005) concerns the moral and ethical implications for the scientists involved in political and military decisions (figures 5.1a–e). Trying to transform such a calamitous event as the atomic bombings into an operatic theme was daring. If images of A-bomb victims had hardly reached museums, how were they ever to reach the stage of the Western opera house and its tradition of elite writers and audiences? Inevitably, only a few (sanitized) voices of the victims appear in the background of *Doctor Atomic*, in part because the topic of Adams's opera centers on J. Robert Oppenheimer and the Trinity test conducted at Los Alamos, New Mexico: that is, the plot is set before the dropping of the bombs on Hiroshima and Nagasaki.

In fact, *Doctor Atomic* focuses primarily on the scientists who built the bomb and therefore, on the historical burden the bomb constitutes for the US. For John Adams, "*Doctor Atomic* represents American ingenuity, principles of freedom, the fight against fascism, but also the onerous responsibility of having been the first country to develop a weapon that can destroy all human life."[1] The figure of the scientist is therefore predominant. As Spencer Weart pointed out, biographies of American nuclear scientists of the 1940s "flourished" in the US at that time of *Doctor Atomic*, with at least seven significant works on Oppenheimer between 2005 and 2008.[2] The general director of the San Francisco Opera at the time, Pamela Rosenberg, had approached Adams in 1999 to make a modern version of Faust, an "American Faust."[3] Adams accepted because atomic energy "was the great mythological tale of our time," and because atomic bombs "dominated the psychic activity of [his] childhood … a source of existential terror" that constituted the "ultimate annihilator of any positive emotions or hopes."[4]

In *Doctor Atomic*, Adams depicts Oppenheimer as the modern American version of Thomas Mann's *Doctor Faustus* (1943–47), which reinvestigated the mythology of Faust in the context of Nazi Germany. The fictional

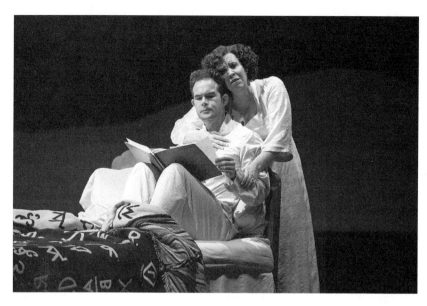

Figures 5.1a–e
John Adams, *Doctor Atomic*, 2005. Photo credit: Terrence McCarthy. Courtesy of the San Francisco Opera Archives.

character in *Doctor Faustus*, Adrian Leverkuhn, is a creative genius with the ambition to compose the ultimate piece of music that would transform society. But when he makes a pact with the devil to enhance his creative abilities, he contracts syphilis (a metaphor for Nazism), which precipitates his downfall (just like extreme nationalism did in Germany). As Adams pointed out, "it is one of the supreme ironies of Nazi racism that a significant number of the great minds that were instrumental in winning the race were émigré Jews."[5]

Not unlike Doctor Faustus, Oppenheimer had deep interest in the arts, especially in Baudelaire and John Donne. In *Doctor Atomic*, the librettist Peter Sellars incorporated lines from Donne's *Holy Sonnets* (XIV, "Batter my heart, three-person'd God": the opening line has a direct connection to the site name "Trinity"). Elsewhere he conveys Oppenheimer's justification, that based on visual impact alone the blinding light of the detonated bomb would send Japan a message, and tries to convince politicians to use the bomb in Japan without any warning:

I explained that the visual effect
of an atomic bombing

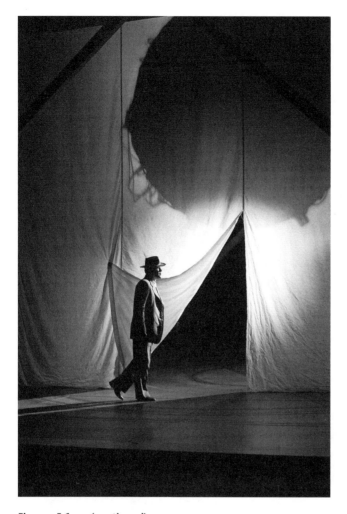

Figures 5.1a–e (continued)

would be tremendous.
A brilliant luminescence
rising to a height of up to
twenty thousand feet.
The neutron effect of the explosion
would be dangerous to life
for a radius at least
two-thirds of a mile,
a brilliant luminescence.[6]

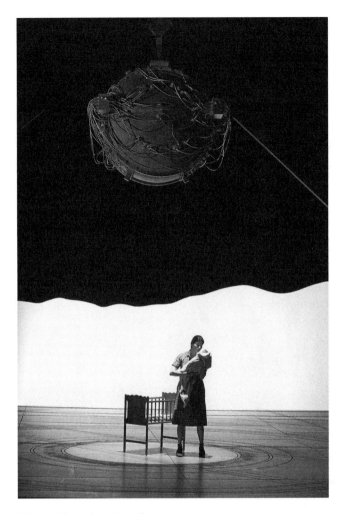

Figures 5.1a–e (continued)

Adams and Sellars clearly portray Oppenheimer as driven and insular, but the opera also features more nuanced and multifaceted figures of scientists, one being the physicist Robert Wilson. Wilson's character idealistically tries to get scientists to sign a petition that would give Japan an opportunity to surrender before using the bomb, and to discuss the larger implications of a scientist's role in warfare; Oppenheimer, on the other hand, believes that science had every right to use its power to discover what lay within its reach, and that the moral consequences fell to others. In *Doctor Atomic*, Oppenheimer expresses his view: "It is improper, for a scientist, to use his prestige as a platform for political pronouncements."[7]

Figures 5.1a–e (continued)

The statement seems paradoxical, coming from the character based on a scientist who produced one of the most lethal weapons in the world. It is true that in *Doctor Atomic*, the scientists discuss the potential of the test to actually ignite the atmosphere (and therefore end all life on earth), but the full extent of the power and destruction the bomb caused was yet unknown.

Just like in the narratives of Hara (who relies on his sister to provide him with clothes after the bomb exploded) and Ōta (who laughed for an instant with her sister while fleeing from Hiroshima's river bank), there are moments in *Doctor Atomic* where the audience's historical knowledge of the bombing makes the details from the everyday lives of the characters seem all the more unsettling. For instance, it is shocking, or at least disconcerting, given the destructive power of the weapon they were about to test, to learn that the scientists at Trinity referred to it as the "Gadget," a noun that could easy apply to an innocuous kitchen appliance: Wilson even suggests a meeting to discuss "The Impact of the Gadget on Civilization." Likewise, in act I, scene 3, to hear all the details of the US Army general Leslie Groves's diet as a child—his stepmother's concern about it, the sweets and chocolate and the weight he lost—seems a trivial digression, especially because he abruptly diverts the conversation and goes to check that the tower on which a test bomb waits to be detonated has not been sabotaged. Such mundane stories as told in drama or in literature are but one way of remembering the incongruous behavior of all people, including those with the power to change history.

In literature, satire is an especially powerful tool used in stories to target the behavior of scientists or military men; Kurt Vonnegut, in *Cat's Cradle* (1963), uses it in his portrayal of the fictitious Dr. Felix Hoenikker as a Nobel Prize laureate and father of the bomb. On the day the bomb was dropped, as we learn through the eyes of his son Newt, Felix Hoenikker was playing with a string in his pajamas and bathrobe. Having formed an intricate figure called the cat's cradle, he approached the six-year-old boy and attempted to show him how to play. It was the first real interaction between the obsessed physicist and his neglected son.[8] Newt is a midget and, as Nagano Fumika explained, he personifies the "Little Boy," who ends up caught between two possessive women: his sister Angela (an American) and his fiancée Zinka (who is Ukranian).[9] Page after page, the mythology surrounding the bomb is slowly scratched away. Spencer Weart acknowledges that this genre of "black humor," which started during World War I with the Dadaist movement, became major in the 1960s, with Vonnegut's books, with Joseph Heller's *Catch-22* (1961) as a paradigmatic portrayal of

Figure 5.2
James Rosenquist, *F111*, 1964–65, Oil on canvas with aluminum, 23 sections. Gift of
Mr. and Mrs. Alex L. Hillman and Lillie P. Bliss Bequest. ©James Rosenquist/VAGA,
New York, & JASPAR, Tokyo, 2017 C1594.

"military insanity,"[10] and in painting with James Rosenquist's *F-111* (1965),
depicting a war plane and atomic cloud (figure 5.2).

The performing arts nevertheless took center stage as the genre that best
represented the scientists and militaries of the nuclear age with two other
dramas (in addition to *Doctor Atomic*). One is Bertolt Brecht's *Galileo* or the
Life or Galileo (1943–75), which Brecht revised after the bombings, and the
other is *Copenhagen* (1998) by Michael Frayn, which focuses on a meet-
ing between Niels Bohr and Werner Heisenberg in 1941 (further explored
later in the chapter). Here again the arts both reveal and give visibility to
dark historical moments, the seeming oblivion of certain events, and the
many nuclear "actors" of the bombings. Even on the stage, the difference
between the Japanese and Western representations is clear and yet, on occa-
sion, complementary.

Doctor Atomic and the Genre of "Docu-opera"

Whereas the A-bomb literature of Ōta and Hara cannot be directly com-
pared to *Doctor Atomic*, given the differences in generation and the cre-
ators' experience of the bomb, Ōta and Hara's pieces are testimonials, and
Adams's opera too is based on true events—although researched through
archives. For Adams, however, *Doctor Atomic* cannot merely be labeled by

"the noxious term *docu-opera*," a term he clearly dislikes for its sense that the plot is "ripped from the headlines." Instead Adams intends his work, including his other operas *Nixon in China* and *The Death of Klinghoffer*, to relate to human events "that have become mythology."[11] As unbelievable as it seems, Wilson did indeed call a meeting titled "The Impact of the Gadget on Civilization," which he recalled in 1970 in "The Conscience of a Physicist."[12]

Sellars libretto, then, in its effort to examine Trinity test mythology, is a postmodern mix of poetry, literary allusions, and scientific jargon gleaned from unclassified documents and transcripts of meetings with participants, or through conventional histories of the bombings. He succeeded in finding a place in the opera house for words such as "stable nucleus," "subcritical mass," "plutonium core," and "icosahedron," together with visuals such as the periodic table of elements and scientific formulas, and the white lab coats and military uniforms used for the characters' costumes. For the staging at the Metropolitan Opera in New York City, sets inspired by Cornelia Parker's explosion-like installation *Cold Dark Matter* (1991) suggest the destruction of war.

Women in *Doctor Atomic* are not entirely invisible, given its women's chorus and the character of Kitty Oppenheimer. She represents the "feminine" consciousness and is reinforced by the libretto's inclusion of poems by Muriel Rukeyser; in fact, Kitty Oppenheimer's character speaks in poetry. The choice of Rukeyser is strategically effective, and not only with the timely allusion in "To Be a Jew in the Twentieth Century" (1944). She recites "The Speed of Darkness" (1968), where in an attempt to get the attention of her husband, whose mind is buried in the nuclear science, she declares: "The Universe is made of stories not of atoms." The ensuing feminist tone in the poem also suggests the historical context of the time.[13] Adams's inclusion of Kitty Oppenheimer serves as a surprising moral compass in the opera; whereas in real life Oppenheimer's wife is in contrast portrayed unflatteringly in the press as a volatile alcoholic,[14] here her character succeeds in humanizing the insular scientists, a necessary move to undermine the mythology of the nuclear age. Adams therefore goes beyond the accelerated and cathartic Cold War need to thematize the "mad scientist" and his monstrous mind through sci-fi films and the endless adaptation on screen of Mary Shelley's novel *Frankenstein* (1818).

Further on, Adams's opera includes the voices of female scientists. Historically, neither Marie Curie nor her daughter Irène Joliot-Curie, Ellen Gleditsch, or Lise Meitner were part of the Manhattan Project.[15] Yet they also played various roles. Some, like Meitner, refused to be associated with the bomb: although she was invited to Los Alamos, Meitner stated "I will

have nothing to do with a bomb."[16] But a few female scientists nonetheless worked on site. Physicist Elda "Andy" Anderson, for example, worked on fission, and physicist and crystallographer Rose Camille LeDieu Mooney-Slater became associate chief on the X-ray Structure of the Metallurgic Laboratory. Chinese physicist Chien-Shiung Wu, who had travelled from Shanghai to study at the University of Michigan, helped develop a uranium-enrichment process at Los Alamos. Their roles might have been more important, but as Ruth H. Howes and Caroline L. Herzenberg stated: "despite such women ... the public and many male physicists refused to believe that women could handle physics."[17] One example is the appreciation of the research of Ida Noddack, a German geochemist. She had not directly participated in the project but had read Fermi's paper and concluded (but also dismissed) that an atom's nucleus might split—something that "Fermi and the rest of the physics community disregarded. ... Her paper was both ignored and on occasion mocked."[18]

The opera also indirectly refers to stories of the many women that Denise Kiernan brought to the public eye in *The Girls of Atomic City* (2013). Her nonfiction novel skillfully retraces the lives and motives of the women (and men) in Oak Ridge, Tennessee, the city built specifically by Manhattan Project engineers to house the nearly 30,000 people employed by the uranium enrichment plants necessary for production of the bomb.

Kiernan tells the story of Dorothy Jones, for example, employed just after graduating because high school girls "were easy to instruct. They did what they were told. They weren't overly curious."[19] Then there is Jane, who was caught between her frustrated ambition to become an engineer— an impossible dream to achieve because, as she was told, "we don't matriculate engineering as a major for females"—her desire to help the war cause, and her obligation to stay close to her widowed father.[20] Just as in A-bomb literature of the *hibakusha*, nonfiction as a genre gives visibility to memories and facts that official histories of the period in the West have forgotten.

Beyond representing the roles of scientists and engineers, both Kiernan and Adams portray the military personnel (Kiernan even addresses how military censorship affected the Superman series titled "Atom Smasher").[21] The warlords are unavoidable figures of postwar art, more so than in art responding to World War II in progress.

Portraying the Doctors and Military Generals of the Atomic Age

In *Doctor Atomic*, General Groves's character is uncompromising too: dictatorial and authoritative, and reacting with a threat (if not outright violence)

to anything in his way. His response to the chief meteorologist who reported poor weather conditions provides a good example:

Five hundred U.S. Superfortresses
are raining incendiary bombs
on four Japanese cities.
Our B-29s are destroying
half of every Jap city they hit.
The President of the United States
is talking to Joe Stalin in the morning
in Potsdam.
This test will proceed as scheduled,
with full weather compliance
or you will spend the rest of your life
behind bars,
Mister Meteorologist.[22]

Although the military helps drive the plot in *Doctor Atomic*, it plays no active part in Michael Frayn's play *Copenhagen*, which centers on a historical visit made during the fall of 1941 by the German quantum physicist Werner Heisenberg to his Danish mentor, Niels Bohr, in Nazi-occupied Copenhagen. The specific purpose of this visit, whether to ask what Bohr knew of the Allied atomic research, to warn Bohr of a German atomic project, to reassure Bohr that was not participating in it, or to propose a collaborative effort to talk the German's out of it, is still much debated among scholars. Furthermore, Frayn's point in the play was to foil any attempts of the three characters (the two scientists and Bohr's wife) to resolve that uncertainty. As Frayn suggests, the reason such questions cannot be resolved is not for lack of historical evidence, but rather, according to Karen Barad's reading of the play, because in Frayn's play "uncertainty is an inherent feature of human thinking." And it is precisely because of these unsuccessful attempts that *Copenhagen* was badly received in the US, as Barad compellingly argues in *Meeting the Universe Halfway*.[23] Historically, however, Heisenberg underplayed his role in the Nazi nuclear program, whereas Bohr wrote to Heisenberg about their encounter:

You ... expressed your definite conviction that Germany would win and that it was therefore quite foolish for us to maintain the hope of a different outcome of the war and to be reticent as regards all German offers of cooperation. I also remember quite clearly our conversation in my room at the Institute, where in vague terms you spoke in a manner that could only give me the firm impression that, under your leadership, everything was being done in Germany to develop atomic weapons.[24]

The military context is unarguably central to the development of the atomic bomb. To be sure, this aspect was underscored by Derrida when he stated, in "No Apocalypse, Not Now": "Moreover, between those whose competence is techno-scientific ... and those whose competence is politico-military, those who are empowered to make decisions, the deputies of performance and of the performative, the frontier is more undecidable than ever, as it is between the good and evil of all nuclear technology. ... [These competencies] have never been so terribly accumulated, concentrated, entrusted as in a dice game to so few hands."[25] Therefore, the military men are not sufficiently present on the stage of *Copenhagen* given that they are an intrinsic part of any war machine.

The same lack of military characters can be found in Bertolt Brecht's *Leben des Galilei* (first translated as *Galileo*, 1938) and even to some extent in its third and final post-Hiroshima version of 1955 (*Life of Galileo*, 1955) (figures 5.3a and 5.3b). In the context of book burning and the 1937 Munich exhibition *Entartete kunst* (Degenerate Art), Brecht had represented Galileo as a scientist questioning the visible and commonly held knowledge of his time, as an insubordinate intellectual who saw science as opening minds to new realities against the fallacy of the Catholic Church.[26] But when Brecht later heard a radio program on atomic science, originally broadcast from the Niels Bohr Institute in Copenhagen on February 27, 1939, the knowledge of the military use of science changed his perspective on the subject. Brecht further stated, "The atomic age made its debut at Hiroshima in the middle of our work. Overnight the biography of the founder of the new system of physics read differently."[27]

Together with his collaborator, Charles Laughton, Brecht rewrote sections of the text to ensure that his central character would be seen in "a new, sharper light."[28] A direct allusion to the bombings is discernable in the closing scene of the final version when Galileo's *Dialogue* crosses the Italian border in the hands of his former student. The scene opens as follows:

(...) But we hope you'll keep in mind
He and I were left behind.
May you now guard science's light
Kindle it and use it right
Lest it be a flame to fall
Downward to consume us all.
Yes, us all."[29]

Through the representation of the Catholic Inquisition, the play directly deals with the topic of censorship, which is at the heart of the nuclear age.

Figures 5.3a–b
Life of Galileo by Bertolt Brecht; Brendan Cowell; directed by Joe Wright; designed by Lizzie Clachan; lighting designed by Jon Clark; projections by 59 Productions; puppet direction by Sarah Wright; at the Young Vic Theatre, London, UK, May 5, 2017. Credit to Johan Persson/ArenaPAL.

But the religious authority does not fully portray the impact of the military men into nuclear matters—for the play was meant to represent the nullity and folly of fascism. Brecht injected the same satiric tone in other plays—such as *Arturo Ui*, in which his portrayal of the gangster-like leader "takes the teeth out of fascism," with the varying degrees of success and failure (as analyzed by Adorno).[30]

On the contrary, by directly bringing General Leslie Groves to the stage, Adams's opera pays respect to the roots of opera itself, as an art form that was born during Italian Renaissance, with its deep interest in Greek mythology, culture, and military history as depicted in sculpture, vase painting, and ancient drama. *Doctor Atomic* therefore adds to the Faustian plot and its tortured scientists a Trojan horse-like war device but in postmodern form.

Keloid Scars on Stage: Of Madonnas, Whores, and Rats

Inevitably, A-bomb-related theatrical performances in Japan represented different themes. It is true that Ōta, but mostly Hara, painted a few cynical portraits of the military men of the time: before the bomb, a drunken drill instructor with gleaming high boots bullies one of Hara's relative in *Summer Flowers*, while later "soldiers with bayonets ... tried to intimidate the fainthearted residents and make them defend this city to the death."[31] There also is the exceptional play *Taisanboku no ki no shita de—watashitachi no ashita ha* [Under the Magnolia Tree—Our Tomorrow, 1962] by Koyama Yūshi, which Nagaoka praised, wishing that the author had written a second part for it.

Although the play does not portray military men, Koyama's drama is a strong metaphor for clueless power and meaningless authority. A policeman imprisons an old woman for having performed abortions (that were illegal at the time). She had lost her nine children to the war and to the bomb. When she is dying in jail, at age sixty-four, the policeman feels remorse when everyone blames him: she had helped so many *hibakusha* women who were scared by what radioactivity would do to the fetuses. He himself had lost a baby born without a brain. As the old woman dies, the ghostly voices of her children and husband call her: *Come quick mummy, come quick honey, after the war, there is peace but not freedom, your grief for us was your jail.*[32]

Apart from these few instances, the representations on the Japanese stage mainly focus on postwar victims left with keloid scars. Betsuyaku Minoru's *Zō* [The Elephant, 1962] and Hotta Kiyomi's *Shima* [The Island, 1957] are good examples with central male characters.[33] *The Elephant*

involves a man with pronounced, elephant-like scars who bares his back in the street to generate sympathetic reactions. In *The Island* a male survivor named Manabu, who has no visible damage as a result of the bomb, finds it difficult to get married because of overall poor health. In this play, women appear only as mothers or would-be brides—mostly in scenes taking place in the kitchen. The character of Kin, a mother described as having masculine qualities, and who was irradiated while desperately searching for her child in the rubble of Hiroshima, dies as an offshoot of the main plot. This is representative of gender roles at the time but also balances the fact that Japanese women were more likely seen as victims than men, as Lisa Yoneyama explained in *Hiroshima Traces*.

Yet *Maria no kubi* [The Head of Mary, 1959], by Tanaka Chikao (one of Japan's "most noted modern playwrights" according to Treat), gives visibility to one consequence of the war usually concealed: the many impoverished women who found themselves pushed into prostitution in postwar Japan. Some tens of thousands of women, called *pan pan* (because they responded to a command made by clapping hands), were patronized mostly by foreign troops.[34] One of the main characters, a *hibakusha* named Shika, is a prostitute by night and nurse by day in Nagasaki. Her face is partially covered by keloid scars, and few marines and other men come to buy the prostitute's services. The plot focuses instead on her efforts, with Shinobu, another prostitute, and two (unnamed) men, to gather the remains of a statue of the Virgin Mary from the badly damaged Uragami Cathedral—since plans for the statue's reconstruction are not certain—and move it to a secret place where a group of Catholics, including the prostitutes, can worship. As such, the play's focus on Christianity which "while inconspicuous in Hiroshima, is plentiful in Nagasaki" as Treat underscored. For him, this "embrace of martyrdom" can be explained by "a response to the continuing legacy of the degradation and humiliation of Christians, and by extension hibakusha, in Japan."[35] The play also tells us of the lasting effect of the bomb. Towards the end, the statue's head, the last part needed to complete the repair, is too heavy to lift; in the cold snow, however, the head "speaks" to Shika's supplications in a voice coming from offstage and finally to the others. Staged more than ten years after the bombings, during the Cold War, the play efficiently puts the nuclear wounds into a temporal perspective: the everlasting mental, social and physical scars and the call for the weapon never to be used again.

In Japan, keloid scars and prostitutes also figure in one of the most fascinating theatrical representations during the aftermath of the bombings and postwar Japan: Satō Makoto's *Nezumi Kozo Jirokichi* (translated as Nezumi

Kozo: The Rat, 1969). The play is based on the legendary character Naka-mura Jirokichi, a Robin Hood–like thief of the Edo period who was nick-named "the rat" (*nezumi*). The play itself is however captivating in that it perfectly fuses traditional kabuki theater with one of the qualities Benja-min praised in epic theater as advocated by Brecht: the ability to produce "astonishment rather than empathy" or, rather, "instead of identifying with the characters, the audience should be educated to be astonished at the circumstances under which [the characters] function."[36] In the case of *Nezumi Kozo*, the strangeness of the plot and its timeframe, the symbolism of the characters, and the staging (Shinto characters, blond wigs, references to Santa Claus, and kabuki music and wooden clappers) contribute to this astonishment.

For his dramatization of *Nezumi Kozo: The Rat*, Satō created five masked Nezumi (rat) characters. Each Nezumi has a different identity although these are not very distinctive and only referred to by numbers in the play: a novelist (#1), a pickpocket (#2), a samurai (#3), and an actor (#4), and a female prostitute named Jenny (#5), and each seek relief from their mis-erable lives. Satō modeled the prostitute's character on Pirate Jenny from Brecht's *Threepenny Opera* (1928). The three Shinto priestesses (religion) pursue the Guardian (Japan's emperor) who is in charge of the Lord of the Dawn (the imperial system), through the sewers (seen as postwar Japanese history). The rats attempt to seek salvation but the priestesses try to manip-ulate the rats. They mock Jenny for mistaking the bomb for a falling star and for wishing to get married, falsely accuse Nezumi #3 of attempted mur-der (on the priestesses) and try to blackmail the starving rats for one million yen. The priestesses also "kill" Nezumi #1 (the novelist) although he reap-pears in the next act—an interesting metaphor of wartime censorship, if not a sharp critic of wartime artists: Nezumi #1 was interested in food more than creating. Seemingly untouched by what happens with the bomb and to the many characters, the Guardian is in charge of the Lord of the Dawn and in search of a public bath.

Depictions of the bomb are verbal rather than visual. In the first part of the play, for example, one of the three Shinto priestesses, Heh-heh, describes "a silver pod" that had come from "the edges of the sky ... like the wind." They describe an "enormous fire" but also the effect of the bomb: "They're screaming amidst it all: Aaaaa! It's as if the earth itself were trembling, as if the earth itself were wailing! I can hear something crackling. Could it be the sound of the human flesh burning!"[37] In a later scene Nezumi #4 will describe the pod as a "blue and flickering star in the south sky"[38] since they are not informed of the bomb, but toward the end of the play, the Nezumis

will remove their robber masks to reveal horrible keloid scars, establishing the silver pod's symbolism.

For Treat, the play is a "gleeful confusion" that he explains by the post–May 1968 underground type of theater in Japan, which makes the work "less revolutionary than comic."[39] Treat questions whether or not a "Hiroshima comedy" is possible and stresses that the avant-garde characters of the play render the attempt impossible. It is true that the play is at time comical. Nezumi #1 sings about turnips and farts, and the priestesses meow at the end of the play, pretending to be cats, then "frizzly bearded" like "Santa Claus!"[40] On stage, the Lord of the Dawn is a six-foot tall phallus that the Guardian handles with difficulty. Whether or not this is appropriate for a Hiroshima piece must unconditionally be questioned like Treat did. At the same time, however, the play must also be remembered for offering a rare attempt at exposing the failures of a social, religious, and political system that was continuing in post-war Japan.

The lack of empathy of the Guardian (the emperor) for his people and his expectation that they will admire and respect the Lord of the Dawn (also representing patriarchy through the large phallus) is a sharp critic of wartime and post-war Japan (a critic that will be revisited after Fukushima as explored in part IV). The priestesses (religion) transmuted easily into cats (Nezumi's predators) and Santa Claus (Occupied Japan). At the end of the play, the only female rat, Jenny, will kill the Guardian. Satō's revolutionary hope is expressed (but seen by Treat as the larceny of a horrible event and emotions for Satō's private design).

Satō creates a startling postmodern collage as the scenes and the historic timeframes shift, and as the allusions to Japan as empire turned nation-state prevail. At the end of the third act, for instance, an air-raid siren sounds and bright light flashes briefly. At the start of the sixth act, a recording of the emperor's World War II surrender speech is played "like the sound of the sea, now near, now far,"[41] but mixed with popular songs. In other references contemporary to postwar European drama, all of the Nezumis wait for relief like Vladimir and Estragon wait for Godot. And, with a nod to the root vegetables also intrinsic to Beckett's symbolism in *Waiting for Godot* (1948–49), Nezumi #1 is obsessed with turnips. In an unsettling scene that pushes the food metaphor further, the priestesses and the Nezumis, voluntarily or not, feed on the triplet baby girls Nezumi #5 gives birth to: a stark inference that Japan ate its future in the war.

The play does not center on the suffering of the victims and does not directly or sufficiently incriminate the military, which is regrettable, but it rather focuses on the collusion between the state, the emperor and Shintoism. In that sense, its pertinence mirrors that of *Doctor Atomic* which

portrays a similar collusion or fusion, that of scientific and military powers typical of the nuclear age. But the arts did not stop with portrayals of those who acted at the top of political, military, and scientific hierarchies. Another hotspot in representation emerged around an unlikely figure: the Hiroshima pilot.

Straight Flush: The Unforgettable Case of the "Hiroshima Pilot"

One lesser-known military figure who catalyzed controversies and artistic representations in the West as much as in Japan is the Hiroshima Pilot, Claude Eatherly. Extended coverage of his story started in 1957, following the publication of a *Newsweek* article, "Hero in Handcuffs," and it has exposed philosophical hotspots for debate, even in the present day, about Eatherly as a focus of either sympathy or outrage.

Major Claude Eatherly was the pilot of the *Straight Flush*, a weather reconnaissance B-29 that flew alongside the *Enola Gay*, which actually carried the bomb; Eatherly cleared its pilot, Colonel Paul Tibbets, to drop the bomb (Little Boy). Eatherly remained in the air force until 1947, and returned to civilian life largely forgotten, unlike Tibbets, who was perceived as a national war hero. According to the *Newsweek* article, since his release from the air force he'd had nightmarish dreams of planes in flames shot over Tokyo, waking up his wife at night screaming, "Bail out! Bail out!" He was arrested for forgeries and burglaries (one at a post office) before being sent to a Veterans Administration mental hospital, after which his marriage ended in divorce and he attempted suicide.[42] Part fabricated, part true, the *Newsweek* article prompted countless news reports in many languages. A year later, Eatherly's case reappears in a book on the bomb and its effect, published in French and English, from the French journalist Fernand Gigon, titled *Formula for Death* (1958).[43] But by then, the references to the bombing of Tokyo were removed and the pilot is reported to shout inhuman screams at night and the phrases "Release it! Release it! ... Not now! Think of the children, the children are burning!" The book is a rare early detailing of the effect of the bomb in words and a few horrible pictures. The photo that spans the sensationalized cover of Gigon's English version of the book is a close-up portrait of a disfigured *hibakusha* woman. While not entirely accurate at times (Eatherly is described to have flown over Nagasaki), the book is strongly anti-nuclear. Another *Newsweek* article about Eatherly in 1959, "Psychiatry, the Curse of Hiroshima," caused even more confusion. It explained that the pilot committed the robberies to be punished by society for his role in Hiroshima, but that the wrong (of Hiroshima) was self-imagined. After the article, an artistic fallout ensued in response to the bombardment of coverage.

Many postwar poems about the bombings directly referred to Hiroshima, and inevitably, some reacted to the *Newsweek* articles. The German writer and poet Marie Luise Kaschnitz wrote about the pilot in *Hiroshima* (1957), making clear that no matter his role, he was complicit and responsible:

The man who dropped death on Hiroshima (…)
Has gone insane, fights apparitions
Made out of dust that come from him,
Hundreds every night.
None of all this is true.
Just the other day I saw him
…
He himself was easy to recognize
On all fours on his lawn, his face
A grimace of laughter, because the photographer stood
Outside the hedge, the eye of the world.[44]

In another example the British poet John Wain acknowledged a claim that would be later contested: whether Eatherly actually gave his pension to Hiroshima victims. His poem is regularly cited as an example of the failure of semi-fictional artworks as a genre—or, depending on the point of view, the failure of a fictional work—wrongly taken as an historical documentary:

Good News. It seems he loved them after all.
His orders were to fry their bones to ash. He carried up the bomb and let it fall.
(…) A hero's pension. But he let it lie.
It was in vain to ask him for the cause.
Simply that if he touched it he would die.
(…) He keeps bawling in movies
And burgling things from shops (…)
Dupe Eatherly, Dupe Eatherly
Why on earth be so human?
Forget the whole thing. Hold a
Press Conference
Just like Harry Truman.[45]

In the visual arts, Mark di Suvero responded to coverage of the pilot with an odd-looking lamp (it was "spooky," according to the artist) crafted from found objects in stainless steel, wood, and fiberglass and titled *Eatherly's Lamp* (1961), in which the lampshade evokes a parachute.[46]

Eventually the *Newsweek* articles of the late 1950s reached the German-Jewish philosopher Günther Anders. Anders' first wife was Hannah Arendt and he studied with Heidegger before becoming known for his philosophical writings opposing nuclear weapons: he is the only philosopher to have

devoted the majority of his writings to the atomic age. Anders started a long correspondence with the pilot: more than sixty letters over a three-year period, published in 1961 in German and translated in English and many other languages (including Japanese). *Off Limits für das Gewissen* (published in English as *Burning Conscience: The Case of the Hiroshima Pilot*) reveals the collision of two different worlds: two different nationalities, educational backgrounds, and levels of vocabulary and consciousness (indeed Anders comes off at times as patronizing).[47]

In these letters Eatherly expressed clear remorse about the bombing of Hiroshima and detailed his feverish link to peace activists and their cause. One pivotal point—perhaps at the crux of the controversy that followed the publications of Anders's book—is the letter Eatherley sent to a group of young *hibakusa* girls from Hiroshima and their reply. In his letter (or Eatherley's recollection of it since the letter is not published), he explained being unable to forget his act, and having feelings of guilt and sorrow. Though he wrote it following Anders's suggestion, his feelings, and especially the reply from the *hibakusha*, are worthy of attention: the young girls stated that, in spite of their narrow escape from death and wounded bodies, they had "sincere sympathy" for him, ultimately adding: "you were perhaps ordered to do what you did or thought it would help people by ending the war. ... but you know that bombs do not end wars on this earth ... We have learned to feel towards you a fellow-feeling, thinking that you are also a victim of war like us."[48]

In his "History of A-bomb Literature," Nagaoka wrote of the book that it unfortunately does not sufficiently include the voices and plights of the victims (there's only one letter from the *hibakusa),* but that it was important in giving an international awareness to people who know little about the bombings.[49]

But the case of the Hiroshima Pilot in fact developed further, in a patchwork of journalist, artistic, and philosophical interpretations and appropriations. At the core of the controversy lie issues relating in general to one's conscience and mental health, and specifically to the reliability of an ex–air force officer involved in the nuclear tragedy. This controversy is lasting: the "Hiroshima pilot" is still represented in the arts today.

The Hiroshima Pilot's Controversial "Poker Face"

The American journalist and novelist William Bradford Huie wrote his own account of Claude Eatherly in *The Hiroshima Pilot* (1964).[50] His book presents a view of the pilot that contrasts with Anders' anti-nuclear

view. This book relects the views some had of Anders's epistolary book, that it was written from the "vast inane of ethical metaphysics" all the while turning Eatherly's case into "propaganda" to further disseminate his own activism for peace.[51] In the press, Eatherly was even at times called the "American Drefyus."[52] On the one hand, Anders offers the letters he exchanged with Eartherly as proof that the former pilot was not mentally disturbed and, as Eartherly suggested to Anders, he was therefore unjustly hospitalized. When reading the letters, indeed, nothing suspicious regarding is mental state can be suspected. It is true that it was first Anders's idea to send a letter to the *hibakusha* in Japan, and that Eatherly requested that Anders send several letters to the US Department of Justice in Washington, DC, fearing there was conspiracy in play to silence his expression of remorse. But Anders's engagement against weapons of mass destruction can be understood. In one letter (though not addressed to Eatherly), he stated: "I am Jewish I have lost my friends in Hitler's gas chambers."[53]

On the other hand, Huie adroitly balances facts from news reports—also pointing out the inaccuracies some reported—as well as from hospital logs and medical and juridical reports, with subjective memories gleaned from Eatherly's wife, brother, co-pilots, and doctors. Although Huie only met with the pilot for a bit more than an hour, the portrait he paints of Eatherly is sometimes compassionate but mostly cruel. He presents several "reasons" as evidence for why Eatherly's remorse was phony—one being that as a gambler and poker player he would do anything for money (one news article called him "Poker Face")—and he indicates other aspects of Eatherly's personality or circumstances that may have caused him to seek attention. Due to Eatherly's erratic behavior, Huie contends, no one wanted to assume responsibility as his legal guardian.[54] Finally, Eatherly's masculinity would have become defective. He may have suffered an aftereffect of radioactive poisoning; his wife's miscarriage was attributed to a "spermatozoa deformity," which he blamed on the Bikini Atoll tests in which he participated, although the couple later had two normal children.[55]

Huie also challenges Anders's status and persona.[56] Anders briefly responded, less to the personal attack than to the case itself in 1982, by arguing that even if the pilot had no remorse, it still is unacceptable to have incinerated an entire city: This argument would be, Anders explained, "'the' *revolution in the history of law*. It would ultimately force the acquittal of all criminals devoid of any remorse, because their absence of repentance—that is to say, the absence of their moral conscience—would establish their innocence."[57]

Acknowledging that Huie was "supporter of US nuclear policies" and his book too judgmental, another American journalist, Ronnie Dugger reinvestigated the case in 1967 in *Dark Star*. The portrait is more compassionate and detailed than Huie's (starting from the pilot's childhood) and including quotations from other militaries involved and world leaders (i.e., that Eisenhower felt "depressed" by the idea of using the bomb).[58] About Ander's letters, Dugger dismissed the idea that Eatherly was "coached" by Anders because "Eatherly made many arresting statements in the correspondence" such as "all mankind is alike" and "our purpose is to stop nuclear disarmament and the disbandment of it and set up a world society."[59] These are only a few examples among many. The letters are indeed worth reading. Dugger, however, suggested Eatherly may not have been forced into a mental hospital by the government in an attempt to silence his anti-nuclear activism. But unlike the two former books, Dugger's book includes testimonies of *hibakusha* (in part through Hersey's *Hiroshima* and through Nagai's and Hachiya's works too).

Whether the pilot was ill, vain, greedy, or genuinely remorseful, the myth of the Hiroshima Pilot remains a radioactive hotspot. A Spanish cartoonist recently devoted a few strips to Eatherly under the title "Grandes personajes de la humanidad" (Great Personalities of Humanity) in 2007 in which he is praised for his remorse and depicted as unfairly sent to a mental asylum.[60] (Anders has been translated in Spanish.) And the pilot's story was also recently romanticized by Marc Durin-Valois in *La dernière nuit de Claude Eatherly* (Claude Eatherly's Last Night, 2012).[61] In Japan, one example is the manga *Kuroi batto no kiroku* (Records of Black Baseball Bat, 1968) by Kaizuka Hiroshi, which was recently reprinted in 2013 and 2015. In the story, a Hiroshima pilot (with a different name) comes back to the city, expresses remorse, and gets attached to a young *hibakusha* boy, teaching him baseball until the boy dies (having been irradiated by the bomb).[62]

Strangely, personal accounts from other military fliers with memories or concerns of either Hiroshima or Nagasaki have left scant visible trace on the public consciousness, at least as compared to Eatherly.[63] But in Alfred Coppel's *Dark December* (1960), an acclaimed American futuristic novel, the protagonist, Major Gavin, replies to a captain who asked him how he felt after firing Titan missiles in a nuclear war that left the US and the world all but annihilated:

How did a young fool think a man felt knowing each Titan carried death for hundreds of thousands? If you thought about it at all you'd end up wanting to kill yourself. So it became a problem in ballistics, a scientific exercise. Dehumanized. That was the only way a missile man could go on with it.[64]

As the novel begins, Major Gavin wanders in the wilderness of what was once California, deeply affected by the possible loss of his wife and daughter, and continues to search for his home. But he soon encounters Major Collingwood, a ruthless officer who believes that survival of the fittest is the only skill humans need. Collingwood poses a threat to Gavin's vow never to kill again, even if just in self-protection. The novel ends not only on a cautionary note but also with hope. In fact, the book is a love story as much as a post-nuclear apocalyptic tale, and that is its strength—another rare radiant ore in nuclear postwar literature (and a rare depiction of keloid scars in the West).

A-bomb Art Today

In the correspondence between Anders and Eatherly, there is mention of a movie deal that would focus on the pilot's life and remorse. The film, tentatively called *Medal in the Dust*, never made it to the screen. In retrospect, the excitement of the Anders and Eatherly for the potential film was naïve, perhaps based on the fact that a film about Tibbets, titled *Above and Beyond*, was released in 1953. Hardly any relevant films were made about the controversial topics his story touches on. Yet awareness has been raised.

In the past, the politics of commemoration in Japan were complicated by the ultimate necessity to remember, the nationalist use of collective memory, the gender and racial politics in which non-Japanese voices were forgotten, and the way the gender divide operated in commemorative efforts. Lisa Yoneyama compellingly addressed these in her 1999 book *Hiroshima Traces: Time, Space, and the Dialectics of Memory*.[65] And, finally, the memory of the atrocities perpetuated by Japan in colonial days and wartime should also not be forgotten.

In A-bomb art, however—be it Japanese or international—the representation of the bombings is now pressed between two forces: one is the finely geared nuclear politico-military machine that succeeded in rendering invisible the victims; the other is the oversaturation of representations in which, like Nagaoka pointed out regarding several late A-bomb literary works, the bombings become a mere regurgitated theme set in the background of adventures or love stories. Thus the risk of the art of Hiroshima and Nagasaki is to become so assimilated as to sacrifice both meaning and visibility.

A contemporary example is the anime *Kono sekai no katasumi ni* [In This Corner of The World, 2016] adapted from Kōno Fumiyo's manga. The story of the anime is more about love and relationship in times of the war than it is about the Hiroshima bombing. And yet, Kōno's *The City of the Evening*

Figure 5.4
Ikeno Kiyoshi, *Trees*, 1960. Courtesy of Nagasaki Prefectural Art Museum.

Breeze, The Country of Cherry Blossom had represented the bombings and the victims in striking strips without diluting their voices.

The ways in which the bombings and the testimonies can be overlooked has been evident, even indirectly, since as early as the 1960s. In Sata Ineko's story *Iro no nai e* (The Colorless Paintings, 1961), a character named Y goes to the Tokyo National Museum to see the paintings of her friend K—one being, in fact, Ikeno Kiyoshi's *Kodachi* (Trees, 1960) (figure 5.4). The artist is no longer alive, but he had come from Nagasaki, suffered from radiation poisoning, and become a relentless antinuclear militant. Next to the last of K's artworks on display that day, all being "devoid of color," hangs his picture with a black mourning ribbon. A few visitors stop to look at

the paintings but only for a couple of seconds—understanding that the artist had died yet knowing nothing about him, his life and his connection to Nagasaki, or the significance of the colorless paintings. The narrator wants to tell the visitors, with their polite and sorrowful gaze at his black-ribboned portrait, that it was not a lack of will due to his cancer of the liver that explains the colorless painting:

But what is the name of the thing that deprived this man of all color? ... They rather seem to be produced by the will to defy, but that defiance had to be painted, even though the colors escaped the artist, and that's why they display an unnamable grief. But this is not apparent to the visitors passing from gallery to gallery.[66]

A-bomb art is therefore located in between invisibility and social assimilation or miscomprehension. What is challenging for the arts, therefore, is not radioactivity's invisibility, but the mythology around nuclear technology. Finally, radioactivity may be invisible, but the atomic age does have color: there is what Hara called the "color of calamity," the "ash-colored" incinerated bodies and the crinkly pink of flesh around the eyes of the victims, as described by Ōta, and the black spots on the corpses of the mother and her child immortalized by Yamahata's camera. The colors are visible in all the dark radiance of A-bomb literature from *hibakusha* writers and others. The atomic age is also green, green like the military costume of Major Collingwood, as depicted by Alfred Coppel:

I turned to ask Graber where I could clean up, but before I could speak, we were confronted by a figure that might have stepped from pages of the 1930 edition of The Army Officer's Guide. ... The green Army blouse was tightly fitted and decorated with a double row of ribbons, good ones: the Silver Star, the D.S.M, the Purple Heart with a cluster, the Korean Service Medal, and one that surprised me—the World War II Victory Medal. I wouldn't have guessed him old enough to have served in the Second World War.[67]

From the standpoint of the humanities, green is the most radioactive color, the one to have particularly persisted during the Cold War—the era I discuss in part III—first with a look at how radioactive monsters in the arts proliferated like real-life nuclear tests.

III Tonight No Poetry Will Serve: Godzilla and Other Cold War Monstrosities

6 Under the Ashes of the Conch Shells, the Bikini and Moruroa Atolls

No survey of the arts of the atomic age would be complete without an analysis of Gojira (Godzilla), a true iconic symbol in worldwide pop culture representing the threat of nuclear power. The monster appeared in Japanese cinema in 1954, in the midst of the Cold War, and at a time when US nuclear testing in the Bikini Atoll first came to public attention. An entire series of films sprang up in its wake. Godzilla is prehistoric in appearance: a dinosaur-like upright stature; a fusion of amphibious and reptilian features with radioactive scales. That look, combined with its destructive behavior empowered by "atomic breath"—a weapon it unleashed in a radioactive heat ray—was enough to scare islanders and Tokyoites alike. Throughout most of the Godzilla films, the paradoxical policies of the Cold War lie beneath the action, as those in power (namely, the politicians and the military) who were expected to protect their populations, instead work toward the apocalyptical end of the entire human species—and all other living beings.

The first film of the series, *Gojira* (1954) is a direct and early response to the irradiation of the tuna boat *Lucky Dragon 5*; the fallout emanating from Castle Bravo, one of the nuclear test devices detonated by the US at Bikini Atoll, contaminated its entire crew in March 1954, bringing back radioactivity to Tokyo.[1] Throughout the film, worries were expressed about the safety of daily food supplies and other aspects of radiation-endangered lives. As the sociologist Saito Hiro explained (see chapter 4), the accident brought a wider national recognition to the plight of *hibakusha* in Japan and prompted the legislation necessary to publicly acknowledge the victims.[2] *Gojira* even included images of and references to the bombing of Hiroshima, thereby making a strong suggestion that the secret of such a technology, once it has been used to "solve" a problem, should die with its creator: in the plot, once Godzilla was traced to the ocean where it had

returned, the monster meets its death thanks to Dr. Serizawa, who also commits suicide after destroying the formula for re-creating his powerful killing device.

The anxiety surrounding Japan's potential to be caught in nuclear war between the USSR and the US was also palpable in the popular ultra-apocalyptical movie *Sekai daisensō* (translated as The Last War, 1961). But the most celebrated (and subtler) expression of that theme was in Akira Kurosawa's film *Ikimono no kiroku* (literally "records of a living being" but translated as "I Live in Fear," 1955). When a man becomes obsessed by his nuclear war anxieties, he tries to force his entire extended family (mistresses included), against their will, to sell their property and move to the relative safety of Brazil. The family members do not take him seriously and consider his deep-seated fears and irrational behavior a sign of incompetence. Although judges declare him insane and send him to a mental asylum, the patriarch's doctor wonders in the end if it is more insane to ignore such fears related to potential nuclear disaster.

Naturally, throughout the many films in the Godzilla genre, radioactive monsters proliferated like real-life nuclear tests. Godzilla battles and win over other monsters: a giant shrimp, giant mantises and tarantulas, King Kong, and even dinosaurs. Godzilla is always annihilated or banished to the ocean but somehow nuclear danger spreads: the radioactive beast even has a son, called Minila, and Godzilla tries to protect him more or less skillfully. Thus the monster has a gender: according to a character in *Gojira no musuko, kaijū-tō no kessen* (Son of Godzilla, Battle of the Island Monsters, 1967), Godzilla may well be a male, so the monster would not be a "kyōiku mama" (a mother putting emphasis on the child's education) but rather a "kyōiku papa."

Although other monsters only act in supporting roles destined to be defeated in battles and thus establish Godzilla's supremacy, Godzilla is not the only star monster of the genre: for instance, in the desert of New Mexico, a nest of giant radioactive ants wreaks havoc in the film *Them!* (1954), and in *Attack of the Crab Monsters* (1957) an expedition sets out to search for a group of US scientists gone missing while doing research on a remote Pacific island—both films to be better explored in chapter 7. And in Japan, Gamera and Mosura form an integral although lesser-known part of the Cold War radioactive bestiary. Gamera is a giant turtle, and Mosura (Mothra in English) a giant caterpillar, first hatched from an egg and than molted into a moth so big it sends cars flying and destroys buildings with a flap of its large colorful wings. At last, these films picture the irradiation of remote populations. In *Gamera* the turtle emerges when a bomb

is accidentally dropped close to an Eskimo village and, most importantly in *Mosura* (Mothra, 1961), the giant caterpillar is worshipped by irradiated Polynesians—a sad presage to the future French testing at Moruroa.

The destruction of boats is a recurrent motif throughout the genre—an obvious reference to the *Lucky Dragon 5*. But in *Mothra*, the few members of the Japanese crew survive the wreckage of their boat in a typhoon and swim to an (imaginary) island in Polynesia, the Infant Island, which is described as already highly radioactive because of nuclear tests. Scientists come to survey the island, and one of them returns to steal two doll-size goddesses worshipped by the islanders, intending to exhibit them in a radioactive-freak show in Tokyo. Meanwhile, the two goddesses, played by the real-life, twin-sister vocal duo known as The Peanuts, sing their famous haunting song *Mosura no uta* (Mothra's Song, 1961), and the now-hatched caterpillar Mothra then swims to Tokyo. Mothra wrecks another boat on the way, and then cocoons itself around the Tokyo Tower. Once transformed into a moth, and in front of powerless military troops, Mothra brings back the goddesses—and their culture—to the Polynesians. Thus the film ends on a note of restored order.

The Bikini "accident" is not just the radioactive burden of the US and Japan; it also is, by force, the burden of the Marshall Islands. *Mothra* can be criticized for its stereotypically cinematographic or orientalist depiction of the Polynesians, and the plot for being inconsistent at times.[3] But its portrayal of irradiation and its allusions to the aftereffects in the region are striking: the little fairies beg the scientists to leave the island because the nuclear tests the foreigners brought have disturbed their lives.

In fact, the Cold War expanded its radioactive poison to many parts of the Pacific Ocean, for which the Tongan and Fiji writer Epeli Hau'ofa advocates the inclusive name "Oceania" in lieu of any other label. "South Pacific," Hau'ofa points out, was "a creation of the Cold War era" that spread with the James Michener novel *Tales of the South Pacific* and the hugely successful Rogers and Hammerstein musical based on it.[4] In the turquoise seas of corals, conch shells, and flying fish, the nuclear military machinery sprawled with the proliferation of not only the US tests, but also the UK tests in the Christmas Island and in Australia, and the French tests at Moruroa and Fangataufa Atolls in French Polynesia. Terrible consequences unfold in those areas today, as Andre Vltchek has detailed in *Oceania, Neocolonialism, Nuke and Bones.*[5]

If the representations of Hiroshima and Nagasaki in the arts broadly found a cohesive basis in Japan in the form of A-bomb literature, the art of the Cold War (and its testing of H-bomb capabilities) is in fact atomized

into the richness of cultural, ethnic, and linguistic diversity of the many islands. Finding one "standard" art form or genre is virtually impossible.

Oceania—originally conceived to regroup Polynesia, Micronesia, Malaysia (now called the Malay Archipelago), and Melanesia—includes more than a dozen nations and colonies "mostly called, politely, territories." According to Vltchek, Oceania is still "helplessly divided" with almost "no comprehensive attempt at integration … to speak with a single voice."[6] In the late 1990s, when Hau'ofa tried to phrase a unifying consciousness of Oceanic countries in his article "The Ocean in Us," he "advanced the much larger notion of a world … of social networks that crisscross … the Earth's largest body of water, the Pacific Ocean" without suggesting cultural homogeneity.[7] Yet, as Noam Chomsky also underscored by quoting Vltchek: Oceania is "a microcosm of almost all the major problems faced by our planet."[8] It was precisely because of this insularity and remoteness that the various groups of islands were initially chosen and colonized by the US for their nuclear program. Elizabeth M. DeLoughrey compellingly analyzed this aspect of the nuclear machinery in "The Myth of Isolates."[9] And the same can be said for the French colonial tests and most of the UK ones too.

What experts like to call Oceania's "dependency syndrome," Hau'ofa referred to as its "neocolonial dependency," which stemmed from the "regionalism" that emerged post–World War II when Australia, France, Great Britain, the Netherlands, New Zealand, and the United States formed the South Pacific Conference. According to Hau'ofa, the later exclusion of the islands from of Asia Pacific Economic Conference (APEC), further exacerbated the islands' perception as an appendage, an empty space, and thus one that does not exist for others.[10]

Consequently, the postcolonial framework is essential to understanding any artistic representations of the Cold War, even if a cohesive art of the H-bomb is problematic to frame. H-bomb art is not characterized by direct artistic eyewitness accounts but rather by those of separatist movements, for colonialism and neocolonialism are in fact tightly intertwined with the nuclear tensions of the Cold War, in the Pacific and in other parts of the world. But Micronesia, Melanesia, and Polynesia had each been made nuclear by force. Moreover, as the former director of the Bureau of Foreign Affairs of Palau in Micronesia, Isaac Soaldaob, explained:

We were colonized by Spain, Germany, Japan, and the United States. … Before the Japanese occupation, there was no concept of private property or ownership; we had our own traditional societies that were based on collectivism. … We were fooled so many times, … We wanted to be nuclear-free, because we knew that the Enola Gay left for Hiroshima from this part of the world, from Saipan. We also saw the dev-

astation to the Marshall Islands. ... But we negotiated with the US. ... People were indoctrinated."[11]

If Japanese and Western A-bomb literature and art was (and still is) so rich that highlighting only a few examples among the many pertinent works proves difficult, the scarcity of the works and the lack of international recognition for the Oceania *hibakusha* is blinding.

Similarly, if the US nuclear policies successfully kept the Japanese *hibakusha* invisible, the US and European policies have masterfully kept the Oceanian *hibakusha* out of sight. The excavation of the dark radiance from their artistic Cold War archive yields pieces of a puzzle almost impossible to reassemble, but it was initiated, perhaps in passing but with striking efficiency, by the New Zealand literature scholar Michelle Keown.[12] As for the visual testimonies, the relentless work of Toyosaki Hiromitsu (form the Atomic Photographers Guild), leaves a resourceful legacy comprising decades of photographic testimonies (figures 6.1a and 6.1b).

The scattered but strong Oceanian works are greater in number or more accessible than those made in response to tests in other regions—whether by the UK, the Chinese nuclear program, the French tests in Algeria, or

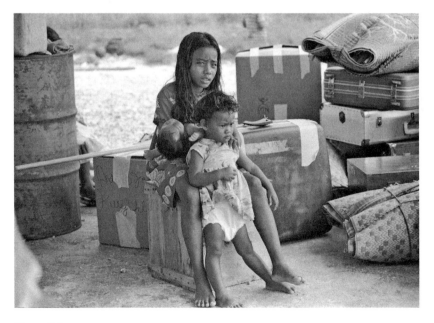

Figure 6.1a
Toyosaki Hiromitsu, *Leave and Loss Ancestors Atoll*, Bikini Atoll, Republic of the Marshall Islands, August 1978. Courtesy of the artist.

Figure 6.1b
Toyosaki Hiromitsu, *Farewell to the Home Island*, Rongelap Atoll, Republic of the Marshall Islands, May 1985. Courtesy of the artist.

the Soviet tests made visible by Julian Charrière and Nadav Kander. Again we find it is not the invisibility of radioactivity that is challenging but the nuclear international politico-military machinery that keeps it under wraps. In terms of representation, the Western use of bombs in Oceania appears in multifaceted ways: overall, the Western, Japanese, and Oceanic representations of the atomic age vary—at times opposed but also, at times, connected.

Beyond the H-bomb Clouds and Godzilla: The *Lucky Dragon 5*

In the West, the efforts of Michael Light are pivotal in giving visibility to declassified pictures (now archived at Los Alamos) of some of the 216 atmospheric and underwater nuclear tests conducted in the Pacific and in Nevada before the US, the USSR, and the UK signed the Partial Test Ban Treaty in 1963. Light's book, titled *100 Suns* (2003), includes his own faithful reproductions of photos taken by cameramen from either the US Army Signal Corps or the US Air Force. The book documents the nuclear tests of the Cold War era not only in photographs but also in words. Light emphasizes a specific series of invisible tests: the 723 underground tests beginning in 1963 for which there are no pictures. The many pictures of atomic clouds

have become familiar, but assembling them in one collection gives perspective to the glaring pervasiveness of the Cold War.

The 100 images from *100 Suns* are piercing, and the limited artistic interference adds to their strength. The title alludes to J. Robert Oppenheimer's quote from the Bhagavad Gita in response to the detonation of test bomb at Los Alamos, New Mexico: "If the radiance of a thousand suns were to burst forth at once in the sky, that would be like the splendor of the Mighty One. … I am become Death, the destroyer of worlds."[13] Each picture is titled simply by relevant data: the number and name of the test, the power of the blast, the location, and the year. This lack of editorializing leaves room to absorb the fullness of the horrific nuclear events and stresses as well their epic proportion. In the photos "080 Bluestone, 1.27 Megatons, Christmas Island, 1962" (figure 6.2) and "099, Bravo, 15 Megatons, Bikini Atoll, 1954" (figure 6.3), for example, the burning mushroom clouds that replace the sun erase any comfort suggested by palm trees-type or warm ocean views characteristic of island life, images that are often commandeered for clichéd, glossy tourist advertisements.

Figure 6.2
Michael Light, *080 BLUESTONE, 1.27 Megatons, Christmas Island, 1962*, 2003, Pigment print. 100 SUNS ©2003 Michael Light.

Figure 6.3
Michael Light, *100 SUNS: 099 BRAVO, 15 Megatons, Bikini Atoll, 1954*, 2003, Pigment print. 100 SUNS ©2003 Michael Light.

The fascinating beauty of the photographs is also juxtaposed by the military's seemingly irrational choice of names for the tests, such as Romeo, Aztec, Apache, Sugar, Hood, and Wahoo. One name however, X-ray, reminds us that half a century later, Marie Curie's dreams for a medical use of radioactivity were quickly burnt to ashes. Initially, the militaries named the tests using NATO's International Radiotelephony Spelling Alphabet (Able, Baker, Charlie, etc.), but after test number 26 they ran out of options. Chris Burden cynically and efficiently mocked that system in his *Atomic Alphabet* (1980), a chart that reads "A for ATOMIC / B for Bomb / C for COMBAT / D for DUMB ..." (figure 6.4). The list was also released in song, along with other more or less militant "sound works" by artists who at the time exhibited at the Ronald Feldman Gallery in New York City—such as Les Levine, Hannah Wilke, R. Buckminster Fuller, and Piotr Kowalski and William S. Burroughs—on the 1982 double-LP album *Revolutions Per Minute (The Art Record)*.[14]

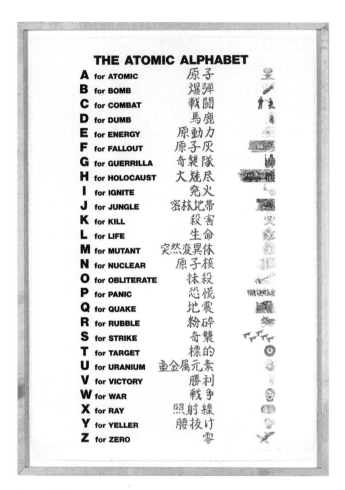

Figure 6.4

Chris Burden (1946–2015), *The Atomic Alphabet*, 1980. Photo etching: sheet, 57 1/2 × 39 in. (146.1 × 99.1 cm); image, 54 × 36 in. (137.2 × 91.4 cm). Whitney Museum of American Art, New York; purchase, with funds from the Print Committee 2003.110. © Chris Burden/ ARS, New York/ JASPAR, Tokyo, 2017 C1466.

Figure 6.5
Ralston Crawford (1906–1978), *Bikini*, 1946. Opaque watercolor and pen and ink on paper: sheet, 10 1/2 × 16 7/16 in. (31.8 × 41.8 cm); image, 10 1/2 × 16 in. (26.7 × 40.6 cm). Whitney Museum of American Art, New York; gift of Charles Simon 77.38. © Ralston Crawford, VAGA, New York & JASPAR, Tokyo, 2017 C1466.

As early as 1946, the American abstract painter Ralston Crawford represented the tests at Bikini Atoll as a direct eyewitness albeit from the decks of military boats (figure 6.5). *Fortune* magazine had sent Ralston as an observer along with a documentary photographer and a meteorologist.[15] His drawings are surprisingly simple and abstract yet still suggest destruction. Predictably, however, none of the works reproduced by Light or created by Crawford help visualize the noxious effects of the tests on the Islanders and the areas, although Light attempted to summarize some of them via a short essay at the end of his collection. One visual effect that *100 Suns* does expose is the Western attraction to iconic nuclear mushrooms. These are the "fabulously visual" tropes of the Cold War, as captured by military photographers who carried tons of film and recording equipment to various lookout points. Many of the pictures controlled and produced by the US militaries were released to the public, not only for the historical record but also for the purpose of emphasizing the power and innovation of the

tests—as long as the size, shape, weight, or inner workings of the testing device were not revealed. The photos turned out to be very effective in fueling visual and collective memories of the fascinating lethal beauty and its potential to obliterate those standing in the shade of the nuclear mushrooms, in the Marshall Islands and in Japan.

Japanese representations of the Bikini "accident" that contaminated the *Lucky Dragon 5* unsurprisingly mainly focused on the Japanese victims. Although Nagaoka did not include the Godzilla film genre in his "History of A-bomb Literature," he did mention other Bikini-related works: *Gyokō* [Fishing Harbor, 1959] and *Ubau mono ha dare ka—dai go fukuryū maru sen'in no shuki kara* [Who Robbed You?—From the Notes of the *Lucky Dragon 5*'s Boatmen, 1958], both by Hashizume Ken, and both of which describe sickness and the fight for life. Shindō Kaneto, who had previously released *Children of Hiroshima*, also portrayed the accident in *Dai go fukuryū maru* [*Lucky Dragon 5*, 1959] (figure 6.6) The film's plot simply follows the crew, beginning with its tranquil fishing expedition to the witnessing of the atomic mushroom and the ensuing sickness, disfigurements, and death.[16]

The art/science compound is here too at work. Just as Takashi Nagai and Hachiya Michihiko were not professional writers before committing

Figure 6.6
Shindō Kaneto, *Lucky Dragon 5*, 1959. Courtesy of Kindai Eiga Kyokai Co., Ltd.

their *hibakusha* testimonies to the page, Ralph Lapp, a physicist who had participated in the Manhattan Project, took up his pen to write *The Voyage of the Lucky Dragon*, an illustrated book that documents the demise of the crewmembers in a tone that has been acclaimed for its blend of scientific knowledge and retrospective compassion.[17]

The radioactive H-bomb wound has also left a lasting scar in Japan: *Koko ga ie da* (Here is the House, 2006), is a children's book with illustrations by the Lithuanian American artist Ben Shahn, who had made several illustrations for articles about the *Lucky Dragon* by Lapp in *Harper's Magazine* (published from 1958 to 1961), and which then appeared with other illustrations in Richard Hudson and Ben Shahn's *Kuboyama and the Saga of the Lucky Dragon* (1965).[18] The story retraces the fate of the boat's radio operator, Kuboyama Aikichi and leaves the reader to wonder if it were possible for Kuboyama to be the last victim of a thermonuclear event before asking: "Can men of all colors, religions, economic systems, and ideologies live together on this planet without engaging in mass murder?"[19]

Two Japanese *hibakusha* writers we've already noted in earlier chapters responded to the Bikini test. Ōta Yōko expressed not only empathy but also the visceral effect of the incident:

The memory of the atomic bomb branded me with a dark stigma. In 1954 ... the Bikini incident occurred; the twenty-three men of the Lucky Dragon were at the point of death. I was socked, to be sure; in my heart of hearts, I thought I had known it would happen. I thought: that's why I've kept writing about the atomic bomb. I became angry. ... In that week or ten days, quick as a wink, my lush black hair turned gray and then white. My blood pressure fell; fingers, toes, the soles of my feet grew itchy; I became unable to soak in the bath.[20]

The *hibakusha* writer Sadako Kurihara's poem on the Bikini test is even more graphic, focusing on the Marshallese *hibakusha*:

I hear the waves of Bikini's blue sea
in each spiral shell of your necklace. (...)
Its like the anger and sorrow of your people
before, in broad daylight ... suddenly, a white flash
flashed on the ocean. (...)
The island people, attacked by intense nausea,
vomited until they had no more fluid.[21]

The effect of the tests on the Marshallese has been harsh. Although not at the epicenter, they still were exposed to radioactivity but also forced to abandon their land. Bikini was evacuated prior to the tests but people were still irradiated in other atolls, such as Rongelap and Utirika. The question

Richard Hudson and Ben Shahn had asked is thus answered: Kuboyama, in the wake of Bikini, was not the last *hibakusha*. In the shadow of the H-bomb clouds, in the shadow of Godzilla, lie the Marshallese *hibakusha*.

Marshallese *Hibakusha* Literature: About Bianca

Because the tests provoked several layers of suffering—irradiation, betrayal, forced evacuations, land loss, and impoverishment of the ecosystem and living conditions—the contamination of the bodies and souls has been expressed in various ways.

Toyosaki Hiromitsu has produced an impressive record of the Marshallese *hibakusha* (among the many other global *hibakusha* he portrayed)—visually and textually since the 1970s. Beyond his expression of collective human empathy, his focus on the Marshallese can also be explained because Japan had colonized that part of the world too, and many islanders still spoke Japanese. Apart from publishing individual photographs and photo albums, he also wrote two thick volumes dedicated to the islands: *Māsharu shotō kaku no seiki: 1914–2004* [Marshall Islands, Nuclear Century: 1914–2004].[22]

Toyosaki's portraits convey the dignity of the islanders. The beauty of these grainy black-and-white pictures is countered by a subtext: the lies told by the American militaries regarding the effect of the H-bomb tests on the island and its inhabitants. As did the Marukis, Yamahata, and Light, Toyosaki includes explanatory text; each picture in his album *Atomic Age* is accompanied by a caption. In addition, the succession and juxtaposition of the pictures—for example, an image of a forty-year-old islander with thyroid medication followed by the picture of two young girls pausing in the middle of a seaside graveyard—adroitly suggests the past, present, and future radioactive wounds of the Marshallese *hibakusha* and of the future generations. Decades later, the effect indeed lingers, and Toyosaki continued his portrayal to the present day with photos in color.

In the Marshall Islands, one of the most powerful expressions comes from a recent collection of poems by the Marshallese poet Kathy Jetñil-Kijiner called *Iep Jāltok, Poems from a Marshallese Daughter* (2017). The title term *Iep Jāltok* is part of a Marshallese proverbial saying translated as "a basket whose opening is facing the speaker," which is also used as a metaphor for young girls who represent "a basket whose contents are made available to her relatives" and the matrilineal society of the Marshallese.

Images of atomic bombs and bombings cannot help but infiltrate her verses. She writes of the "rain of bombs" that left "puddles of silver shrapnel," and of a body with "rows of ribs smiling / grotesque grins through the

skin."[23] What comes to mind is a photograph of a military officer assessing a young boy whose skin was burnt by the ashes from the Bravo test. Just like the works of Ōta Yōko, and even like John Adams's dramas, Jetñil-Kijiner's poems belong to the genre of documentary literature. The poem "History Project" in particular investigates the Marshallese nuclear archives:

(…)
I weave through book after article after website
all on how the U.S. military once used
my island home
for nuclear testing
I shift through political jargon
tables of nuclear weapons
with names like Operation Bravo
Crossroads
and Ivy
quotes from american leaders like
 90,000 people are out there. Who
 gives a damn?
(…)
I glance at a photograph
of a boy, peeled skin
arms legs suspended
a puppet
next to a lab coat, lost
in his clipboard[24]

As in A-bomb literature, the stylistic and beautiful descriptions of the island contrast with its nuclear wounds—and sometimes the other way around:

I read first hand accounts
of what we call
jelly babies
tiny beings with no bones
skin—red as tomatoes
the miscarriages gone unspoken
the broken translations
 I never told my husband
 I thought it was my fault
 I thought
 there must be something
 wrong
 inside me

I flip through snapshots
of american marines and nurses branded
white with bloated grins sucking
beers and tossing beach balls along
our shores
(...)
let them blast
radioactive energy
into our sleepy coconut trees
our sagging breadfruit trees
our busy fishes that sparkle like new sun
into our coral reefs
brilliant as an aurora borealis woven
beneath the glassy sea
God will thank you they told us
(...)[25]

Here too, radioactivity has a color. It is red, like the color of the jelly babies (in 1951, there were 574 stillbirths and miscarriages compared to 52 before the bombs, as Jetñil-Kijiner wrote in her poem, "Monster," performed in front of the Hiroshima dome in 2017). And it is white like the lab coats and bloated smiles. It also is black, like the hair of Jetñil-Kijiner's six-year-old niece, Bianca—hair that fell out due to chemo treatments, and they didn't even save her life. Bianca, who died too young, had learned at a young age particular words in the English vocabulary: "Most Marshallese / can say they've mastered the language of cancer."[26] Radioactivity is not just a contamination anchored in the past but one that still affects the lives of the Marshallese today. Jetñil-Kijiner's poem explains that cancer in haunting terms: there was a war in Bianca's bones in which "white cells had staked their flag."[27]

It could be argued that poetry is just fiction and therefore lacking in scientific evidence. But as early as the 1970s by Darlene Keju-Johnson, a key Marshallese medical practitioner who worked for her government's health ministry, initiated epidemiological studies (something the US never did) that brought to light some wounds Jetñil-Kijiner articulated in poetry.[28] She had previously exposed the cancers—in breasts, in the most private places of the body, in the reproductive organs—and the deformed children (a child from Rongelap had feet like clubs), and the stillbirths: "These babies are born like jellyfish. They have no eyes. They have no heads. ... A lot of times they don't allow the mother to see this kind of baby because she'll go crazy. It is almost too inhumane."[29] These are the radioactive "monsters" or rather "monstrosity" of the Cold War until our contemporary times.

Adding to the nuclear physiological and psychological traumas was also the human betrayal: in 1946, most Marshallese did not speak English, but Bikini's leader, Chief Juda, agreed to let the US military use the island because he trusted the government's motive when told the bomb would be "for the good of mankind, and to end all world wars." He knew that the word "mankind" was used in the Bible, and so he had replied: "If it is in the name of God, I am willing to let my people go."[30] For the betrayed Chief Juda and the people of Bikini, however, no kingdom of heaven awaited them. After a first evacuation, they were left, unwarned, to starve for a year on a small sand island called Rongelap, where they were exposed to radioactive fallout, and then relocated several times.

Missionaries have played a great role in facilitating the intrusion of white men in many parts of the world, doing so in the name of the God they believe in. After the bombing of Urakami Cathedral in Nagasaki, President Truman invoked what he imagined to be divine intervention: "We thank God that it [the atomic bomb] has come to us instead of to our enemies, and we pray that he may guide us to use it in his ways and for his purposes."[31]

Jetñil-Kijiner's poems brilliantly put into perspective the ways in which the West has historically dismissed the cultural significance of the islands, never mind the rights of the islanders themselves. Her poems tell of Liwātuonmour and Lidepdepju, the two goddess-sisters who embody nature and who were silenced and separated by a missionary. They tell of another missionary, Jetñil-Kijiner's great-grandfather, who poignantly sang: "Another home in not as good / Only one is best."[32]

The East/West compound is here very clearly conveyed. When Keju-Johnson engaged in antinuclear activism she discovered that the US government hadn't much changed its attitudes since referring to the Marshallese as "savages." A letter from a government agency, she said, read "like a page out of Interior's Bureau of Indian Affair's handbook on how to manage 'the natives.'"[33] Other direct testimonies from the victims can further be found in militant literature, for example in the proceedings of the Nuclear Free and Independent Pacific (NFIP) Conference.[34]

Whether artistic or militant, Jetñil-Kijiner's poems and Keju-Johnson's testimonies are considered unofficial history, but they offer a necessary counterpart to the series of disastrous Atomic Energy Commission (AEC) official reports on the nuclearization of the US colonies, as analyzed by DeLoughrey in "The Myth of Isolates."[35]

In addition to these testimonies, America's own *hibakusha* should not be forgotten. Just like Major Collingwood turned against his fellow military staff members in Coppel's *Dark December*, members of the US military at Bikini were gravely affected too: Robert Del Tredici captured in photographs the

deformed bodies of Bikini's military staff; Toyosaki took photographs in the US to partially document what he calls "the victims of the Manhattan Project" and of the Pacific;[36] and in another nonfiction novel, *The Day We Bombed Utah* (1984), John G. Fuller based his plot on mainland American tests.

The Day We Bombed Utah (1984) focuses on the incompetency of the AEC and the tests in the US. In the novel which starts at the time of a test done in 1953, the inhabitants of Cedar City are at first only slightly disturbed by "the ugly mushroom cloud [boiling] upward just before sunrise to create a false dawn that put the sun to shame." They were told the fallouts would have no serious consequences, but the assessment soon changed. The AEC men were "polite but worried," warning: "There's going to be a lot of radioactive dust. ... Dan felt a sense of doom. ... There would be compensation, of course."[37] Other failures and breaches of trust ensued along with the toxic effects on the health of land, humans, and animals.

It is both difficult and troubling to compare these distant, irradiated "sibling" *hibakusha*. The tests themselves were different (desert versus ocean), and the Nevada test site *hibakusha* received more compensation than the Marshallese, as Vltchek explains, in addition to the creation of a double standard for the safe level of radiation exposure at Bikini and in the US. Worse, Bikini still remains uninhabitable to date; as Vltchek further underscores, twenty-two atolls were contaminated, and out of the two thousand survivors who were awarded nuclear test compensation, nearly half died without receiving the full compensation: the payments were delayed, however, because if there were fewer survivors to compensate, the total amount of payments would decrease.[38]

Visualizing the extent of the US tests in the Pacific and damage to the Pacific *hibakusha* is still a difficult task today. Once more we see that radioactivity is not a challenge for the arts to represent, explore, and confront, but the military-produced images of radioactivity have created other significant "visibility" challenges. In the 1980s, Derrida said that discourse regarding the nuclear apocalypse is "fabulously textual."[39] This textuality encompasses structures of information, communication, and language—including non-vocalizable language and codes—as well as imagery. The Cold War has thus been made "fabulously visual," but the militaries, having produced their own ready-for-consumption images, here again eclipse the victims.

Oceanian Militant Literature: No Ordinary Sun

Within the cultural diversities of testimonies by Oceanian peoples, militancy and anti-colonialism are the frameworks of H-bomb literature. In "We are the Ocean," Hau'ofa considered the awareness of the Oceanian identity

to be crucial because the people of Banaba were convinced to give their land to phosphate-mining companies *"for the benefit of the British Empire"* and, as we have seen, the Bikini inhabitants were told that the use of their land for atomic tests *"would benefit all mankind."* Given that the Westerners who had profited from their sacrifice have forgotten or were doing their best to do so, Hau'ofa sensed that more land and resources stealing could follow.[40] Resistance is therefore key to H-bomb literature.

Palau (Belau) is part of Micronesia, as is the Marshall Islands. Cite Morei's poem "Belau Be Brave" is another poem whose dark beauty still radiates today. For Michelle Keown, the poem is a "response to a political standoff over military issues which took place between the Palau people and the US government in the early 1990s," when Palau was encouraged to disregard its antinuclear constitution of 1979 and provide more land for military purposes in exchange for aid.[41] In this neocolonial context, Morei's poem clearly stands against the Western wave of radioactivity like a bright chant of resistance:

Belau be brave ...
thy nobleman's creed is in the grave,
decaying by greed, their loyal deeds once engraved,
at Ulong in Wilson's log,
are gone, lost in history books
(...)
Why do people rave? Why do I feel rage?
(...)
Beachcombers, traders and foreigners
came and claimed ...
They exclaimed, "What beautiful real-estate,
best they be barriers for our disasters,
maybe, forward bases for carriers ..."

For Goodness sake is not Bikini enough?
Mururoa, Hiroshima? Nagasaki?
Is Three Mile Island still without life?

Belau be brave, our lives at stake.
Never sell your seas, your soul
For everlasting food stamps.
(...)"[42]

Some might judge politically committed art as an ineffective tool in the art of persuasion. Indeed, according to Vltchek, after being indoctrinated to believe that they needed protection, and being presented with lucrative cash offers, the Palau changed their constitution and the US built a

large military base to house a fleet carrying (or capable of carrying) nuclear weapons.[43] But the poetry is still a strong testimony of the refusal to comply with the Western nuclear and neocolonial logic. Its resistance still resonates today and has not lost any meaning.

Keown uncovered several more H-bomb poems, especially in New Zealand. The country was neighbor to the US, British, and French tests (New Zealand is geographically part of Polynesia). Among them, Hone Tuwhare's Māori poem "No Ordinary Sun" (1958) stands out because it counters, as Elizabeth DeLoughrey phrases it, "the ways in which nuclear discourse is naturalized through the use of solar metaphors."[44] Against Oppenheimer's cosmic metaphor of a thousand suns, "No Ordinary Sun" glows all the more:

Tree let your arms fall:
raise them not sharply in supplication
to the bright enhaloed cloud.
Let your arms lack toughness and
resilience for this is no mere axe
to blunt nor fire to smother.
(...)
Tree let your naked arms fall
nor extend vain entreaties to the radiant ball.
This is no gallant monsoon's flash,
no dashing trade wind's blast.
The fading green of your magic
emanations shall not make pure again
these polluted skies ... for this
is no ordinary sun.[45]

Tuwhare had seen the devastation of bombed Hiroshima. He was part of the New Zealand division of the British Commonwealth Occupation Force stationed in Japan after the bomb and therefore explained: "The main theme is ... the horror and desolation that an H-bomb would bring, something I feel very strongly [about]. ... I am aware all the time of the threat that is hanging over our world."[46]

The poem should also be understood in terms of Māori cosmology, in which the environment can be protected and embodied by deities. As Keown explains, "Trees fall within the domain of Tane, god of the forest, while the earth in which they grow is the body of Papatuanuku, the earth mother." To attack the environment is to desecrate Papatuanuku, according to Keown, who also connects Tuwhare's poem to one by another Māori writer, Patricia Grace. In "Journey" (1980), Grace described earth-moving machines as making incisions in the body of earth mother.[47]

In the visual arts, the Māori artists Brett Graham and Ralph Hotere also created works responding to the many tests. Although it is not directly related to a specific test but rather to forces opposing efforts of peace activists, Hotere's *Black Phoenix* (1984–88)—made of fire-blackened timbers salvaged from a fishing trawler in a boatyard near the artist's home—is characteristic of his often symbolic and highly political work; fully installed in an exhibition space, the timbers lie flat on the floor and lead to the boat's prow, from which a long expanse of upright timbers span the wall. As curatorial text from an exhibition in Wellington, New Zealand, explains, this strident work "states the artist's opposition to nuclear testing in the Pacific, the bombing of the *Rainbow Warrior*" and to other environmental damages.[48]

Brett Graham's *Ground Zero Bikini* (1996) (figures 6.7a–d) from the exhibition *Bravo Bikini*, on the other hand, is an installation that suggests a scientific modeling of military targets, a sand-dwelling shellfish, and also the bra of a bikini. Graham was inspired by the writings of Teresia Teaiwa, an I-Kiribati and American scholar and poet, which explored how the swimsuit made the living history of the nuclearized Marshallese invisible (analyzed in part I), thus provided added context for the two oval bra-evoking shapes of the installation. For the artist, the carved figures represent "the 27 atolls in the Bikini Group. ... Only two of the local island groups have received reparation from the United States government." (Hence only two of the twenty-seven carved figure are intact.) Moreover, the white-on-white theme symbolizes the radioactive ash that snowed on the islanders as much as "a veiled comment about what happens to 'tribal art' when placed in a white space."[49]

In spite of these few artworks, and compared to the highly visible, sublime beauty of pictures of H-bomb mushrooms made available by military sources, Oceania's *hibakusha* are still invisible in the West, even more than the Japanese *hibakusha*. This, once again, addresses the challenge for the arts, more than depicting radioactivity itself.

Artistic traces other than the ones found here, in the East as much as in the West, certainly lay scattered in the ashes of conches waiting to resurface. But just like the disfigured ghost of Oiwa, who haunts her killer in the Japanese Kabuki play, slowly, the nuclear victims return to haunt the West—or the colonialists—in "H-bomb literature" that expands to the documentary film genre: first is Robert Stone's *Radio Bikini* (1988), a highly charged look at Operation Crossroads in 1946 (it includes interviews with a Bikini chief whose people were relocated to clear way for the testing, and a US Navy pilot involved in dropping the bomb); and second is Adam Jonas Horowitz's *Nuclear Savage: The Islands of Secret Project 4.1* (2011), which addresses

Figures 6.7a–d
Brett Graham, *Bravo Bikini*, 1996. Photo credit: Brett Graham.

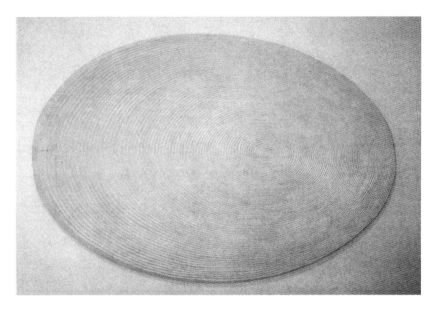

Figures 6.7a–d (continued)

the human and political legacy of Marshall Island testing from 1946 to 1958. Similarly, in New Caledonia and French Polynesia, the H-bomb literature cannot be disentangled from themes of diaspora, resistance, militancy, and independence.

The Shattered Emerald Islands: Moruroa and Fangataufa

The French tests in Polynesia bear the same pattern as their American counterparts, though the French government continued atmospheric testing until the 1970s even if the US, UK, and the USSR signed the Partial Test Ban Treaty in 1963. Here too, secrecy and invisibility of the effects of the tests are blinding. But the French nuclear tests in the Pacific were also represented in what Michelle Keown called "a substantial corpus of Polynesian creative writings ... politicising the relationship between Pacific Islanders and the ocean which sustains them."[50] Indeed, the French tests were conducted in the background of decolonization and anti-colonial movements: General Charles de Gaulle could not stop the Algerian independence, and transferred the nuclear testing from the Algerian desert to the Pacific, mainly to two atolls in the Tuamotu Island group, Moruroa (known as Mururoa in French) and Fangataufa, prompting other independence movements (that ultimately failed).

Figures 6.7a–d (continued)

In the arts, the central antinuclear figure in this region was the Mā'ohi poet Henri Hiro, who organized protests and created artworks. In "Tauraa" (Invocation, circa 1970), he wrote:

Oh forces of nature—heed!
Listen to the story of Paraita with the
eyes full of longing
Listen to the call of God who makes
plants grow
Already rodents threaten her

Tahiti is withering
gnawed by insects
Oh forces that launches trees to the heavens
Come touch the slipping hand
(...)[51]

Hiro also hoped that younger generations would reconnect with their roots and culture, which had been cut off by colonization. Written in the 1970s, the poem "'Oihanu e" (God of Culture) does not explicitly mention the tests but explains that after "a foreign light has fallen upon him,"[52] the scars of 'Oihanu must be healed for the new generations:

(...)
and since the king has changed names,
a food prohibition has been decreed
—and this long since
So that the verdant shall fade
And the trees may no longer bear fruit.
The Torea bird is silent.
The grasshopper is smothered.
It is a prohibition of oppression
Intended to make time stand still
to extinguish the fire of Tiairi
to put out the light of the past
(...)[53]

The poems, together with those by Hubert Bremond and Charles Manuthai, who both published at the same time as Hiro, are more anticolonial than explicitly antinuclear. As Keown explains, they also lament the economical dependency brought by continental France. But the depletion of the environment and culture could not be hidden much longer. For Keown, the poems are "one of the earliest collections of antinuclear poetry to emerge from French Polynesia."[54] The East/West, art/science and political/apolitical compounds are here too clearly visible.

Keown also refers to L'Île des rêves ecrasés (Island of Shattered Dreams, 1991, published in English in 2007), by the Mā'ohi and French Polynesian writer Chantal Spitz. The novel is by far one of the most powerful to address the colonial and nuclear plight of Moruroa and other Polynesian islands. The story is multigenerational, with characters enmeshed in the upheaval brought to this peaceful island (given the fictional name of Ruahine, but similar to Spitz's home island Huahine), as its status became one of a "Territory." There is the arrival of the white people ("branches of the same tree that gave us life," as the song of Ruahine goes): first came the missionaries

later followed by the militaries, who not only disregard island customs, women's respected status, and religious practices, but also send the young to World War II. There is the love between a young Polynesian woman and an upper class Englishman, who forces a Western name on their child, just like the French renamed Moruroa "Mururoa": he calls her Emily but she will rename herself Emere. Then there is the doomed love story between Emere's twenty-eight-year-old son Terii and the forty-year-old Laura (who came from continental France to work on the military base) and conduct the nuclear tests on Ruahine:

As the countdown reaches zero the "Voltigeuse" fires forth from the belly of the earth to climb into the sky over the Great Pacific Ocean. Laura has programed it to self-destruct two minutes after takeoff. All Ruahine's inhabitants can see the "Voltigeuse" explode in a magnificent fireball, seemingly bigger and brighter than the sun itself.[55]

As in the literary testimonies of Ōta, Hara, and Jetñil-Kijiner, the description of the beauty of the "landscape" before and after the persistence of the colonialists is striking. The island is described in the opening of the book as "a peaceful island, an emerald garland floating since the dawn of time on the limitless ocean: Ruahine, a ship whose sails rise against the sky, steep cliffs behind which the sun, tired of its own incandescence, plunges every evening to refresh itself in the bountiful sea."[56] After the tests, things change gradually: every week the colonialists and the politicians exhibit their happiness and wealth while workers and their families crowd more tightly into shantytowns with their malnourished children. The Polynesians and military personnel were not close to ground zero like Ōta and Hara, but the betrayal still has strong radioactive effects. Spitz's omniscient narrator suggests that this betrayal has also been made possible through the complicity of a few greedy native Polynesians: "They took our land for themselves with the help of some of our own people, thirsting after undeserved power. They shattered our established order, forcing the world upon us."[57] But as Keown underscores, Spitz also "anchors her polemical attack upon French military imperialism firmly within Polynesian spiritual beliefs in the sanctity of the natural environment."[58]

Because the plot concentrates on the earliest nuclear tests, the novel does not address the effects on the irradiated populations: a higher rate of cancer, stillbirths, and disabled children, as well as on ecological catastrophes. Albert Drandov and Franckie Alarcon will later describe these aftereffects in comic strips titled *Au nom de la bombe* (In the Name of the Bomb, 2010). The strength of Spitz's novel, however, derives from a style of postcolonial

writing in which Western (mostly French) and Tahitian languages exist in opposition but fuse at times in the story (and formally in the text). Yet the suffering perpetrated by the white colonialists in the novel destroys any idealized view of (or hope for) a real fusion of the many cultures. With the nuclearization of the islands came another key colonial measure: *reo mā'ohi* or *reo tahiti* (the Tahitian language) was declared illegal in the 1960s and excluded from the French colonial education system until 1981 for elementary schools and officially introduced in middle and high schools in 1996. The US had similar language restrictions in Hawaii too, therefore "making way for English and French linguistic and cultural dominance."[59]

The Mā'ohi poet and writer Rai Chaze also depicted the bombings in *Vai* (1990), a book made of several short stories about Tahiti and with an epigraph by Henri Hiro. Born of *metis* parents, Chaze expresses in her book the love-hate relationship with the Occident, between a grandfather who had played in Paris with Django Reinhardt, and the senseless educational system imported from continental France that prohibits her native language. The missionaries, colonization, prostitution, and the bomb gradually appear, transmuting the bountiful island into a radioactive and trashed Eden where food cannot be eaten safely anymore: "Unfortunate one! You ate the forbidden fruit. You will be chased from paradise. But before that, you will suffer. You will suffer until death." A fisherman, who had eaten the (contaminated) fruit of his own labor, suffers from a hellish itchy skin until "the night has pity of him and takes him away from Eden."[60]

The poetry of the stance is heightened by the osmosis between nature and culture (contrasting with Western modernity's separation of the two), when islands and natural features are personifications and the other way around. In "Caesura," Chaze juxtaposes an unspecified narrator's reaction after one nuclear test with her perception of the Western scientists or military nuclear personnel:

In the island of the night, the soil trembled.

The light of the intelligent people has risen over the flows like a mushroom. And the ground trembled. I gripped the wall covering the reef. And the earth continued to tremble, I trembled with her from fear, from cold; from scares, from emotions and from within me [de froid; d'effroi, d'émoi et de moi].

Boom!

(…)

The wall was cracked and the sea sprung out. The intelligent men danced the ball of fear.

From their apocalyptical costume, they colored the inner thighs of their pants in yellow. To the violin of the sirens, they quivered, they shivered and reeled, drunk of panic until that earth became quiet.

Bloated by pain, the island of the night became quiet, exhausted. The sea rose, with a salty taste, muffling the whining of her wounds.

(...)

The intelligent men closed their eyes not to see.[61]

Western men, the "intelligent men," raped the island and looked away from the painful ecological effects. As Dina El Dessouky pointed out, some code names for the French tests were female, such as "Brigitte" or "Hortensia," which "suggest France's vision for the atoll as a series of barren, female striking zones at the disposal of French nuclear violence."[62] For Chaze, the Mā'hoi identity is unshakable in spite of all this: in the introductory short story, "Genealogy," a young girl in search of her genealogy finds it in the ancestral branches: "On the tree that nothing can uproot, not north wind, not cyclone, not progress, not nuclear bombs, not the army, not laws, not the tidal wave, not death. ... On the tree you have found your ancestors. On the tree, your tupuna [ancestors] watch over you."[63] Nothing can uproot the Mā'ohi identity. But the impact of the patriarchal bomb is strong and lasting. Just like Jetñil-Kijiner and her niece Bianca, Chaze described the death of a young girl called China who suffered from leukemia. The impact of the Western colonial and patriarchal system in the Pacific is also strong, and the impact of radioactivity still a contemporary burden.

In her novel, Spitz had described how military men did not remove their hats in sacred places where only women were permitted to wear head coverings, and Jetñil-Kijiner has emphasized in her poems that Western domination meant the depletion of women's social status and motherland. In New Caledonia, Déwé Gorodé describes how alcoholism led to domestic violence while the presence of French military becomes familiar and the resources of nickel, bananas, and coffee are eaten away: "the caterpillars tear out the heart of the mountains."[64]

The H-bomb literature of Oceania also includes New Caledonian poetry. New Caledonia is geographically part of Melanesia, but remains today a French territory. The imagery in Déwé Gorodé's poem "Clapotis" (Wave-Song, 1974), from her book *Sous les cendres des conques* (Under the Ashes of the Conch Shells, 1985), removes any trace of exoticism stereotypically associated with island life. In a pattern similar to what we've seen at times in the prose and poems of Japanese A-bomb literature, the quiet beauty of Gorodé's verses is at first overcome by the strength of the verses she shapes to express her anticolonial stance:

(...)

In this sun

the earth all around

is empty of water
Only the endless wave-song
beyond the barb-wire
is a lullaby that rocks our enclosed and watchful sleep
is a confession
of a journey via Valparaiso
beneath the huge white mushroom cloud infecting the sky over Mururoa
a scream
deafening cry
echoing the cries of Santiago's tortured
(…)
carrying us forward
in dignity
stronger and more serene
more timeless than that of the ageless majestic
stone guardians of Rapanui[65]

What makes this poem central to the arts of the nuclear age is the circumstance in which the poet wrote it, at the Camp-Est prison in Nouméa. Gorodé is Kanak—and not "Canaque," the latter being a French (and initially derogatory) nomenclature imported from Hawaï: the letter *K* has been reassimilated into the native language since the formation of the FLNKS (Kanak and Socialist Liberation Front) as a statement of solidarity with the call for independence. At first it would seem that this has nothing to do with the nuclearized nations, yet it does. Gorodé had spent time after her university years in the south of France, not long after the period of civil unrest across the country during May 1968, to study literature. She became politically engaged in several independent movements—hence her arrests, before becoming a preeminent political figure of the government. Most importantly, she attended a 1975 Nuclear Free and Independent Pacific (NFIP) conference. She wrote *Under the Ashes of the Conch Shells* during the anticolonial uprisings, which also led her to take on additional political roles.[66]

Thus, Déwé Gorodé's "The Wave-Song" cannot be disentangled from other poems such as "Word of Struggle," in which she talks about "radical poetics" and a "politic of struggle," and from "Behind the Walls," which gives visibility to "generations down-trodden humiliated beaten / in the icy silence of colonial tombs."[67] Gorodé became a politically active artist, like other postwar intellectual figures in continental France. Jean-Paul Sartre, for instance, had accepted in 1956 an article titled "The Frog and the Bomb" for the journal he edited, *Les Temps Modernes*.[68] In his own words, Sartre talked unequivocally about his opposition to the bomb: "What the bomb represents is the negation of man, not only because it risks destroying the

whole of mankind, but because it makes the most human qualities vain and ineffectual."[69] Sartre's views on the bomb stand out because writers and artists in continental France rarely represented the nuclear tests in their work.

Moruroa and Mururoa

There are, however, sharp contrasts between Oceanian representations of the nuclear tests and the rare occurrence of representations in continental France. A 1969 Franco-Italian film *L'Arbre de Noël* (The Christmas Tree, 1969) by the British filmmaker Terence Young (mostly known for his James Bond series), was released a year after France's first test in the Pacific but seven years after France conducted tests in the Sahara. The film tells the story of how the son of a rich, widowed Franco-American industrialist is irradiated after a plane carrying a nuclear weapon accidentally explodes off the coast of Corsica (which interestingly still has anti-French separatist feelings); the ten-year-old boy is dying of leukemia.

Another more recent example is *Noir Océan* (Black Ocean, 2010) by Marion Hansel, which follows the life of several military sailors participating in the tests. While visually stunning, the full complexity of the tests in French Polynesia is not addressed—for at no point are the Polynesian points of view brought to the screen. The few female Polynesians included are token characters—represented only as means to facilitate the sailors' entertainment—but these "relationships" are not seen in the film as problematic. As Chantal Spitz clearly has underscored, however, "there was no brothel here before, there was no prostitutes before and ... that [reality] fell on us. ... It was a world that we didn't know that arrived head on."[70] The film, at least, gives visibility to the militaries that were also exposed to radiation: defining victimhood is another challenging task for the arts of Oceania, given the fact that only a handful of the many military victims have recently been compensated.[71] And yet, from 1960 to 1996, France conducted about 210 tests in Polynesia and Algeria.

Furthermore, art is not always a "saving power," to use Heidegger's terminology (see chapter 2). A deplorable instance of such a case appears in *Mururoa mon amour* (1996) by Patrick Rambaud, writing under the pen name Marguerite Duraille; "she" is not to be confused with "Duras," although that's exactly what the author of this pastiche seems to have intended.[72] The book is an outright sexist and racist reduction of the original, overtly criticizing and mimicking Marguerite Duras's literary style and describing Tahitian men in very derogatory terms. The book would not be worth mentioning if it did not steal its name, perhaps unwittingly, from *Moruroa*

mon amour (1974), a militant work by Bengt and Marie-Thérèse Daniels-son, who purposely chose to avoid the Francophone spelling "Mururoa." The couple's writing has also targeted the "colonial bomb."[73] As a result Danielsson's book has been harshly criticized by French nationalists.[74] Marie-Therese Danielsson was a founding member of the local group called Moruroa e Tatou (Moruroa and Us), a nuclear veterans association.

Most importantly, although their writings had not the sophistication of literary writers and poets, the Danielssons shed light on the pivotal and historical separatist figure Pouvanaa a Oopa—or "Te Metua," meaning "the father" or "the wise" in Tahitian—who was wrongly convicted of arson and other acts of unrest within the capital city of Papeete in 1959 and exiled before finally being pardoned a decade later.[75] These accusations remain at the center of debates regarding their possible connection with efforts of the French government to rid the island of those opposed to its nuclear program.[76]

Neocolonialism is at the heart of the French nuclear policies and the government's often senseless or insensitive decisions: the French militar-ies inexplicably designated a "dangerous zone," forbidden to boats and planes, designed in the shape of a champagne cork. In addition to choosing female names for the individual tests codes, the underground nuclear tests in the Pacific used names of iconic, powerful, or strong figures from Greek mythology, for example, Theseus, Clymene, Oedipus, and Ulysses.[77] Greek mythology and even Greek atomism are put to ashes, together with Marie Curie's hopes for a medical use of radioactivity. France, the Western sibling, the branch of a same tree as Polynesia, betrayed its own roots.

Recent documentary film and writings have addressed the French colo-nial and nuclear policies: Christine Bonnet and Jean-Marie Desbordes made a documentary film titled *Aux enfants de la bombe* (To the Children of the Bomb, 2013), dedicated to a French nuclear engineer who kept on photographing the tests despite their known dangers; the film's producers intended to increase awareness of harmful mistakes in government poli-cies. And Bruno Barillot, a contributor to the testimonies published in 2013 in *Witnesses of the Bomb*, spent his career as a nuclear whistleblower, and focused especially on the health of men, women and children islanders.[78]

But still, in Western films and arts, how many have really cared to tell? Who has cared to take the political and nuclear burden? As Spencer Weart has underscored, such realities make some artists flee. The British novelist John Braine stated: "Whenever I think about the H-bomb, I can only give way to despair, which is to say that I can only stop thinking of it." Louis Malle stated: "For nothing in the world would I make a film about the

H-bomb." And John Cassavetes affirmed: "It's too much for me. Frankly, the very thought of atomic warfare … threatens to throw me into a panic."[79] Instead, science fiction novels and a few low budget films loosely took over the H-bomb and its aftereffects, given that post-apocalyptical stories are easily produced: cheap sets and very few actors (a topic to be explored in the next chapter). Invisibility remains the particular dark power of the nuclear age even today. In spite of this clear lack of Western representation of the global *hibakusha*, Western artists have not been silent—militancy often rouses a rallying cry.

The Color and Gender of Power: The Militant Cookbook and Songbook

In the West, the American writer Kristen Iversen brought to light the impact of state censorship during the Cold War with her book *Full Body Burden: Growing Up in the Shadow of Rocky Flats* (2013). Rocky Flats in Colorado opened in 1952 as a facility producing nuclear weapons. Soviet threat was strong at the time, Iverson explained, as were the American government's efforts to conceal what was going on at the plant, as the following statement of intention reveals: "The Atomic Energy Act of 1946 creates an impenetrable wall of secrecy around the U.S. nuclear establishment. All government decisions and activities related to the production of nuclear weapons will be completely hidden."[80]

In spite of this, Western artists (and concerned citizens) were not docile when it came to welcoming the nuclear age. In Iverson's work of narrative nonfiction—based on interviews, government documents, and court testimonies—she reports not only the close calls, such as a near-miss plutonium meltdown, but also the many protests, including one at which the poet Allen Ginsberg, who wrote "Plutonian Ode" (1978), was arrested. The police officers then laughed, saying, "We're equipped to deal with terrorists, but we're not equipped to deal with you people."[81] Antinuclear militancy is also paradigmatic of Western art of the Cold War, sometimes in surprising ways.

One thoughtful and perhaps surprising work integral to the art of the atomic age is the American cookbook *Peace de Resistance* (1970) by Mary Clarke and Esther Lewin (from the group Women Strike for Peace), with illustrations by Jay Rivkin.[82] Many would dismiss a cookbook as not being "real" art or activism. Yet its drawings, its recipes from all over the world (collected by peace activist Mary Clarke), and its conceptual idea are worthy of attention. It was created to help "busy women who have one foot in the kitchen and one foot in the world" to cook quickly so as to have time to

Figure 6.8
Maruki Iri, Maruki Toshi, The Hiroshima Panels, *X Petition*, Ink, Japanese Paper, 1955. Courtesy of Maruki Gallery for the Hiroshima Panels.

protest and talk, particularly in international conferences about the "disposal of atomic refuse, and SALT talks."[83]

Most importantly and historically, the book gives visibility to Women Strike for Peace (WSP), a movement commonly forgotten in nuclear and history textbooks. Started in 1961 by Bella Abzug and Dagmar Wilson, WSP was one of the largest antinuclear (and anti-Vietnam war) movements in the US; it saw about sixty thousand women protest in sixty cities over several decades, during the Kennedy, Nixon, Carter, and Reagan presidencies. Kennedy acknowledged the women for their activism during the Cuban Missile Crisis, which led to the signing of the Partial Test Ban Treaty in 1963.[84] By 1981, the group helped organize the Nuclear Disarmament Rally, gathering about a million people in Central Park.

Departing for a moment from the militancy at the heart of H-bomb art in both Oceania and the West, we can look back at Japan and the Marukis. In their wall panel *Petition* (1955) (figure 6.9), the artists portrayed the success of a movement initiated by Tokyoite housewives to collect signatures against the nuclear tests in a country "where the cherry blossom is the traditional—fragile harbingers of spring after the long death of winter."[85]

Songs have long roused the masses as a worldwide art form for protest. The songs in the *Greenham Songbook*, a collection chanted in the UK by the Greenham Common Women's Peace Camp opposed the storage of nuclear weapons at the RAF Greenham Common in Berkshire, England, where the US Air Force was allowed to store ninety-six cruise missiles. With titles such as "Silos Song," "Four Minutes to Midnight," and "Take the Toys from the Boys," here too militancy is key:[86]

We are women, we are women
We are strong, we are strong
We say no, we say no,
To the bomb, to the bomb[87]

Figure 6.9a

Robert Del Tredici, *A Woman of Greenham Common*, October 29, 1983, photograph. The photo of one of three thousand women who surrounded the Greenham Common Cruise Missile Base in the fall of 1983 and cut down half of its nine-mile chain-link fence. The constable in the background is stymied because he has orders to arrest trespassers but no orders regarding people who cut down fences but who do not trespass. For years women maintained a presence at the gates of Greenham Common to protest the establishment of American Cruise missiles in England and to register their concern about the genocidal nature of the arms race. RAF Greenham Common, Newbury, England. October 29, 1983. Photo credit: Robert Del Tredici, the Atomic Photographers Guild.

In May 1982, 250 women and girls formed a peaceful human chain around the camp, and 34 of them were arrested. The protest grew to 70,000 protesters by 1983—and hundreds of more arrests, as pictured by Del Tredici (figures 6.9a and b). The camp was dismantled permanently in 2000 after the removal of the missiles.[88]

In 2003, Achille Mbembe revisited and critiqued Michel Foucault's biopolitics, a concept now used and developed in social theory to examine how populations (subjects) exist under a regime of authority (the state) and under the law. As Mbembe explains: "In Foucault's terms, racism is above all a technology aimed at permitting the exercise of biopower, to regulate the distribution of death and to make possible the murderous functions of the state." Whereas Foucault, writing in the mid-1970s, focused on Nazism,

Figure 6.9b
Robert Del Tredici, *Greenham Common Arrest,* October 29, 1983, photograph. British police resolve the dilemma of what to do with women who cut down fences but do not trespass by dragging them onto the Greenham Common site and then arresting them for trespassing. RAF Greenham Common, Newbury, England. October 29, 1983. Photo credit: Robert Del Tredici, the Atomic Photographers Guild.

Mbembe encompasses a range of biopower occurrences, from colonialism to Nazism to the use of depleted uranium.[89]

Yet sexism is also a technology of power. In 2003 as well, written with additional perspective in the aftermath of 9/11, Sontag reiterated Virginia Woolf's observation in her book-length essay *Three Guineas* (1938), that war has a gender, and that gender is male. "Obviously," Woolf had written, there is for men "some glory, some necessity, some satisfaction in fighting which we have never felt or enjoyed."[90] After World War II, the Vietnam War, and the 9/11 attacks, Sontag wove Woolf's words into her own statement on the divide in gender: "Men make war. Men (most men) like war since for men there is 'some glory, some necessity, some satisfaction in fighting' that women (most women) do not feel or enjoy."[91] So if war is primarily men's doing, then nuclear warfare is not just the doing of men but of white men. That means nuclear power begins as the color white before it spreads to other colors in other places and perhaps other genders: Indira Gandhi's 1974 "peaceful" test, Smiling Buddha, caused many tensions since it was conducted close to the border with Pakistan.

Figure 6.10

Nancy Spero, *Sperm Bomb*, 1966, Gouache and ink on paper. 68.6 x 86.4cm. © The Nancy Spero and Leon Golub Foundation for the Arts/VAGA, New York/JASPAR, Tokyo, C1466, Courtesy Galerie Lelong & Co., New York.

Yet as we've seen earlier in the chapter, Chantal Spitz and Rai Chaze both wrote about the white male power inherent in missionaries and the military territorialization of the islands and Mother Nature. In the visual arts, Nancy Spero addressed the obscenity of war and the nuclear age by creating a phallic, patriarchal, atomic (white) mushroom cloud in *Sperm Bomb* (1966) (figure 6.10), part of her *War Series*. Barbara Kruger's *Untitled (Your Manias Become Science)* (1981), a black and white photograph, offers a similar perspective of the atomic mushroom with a telling title.

One needs not be a woman to feel threatened by the white dominative nuclear power. In an uncompromising short story "Astronaut's Return," from his collection *Exterminator!* (1973), William S. Burroughs created his own version of an origin myth to address what he ultimately calls "white lies" and "the long denial" of white voices "from Christ to Hiroshima." It begins: "According to ancient legend the white race results from a nuclear

explosion in what is now the Gobi desert some 30,000 years ago." Burroughs explained how the science and technologies that created the explosion were wiped out, but the survivors "became albinos as a result of radiation and scattered in different locations." They lived in caves, where they contracted a virus that "Freud calls the unconscious [and that] spawned in the caves of Europe on flesh already diseased from radiation."[92] But the albinos emerged and entered society:

When they came out of the caves they couldn't mind their own business. They had no business of their own to mind because they didn't belong to themselves any more. They belonged to the virus. They had to kill torture conquer enslave degrade as a mad dog has to bite. At Hiroshima all was lost. The metal sickness dormant 30,000 years stirring now in the blood and bones and bleached flesh.[93]

Radioactivity has thus a color: it is white.

Gustav Metzger, who was born to Polish Jewish parents in Germany and came to Britain as a refugee at age thirteen in 1939, is central to the group of antinuclear artists who create auto-destructive artworks—whether painting, sculpture, or construction—intended to exist, as the manifesto explains, for as little as a few minutes or as long as twenty years before disintegrating and being scrapped. At the beginning of his "Manifesto Auto-Destructive Art" (1960) Metzger stated:

Rockets, nuclear weapons, are auto-destructive.
Auto-destructive art.
The drop drop dropping of HH bombs.
Not interested in ruins, (the picturesque)
Auto-destructive art re-enacts the obsession with destruction, the pummeling to which individuals and masses are subjected.[94]

The modernist separation between art and science and political/apolitical artworks is here again questioned, yet the connection had never really been severed. More "intra-actions" can be detected during the Cold War.

Doomsday Countdowns in Songs: Iron Maiden and Sun Ra

After the bombings of Japan, some of the scientists who had worked on the Manhattan Project published the *Bulletin of Atomic Scientists* and adopted the logo of a doomsday clock, which first appeared on the cover in 1947, and placed the hour and minutes hands of the clock to read "7 minutes to midnight" (hence the Greenham Common Women's song "Four Minutes to Midnight"). The clock itself was designed by the artist Martyl Langsdorf, wife of one of the scientists of the Manhattan project. She explained the compelling need to oppose another use of the bomb after the war: "I tried

many concepts and I thought about it, and all the scientists felt an urgency to explain what had happened with the bomb, and because of the extreme urgency, I remember, the clock seemed to be important."[95]

The minute hand has since fluctuated forward and back depending on how far the bulletin's Science and Security Board determines the world is from nuclear or man-made apocalypse. By 1953, the clock had reached "2 minutes to midnight," for instance, but with the official end of the Cold War in 1991, the doomsday clock moved backward to read "17 minutes to midnight." In 2018 the clock moved ahead from its 2017 time by a half minute to read, once again, "2 minutes to midnight."[96] This very same clock is the one that the band Iron Maiden used as the catalyst for their song "2 Minutes to Midnight" (1984). The song's antinuclear and antiwar message cannot be mistaken and echoes Oceanian poetry, the US cookbook, the Japanese petitions, and British Greenham chants. After underscoring the financial gains of warfare, Iron Maiden sings:

(...)
2 minutes to midnight
The hands that threaten doom
2 minutes to midnight
To kill the unborn in the womb
(....)
The napalm screams of human flames
Of a prime time Belsen feast, yeah!
As the reasons for the carnage cut their meat and lick the gravy
We oil the jaws of the war machine and feed it with our babies
(...)[97]

From the Cold War era to the present, in the US and UK alone, the number of popular songs recorded with nuclear themes is mind-boggling and can be counted by the hundreds. Many of these songs were not hits, had no lasting power, and many made only tangential references with no pointed antinuclear protest themes, but some still radiate today. A few significant, more-militant examples follow here (although I explore several in the next chapter) which varies in genre but not in political commitment. In 1965, Barry McQuire voiced plaintive fears expressed in lyrics written by P. F. Sloan in his #1 hit single "Eve of Destruction." The reference to nuclear power couldn't be more real, and justified the song's title: "If the button is pushed there's no running away / There'll be no one to save with the world in a grave." "God Save the Queen" (by the Sex Pistols, 1977) equates the royal figurehead with a "fascist regime / They made you a moron / a potential H bomb." "Nuclear Device" (by the Stranglers, 1979) is a political

tract commenting on a regime in Australia that (among other wrongs) has bought cheap land for uranium mining. "Man at C+A" (by the Specials, 1980) combines a surprisingly upbeat tune with the occasional discordant tone and the following refrain: "Warning, warning, nuclear attack / atomic sounds designed to blow your mind, World War Three … Rocking atomically / In this third rate world." Another notable song is "Nuclear War" (by Sun Ra, 1982), which phrases the problem in simple terms: "Nuclear war, yeah / This motherfucker / Don't you know / If they push the button / Your ass gotta go."[98]

For some bands and songwriters, their engagement in political resistance endures. Iron Maiden released another spot-on song, "Brighter than a Thousand Suns" (2006), with references to the Manhattan Project and test sites: "Out of the universe, a strange light is born / Unholy union, trinity reformed / (…) / Whatever would Robert have said to his God."[99] Robert Jungk used the "brighter than" phrase for his 1958 testimonial *Brighter than a Thousand Suns: A Personal History of the Atomic Scientists*, a book that Nagaoka Hiroyoshi praised. Jungk explained that while much had been written about the achievements of the scientists, little had been said about the human and moral dilemmas they faced. Jungk had met with survivors but felt nothing had changed. He feared that the scientists' focus on research and not the victims would not prevent such tragedy from happening again: thus the bomb should not be forgotten.[100] Scientists in Japan, more so than anywhere, one would imagine, were determined not to forget. A comprehensive report by Shohno Naoimi documented A-bomb-related research conducted by Japanese scientists as well as antinuclear movements in the country, ranging from early precautions designed to cope with US air raids during World War II, through the Occupation and the Bikini incident, to nuclear disarmament education.[101]

Militant Scientists and Musicians: the Joliot-Curies, Picasso, and Boris Vian

The Russell-Einstein Manifesto and the publications of the *Bulletin of Atomic Scientists* are commonly known antinuclear efforts originating in the US. Compared to these, nuclear militancy in France materialized in responses spanning the art/science and political/apolitical spectrums as well, is fairly unknown. Irène Joliot-Curie lectured for peace and for the votes for women in the 1930s and 1940s, and both Joliot-Curies received peace awards. Frédéric Joliot-Curie became the first president of the World Peace Council (WPC), an organization with communist-inspired doctrines formed in 1950 to advocate universal disarmament; its meetings attracted such

renowned personalities as Jean-Paul Sartre and Picasso. The WPC launched the 1950 Stockholm Appeal that demanded the "absolute interdiction of the atomic weapon, an horrific weapon and of mass destructions" and an international control to enforce the measure.[102] The appeal was signed by millions of people around the world, including Marc Chagall, W. E. B. Du Bois, Pablo Neruda, Simone Signoret, and Jacques Prévert.[103] It also was celebrated through expression in the arts: Tōge Sankichi wrote a graphic poem, "Appeal," published in *Poems of the Atomic Bomb* (1952).[104] Picasso drew a portrait of Joliot-Curie for the ninth anniversary of the peace movements in 1959, although his most famous peace-related drawing depicts the white dove that remains the emblem of the WPC to date.

In music, the surrealist writer and poet Boris Vian, remembered today primarily for his novels, sung *La java des bombes atomiques* (The Java Dance of Atomic Bombs, 1968), with a joyful rhythm that surprisingly enhances the cynical lyrics. In the song, his uncle, an "atomic bomb enthusiast" crafts his own A- and H-bombs because making them is "a piece of cake."[105] As the song goes on, the uncle blows up a group of officials coming to check on his experiments:

The situation was awkward
So he was sentenced
And then pardoned
And the grateful nation
Immediately elected him
Head of the government.[106]

Cynicism can color what might at first strike some as parody, and contribute to the anti-nuclear movements. Ten years earlier, Yves Klein had sent a letter to the International Conference for the Detection of Atomic Explosions that took place in Geneva in July 1958. "Les explosions bleues" [The Blue Explosions] briefly presented Klein's "humanitarian" proposition— offered with complete "humility but also in full conscience as an artist"— regarding atomic and thermonuclear explosions. He explained further:

This proposal is simple: paint A- and H-bombs blue in such a manner that their eventual explosions should not be recognized by only those who have vested interests in concealing their existence or (which amounts to the same thing), revealing it for purely political purposes but by all who have the greatest interest in being the first to be informed of this type of disturbance, which I deem to say is all of my contemporaries.[107]

Klein mentioned his willingness to negotiate the payment due to him, not only for his artistic contribution but also for the price of the colorants.

He insisted that his IKB (International Klein Blue) was superior to cobalt blue, which was, according to him, "ignominiously radioactive."[108] Klein was referring to the cobalt bomb, a type of salted bomb with extremely concentrated radioactive fallout. Leo Szilard had mentioned it in 1950 only to demonstrate nuclear technology's potential to end life on earth. A reflection of the general public's awareness of cobalt bombs can also be seen in Agatha Christie's 1954 mystery *Destination Unknown* 1954, when a female character mentions cobalt and atom bombs in conversation about a fictional scientist named Betterton who'd been in all the papers; she wistfully remembers cobalt as a lovely color from her childhood paint box, before declaring that radioactive experiments were never meant to be. In a postscript to his letter, Klein suggested that the fallouts as well as the explosions would be inalterably tinted blue. As already underscored in chapter 2 in regard to Warhol, Moore, and Noguchi, even apolitical artists produced anti-nuclear messages.

On the one hand, it can be argued that unfortunately, the in spite of militant works by scientists and artists, the Stockholm Appeal's interdiction never fully materialized, and some of those supporting it encountered their own struggles as peace activists: Soviet Russia went ahead with their nuclear tests (the one nicknamed Tsar Bomba in the West, detonated on October 30, 1961, is still to this date the most powerful in the world). Although Joliot-Curie was involved in the formation of the CEA (retitled in 2009 the Alternative Energies and Atomic Energy Commission) to work on a nuclear reactor, the CEA went on without Joliot-Curie to later build bombs. Oppenheimer, who had taken a post at the US Atomic Energy Commission in 1947 and become a lobbyist for international arms control, suffered backlash after the war for having ties with communists and lost his security clearance. According to Édouard Launet, in his semi-fictional novel *Sorbonne Plage* [Sorbonne Beach, 2016], André Malraux had heard about it after a trip to the US and cried out "Oppenheimer should have said right away: 'I am the bomb, leave me in peace.'"[109] On the other hand, the persistence of artists and scientists with their songs of resistance and petitions participated to the anti-nuclear efforts that ultimately led to test ban treaties.

Coral, Basalt and Environmental Racism

Militancy is therefore central to H-bomb literature. By the 1990s, given France's insistence to pursue nuclear tests in the Pacific, militant literature expanded into New Zealand, where testing had taken place for three decades: "New Zealanders woke up in 1962 to Strontium 90 coming down

in rain on Christchurch. This was radioactive fallout from the first series of atmospheric bomb explosions made by France at Moruroa."[110] *Below the Surface: Words and Images in Protest at French Testing on Moruroa* (1995) is a collection of antinuclear works that are also evidently anti-French. In its fusion of poetry, literature, and drawing, the content is very similar to *Nuke-Rebuke* (1984) edited by the American poet Morty Sklar, which also included testimonies by the *hibakusha* writer Hayaski Kyōko and pictures by Yamahata Yōsuke.[111] Militancy is a characteristic of H-bomb literature in the East and in the West—the only difference being that the Westerners suffered at the hands of their own government and that the artistic production was not always positive (as the next chapter will emphasize).

Strangely, there are extremely few artworks relating to the overseas nuclear testing in France—or at least in continental France. For the commemoration of the fifty years of struggle of French Polynesia since the first nuclear test, a festival was organized including a selection of tableaux vivants and the commission of artworks, such as *TĀFAIMAHAEHAE* (2016) by Viri Taimana (figures 6.11a–c). The title can be translated with the phrase "to repair the wrench for the wrath to stop." The sculptural installation (made from coral and basalt) represents the atolls, torn by a red line that signifies the scar left on the lands and in the minds of the people. Outside of France, the 2017 Honolulu Biennial exhibited works by Brett Graham and installations by Jetñil-Kijiner on the colonization and nuclearization of the Marshall Islands, and also works by US-born but Tahiti-raised artist Alexander Lee on the French nuclear testing.

Western and Oceanian artworks are all part of the H-bomb literature. They are scattered in many mediums, places, and time frames, sometimes gathered for specific art projects. But the numerous artworks should not overshadow the fact that works with demeaning, reductive, or otherwise detrimental references to the victims and survivors were also produced in the West at that time. Now that the antinuclear (and antiwar) movements have faded away, many of the Oceanian *hibakusha* still have no visibility: the videos of the American tests in the Pacific, which were declassified in 2017, were greeted without a single word about the Marshallese Islanders.[112]

This is typical of what Toyosaki calls "environmental racism."[113] Among the many global *hibakusha* he portrayed, Toyosaki looked into circumstances surrounding the death of John Wayne.[114] The American film *The Conqueror* (1956)—otherwise known as "the film that killed John Wayne"[115]—was a Cold War orientalized tale lauding the conquest of lands and women starring Wayne and Susan Hayward along with Native American extras (cast as Mongolians). The film was shot close to a former nuclear test site in Snow

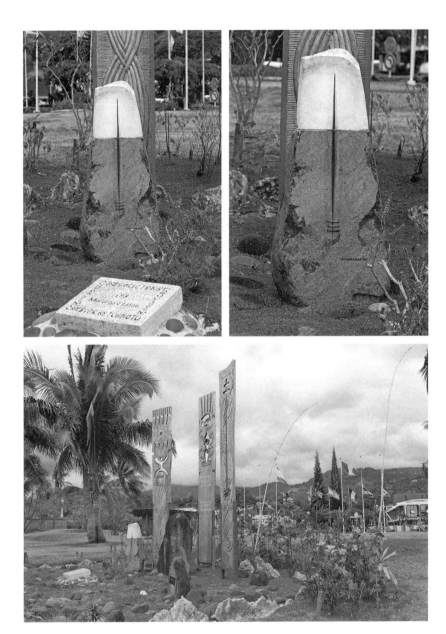

Figures 6.11a–c
Viri Taimana, *TĀFAIMAHAEHAE*, basaltic stone, coral, paint, aluminum rods, 2016.
Assistants: Ludovic Tchong and Léon Tamata. Courtesy of the artist.

Canyon, Utah, and by the 1980s, it was blamed for the high rate of cancer deaths among the cast and film crew (reportedly 91 out of 220). Some attributed Wayne's death to cigarette smoking, thus disregarding any connection to the skin, breast, and uterine cancers Susan Hayward developed during a ten-year period, before succumbing to a brain tumor (Hayward was not a smoker).[116] Tellingly, none of the effects on the Native American extras were mentioned in the few articles that covered the irradiation of the film crew. This environmental racism goes beyond the East/West compound to reveal casualties of the Cold War scattered in many places.

As mentioned earlier in this chapter, Derrida wrote of the "fabulously textual" of nuclear "weaponry" and chose the latter term specifically, because in his view if nuclear *war* had been fought we wouldn't be here to discuss it. The apocalypse has not happened, but we can say that nuclear war has happened, as evidenced by the hundreds of bombs tested in the Pacific by the US (with some tested in the US), the UK, and France, to which we should add the Russian and Chinese tests. Nuclear war has thus happened, but the victims are not among the "political enemy." Numerous ecosystems, lives, and societies were depleted and bombed in the many emerald islands, military staff was irradiated, all of which with consequences still currently unfolding, and Western radioactivity atomized more lands and ethnicities than in the Pacific during the Cold War via uranium mining—the great invisible monster of the atomic age.

Today the plight of the many *hibakusha* is in danger of being overshadowed by new types of whitewashed imagery like the kind suffused in Disney's *Moana*—a tale where a green radium-like glowing stone must be replaced in the heart of a volcanic demon represented by a huge mushroom-like cloud of fire. This is something troubling given that Disney was not left untouched by politico-nuclear contaminations through their lesser known production *Our Friend, the Atom* (1957), as we will see in chapter 7. Such sublime imagery has also infiltrated science fiction and doomsday narratives typical of the Cold War era's cultural production, and which are also part of an artistic nuclear chain reaction.

7 Mining Glories and Fueling Western Modernity: About the Martian Colonizations

As Paul Brians, the central figure in the scholarship of the genre of post-apocalyptic literature, admitted in his overview of science fiction in the Cold War era, monsters have always been a part of the genre "and the atomic bomb soon became just another convenient beast incubator."[1] Susan Sontag also explained how narratives concerning contaminated bodies and body snatchers (such as those based on the H-Man and "The Blob") became "the vampire fantasy in new dress."[2] And yet the irresistible allure of Cold War–era sci-fi films comes from more than just the panoply of radioactive monsters that wreak destruction. Scenes of monstrosity-induced panic, and the screams that punctuate them, are entertaining even if scary. The genre elicits disgust and fright, but our feelings are sufficiently put at a distance thanks to cheap special effects and poor acting. In truth, this is the charm of the genre.

In *Them!* (1954), giant ants appear near a nuclear test site in New Mexico, and scientists and the military join hands to annihilate them and their queen ants. In *The Beginning of the End* (1957), gigantic radioactive locusts attack Chicago (the city where Fermi's atomic experiments took place). *Attack of the Crab Monsters* (1957) is set on a Pacific Island, where scientists must destroy half-human, half-crab monsters. And in *Bijo to ekitai ningen* (translated as "The H-Man" but literally meaning "Beauty and the Liquid Man," 1958), by *Godzilla* filmmaker Honda Ishirō, a nuclear experiment in the Pacific contaminates a ship and turns the men on board into an invisible liquid. The plot thickens: The liquid has the power to attack humans, and transforms them into the same blob-like liquid. The H-men eventually make their way to Tokyo and are responsible for the "disappearance" of a drug-dealer, and the boyfriend of a cabaret singer—the "beauty" of the film. A scientist/professor from a nearby university attempts to convince police that the boyfriend's demise is related to the crew's, but in the meantime one of the H-men stalks the singer and forces her into a sewer. A chase

ensues and the scientist/professor sets out to save her. The suspense is palpable: Will the male scientist hero win the heart of the beauty? Yes, since the nuclear family (here, the meaning of that term as the reproductive heterosexual couple, resonates in an ironic pun) cannot be atomized—at least not on screen.

As Sontag has pointed out, such movies bring an initial feeling of satisfaction. In "The Imagination of Disaster" she explained how fantasy in the form of the popular arts does two jobs at the same time: with its spectacular settings, exotic dangers, and happy-ever-after endings, it allows us to confront the "unremitting banality and inconceivable terror" of our destiny head on; it lifts us from our routine and distracts us from dread—in this case the fear of Cold War and radiation poisoning. Sontag's interest in the genre seems natural, given her lifelong focus on examining high and low culture alike, and as she explained: "Science fiction films are not about science. They are about disaster, which is one of the oldest subjects of art." These films are "concerned with the aesthetics of destruction, with the peculiar beauties to be found in wreaking havoc, making a mess."[3] The bigger the set destroyed, the better the movie.

Significantly, however, Sontag concludes that overall the films are an "*inadequate response*" since they offer no social criticism: "no criticism, for example, of the conditions of our society which create the impersonality and dehumanization which science fiction fantasies displace onto the influence of an alien It."[4] The same can be extended to apply to nuclear-themed sci-fi plots.

In *Monstrosity: The Atomic Brain* (1963), for example, when a wealthy elderly woman pays a mad atomic scientist to have her brain transferred to the body of a beautiful young woman, fears of the Cold War and the lethal effects of radioactivity are displaced by the dream of achieving immortality (a Holy Grail-type of dream). The plot was explored in literary form too, in the short story "Letter to a Phoenix" (1949) by Frederic Brown, in which an irradiated man ages only one day every forty-five years. The theme has its own lasting half-life.

Sontag wrote her analysis in 1965, as David Dowling acknowledged in *Fictions of Nuclear Disaster*, and as he admitted (albeit writing some decades ago himself, in 1987). He rightly pointed out that Sontag referred to pulp genres of the 1950s, but he too quickly concludes that her criticisms regarding the inadequacies of the genre are "typical of the rejection of disaster literature."[5] Sontag's judgment solely applied to science fiction films. Downing himself, however—despite his insistence that there were compellingly original nuclear disaster stories to be found since the

genre became more sophisticated than they were in comic books such as "Wham!"—struggled at times to find convincing storylines outside of sci-fi, for the only *hibakusha* voices Dowling referenced were the ones mediated by John Hersey in *Hiroshima* and Edita Morris in *The Flowers of Hiroshima*.

In fact, nowhere else can the impact of Press Code censorship in Japan and the Atomic Energy Act of 1946—which in the name of national security built a wall of secrecy around decisions and activities regarding nuclear-related research and production—be better detected in the West than in the US atomic-power infused fictional literature and films of the Cold War. As I emphasized in chapter 2, Martin Heidegger (in 1954) envisioned art as a "saving power" against technological "Enframing" (the dangerous or irresponsible use of science and nature). Militant art has already revealed the potential of this saving power. But can it be that the arts, as a way of expressing our "being" in the world, might serve as an enframing too? Considering the use of the arts for war propaganda, the answer to that question is an unequivocal yes.

Yet that artistic enframing concerns but is not the sole characteristic of postwar science fiction and postwar fiction as a whole. And not all of these artistic expressions are "inadequate" even though finding one that "glows" is not easy. The atomic age deeply rooted itself in Western culture: Paul Brians listed about eight hundred entries until the end of the Cold War in *Nuclear Holocausts: Atomic War in Fiction*. He also argued that the great majority, in early science fiction writing in particular, are of "shameful inadequacy" compared to Japanese A-bomb literature, and that only few literary fictions are fully relevant.[6]

The artistic enframing applies more consistently elsewhere. In tandem with World War II and the Cold War, uranium mines fuelled bomb production and then nuclear power plants. Oddly, it's hard to find a feature film or a literary fiction that takes mine-related activities as its main topic, and the same applies to mining as a topic in the visual arts. And yet, the stakes in uranium mining were high—ethically, historically, and geopolitically—in ways still prevalent in our globalized world.

Historically, we saw in chapter 2 how Einstein, in his 1939 letter to Roosevelt, warned that the Germans had stopped selling uranium from Czechoslovakian mines. Einstein suggested alternatives, which led to the exploitation of mines in Belgian Congo and Canada. Geopolitically, the need for uranium resources became a Cold War agenda. President Eisenhower's Atoms for Peace speech of 1953 publically sought to solve the "fearful atomic dilemma" with an ethical argument: in order to "allow all peoples of

all nations to see that, in this enlightened age, the great powers of the earth, both of the East and of the West, are interested in human aspirations first, rather than in building up the armaments of war."[7] The prospect allowed for the circulation of some information about mined resources, but that information was not transparent and did not benefit "all peoples."

In a 1945 newspaper article, George Orwell emphasized that the bomb would change politics in specific ways: unlike other cheap weapons enabling the oppressed to revolt, the "fantastically expensive" bomb and the need for an enormous industrial effort to build it meant that the "power will be concentrated in still fewer hands," that the earth will be parceled off into great empires, and that "the atomic bomb may complete the process by robbing the exploited classes and peoples of all revolt."[8] Great wealth has been mined by Western powers (and still is today) at the expense of Africans in their many nations, of Native Americans in the US, of First Nations people in Canada, and of others in Eastern Europe.

To this can be added the physical and emotional impact on the miners. The sci-fi writer Olaf Stapleton predicted as early as 1930 the outcome of the discovery of a new power: "When rumour got afoot that in [the] future mechanical power would be unlimited, people expected a millennium. ... Unfortunately the first use made of the new power was extensive mining at unheard-of depths in search of metals and other minerals. ... This involved difficult and dangerous work for the miners. There were casualties. Riots occurred. The new power was used upon rioters with murderous effect."[9]

Both arguments were prescient. The US and Great Britain had monopolized the sources of uranium via exclusive treaties, but as early as 1945, Soviet Russia overtook and stole uranium from the Czech mines.[10] At the same time, France exploited mines first in continental France then in its colonies and former colonies, resulting in unfair prices (and casualties); it founded an atomic European partnership, Euratom, in the 1950s, in tandem with the development of the European Economic Community.[11] The Western needs for uranium led to a strong neocolonial global market still in existence today, and with contaminations still debated to date. Radioactive giant ants and Godzilla thus look inadequate to help visualize the many effects of uranium mining.

The postcolonial framework is here again central. Similar to the efforts Epeli Hau'ofa made in Oceania, the Senegalese nuclear physicist, Egyptologist, and politician Cheikh Anta Diop advocated for a unified African continent in his book *Black Africa*, even before Senegal's independence from France in 1960. For Diop, this meant putting an end to the Westerners' depletion of African resources, including uranium mining:

Belgian-American interests, preparing for the political instability that would prevail in the colonies following World War II, working at maximum rates and beyond, mined all the uranium of the Belgian Congo in less than ten years and stockpiled it at Oolen in Belgium. The Shinrolowbe mines … today are emptied, having supplied the major part of the uranium that went into the Nagasaki and Hiroshima bombs.[12]

He concluded: "this one example shows how fast our continent can have its nonrenewable treasures sucked away while we nap."[13]

In such circumstances most sci-fi films—particularly the scenarios in which a Caucasian hero fights against alien colonization of the universe that usually occurs via a nuclear device—are indeed inadequate if not arrogant. A few Western anti-colonialist literary scenarios are worthy of attention, but the lack of representation of uranium mining and of the radon *hibakusha* in the arts and public debates is striking. As the historian Gabrielle Hecht stated: "Like other master categories that claim global purview, the 'nuclear' both inscribes and enacts politics of inclusion and exclusion. Neither technical function nor radiation sufficed to make African nations and their mines 'nuclear' in geopolitical terms."[14] As of today, most African states still have not nationalized their resources (and not just in uranium). Due to the lack of safety precautions in the earliest days of mining, the land, bodies, and minds of numerous areas are still radioactive.

Toyosaki Hiromitsu—who is perhaps the only photographer with Robert Del Tredici to have portrayed many of the mining *hibakusha* during the Cold War—has referred to these situations (for people in Africa, Oceania, Canada, the US, and to some degree in aboriginal Australia) as environmental racism. Three recent works also address this phenomenon, but only in the West: Jim Harding in *Canada's Deadly Secret: Saskatchewan Uranium and the Global Nuclear System*; Peter C. van Wyck in *Highway of the Atom* (also dealing with First Nations peoples in Canada); and Traci Brynne Voyles in *Wastelanding: Legacies of Uranium Mining in Navajo Country*.[15] Spencer Weart mentions mining only in passing, tentatively acknowledging that "perhaps" it has caused cancer.[16] Such a statement denies the struggle of communities to gain recompense through the US Radiation Exposure Compensation Act, a bill that originated in efforts as early as the 1970s but which was signed into law by president George H. W. Bush in 1990. It also broadly disregards the Western corporate exploitation and depletion of the resources.

Derrida's argument in "No Apocalypse, Not Now" (as I've explored in several chapters so far) must thus be extended: the specificity of the Cold War nuclear apocalypse is first and foremost the collusion between scientists and the politico-military spheres, but the nuclear corporate CEOs also collude with them, because their industry fuels weapons as much as reactors (and nuclear medicine apparatuses).

Figure 7.1
Sigmar Polke, *Uranium (Pink)*, 1992, chromogenic color prints. ©The Estate of Sigmar Polke, Cologne/JASPAR, Tokyo, 2017, C1594.

In the visual arts, there are no celebrated figures such as Warhol, Dalì, or Gustav Metzger who represent the uranium mining *hibakusha*. Gerhard Richter's abstract series of paintings titled *Uranium* (1989) rather relate to Chernobyl. Together with the pink-tinted photographs in Sigmar Polke's uranium series, for which the direct exposure of the film to uranium creates the effect, the works as a whole are autonomous (apolitical) (figure 7.1), suggesting an atmosphere more than an image. Yann Arthus-Bertrand photographed a bird's-eye view of the discharge area from the Rössing mine in Namibia, but only in a single snapshot. Moreover, there is no literary or artistic scholar who has started, like Nagaoka in Japan or Keown in Oceania, to uncover what might be the buried riches of uranium literature.

Thus once more we see that the invisibility of radioactivity is not a challenge for the arts, but rather that the arts have responded (or not) to ways in which Western nuclear Cold War policies have rendered nuclear traumas invisible. Investigating the many recurrent patterns of Western science fiction, literature, and comics of the Cold War will help examine the "saving power" and "enframing" of the arts of the atomic age.

A World Aflame: Nuclear Tests in American Literature

Among the many American nuclear-themed novels of the Cold War, anxieties toward the USSR, but also national pride, exist under the surface.

Surprisingly, however, in spite of Press Code censorship and the Atomic Energy Act, several credible depictions of atomic bombs slipped through the cracks. They are of interest also because they are used in order to plead for an end to the arm race.

Based on their reading of John Hersey's *Hiroshima*, Leonard Engel and Emanuel A. Piller wrote an imagined but credible rendition of the near-future bombing of Chicago in *World Aflame, The Russian American War of 1950* (1947):

Now a fearful procession of the burned and injured was coming out of each of these streets. ... Several of the wounded were vomiting as they walked—a first effect of the immense doses of gamma radiation to which they had been exposed. ... Their burns beggared description. Hair and eyebrows were entirely gone. Huge patches of skin hung from their hand and faces. Their clothes were charred shreds.[17]

The effects of the bomb are listed like (or *enlisted as*, we might say) literary deterrents to counter the nuclear build up. Brians has noted other works with the same subtext worthy of attention. For instance, Philip Wylie, in *Tomorrow!* (1954), shaped his plot around the lives of residents in twin cities of the Midwest who are caught between opposing views on the need for civil defense. Wylie based parts of the novel on his own experience as a government consultant on civil defense. *Tomorrow!* offers a very different account of the bomb than Wylie's short story "Blunder" (1946) or his novel *The Smuggled A-Bomb* (1951), that are either unrealistic or irrelevant.

Martin Caidin—who achieved fame when his novel *Cyborg* (1972) was loosely adapted for the popular TV movie *Six Million Dollar Man*—is also noted for having been an adviser on civil defense. He thus depicted people suffocating and being burned alive in *The Long Night* (1959), about a nuclear attack on New York City.[18] Another well-known American science fiction writer working in the nuclear-themed genre is Pat Frank. According to Brians, even if the novel has numerous flaws, *Alas Babylon* (1959) is still a horrifying account of radiation sickness and social disorder, especially compared to his first novel, *Mr. Adam* (1946). In that books' plot the bomb rendered sterile every man on the planet but one, Homer Adam, who was miles below the surface of the earth in an old silver and lead mine in Colorado; as the only one able to save humans from extinction, the symbolically named Adam is much in demand from the women of the planet. Frank later considered the novel a farce, but the theme was recurrent as explored later in this chapter.

Helen Clarkson's *The Last Day: A Novel of the Day After Tomorrow* (1959) is by far one of the best Western radioactive novels. Although on occasion she inaccurately portrays the impact of radioactivity, her storyline has poignant

descriptions of radiation sickness and death: as the story goes on and nuclear war happens, they die in six days, at the threshold of Christianity's symbolic seventh day of rest. Apocalyptical narratives recycling Western religious (mainly Christian) tropes also found particularly fertile ground in the Cold War nuclear age. But here, just like Rai Chaze underscored in Polynesia how the missionaries, followed by militaries and the bomb chased the inhabitants from their Eden island, one of Clarkson's characters states: "The Garden of Eden story was not history, but prophecy. This was Eden and we didn't know it. … And the knowledge of good and evil was our downfall. We knew the difference and yet we chose evil."[19]

The novel is worthy for several other symbolic aspects. First, cynicism punctuates the descriptions of beautiful postcard-like seaside landscapes. For example, while on vacation, the protagonist Lois and her husband Bill (who worked for the AEC) listen with their neighbors Eric and Sally to official radio broadcasts on the possibility of nuclear war. Brahms's *Lullaby* (1869) plays after the bulletin. The lyrics are not mentioned, but the literal translation of the German to English follows here: "Tomorrow morning, if God wills, you will wake up once again." Second, descriptions of flora and fauna color the landscape (roses, beach plum, bayberry, and pine grow in abundance, robins fly over sand bluffs and rippling water), and a cat they name Mysterious appears near their summerhouse: "She used that nose the way we might use a Geiger counter to detect danger we couldn't see or hear."[20] All these references to nature reinforce that the bomb does not solely affect humans.

Not surprisingly, given that the narrator is a woman, the novel gives voice to viewpoints held in pacifist movements such as the Women Strike for Peace, a budding group at the time, but it also hints at the era's gender divide, especially when it comes to attitudes about war. In the wake of the news broadcast, for instance, the husbands try (more or less successfully) to silence the alarmed women. Eric stresses that the targets would be military or industrial. Sally disagrees, commenting on the way the bomb strikes indiscriminately—emphasizing that civilian bombing was what brought Germany and Japan to its knees during World War II. Bill attempts to convince her that some rationale or power of reason (presumably male) would prevent the use of nuclear weapons:

Bill spoke more loudly than usual.

"Sally, let's be realistic about this! Even Hitler did not use poison gas because gas follows the wind, and no one can predict the way the wind will blow. Fall-out is just as unpredictable for the same reason—it's wind-borne. When we set off the Bravo bomb in 1954, the wind changed direction at the last moment and carried fall-out to

places we had supposed outside the danger zone. There've been rumors of a similar accident in Russia. If war does come now, it will be just another war, fought with conventional weapons, like the Korean business."[21]

When the news commentator explains that in an "unthinkable" nuclear emergency, the Office of Civil and Defense Mobilization would broadcast instructions on how to best avoid the dangers of radiation; he labeled pacifists as "alarmists" with the same dismissive tone the husbands used to accuse their wives of being communist since they call for peace.[22] Yet in the novel, women are not secondary to the plot or hidden in the background. They are fully active and thinking individuals. Lois, the main character, who is also the narrator, stands her ground:

I looked at Bill. "Is it communism to want peace in a nuclear age? You're sounding now like that editorial in *Life*, long ago, that said the only people who wanted to end nuclear testing were 'scared mothers, fuzzy liberals and weary taxpayers.' In other words: mothers are a lunatic fringe, a minority group, and if they don't like it here, let's send them back where they came from!"[23]

Clarkson's book is just as revealing of the Cold War anxieties as it is of the difficulty to challenge the patriarchal order, even in the worst situation. The gender divide she portrays is not always clear-cut according to tradition or stereotype. At the beginning of the story, for instance, a mother smiles cruelly when slapping her toddler for not following her quickly enough. The gender subtext also works as a telling metaphor of governmental authority versus the civilian fear during the Cold War. The problem is not inherently gender but is concerned with dominance, even though the imbalance of social power between men and women at that time must not be undermined.

Dowling referred to Clarkson's novel as well as to Judith Merril's *Shadow on the Hearth* (1950) in the following parenthetical remark: "(Is it an accident that some of the most powerful literary works in the this vein ... should also be by women?)."[24] Nevertheless, novels by men are not immune from critical views of male power: as we saw in chapter 5, Alfred Coppel's *Dark December* tells the story of a ruthless military men that still rings true today. Russell Hoban's award-winning *Riddley Walker* (1980) is a dystopian novel set years after a nuclear war set back world civilization to a level suggestive of England's prehistoric Iron Age. Hoban created a unique English dialect for his tale, using phonetic spellings and breaking down multiple-syllable whole words into fragmented compounds (e.g., "sir prizes" for "surprises"). In the opening scene, two starving parents without the tools to hunt or prepare food to feed their child agreed to eat the child, along with a man who

has a cooking pot. The metaphor, in which the adult generation sacrifices its young, and therefore the future, is resonant for the Cold War and reminiscent of the moment in which priestesses and Nezumis feed on Nezumi 5's babies in Satō Makoto's postwar play *Nezumi Kozo: The Rat*.

Such novels, therefore, contrast with those that vaguely describe the effects of the bomb or depict nuclear war as bodiless and painless. In *The Murder of the U.S.A.* (1946) by Will F. Jenkins, large US cities were "simply erased" by bombs so that a third of Americans were ignorant of the war. "Some few individuals may have seen instantaneous flares a thousand times brighter than the sun. There may even have been persons who momentarily felt an intolerable radiant heat, as from the opened door of a blast-furnace. But they did not really know what was happening." The novel centers on Lieutenant Sam Burton and his police-like inquiry to discover the identity and nationality of the bomber. "Not so much as cap-pistol had been fired in retaliation for the murder of seventy million Americans. ... The United States had not been defeated in war. It had been assassinated."[25]

Jenkins's definitive and defensive nationalist stance could be explained by Pearl Harbor and the Russian threat, but then again, using more atomic bombs and military force to solve nuclear war does nothing but reinforce Cold War nuclear policies. Patrick B. Sharp minced no words when he declared that Jenkins's point of view "echoed the common World War II argument that there was no such thing as a Japanese civilian" and that they should have eradicated every single one.[26]

An accurate depiction of bombing, however, is not a crucial ingredient in the recipe for relevant plots. Coppel's book describes neither bombing nor its effects, but its storyline is still particularly pertinent even in today's world. Concerning a technology that has contaminated lives and cultures for more than a century, more patterns emerged in the West that are of interest, also because they illustrate Sontag's point about science fiction. The literary and filmic radioactive mutations and deformities must be acknowledged, just like the real life ones, and also because they are cultural productions.

Western Nuclear Fictions and Atomic Mutants

According to Brians, if atomic war stories written by Western authors in the first few years after Hiroshima were not especially lauded for their aesthetic qualities or spot-on accuracy, they at least conveyed an appropriately admonitory tone compared to what followed after 1947. The bombings in Japan might have vindicated science fiction as a form of prophecy, but the

post-bombing form of the genre seemed at a lost "to interpret the new reality effectively."[27] As the Cold War developed, the tendency toward improbable or even non-nuclear themes became more pronounced.

One problem with post-1945 stories involved the application of fantastical technologies in increasingly complex scenarios. Implausible non-atomic devices that had been explored prior to the bombings continued to flourish on the page, but now that the capabilities of atomic power had become credible, they lost part of their allure for sci-fi writers.

Within a few years, however, so-called genre outsiders began to notice a seeming urgency to move past stories about A-bomb technologies without fully embracing their significance, and rush instead toward wildly overstated optimism about atomic power.[28] Regarding fictional atomic gadgets, Paul Boyer recalled how several scientists tried to slow down the frenzied imagination of science fiction writers: John W. Campbell Jr., an MIT-trained physicist, hoped science fiction and science writing in general would become more scientifically plausible.[29] Indeed, some scientists warned as early as 1947 that atomic energy could become a hugely important factor in research but would not likely be practically applied because the level of radiation at a power plant could render an entire city inhabitable.[30] Several power plant disaster stories are thus worth a look and were given visibility by David Dowling.[31]

So, aside from plots that depend on scientifically ludicrous scenarios, there are those that present the use of the bomb as justified. Brians notes an example in *The Tide Went Out* (1958) by Charles Eric Maine, in which the bomb splits open the earth and drains its rivers and seas as if it were emptying a bathtub. An example of a novel that alludes to the bomb as a transmuted device for survival is Edmond Hamilton's *City at the World's End* (1951), in which a super-hydrogen bomb blasts an entire city a million years into the future, where a devastated population on the barren planet will look to be saved by another dropping of a bomb. Brians's point about sci-fi literature can be extended to film: In the British movie *The Day the Earth Caught Fire* (1961), two simultaneous nuclear tests conducted by the US and the USSR cause severe climate change by changing the positioning of Earth's axis, moving its orbit toward the sun. Although the few scenes of climate refugees making their way through the streets of a deserted London are very convincing, the scientists' solution—to set off a bomb to reorient Earth—is both ludicrous and desperate in its attempt to find a positive use for the nuclear weaponry.

As Brians also suggests, such sci-fi scenarios were fuelled at times by the prognostications of military men themselves who fantasized about the

potential for World War III fought by "robot battle machines" and Buck Rogers–like gimmickry. Such fantasies can be found in a 1946 pamphlet titled *War in the Atomic Age?* by Walter Karig, a US naval reserve captain whose partial agenda was to prove the navy would not become obsolete.[32] No matter how informed a writer is, nationalism has a strong impact in such narratives in time of war.

Another surprisingly recurrent theme employs a somewhat benign atomic mutation—not blindness but rather telepathy. One particularly dark narrative about telepathic mutants is *The Chrysalids* (1955) by the British writer John Wyndham. The novel is set in a post-apocalyptic community whose members believe that they must practice a form of eugenics to counteract mutations.

The genre includes other narratives about mutants and their evolutions, such as Wilmar Shiras's stories in *Children of the Atom* (1953), and *Mutant* (1953) by Henry Kuttner, whose works are known collectively as the "Baldy stories" because of their hairless mutant characters. (Kuttner wrote all but one of these stories prior to the bombing of Japan.) Brians expressed his lack of surprise that such stories existed before Hiroshima because of "Adolph Hitler and his anti-Semitic crusade." Unfortunately, in these mutant sorties, the fight of good versus evil is undercut by the troubling theme of racial superiority. Brians pointed out as well how Kuttner denounced Hitlerism—and managed not to alienate readers outraged by wartime events—all the while contemplating the elimination of *homo sapiens*. As Brians concluded: "But neither the holocaust nor the threat of a nuclear holocaust would seem to have deeply or permanently affected the extreme elitism which Kuttner shared with so many of his SF contemporaries."[33]

American comic book superheroes have also been transformed via contact with radioactivity. A radioactive spider bit Spider-Man (the character emerged in the 1960s), and Sontag reminds us that Superman came from Krypton, a planet exploded by a nuclear blast. Some superheroes, however, are resistant to atom bombs: Wolverine survived the bombing of Nagasaki as a POW with some convincing wounds although they heal in a few seconds, as told in the main story of the franchise, *The Wolverine* (2013).

The descriptions of the effect of the irradiation coming from the many atomized lands, however, are different. The children born out of atomic landscapes have no super powers: the Radium Girls' necrosis of the jaw and their amputated limbs; the horrific burns of the *hibakusha* of Hiroshima and Nagasaki; the radiation sickness, hair loss, cancers, jellyfish babies, and

deformities of the Pacific *hibakusha*. But they were and still are discrimi-
nated against like the many Western literary mutants, or remain hidden
behind a newspaper like the slugs in Ōta's living quarters.

The atomic mutant is but one pattern of stories. Many other narratives
displaced the nuclear anxieties into more "confortable" themes: the bomb-
ings struck a cord in terms of gender and sexuality, yet at times in particu-
larly aberrant ways.

Patriarchal and Sexual Fantasies in Nuclear Narratives

Radical extinction is another recurring theme in Cold War narratives. The
fantasy to destroy humanity in order to wipe the slate clean and start a new
race flirts with the delusional aspirations for the Arian race, but such nar-
ratives also suggest a subplot in which fantasies of rape and female submis-
sion thrived in order to justify a male breach of monogamy.

Outside of literature, the song "Thirteen Women (and Only One Man in
Town)" (1955) by Bill Haley and His Comets goes as follow:

Last night I was dreamin'
Dreaming about the H-Bomb
Well the bomb-a went off and I was caught
I was the only man on the ground
There was-a thirteen women and only one man in town
(...)
I had two gals every morning
Seein' that I was well fed
And believ-a you me, one sweetened my tea
While another buttered my bread
(...)[34]

In this case the lone man had his pick of many women, but in "Thirteen
Men" (1962) a cover of the Comets version sung by Ann-Margret, the gen-
der tables were turned—a rare occurrence in this theme of post-apocalyptic
pop culture—and the men docilely provide her every need. Films such as
The Last Woman on Earth (1960), directed by Roger Corman, the so-called
Pope of Pop Cinema, and *Five* (1951) also explored such love "triangles."

In prose form, Brians listed examples of such works that were written
even until the 1980s, also noting their depiction of particularly sadistic sex,
torture, and rape. "These are quintessentially masculine novels aimed at a
male audience," he explained. "The fascination of rape haunts these works,
recurring again and again."[35] Yet, as Brians admitted, these were less shock-
ing compared to the incest if not pedophilic fantasies that thrived.

In the typical post-nuclear apocalypse, only one nuclear couple (usually white) survives, and from this lone couple flows a new race. Pre-Hiroshima, in *Last and First Men: A Story of the Near and Far Future* (1930), explored in chapter 1, Olaf Stapledon first recognized the impact of such an impossible burden on a woman's body. Of the two women who survived, "one had died and the other was almost a cripple, both martyrs to the task of motherhood." But on the other hand, he also refrained from condoning pedophilia, as shown by a passage in which "the eldest girl [who] had crossed the threshold of physical maturity" stands up to the male leader: "The leader told her that it was her duty to begin bearing children at once, and ordered her to have intercourse with her half-brother, his own son. Having herself assisted at the last birth, which had destroyed her mother, she refused. ... This was the first serious act of rebellion." It's important to note, however, that in the novel, the prospect of giving birth at such an early age has made her rebel, not the incest and after few equally debatable twists in the narrative: "Meanwhile sexual and parental nature had triumphed where schooling had failed. The young things inevitably fell in love with each other, and in time, several infants appeared."[36] The patriarchal authority is changed but restored.

In fact, that such plots existed before Hiroshima is here too unsurprising. Their themes of procreation and the survival of the species are recycled from Old Testament stories—Adam and Eve, Noah's Ark—but in a nuclear world, smashing along the way (or conveniently ignoring) basic scientific knowledge about the effects of inbreeding and radioactivity. Thus, they can be considered as indicative of the challenges in thinking newly about how an unprecedented event changes prospects for survival. But what is certain is that, as Brians underscored, this tells us about the writers and readers who are drawn to plots that justified incest, pedophilia, and rape.

As Brians has noted, Ward Moore's "Lot" (1953) and the sequel "Lot's Daughter" (1954) both allude to the story in the book of Genesis, in which the appalling judgment of Lot to sacrifice his two virgin daughters to the Sodomites (an offer they actually refuse). The biblical Lot's story spirals into his unwitting acts of incest when his daughters rape him to bear children. The protagonist of Moore's stories abandons his wife and two sons at a gas station, thinking of them as no more than "parasites," and flees suburban Los Angeles in the aftermath of atomic blasts, with only his daughter and fathers her a son. In "No Land of Nod" (1952), Sherwood Springer shifted the blame for committing incest onto women when he makes a mother plead with her husband to continue the race by having intercourse with their three daughters. Brians refers to other novels that justify sexual

relations with very young girls.[37] In some scenarios, the authors' symbolic aims are obvious, but in others, the motives are less visible, like latent radioactivity.

Stapledon's *Last and First Men*, on the one hand, imparts a sense of perpetual doom, and the disastrous ends of the wars he chronicles in each of his sixteen chapter-episodes confirms their ineffectiveness. But on the other hand, other nuanced scenarios regarding the nature of family life suggest that Stapledon, like other writers addressing the post-apocalypse nuclear family, gave little thought to questioning the heterosexual patriarchal system. For instance, the Artic exploration team that survived the apocalypse in the novel comprised twenty-eight men and seven women, and Stapledon describes their life before they knew about the atomic doom as follows: "Beside managing the whole domestic side of the expedition, the seven women were able to provide moderate sexual delight for all, for in these people the female sexuality was much less reduced than the male."[38] That summary reveals the misogyny underlying an assumption that women would willingly become domestic and sexual slaves for a multitude of men, glad to be of service for their wombs alone, untroubled by committing incest, or, as all these mentalities suggest, undeniably heterosexual. Homosexuality was made invisible at the time but none of these narratives suggest that love and compassion are relevant components in saving humanity, but rather that dehumanization via female submission is.

Gore Vidal's *Kalki* (1978), written some decades after Stapledon's book, also reveals double-edged meanings in which horrific practices are smuggled into an overall relevant plot. The novel's narrator is Theodora Hecht Ottinger (known simply as Teddy), a bisexual test pilot with an engineering degree who is assigned to report on James J. Kelly. Kelly is an American former soldier claiming to have been reincarnated as Kalki, the leader of a Kathmandu-based religious cult, but Teddy has to make sure Kelly's cult is not just a front for international drug traffickers. In what started as a hoax, Kalki delivers a message about a (more or less nuclear) doomsday. His claim to be the final avatar of Vishnu harks back to Oppenheimer's famous remark after the Los Alamos test, "I am Siva, the Destroyer of the Worlds," which the book directly cites.[39]

On the one hand, the narrative is not insensitive to nuclear traumas. *Kalki* puts in perspective how Western gurus and military fanatics can hijack the bomb, and that the world would be better left to animals if the nuclear arsenal was to be developed. On the other hand, however, the earth is actually left to trained monkeys who had been taught sign language by Caucasian Westerners—a Penny Patterson twist that would not

be possible after Donna Haraway's *Primate Visions*. The Caucasian God puts himself/herself at the origin of a new Darwinian-like transition between apes and humanity all the while rerouting the African origin of the human species.

At least, in Vidal's novel, human imbecility and male pride bring humanity to a final end, which sufficiently puts the Cold War in perspective. Yet, upon learning that she was sedated and raped (the method that was used to determine that she was sterile, a condition that allowed her to survive the apocalypse so only Kalki and is wife could procreate), Teddy declares: "That explained the soreness in the pelvic region. I was properly shilled. Had I proved to be fertile, I would not have been immunized. Rape seemed, suddenly, trivial."[40]

Seen from today's standpoint, these Western stories and novels, while they express nuclear fears, do not pinpoint the nuclear policies of the Cold War in terms of the dominant patriarchal use of nature and of people, and register their impacts on Eastern cultures: the rape of mother earth (Moruroa) by the Western French nuclear missiles, as described by Polynesian writer Rai Chaze; the importation of brothels along with bombs, as described by the Polynesian writer Chantal Spitz; the undermining of Marshallese female status and depletion of the land and bodies invoked by the Marshallese poet Kathy Jetñil-Kijiner.

Of course, not everything is black and white. Not all Pacific societies offered a better social status for women and children, and some Western novels do explore the patriarchal system successfully. In Judith Merril's *Shadow on the Hearth* (1950), a mother has to consistently repel the sexual advances of a civil defense officer.[41] Alfred Coppel's *Dark December* (1960) is here again relevant: Major Gavin saves Lorry from being raped, and in return she helps him and saves his life. Finally, in Stanley Kubrick's political satire *Dr. Strangelove* (1964), the film's title character, an ex-Nazi scientist, explains his plan for survival to a US general and other government officials congregated in the War Room: he proposed having a selected pool of several hundred thousand men and women (with a ratio of ten females to every male) while his hand instinctively does the Nazi salute. The plot of human extinction is finally cynically linked to its Western fascist origin, together with the male dreams of exotic (Eastern) harems.

Without a doubt, narratives that justify rape and pedophilia are immoral—inappropriate, in any circumstances—and thus are a form of enframing. But other unethical tales continued to proliferate, especially those that relate more to dominant cultures of the nuclear age: the tales of intergalactic conquests.

Soft Rain in Dark December: Alternate Sci-Fi Narratives

The belief in what Brians calls "Man's Unconquerable Will" still flourished in science fiction after Hiroshima, with examples ranging from A. E. Van Vogt's "The Monster" (later retitled "Resurrection," 1948) in which a man defeats aliens all by himself in an atomic duel, to L. Ron Hubbard's *Battlefield Earth: A Saga of the Year 3000* (1982).[42] In Hubbard's novel, a handful of humans transition with ease from the use of arrows to nuclear warheads to conquer and be masters of an entire galactic empire. In an earlier example of a story worth noting, Arthur C. Clarke's short story "Loophole" (1946), Martians respond to Hiroshima and Nagasaki by trying to prevent the proliferation of nuclear weapon use in outer space, and for their peace-keeping efforts they are bombed and eradicated by none other than the US. As with earlier narratives we've seen that justified the bomb—at least in the opinion of many in the West, as Brians has reminded us—early responses to the bombings in 1945 were based on their use as an expedient way to end the war.[43]

Not every Martian story ends on a futile note like "Loophole" does. Brians particularly favors Ray Bradbury's "The Million-Year Picnic" (1946–47), which was later published with other stories under the title *The Martian Chronicles* (1951). The story begins as the nuclear family (father, mother, and three sons) flies to Mars, ostensibly, as the boys are told, for a picnic. The real purpose, as it turns out, is to escape from war-stricken Earth. The genre of Martian colonization of the earth is reversed. The boys look forward to seeing the Martians, and their father leads them to a canal and tells them to look into the water. Of course, the "Martians" they see as the story ends are their own reflections. They were the Martians, the new residents are the colonizers.

Another pertinent story from *The Martian Chronicles* (1951) is Bradbury's "There Will Come Soft Rains," in which household robotic appliances orchestrate their daily mechanical ballet of chores in an empty house left standing in a completely deserted town, from breakfast to dinner, including to the preparing of an afternoon bridge table and martinis. At four-thirty, the nursery too is animated, highlighting the absence of the children in a very efficient way:

The nursery walls glowed.

Animals took shape: yellow giraffes, blue lions, pink antelopes, lilac panthers cavorting in crystal substance. The walls were glass. They looked out on color and fantasy. ... The nursery floor was woven to resemble a crisp cereal meadow. ... There was a sound ... like the lazy bumble of a purring lion. ... Now the walls dissolved into

distances of parched weed, mile on mile, and warm, endless sky. The animals drew away into thorn brakes and water holes.

It was the children's hour.[44]

In these lines, the senselessness of the bomb is suggested via the elaborate production of color and sound for disappeared (annihilated) children, a discreet anti-bomb comment also made evident in Bradbury's reference to arts and civilization in the face of total annihilation:

Nine o'clock. The beds warmed their hidden circuits, for nights were cool here.

Nine-five. A voice spoke from the study ceiling: *"Mrs McCellan, which poem would you like this evening?"*

The house was silent.

The voice said at last, *"Since you express no preference, I shall select a poem at random."* Quiet music rose to back the voice. *"Sara Teasdale. As I recall, your favourite ...*

"There will come soft rains and the smell of the ground,

And swallows circling with their shimmering sound;

(...)

Not one would mind, neither bird nor tree,

If mankind perished utterly;

And Spring herself, when she woke at dawn,

Would scarcely know that we were gone.[45]

Bradbury ends the story with the house undergoing its own apocalyptic explosion, offering a parallel to the human demise in a paragraph that explains how animal voices in the nursery one by one quieted and died.

In many of the stories of Bradbury's *The Martian Chronicle*, like in Olaf Stapeldon's novel but unlike Bogdanov's *Red Star* (1908), women are unfortunately reduced to being sentimental partners (in the bedroom) or obedient mothers and food providers (in the kitchen). If they are self-assertive, they are ugly. But the bomb is never celebrated and is instead invalidated.

Science fiction is still immensely popular today, and therefore subject to recycled (updated) themes and adaptations. In 2012 Jon Towlson drew on Sontag's argument about problems inherent to science fiction and extended it to the twenty-first century; he convincingly demonstrated how the Cold War patriarchal authority, which was losing power because of the New Left and the Watergate scandal, felt the need to rehabilitate itself. For Towlson, there is a correlation between the Cold War disaster movies, those that began to appear in the 1990s (the time of millennial angst), and post-9/11 catastrophe movies. Therefore, he concluded: "Sontag's evaluation of the genre in 1965 still holds true today. ... For as long, then, as sci-fi/disaster movies instead opt to propagate the ideology that patriarchal authority is

infallible and governments are necessary to protect us, we should consider them as "inadequate responses."[46]

Few scenarios, however, managed to escape the patriarchal net. In one film, *The Day the Earth Stood Still* (1951)—itself adapted from the 1940 story "Farewell to the Master" by Harry Bates—a male humanoid, who had landed in a flying saucer in Washington, DC, pairs up with a woman to bring peace and literally disarm the military by relying on an interplanetary police of robots dedicated to living in peace. This Christ-like analogy became a Noah's Ark analogy in the 2008 version of the film. In the end the peaceful male character wins over the aggressive institution.

In *Terminator 2: Judgment Day* (1991), Sara Connor is training her son John to be the future leader of a resistance movement targeting an artificial-intelligence takeover of nuclear missiles. The Virgin Mary–like analogy is balanced by her defiance of authority which in turn sparks a revived atomist investigation of free will and determinism: Will time travel help prevent the nuclear apocalypse to happen in the future?

Finally, another particularly pertinent plot is *Mad Max: Fury Road* (2015) by George Miller, the fourth installment of the *Mad Max* film franchise. In a post-nuclear apocalyptic world, Max and Furiosa (the modern nuclear couple) fight side by side against the patriarchal fascist order that dominates natural resources and people, sexually enslaving women and forcing them into motherhood. In this good versus evil scenario, the power of love and salvation eventually wins out, when Nux, one of the war boys, turns against the patriarchal state. A more multicultural cast would have been a welcome improvement to the film, but the Caucasian colonial "biopower" is nevertheless represented by white paint applied to the bodies of the war boys—a costuming special effect suggesting that a dominant state of mind is not entirely predetermined by skin color or gender.

In sci-fi literature, Alfred Coppel's *Dark December* (1960) has a narrative whose dark radiance is worth excavating here too since it conveyed an early awareness of Western imperialism. When trying to board a US plane, Major Gavin realizes that:

The plane was crowded with a delegation of Japanese agricultural experts and Korean military staffers. Perhaps it was in some way symbolic that they should occupy the cabin and I was left over. In the society to come, I thought, the relatively untouched people of Asia would now have precedence over the Caucasians who had botched up the world and decimated themselves. It was something to think about.[47]

Had the plane carried Marshallese or Polynesian islanders, a few Nigerien or Namibian citizens, and some Native Indians too, the picture would have been more accurate.

Had Press Code censorship and the Atomic Energy Act secrecy been less efficient, the trends in fiction and film may have been slightly different. But it is certain that the monsters on the page and on the screen numbed us to the nuclear age and prevented us from looking at other atomic realities, namely the Pacific *hibakusha* and, ultimately, the uranium mines. But the popular arts must not be deemed completely incompetent when it comes to bringing awareness to important issues: a handful of comics and cartoons push beyond the pictorial tropes of radioactive monsters to reveal the many mining *hibakusha* of the Cold War in the US, Canada, and many African nations. The problem is not one of medium, but of the narrative and politics of representation.

The Nuclear Indians of the Black Hills and Red Rock Reservations

Not all nuclear-age comic books tell tales in which ray guns and missiles are the weapons of choice. Leonard Rifas's *Paha-Sapa, The Black Hills* (1979), for instance, gives visibility to the destruction of resources in mines located in the holy land of the Black Hills (Paha Sapa) of the Lakota Nation (figures 7.2a and 7.2b), a territory expanding from western South Dakota to Wyoming. The cartoon explains how the Treaty of Laramie (the one signed in 1868) and the ensuing gold rush in the region first took the land away from the Lakota, and then the new radium rush depleted the remaining resources. Kerr-McGee and Union Carbide corporations were drilling "800 billion of dollars worth" of uranium to use in nuclear power plants and atomic warheads, leaving behind radioactive contamination, dry wells, and "boom-towns."[48] The uranium rush as a reincarnation of the gold rush can be detected in songs too, such as Elton Britt's "Uranium Fever" (1955), and especially in this lyric from The Commodores' "Uranium" (1955): "Oil's old fashioned and gold don't glitter no more."[49] Warren Smith's "Uranium Rock" (1958) was later covered by The Cramps: "I got a big Geiger counter, it's pretty good rig / When the needle starts clickin' its where I'm gonna dig / Money-money honey, the kind you fold / Money-money honey, rock'n'roll."[50] Big companies, however, were the ones prospecting and prospering. The real-life radioactive monsters are not giant locusts or ants but rather the giant vampire-like corporate entities with their contaminating activities and cutthroat policies. Just as in the case of the Pacific nuclear

Figures 7.2a and 7.2b

Leonard Rifas, *Paha-Sapa, The Black Hills* (Energy Comics #1), 1979.

testing, their impact operated at several levels: irradiation of land and people, cultural dismissal, and resources stealing.

Robert Del Tredici photographed and collected a few testimonies from radon *hibakusha* including Jeannette and Bernard Benally from the Red Rock (Red Valley) Navajo Reservation in Arizona (figure 7.3). Starting in 1950, Benally was employed at many places including the Oak Spring Mine, Slick Rock, Monticello, and Salt Lake. He had lung cancer at the time Del Tredici took the photographs (1982):

At Oak Spring I found out I was sick. I was bleeding from inside, from the mouth, and my supervisor told me I had to go into the hospital. ... I had an infection on my lung so they cut some pieces out from me. I stopped working in '65 and after I've been in various hospitals.[51]

The effects of the exploitations of the mines during World War II and the Cold War were several. The first was on the health of the workers, since they initially worked without protection: "I used to go in and haul the rocks out," he recalled, "and I guess that's where I got hurt, because there was a lot of dust after they did the blasting and we went in right away."[52] The naked faces exposed to radioactive dust and radon were also visible on Kerr-McGee's 1952 corporate promotional film. According to the historian Marsha Weisiger, the dangers regarding radon in uranium mines were known since the late 1940s, but the AEC (the sole legal buyer of uranium until 1971) refused to set safety standards for too long a period, even though measures such as adequate ventilation, mandatory daily showers, and changes of clothing were known to reduce hazards had been taken earlier in Belgian Congo. This simply would have "cost too much and slowed the arms race."[53]

In numerous mines, radioactive scars were also cultural. Traci Brynne Voyles strikingly analyzed such impacts, mostly on the Diné and Pueblo Indians in New Mexico, noting the "affect of power relations between colonizer and colonized; [and how] it has shaped the experiences, bodily health, and life expectancy of the Diné long after the problem should have been rectified." For example, the uranium mining industry moved from west to east, which goes against the way in which the Navajos express geographical knowledge, and thus exacerbated centuries of colonial de-territorialization and misrepresentation.[54]

One film that sensitively portrays the cultural, geographical, and environmental colonization of a South Dakota reservation is *Thunderheart* (1992), directed by Michael Apted. The plot is loosely based on events that occurred in 1973 during the Wounded Knee incident involving militant activists and

Figure 7.3

Robert Del Tredici, *Uranium Miner with Lung Cancer, Red Rock Navajo Reservation*, August 18, 1982, photograph. Bernard Benally worked as a uranium miner for six years. "I used to go in and haul the rocks out, and I guess that's where I got hurt, because there was a lot of dust after they did the blasting and we went in right away." Photo credit: Robert Del Tredici, the Atomic Photographers Guild.

the FBI; in the film version, an FBI agent named Ray Levoi investigates a murder on the reservation only to uncover a local government-sponsored plan to strip and mine uranium on leased native lands. A complicated conspiracy ensues involving kickbacks paid to those who ignore the law. Apted's making of *Incident at Oglala*, an earlier documentary film that reported on a similar conflict, perhaps contributed to *Thunderheart*'s avoidance of orientalist depictions, though in the film the uranium mine and contamination it caused figure only in the background of the plot.

But the scars were deeper, just like the ones Westerners caused in Oceania when corporations were bent on destroying a system in which women had social status and rights of ownership, and were esteemed political figures. Behind that was a government policy in which there was an "American insistence [on] recognizing the political leadership only of men [and which] all went hand in hand to undermine the strong position of Navajo women in the tribe."[55] The consequences socially were dire, ranging from alcoholism, crime, domestic violence, and sexual assault made all the more dreadful by reduced accessed to social services.[56]

In *Thunderheart*, Ray discovers the murder of Maggie Eagle Bear, the only consistent female character of the film, at the same time that he finds out about the uranium drillings and the contamination of water. Maggie is not as blatantly symbolic as Betty, the daughter of a radium ore mine owner in Michel Darry's *The Race for the Radium* (1936), explored in chapter 1 and 2, who was the metaphor for the atom; in that novel Betty's kidnapping by the German greedy character is a post–World War I allegory for what happens if the atom falls into the wrong hands. But Maggie serves as a metaphor for the desecration of nature and, being a schoolteacher, her murder also signifies the loss of educational opportunities for her tribe.

In real life the impact of uranium mining also resulted in the depletion of natural resources. In the US, for example, Monument Valley produced about three million pounds of uranium for the Manhattan Project, while the Colorado Plateau provided for the arms race.[57] As Rifas explained in his comic book, the uranium was drained just like gold, which means that very little of the proceeds if any at all, benefited the Native Americans.

Like he did for the Marshallese, Toyosaki captured on film the images of many mines and the portraits of Native American radon *hibakusha* from the Lakota and Navajo Nations; he complemented the photographs with text (figures 7.4 and 7.5). These words and pictures tell of radioactive contamination of native lands in the Grand Canyon and in North Dakota, but also of the contamination's effect on the workers' health—the cancers, crippling

Figure 7.4
Toyosaki Hiromitsu, *Uranium Mine Victims, James Garrett. Lakota Nation, USA. Director for Environmental Affairs of the Cheyenne River Reservation*, The World Uranium Hearing, Salzburg, Austria. September 1992. Courtesy of the artist.

Figure 7.5
Toyosaki Hiromitsu, *Uranium Mine in the Backyard. Red Rock, Navajo Indian Reserva-
tion, Arizona, USA*, June 1980. Courtesy of the artist.

accidents, and deaths of newborns—as well as the misinformation that cir-
culated about them.[58]

Marsha Weisiger also detailed such trauma. Her starting point is *Return
of the Navajo Boy,* a documentary by independent filmmaker Jeff Spitz
that aired in the US on PBS in 2000 and based on the "Navajo boy" John
Wayne Cly (named by John Wayne himself who was filmed extensively in
the Monument Valley as seen in the previous chapter) and his family. She
also compares it to 1950s promotional films for the uranium industry (in
particular of Kerr-McGee) and underscores detrimental colonial and corpo-
rate policies and how it affected the Diné. The grandmother of the family,
Happy Cly, was forced to place her toddler son John Wayne Cly in the care
of missionaries; the boy's mother had died of lung cancer, and Happy was
also too sick with cancer to care for him. Spitz and Weisiger give light to
the contrast between an idyllic Cold War–era film produced as advertising
for the uranium industry, and "a family history of exploitation and loss."[59]

The depleted emotional and economic lives of the nuclear families of
Native Americans conveyed in interviews with the filmmaker contrast
sharply with the clips from the Kerr-McGee 1952 corporate promotional

film, which seemed intent on showing traditional Navajo (Diné) Indians "living on the ground hallowed by their ancestors, looking forward to the future of many brilliant tomorrows,"[60] ready to become "modern" Indians. But in fact, when "tomorrow" came, the miners, their families, and their lands were atomized. Atomic transmutations have socioeconomic, not merely technological, effect. If Western sci-fi narrative themes were relevant here for comparison's sake, they would be the narratives of cloning, in which the Westerners tried to reproduce the "others" in their own image—cloning, for Baudrillard is "denying all alterity."[61] But this would not be a culturally inclusive approach to the problem and would not give visibility to the nuclear wounds caused by uranium mining.

Through these scarce but strong artworks, together with few Indian characters in John Adams's *Doctor Atomic* (in the staging of the Metropolitan Opera in New York), radioactivity becomes visible. It is black and red, like the irradiated populations of Black Hills and Red Rock. It is red, like the infected lungs of the radon *hibakusha* and the stillbirths, and white, like the white coats of the many hospitals they visited. It is also yellow, like the yellowcake produced by processing uranium ores. A rare appearance of the concentrate of uranium in the arts is in a lyric-less song by The Stranglers, "Yellowcake UF6" (1976), that was released on the "B-side" of the 1979 single "Nuclear Device (The Wizard of Aus)" in protest against the neocolonial mining of uranium and weapon testing conducted in Australia.

The visibility of these "others" is rare, however, and the same can be said for "other" exposed American *hibakusha*: a 1980 article in *Life* magazine referred to them as the "The Downwind People" who were exposed while living nearby test sites in the US.[62] Some were discussed in a book-length essay by the environmentalist Terry Tempest Williams, *Refuge: An Unnatural History of Family and Place* (1991), which began with the author's conviction that the breast cancer in her family was the result of nuclear fallout in the environment in which she grew up. To these must also be added the efforts of Toyosaki and Del Tredici regarding the US military and their families, and the body of art by Patrick Nagatani (figures 7.6 and 7.7), a Japanese American photographer born only a few days after the bombing of Hiroshima, his family's hometown, and who died in Albuquerque, New Mexico, in 2017. His photographic collages juxtaposed images of Native Americans, Japanese tourists, monuments, nuclear missiles, and military installations to suggest the negative effects of atomic testing on humans and the environment. Although these seem but a few examples of artworks produced in response to testing and mining in the US, far more exist than in response to the Canadian and French neocolonial mines.

Figure 7.6
Patrick Nagatani, *Trinity Site, Jornada Del Muerto, New Mexico*, 1989. Ilfocolor (Type C). Courtesy of the artist.

Canadian Nuclear Dragons versus First Nations' *Hibakusha*

Canadian mines are pivotal in any study of atomic-age mining because they provided uranium for the Manhattan Project. Few visual traces are by amateur photographer Hans Heinrich Maximilian "Henry" Busse. In the 1940s, Busse was a pipefitter's helper at the Eldorado Mine in Port Radium where he joined the mine's photography club. Busse went on to invest in a photographic studio in Yellowknife, thereafter producing an estimated 30,000 to 50,000 photographs now archived by the government of the Northwest Territories. Regarding testimonials, Peter C. van Wyck, in *Highway of the Atom*, gave visibility to some from former mine workers in the same area, but he acknowledged that they were too loyal to their company and sometimes contradicted claims made by other First Nations people.[63]

In much the same way that Leonard Rifas brought awareness to the Lakota lands, an art student named Shelby Sopher collaborated with a commercial fisherman named John Piper to create a comic book that would

Figure 7.7
Patrick Nagatani, *Radium Springs, New Mexico*, 1989. Ilfocolor (Type C). Courtesy of the artist.

shed light on uranium mining in Canada. *Nuclear Dragons Attack!* (1978), a self-published educational comic with a print run estimated at only a thousand copies, uses words and pictures for dual purposes: it depicts mining corporations as raping the land of the Metis and First Nations Aboriginals and expresses concerns about their bleak future. On the cover, the corporate officials hide behind destructive dragons. The dragons become a metaphor for uranium ores that are radioactive (potentially noxious) but also rich in energy and for the nuclear industry.[64]

More testimonies of individuals near living Elliot Lake, Ontario, many of whom live downstream in the Serpent River Indian Reserve, appear in the documentary *Uranium* (1990) by Magnus Isacsson, which also brings to the surface chilling statistics about contamination.[65] The contamination of the Dené and Inuit lives and land in the Saskatchewan and Northwest Territory provinces parallels similar cases in the US. According to Jim Harding in *Canada's Deadly Secret* (2007), the nuclearization of the First Nations people resulted in stolen lands, political betrayals, controversial handling

of "tailings" (waste products resulting from yellowcake processing), spillage, and other industrial contamination—summed up in general terms as biopolitical struggles for recognition of, if not recompense for, the victims.[66]

Furthermore, Harding's book also reveals how these struggles have been exacerbated by the intricate web of bureaucratic entanglements stemming not only from corporate mergers but also from changes in departments of energy, political and state associations, councils and boards, treaties and trade agreements, and environmental programs. These institutional transformations further catalyze stakeholders with mining interests outside of Canada, including markets in France and Japan.[67] This is the atomic sublime—sublime in the philosophical sense, a greatness that brings feelings of fear, anxiety, or pain before being controlled by reason. What Hardt and Negri call "a globalized biopolitical machine" fully operates every aspect of obtaining, processing, and distributing sought-after radiated ores.[68] These "nuclear dragon" machines are powerful and reminiscent of George Orwell's prediction that the world would be parceled off between superpowers engaged in warfare (in this case, economically): Del Tredici, for example, documented with photographs the Key Lake mine in the Saskatchewan province, called "the Saudi Arabia of uranium mining "because it contains the richest uranium ore-bodies in the world"[69] (figure 7.8). But he also took pictures of the radioactive spillage at the tailings at Elliott Lake and of related Aboriginal anti-uranium mining protests, as well as regular activities at Port Hope (figure 7.9). There was no need to go to Mars to conquer and drill the Martian's resources.

Another glaring issue related to the biopolitical machinery of mining concerns its lack of transparency: for instance, none of the Dené knew they were contributing to atomic bomb production, as Julie Salverson explained in *Line of Flight: An Atomic Memoir* (2016).[70] Canada, usually perceived as a peaceful country, produced a large part of the uranium used for the Manhattan Project at the Port Radium site in the Northwest Territories, where Busse took his many amateur photographs. (In 2007, Harding also explained that some of the current uranium extracted and processed in Canada is used for depleted uranium weaponry.[71]) Although Salverson based her memoir in a personal struggle that is indeed traumatic and should not be overlooked, her book is less about actual atomic realities than radioactive memories in the metaphorical sense. While she writes about the irradiation of the Dené—a rare instance in the arts—and follows a radioactive trail back to Hiroshima, the atomic traumas are grounded in the past and brushed off in only a few pages with statements that are at times somewhat condescending to the native and Japanese peoples. Her memoir at least gives a bit of

Figure 7.8
Robert Del Tredici, *The Richest Uranium Mine on Earth*, September 17, 1986. Ilford HP5+ black-and-white 35 mm. film. The Gaertner Pit of the Key Lake open-pit uranium mine is located in Northern Saskatchewan, Canada. Canada is the largest producer and exporter of uranium in the world. Radiation levels from rich ores inside this mine can reach 7,000 times higher than background. Courtesy of the artist, the Atomic Photographers Guild.

visibility to the Canadian *hibakusha*, but their land, families, and memories are still atomized today.

The 1999 documentary titled *A Village of Widows*, which prompted Salverson to look at the plight of the Dené, remains a far more effective portrayal of the issue, but the problem again is not one of medium as much as the ethics of representation. The film focuses on a group of Canadian Sahtu Dené traveling to Hiroshima to apologize to the *hibakusha* and examines issues regarding the blurred lines between victim and perpetrator. Together with Isacsson's *Uranium*, these documentaries intend to counteract past practices—and the representations of them. *The Romance of Canadian Radium*, for instance, which was made in 1930 to "document" the Eldorado mining activity, praised the "belief in magic minerals," something "stranger than myth" because "radium cures cancer."[72]

In the arts, some narratives are however relevant. In Michel Darry's *The Race for the Radium* (1936), the character of the Native Indian does help

Figure 7.9
Robert Del Tredici, *Getting Ready for Canada Day Parade in Port Hope*, July 1, 2000, photograph. Port Hope Summer Parade Warm-up. Three Port Hope mothers get ready to march in the annual summer parade. One of their children joins for the group portrait. Many of the inhabitants of Port Hope prefer to believe the assurances of the town's uranium refinery that no adverse health impact. Courtesy of the artist, the Atomic Photographers Guild.

the French and British journalists to rescue Betty (i.e., the atom) from the evil German during the Canadian radium rush, but the price he paid for this help was not predicted. In fact, one novel gives a better perspective to the colonial nuclearizations. In Alexander Bogdanov's *Red Star: The First Bolshevik Utopia* (1908), the Martians were planning to invade Earth for its resources in radium. But since Earthlings are so violent, the "colonization of Earth requires the utter annihilation of its population."[73] It is precisely because Martian civilization is more advanced (in the communist world-view of the narrator) that Martians instead opt for a different tactic that would benefit both sides. Another interesting plot that focuses on contaminated mines is the sci-fi film *Radon* (released in Japan as *Sora no daikaijū Radon*, or Radon, Giant Monster of the Sky but translated as "Rodan," 1956) by the *Godzilla* filmmaker Hondo Ishirō: a monster emerges from a coal mine to destroy lives and lands. But these, of course, are fictions. The reality was very different.

Nuclear African Nations: The Colliding Powers of France and Niger

The impact of the French mining of uranium sources in and out of France is also crucial to the atomic age. Realizing that its own deposit was not inexhaustible, France had looked for new places in which to prospect. Toyosaki's photographic and textual testimonies also include a portrait of Luke Onyekakeyah (figure 7.10), president of a Nigerian environmental NGO. Toyosaki reports stories of land (and water) contamination by a French company and the lack of inquiry into the health of the workers onsite. The portrait was taken after the company, Total Companie Minière, had stopped a ten-year partnership and exploitation of the area in 1989. But France had in fact already found uranium via its former colonies. One of the biggest resources in uranium for the French industry was and still is Arlit, in Niger. The region had been exploited since at least 1968, when the CEA (Atomic Energy Commission) made Arlit and Akokan their concessions in Niger.

Similar to the Kanak poet Déwé Gorodé's political engagement in Oceania is the writer Boubou Hama's political role in the Republic of Niger after its independence in the 1960s, via a complex evolution of federations and unions. Hama, one of the country's most famous intellectual and political figures, became part of the government (under its first president Hamani Diori) and even negotiated uranium prices with France in the 1970s, with the CEA and President Georges Pompidou. But after comparing the price of petrol and of the electricity produced at French power plant, and comparing revenue a typical French mining town received compared to what France paid Niger, Hama and the Nigerian delegation were indignant. According to their calculation, the price of a ton of processed uranium should have been multiplied by forty-two. They thus asked how could anyone believe that Nigeriens would not be "ulcerated" by the difference.[74] The new Nigerien government negotiated with its old colonial master in February 1974. In April of that year, a military coup put Diori in jail and then under house arrest. "Coercion itself," says Achille Mbembe, "has become a market commodity."[75] The same can be said for corruption. Mbembe stressed how war machines developed in areas where minerals and the laborers who extract them are subject to states' postcolonial policies.

Although no French comic book artists seem to have attacked the mining industry like their counterparts in the US and Canada have, in 2012 a column appeared in the French satirical journal *Charlie Hebdo* to explain that France chose the poorest country in the world, mined 100,000 tons of uranium through its national nuclear corporation AREVA (now currently named Orano), benefited from 13.2 billion euros in 2008—that is, five times Niger's gross domestic product—and was prospecting for a new

Figure 7.10
Toyosaki Hiromitsu, *Uranium Mine Victims, Luke Onyekakeyah. President of Nigerian Environmental Organization, NGO, Earth Search*, The World Uranium Hearing, Salzburg, Austria. September 1992. Courtesy of the artist.

mine.[76] Orano, an international conglomerate of corporate divisions and business partners implanted across the globe, had defined itself (when still called AREVA) as the "world energy expert" with the motto "Energy is our future, don't waste it."[77]

Some eight decades after its publication, we can read the message in Darry's novel *The Race for the Radium* differently. It is not anymore the malevolent German who is kidnapping Betty (the feminine metaphor for the atom and radium ore) but rather a cast of French politico-corporate characters with the expectations that the natives will help, like in the novel. In a 2006 speech at the Académie française, the Algerian writer Assia Djebar suggested the strength of geopolitical power at the heart of "Betty's" civilian and military use. The Euratom (European Atomic Energy Community), she said, was founded in 1957 "in a Europe that desired to be new, and united, in order to guarantee independence from US energy" and that when "Euratom was realized, it also was in part because the Algerian War occupied the minds of many."[78] If France loses its colonial influence, another dominative system must be put in place.

The impact of mining and the colonial legacy in Niger and in other former colonies are still radioactive and thus validate Orwell's statement. Economically, most mines are still not nationalized. Niger only shares about 30 percent of the capital for Arlit's mine to date. The neocolonial exploitation of resources exists in the midst of a colonial territorial dispute: mines are in fact located on territory inhabited by the Tuareg people, which had been divided among Mali, Algeria, Libya, Niger, and Burkina Faso by the former colonial master, France—and this territory is one of the largest uranium energy deposits on the African continent. Adding to this is the advancement of the US imperialist agenda and what Jeremy Keenan calls the "Bush administration's fabrication of the Saharan-Sahelian front in its global 'war on terror.'" In 2007 the Niger Movement for Justice, with some participation from Tuareg peoples, directly attacked AREVA's mines to protest the unfair exploitation of the resources, the disregard for local cultural practices, depletion of the health and the environment of local people and workers, and ultimately climate change caused by mining activity. Rebellions were reported in the 1990s already and while the NMJ has split, a branch of Al-Qaeda in Niger kidnapped seven foreign workers from the mine in 2010 (four of whom have been released in 2013).[79]

In the 1980s, the punk band Clash was not that far from envisioning reality with these lyrics from the single "Stop the World" (1980): "They took it into the nuclear mine / Judging by this, they left nothing behind. / Down in the bunkers in the crust of the earth / now crouch the wealth and noble of birth." The song was the B-side of "The Call Up," and on the flip

side of the record jacket is an image of a nuclear shadow (a trace of an atomized body, one of many such shadows left after the bombing of Hiroshima) and the address for the Campaign for Nuclear Disarmament.[80]

In addition to neocolonial use of resources, there are health concerns that have become colliding points of view between NGOs and AREVA (and they have been recorded in documentaries and news reports).[81] France has historically caused such wounds. In Madagascar, Gabrielle Hecht conducted interviews with miners who worked until its closure in 1967 (after that the resources were drained) and found that the supervisors at the mines disparaged the "Tandroy and Betsileo workers as irredeemably uncivilized, so primitive that they would not even benefit from job-training programs." Not only were safety regulations in their infancy, but mining companies paid the workers very little (after more than a decade of work; for instance, one had accrued only enough savings to buy 50 cattle and a few personal items such as a bicycle and a watch). Meanwhile the "tales of rock slides and lost body parts" abounded. If we were to choose one genre of Western fiction as analogous to these stories, we might look to horror stories with Dracula-like antagonists. Hecht also documents stories in Gabon around that time (1960s) of not only more security-driven running of the mine but also of inconsistent managerial decisions and racism in a vampire-like company that must perpetually seek out new blood, the healthy but perhaps unskilled miners assumed to be "radiation virgins."[82]

In the arts, the French exploitation of mines were visualized by few artworks: Toyosaki's portraits or a column on the topic in *Charlie Hebdo*. France's Cold War censorship body, the Très Secret-Défense, exerted strong pressure on the media and on cultural production. France's mine in Niger, as well as those in Kazakhstan and Canada (and even France's own past mines) thus have little visibility, even today. *Charlie Hebdo* dedicated few columns to the ones in continental France, and their radioactive wounds were uncovered only recently, in particular in the Limousin area, where an entire village (its lake included) was built on radioactive rubble and yellowcake buried in shallow sites, and where contaminated water is only one of many serious threats to the residents.[83]

A militant theatrical play from the late 1950s titled "Quand Marcoule sera conté" (When Marcoule's Tale Will Be Told, 1957) expresses the local frustrations against the government's installation of a CEA—which conducted the first military and industrial experiments with plutonium—in the southern town of Marcoule. The government explained at the time that it would transform the postwar lives of Marcoule's peasants whose stricken rural area had yet to recover from the war.[84] Just like Kerr-McGee had praised

the potential of the "modern Indian," France's atomic energy commission touted the benefits of modernization for French peasants as well.

The impact of state censorship is strong, but the artistic enframing can be better detected in the collusions between art, science, and nuclear-related interests (both economic and political) that lie in other once-invisible activities: corporate patronage and corporate "literature."

The Resourceful US and French Nuclear Corporate Patronage

Artistic enframing does not reside in a medium but results from the way it is used. The nuclear industry reached out to artists in many ways. In the US, cartoons were one of them. Leonard Rifas has argued that both the nuclear industry and those participating in anti-nuclear movements produced "special-purpose comic books to explain their views," to foster an understanding of how "nuclear power won and lost the 'public acceptance' that it now tries to win back."[85] The body of corporate literature spotted by Rifas is large, and it directly tapped into science fiction's futuristic dreams.

As early as 1948, General Electric (which also worked for the military) sponsored the comic book *Adventures Inside the Atom* (1948). The comic starts in ancient Greece, where "doubters" challenged Democritus's insistence that even something as solid as gold "is made up of tiny particles we cannot see." Successive cartoon panels depict how the atomist stance shifted over centuries from Aristotle to alchemists to John Dalton to Niels Bohr. The book finishes with promises of future "atomic disintegrator guns."[86]

Many similar-minded comics were produced in tandem with exhibits, like *The Atom, Electricity and You!* (1968) and *The Story of Electricity* (1977).[87] The Walt Disney company projected its corporate expression of the atom as a genie in a bottle, capable of good (and evil, which can be mitigated with responsible human safety precautions and controls), with its pro-nuclear animation, *Our Friend, the Atom* (1957). The film was co-produced with the US Navy and General Dynamics, and it aired on television for the first time in the US on January 23, 1957. A book sequel intended for use in the classroom followed with the ultimate message: "The atom is our future."[88] The opening of the animation makes a fantastical shortcut between nuclear submarines and the *Nautilus*, Captain Nemo's submarine in *Twenty Thousand Leagues Under the Sea* (1870), and also links to Greek concepts of the atom. The Disney film conveyed the domination of nature with clips of a Middle Eastern fisherman who harnesses the evil genie in a lamp, and is thus tinged with an unfortunate orientalist attitude. Disney adapted the character for its animated film franchise *Aladdin* (1992).

Herein lies the nuclear mythology that originates when corporate interests adopt children's literature to further their own agendas. Weart has explained how the science behind (and the use of) the atom inspires anxiety. There were nuclear "air raid" drills in the 1950s and cartoons such as *Duck and Cover: Bert the Turtle* (1951). But fear of radioactive contaminations as well as possible Russian attacks exacerbated by the context of the Cuban missile crisis in the early 1960s prompted others. Frank and Eleanor Perry portrayed these anxieties successfully in *Ladybug Ladybug* (1963), a film that follows a group of children as they attempt to gain access to their home or to a bomb shelter and attempt to protect themselves as fear builds up. The trust of the generations terrified by atomic threats had thus to be regained by the industry if the building of power plants was to start.

Such corporate partnerships have become familiar in today's art world. Companies as diverse as car manufacturers (Volkswagen and Hyundai), retail outlets (Japan's Uniqlo), financial services groups (HSBC), and energy giants (Exxon and BP) underwrite museums and art exhibitions. Some have become controversial and generate militant protests.[89] Nuclear corporations are no exception. Such financial involvements are no surprise: the operation is tax deductible.

In France, just like the partnership between the multinational nuclear corporation Rio Tinto Group and the Art Gallery of Western Australia, which I explored in chapter 2, AREVA (now Orano) sponsors the Guimet Museum of Asian Art (Musée national des arts asiatiques Guimet) in Paris. The museum's collection, amassed during expeditions and in colonial times, is still displayed with curatorial comments expressing demeaning colonialist attitudes. Yet, unlike Rio Tinto, which directly funds exhibitions of Australian Aborigine artists, AREVA has never promoted the Malagasy, Gabonese, or Nigerien artists, let alone any artifacts of Tuareg culture.[90] The ethics of such maneuvers are therefore highly controversial for two reasons: first, they perpetuate double standards inherited from the country's colonial past, and second, they derive directly from the use of artistic and scientific objects in world's fairs and world exhibitions, some of which in the late nineteenth-century displayed native peoples (or persons dressed to represent them) from the colonies in human zoos (as we saw in chapter 2). These fairs were contemporaneous to Marie Curie's time and to colonialist expansions.

By 2016, AREVA became a patron for the renovation of the Boubou Hama National Museum—Boubou Hama being the writer who tried to negotiate fair prices in the uranium mining industry in the 1970s. The museum has several pavilions "from the dinosaur age to the nuclear age."[91] Curatorial comments in a statement made to welcome the viewers to the uranium

pavilion included an invitation to recruit future local miners.[92] The integration of the art/science compound into many forms of response from many factions can be demonstrated by the fact that AREVA (Orano) managed to involve in its scientific committee the philosopher Michel Serres, noted for his exploration of intersecting trends in science, philosophy, and literature.[93] Predictably, the nuclear industry is full of resources.

The CEA in Saclay, France, directly commissioned onsite artworks to celebrate interdisciplinary practices and a place where "there is space for all cultures."[94] In 2008, the Institute for Radioprotection and Nuclear Safety (IRSN) in France, *Vous avez dit radioprotection?* (Did you say radioprotection?) curated an art/science exhibition in which artists where invited to communicate about nuclear safety.[95] As one of the organizers said, echoing the sensibility of C. P. Snow, the institute reached out to artists because: "On a subject like this, the exhibition could not have worked if it had been built around experts 'talking down' to the general public."[96]

The exhibition also toured in Switzerland, Argentina, and Finland where, perhaps coincidentally, AREVA has deals or partnerships. Herein lies another artistic enframing created and disseminated by a scientific agenda. The radioactive contamination of the arts and the humanities is clear. AREVA was renamed "Orano," and Orano derives from the ancient Greek Ouranos, which became Uranus (a Greek deity). Clearly, given this example and the use of Democritus by General Electric, talking about the atom today dramatically differs from the way in which the ancient Greek atomist discussed it.

The practice of enframing is not unique to the West, and the intention of the artist is not always clear. In Japan, Astro Boy (or "Tetsuwan Atomu" meaning "Mighty Atom") is culturally very conspicuous. His sister is "Uran" (uranium) and his rival robot is "Puto" (plutonium). Regarding Japan's past uranium mine, Ningyo-toge, the manga artist Saitō Takao produced *Ningyōtōge Daisatsuriku* (Ningyo-toge's Great Massacre, 1979).[97] Contrary to the title, the manga is a rather idealist if not flattering account of uranium mining of the time; paradoxically, the atom is represented by the single consistent female character present throughout the story, Wakako (comparable to Betty in the West), who is violated by terrorists and almost everyone else. The manga reflects the author's point of view regarding women and the atom: being dominated is the atom (woman)'s fate.

A contemporary Eastern example is Kimsooja's *Earth-Water-Fire-Air* (2010), a beautifully produced pre-Fukushima apolitical video that was exhibited according to her instructions at a South Korean Yeonggwang nuclear power plant (figures 7.11a–d). The piece itself is a four-channel video installation representing the four natural elements in slow motion,

a

b

Figures 7.11a–d
(a–b) Kimsooja, *Earth-Water-Fire-Air*, 2010. Installation View at Nuclear Power Plant
Art Project—Yeonggwang, South Korea, 2010. Organized by the National Museum
of Contemporary Art, Korea. Courtesy of Kimsooja Studio. (c–d) Video Installation,
PERM Museum of Contemporary Art, Russia, 2012.

c

d

Figures 7.11a–d (continued)

perfectly representing the osmosis between technology (the video screenings) and nature. *Earth-Water-Fire-Air* was a public commission initiated by the National Museum of Contemporary Art Korea, with the ambition to exhibit art in a new way, by combining it with references to South Korea's industrial strength. According to the director of the museum at the time, Soon Hoon Bae: "In the West, humans had to tame nature through conquest in order to use nature. But in Korean culture, people believe in living in harmony with nature."[98]

Unfortunately, however, Soon Hoon Bae is not just an art lover but also was the Korean Minister of Information and Communication, and the head of automobile manufacturing firm Daewoo. While the piece is apolitical (a rare occurrence for nuclear-related artworks), it cannot be taken out of the country's politics. The South Korean Korea Electric Power Corporation (KEPCO) signed in 2010 a deal with AREVA (Orano) to join the Imouraren mine in Niger. AREVA's website explains that "KEPCO will take 10% of the mine's stake. ... In return, KEPCO is entitled to 10% of the mine's life long production to exclusively supply its reactors in Korea."[99] The company also has possible shares in the Canadian Denison Mine. The many compounds still interact, in an infinite number of molecular structures through which art becomes entangled: art/science, East/West, civilian/military, during the Cold War and until today. It is difficult at times to know the intention of the artist, but the molecular nature of the many compounds is clear.

Art and Cold War Policies, Then and Now

In the classic film *Forbidden Planet* (1956), since a possessive and choleric father on a distant planet cannot be calmed, not even with neutron ray guns, he pushes the red button, annihilating himself together with the planet on which he was living. His daughter and a space crew escape on time: the new young men are in control. The film explores the generational handover of the daughter and is telling of the desire to improve the relationship with her (who, not unlike the aforemention Betty, symbolizes the atom). However, sitting in Japan, the Marshall Islands, the Colorado Plateau, or near Niger's and Namibia's uranium mines, it's questionable how relevant the atomization of a remote world would seem to the *hibakusha*, and how "inadequate" a response to their suffering, if not dismissive to it, or outright offensive.

At best, these storylines are of interest to detect the values that circulated in the West during the Cold War era and beyond, based on the restricted information the public had access to. In *Invaders from Mars* (1953), when a pre-teenage boy is entrusted by the military with weapons to fight against a Martian infiltration that had tried to prevent humankind's nuclear stockpiling, we learn more about the Cold War military-oriented men in the West, than about anything else.

In 1957, Roland Barthes made a relevant statement in his *Mythologies* about how we project our self-image on Martians: "What is the most significant, is that Mars is implicitly endowed with a historical determinism modeled on that of the Earth." The Martian myth, for Barthes, starts with

the Russian space program but mainly "tends fatally towards a narrow anthropomorphism,"[100] an anthropomorphism of class. Here the powerful ruling scientific-politico-military class must destroy the aliens modeled after anti-nuclear militants—a true Cold War tale. The same can be said of non-Western aliens. In *Chikyū bōei-gun* (translated as The Mysterians, 1957), by the *Godzilla* filmmaker, aliens who master the atom invade Japan and try to steal women and revive their dying race. This tells us more about occupied Japan (and postwar prostitution) than about Sputnik and the space race. Bradbury was right: the Martians are humans.

Radioactive monsters still represent the nuclear fears of the Cold War that had profoundly marked entire generations. But it is true that they "inculcate a strange apathy concerning the process of radiation, contamination, and destruction," as Sontag stresses.[101] Similarly, as when Adorno stated that writing lyric poetry after Auschwitz was barbaric, surely the spectacular and entertaining "aesthetic of destruction" analyzed by Sontag can be seen as equally insensitive—so long as it conveys phantasmatic representations of the effect of radioactivity and aberrant sexual and racial messages. In fact, together with images of the swimsuit bikini, such films feed the visual tropes of the Cold War that filled the void left by military censorship. They cultivate the everyday radioactive in unconscious homeopathic doses.

In truth, just like Derrida argued, texts by Kafka or Joyce deal "more 'seriously'" with the apocalypse than "present-day novels that would offer direct and realistic descriptions of a 'real' nuclear catastrophe."[102] If Derrida had access to Japanese A-bomb literature, however, his statement might have changed. The testimonies are powerful deterrents, but only a handful of them were translated in French during the two years after his statement. On the form, however, his point of view on the apocalypse's rhetorical condition is pertinent even today. Novels like William S. Burroughs's *Naked Lunch* (1959) does a far better job than Ward Moore's "Lot" (1953), the latter tried to justify incest in a post-apocalyptical world. While infamous and offensive to many readers, Burroughs's crude description of child rape in *Naked Lunch* (1959) is one antidote to the dominative use of people.

Furthermore, in "Astronaut 's Return," Burroughs explained the nuclear disease of the Caucasians:

… white white white as far as the eye can see ahead a blinding flash of white the cabin reeks of exploded star white lies the long denial from Christ to Hiroshima white voices always denying excusing the endless white papers why we dropped the atom bomb on Hiroshima how colonial peoples have benefited from our rule why look at all those schools and hospitals overgrown with weeds and vines windows

Figure 7.12

Toyosaki Hiromitsu, *Uranium Mine Victims, Cleophas Mutjavikua, General Secretary of Uranium Mineworkers Union of Namibia (left) and Joe Hangula, Safety Commission at Rossing Uranium Mine*, The World Uranium Hearing, Salzburg, Austria, September 1992. Courtesy of the artist.

melted dead hand frayed scar tissue lifted on a windy street lying white voices from the Congo to Newark the ancient mineral.[103]

This deals with the Cold War in a more effective, even ontological fashion, working toward cutting out the nuclear (drug) dependency by exposing the senseless Western systems.

But the drug habit is deeply engrained and new images emerge: Moana and SpongeBob, as the Marshallese poet Jetñil-Kijiner already underscored. And the radioactive terrain is wider. There are the Nigerien Tuareg, the Gabonese, Malagasy, and Namibians, and to whom should be added the Tibetans who suffered from the Chinese mining and processing of uranium as much as from nuclear tests. There are the Australian Aboriginals, who were represented by Toyosaki (figures 7.12, 7.13, and 7.14) and also Jessie Boyland in contemporary photography.[104] There are mining problems in Scandinavia, in Uusimaa and Lapland, and more depleted lives and land for the Adivasi tribes in India's state of Jharkhand, rendered visible in the 1999 documentary *Buddha Weeps in Jaduguda* (1999).[105] There also is the uranium

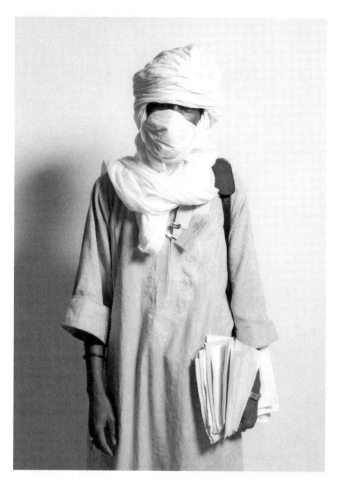

Figure 7.13
Toyosaki Hiromitsu, *French Nuclear Testing Victims, Mohamed Mohamed. Tuareg, Nomadic Herdsmen of the Sahara Desert*. Courtesy of the artist.

that fuelled Soviet bombs, produced by prison labor in East Germany or coming from Uzbekistan and Kyrgystan.[106] The terrain might expand simply because *there is still no international safety regulations or legislation regulating uranium mining*—even though most mines are operated safely by now.

Furthermore, also blinding is the fact that, while state censorship has been reduced since the postwar time, self-censorship by powerful media entities is widespread. Noam Chomsky and Andre Vltchek analyzed it in the US in *On Western Terrorism, From Hiroshima to Drone Warfare*.[107] In France, Pierre Vermeren explained that media groups are owned by industrialists

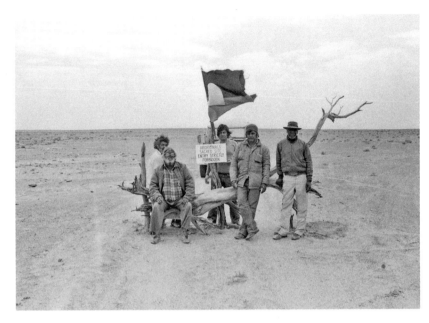

Figure 7.14
Toyosaki Hiromitsu, *Protecting the Sacred Site*, Roxby Downs [now changed to Olympic Dam], South Australia, September 1983. Courtesy of the artist.

that have international market interests (such as Lagardere and Dassault) while former colonies have now complicit governments quickly disposing of dissident voices.[108] Regarding uranium mining, news is reported, even if rarely, but for the most part not analyzed or truly investigated.

Therefore, how to represent these atomized lives? How to go beyond the visual tropes that are still changing and transmuting? Some alternative ways of mediating voices have recently emerged in the arts. In 2016, the Flagstaff Arts Council in Arizona organized an open call for artists to portray "a vital issue—uranium mining and the consequences of contamination and exposure on the people and their land."[109] The project was to offer a four-day encounter with Hopi and Navajo people, with field trips and educational workshops on uranium mining's history and impact. In Australia, "Nuclear Futures" was a three-year program of artistic activities that supported "artists working with atomic survivor communities."[110] The installations titled *10 Minutes to Midnight* (2015) and *Ngurini (Searching)* (2015) are two multichannel projections produced by a "creative team" including the voices of the Aborigines who had to leave their land.[111] This approach can be celebrated. But decades after Said's *Orientalism* and in spite of the

development of post-colonial theories, the voices of the radon *hibakusha* are taken between two forces: the importance to voice the traumas, and on the other, the risk of orientalist representations. And yet the communities are no less human than those of other *hibakusha* in Japan and Oceania.

One cannot but notice, however, that, compared to the extremely large number of artworks in response to Hiroshima, and to Chernobyl and Fukushima as we will see in part IV, there are too few portraying uranium mining's *hibakusha*, especially given the corporate use of the arts as a communication tool. Here too, what is challenging for the arts is not radioactivity itself, but the finely geared nuclear machinery together with its own enframing. Adrienne Rich's poem "Power" (1974) may give us a clue to the issue:

Living in the earth-deposits of our history
(…)
Today I was reading about Marie Curie:
she must have known she suffered from radiation sickness
(…) it seems she denied to the end
the source of the cataracts on her eyes
(…) she died a famous woman denying
her wounds
denying
her wounds came from the same source as her power.[112]

More than thirty years later, Rich published *The Dream of a Common Language: Poems 1974–1977*. The title poem of the volume, which begins with a personal, erotic moment, turns abruptly to "the knowledge of crimes committed in our names by aggressive authority." At the time Rich wrote the poems, among the crimes she was thinking of were rendition and torture. The question she then asks is timeless, reminding us once more of Adorno in the past and of our own relationship to poetry in the future. "How can poetry, in its fullest sense," she asks, "coexist with or even affect [such] things."[113]

Cold War polices and nuclear industries are still denying the wounds they inflicted, thinking denial is the source of their power. But denial is the source of their demise—loss of trust from the general public. For the arts, as for now, no poetry serves, but what is certain is that if the arts acknowledge their wounds, the artistic enframing, then this allows for ethically engaging with past and future nuclear traumas. These wounds should not be denied. The questions that remain are: What will be remembered? How to give visibility to the many atomized Cold War *hibakusha*, in particular after Fukushima?

IV Fukushima and Other Clouds of Suspicion

8 From Power Control to Power Plant

Because the atomic age at large introduced new forms of lethal warfare as well as radioactive contamination, leaks, accidents, irradiation, and the need for evacuation zones, the art of the atomic age is first and foremost an art of catastrophe. The March 11, 2011, disaster involving the Fukushima Daiichi nuclear power plant—the result of an earthquake at Tohoku (the Great East Japan Earthquake) and a subsequent tsunami—was the most catastrophic nuclear incident since the April 1986 accident and fires at a Chernobyl power plant in Ukraine.

The art in response to Fukushima and Chernobyl does not escape the parameters of representation—the various compounds and dualities—I've underscored in the chapters of this book so far.

For Fukushima, the photographic album by Shiga Lieko, for example, titled *Rasen kaigan* (Spiral Coast, 2013), portrays people in (and the landscape of) the seaside town of of Kitakama, an area in Japan's Miyagi prefecture that was badly hit by the earthquake and tsunami. As such, the series embodies a paradigmatic representation of the ethics of suffering (figures 8.1a–e) Shiga documented festivals and official events for the residents. But *Spiral Coast* is distinctive in that in the album, the images before and after the earthquake are mixed and cannot be distinguished (there are no captions in her book), and distinctive for the startling beauty and poetry that emanates from it; the series viewed as a whole captures a sense of foreboding.

As Ōta Yōko or Hara Tamiki before them, Shiga and the other artists representing the Fukushima accident still confront the difficulty framed by Adorno: whether it is possible to write poetry that adequately represents suffering, and whether it is possible to justify aesthetic pleasure from descriptions of such suffering. Shiga's photographs also address the issue Susan Sontag emphasized in 2003, that photographs objectify their subject because "they turn an event and a person into something that can be

Figure 8.1a
Shiga Lieko, *Rasen kaigan (Spiral Shore) 46*, 2011, c-type print. © Shiga Lieko, Courtesy
ROSEGALLERY.

possessed," and the objectification of the suffering of others is ethically
unsustainable.[1]

The body of work contained in Shiga's *Spiral Coast*, however, neither
trivializes nor objectifies its subjects. Nor does it use contrasting effects
("before/after" images of the earthquake)—though other photographers
such as Hatakeyama Naoya used these quite successfully. Instead, Shiga cre-
ates a unique sparkling darkness imbued with images that are overexposed
or saturated with light; their ghostly presence itself suggests that viewers
hold their aesthetic enjoyment of the work at a distance—a suggestion
intensified by the way she has chosen to exhibit and publish her work.

In the exhibition space, the large-format photographs are scattered
everywhere, haphazardly hung in a disorganized and oppressive maze that
forces an "up close and personal" approach to viewing. The photographic
notebook titled *Rasen kaigan—notebook* (Spiral Coast—notebook, 2013),
published the same year as her album, comes packaged in wrapping paper
printed with one of her photos—an elusive, misty landscape punctuated by
warm sparks of light. But in order to access the contents of the notebook,
the paper and its picture must be torn apart.[2] This act of destruction mir-
rors devastation caused by the earthquake, the tsunami, and the nuclear

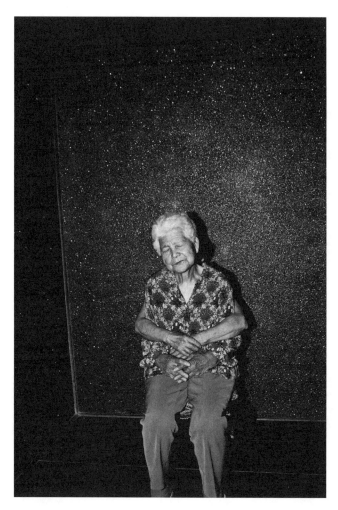

Figure 8.1b
Shiga Lieko, *Mother's Gentle Hands*, 2009, c-type print. © Shiga Lieko, Courtesy ROSE-GALLERY.

Figure 8.1c
Shiga Lieko, *Child's Play*, 2012, c-type print. © Shiga Lieko, Courtesy ROSEGALLERY.

disaster. Once more aesthetic pleasure is displaced but acknowledged: Shiga's autonomous (apolitical) mementos emit a dazzling but dignified visual poetry that resists any judgment of inauthenticity.

Some of Shiga's photographs evoke post-apocalyptical film stills in which suspense is heightened by anxieties of irradiation—the Miyagi prefecture being north of Fukushima. A storm of contradictory information about the effects of the nuclear catastrophe on the health of inhabitants and wildlife followed the accident, and the radius of the exclusion zone extended. Just like for Chernobyl, it will take several decades to fully grasp the consequences. Because of the earthquake and the possible irradiation, photographs bring up a number of questions. How not to wonder about the

Figure 8.1d
Shiga Lieko, *I Was an Alien*, 2012, c-type print. © Shiga Lieko, Courtesy ROSEGAL-
LERY.

fate of the inhabitants portrayed? Did the elderly woman who requested
that Shiga photograph her for a funeral portrait actually survive the sub-
merging tremor? What about the girl in the wrecked kitchen, trying to keep
her Hula Hoop spinning; was she contaminated? How much longer do the
man and the dog he rescued have to live? Will the survivors of the tsu-
nami also survive the waves of radioactivity, the ones that kill over several
decades? The visual poetry is therefore subdued if not suppressed by the
context of the photographs.

In the end, even for Sontag, the beauty we find in the representation of
suffering is not the issue. Taking as an example the photographs of Sebas-
tião Salgado, Sontag believes that the actual problem lies less in their aes-
thetic appeal or even their marketable qualities than in the fact that he
portrays victims from faraway lands as a single group whose individual
plights, ethnicities, and names are eluded. Thus the pictures "focus on the
powerless, reduced to their powerlessness."[3] That reduction in turn elicits
a fatalistic response to the cause of their suffering. Although Shiga's work
avoids orientalist depictions of the accident in Japan, the fate of the per-
sons portrayed remains unknown. In the shadow of a nuclear accident,
however, Shiga's work can be viewed as paradigmatic of the difficulty for

Figure 8.1e
Shiga Lieko, *Taro and Hanako*, 2010, c-type print. © Shiga Lieko, Courtesy ROSEGAL-
LERY.

civilians to access information relating to radioactive contamination and its long-term effect.

The art of Fukushima, therefore, must not only address the same ethical considerations as other works responding to suffering in different periods of the atomic age, but also tackle the same artistic compounds in somewhat different contexts. As I noted in chapter 2, Jean-Luc Nancy argued that military or civilian atomic catastrophes, despite their differences, remain "inherently irreversible in which the effects spread across generations, across the soils, all the living species."[4] While A-bomb and H-bomb literature (and to some extent the responses to uranium mining) results directly from warfare, Fukushima is a nuclear accident triggered by a natural accident. Nevertheless, the civilian/military compounds is present here too. The language used to describe the trauma of Fukushima refers to war: For the philosopher Nishitani Osamu, it was "a war without enemies."[5] The Fukushima musician Ōtomo Yoshihide, with repeated analogies to someone being stabbed or murdered, compared the situation to a "massacre" that is "killing slowly, like DEATH itself."[6] Finally, after Fukushima, Kenzaburō Ōe (who had previously written a much celebrated book on Hiroshima) reminded us that secret accords in the 1960s allowed the US military to introduce nuclear weapons into Japan.

Therein lies the ambiguity of contemporary Japan: it is a pacifist nation sheltering under the American nuclear umbrella. One hopes that the accident at the Fukushima facility will allow the Japanese to reconnect with the victims of Hiroshima and Nagasaki, to recognize the danger of nuclear power, and to put an end to the illusion of the efficacy of deterrence that is advocated by nuclear powers.[7]

In the context of the atomic age, however, as I present it for this book, it is important to acknowledge, on the one hand, the near impossibility of separating the casualties of the earthquake from the nuclear disaster for Fukushima and yet, contrary to Chernobyl, the nuclear accident at Fukushima did not directly cause death. Therefore, the sober pictures of the mourning families and relatives in Chernobyl taken by Igor Kostin, Victor Maruchenko, and Guillaume Herbaut, for instance, are as important to analyze as the use of footage of a dead child's body found in the rubble of the earthquake that were controversial and not just for local residents, as shown in the Japanese documentary *311*.[8] The ethic of representation of loss and suffering is central to discuss in the works, but the latter work is not directly linked to the nuclear age.

To restate the problem in another way, it is crucial to note that despite the radioactive presence in both catastrophes, Fukushima and Chernobyl

had different causes and different ramifications: both catastrophes were graded level 7, yet in Japan, about a hundred elderly and sick people died due to the stress of the evacuation (not from radioactivity)—that is if official reports can be trusted. Predicting the potential extent of the radiation-related casualties on human life, wildlife, and the environment also remains a near impossibility. The "absurdity" of the situation—as Nishio Baku, the co-director of the Citizen's Nuclear Information Center explained—is the use of the death toll "as the rod by which to measure a nuclear accident's destruction."[9] And such a measurement does not take into account the wholeness of the distress: almost 200,000 people were forced to evacuate because of the Fukushima incident. These life-altering decisions, absurdly, too often lie buried in the metaphoric rubble of catastrophe.

In the arts, and in contrast to the small number of artistic responses elicited by uranium mining, the large number of artworks depicting the accident at Fukushima in and outside of Japan can be considered oversaturation. In addition, projects such as the Fukushima Biennale, and the works supported by Art Support Tohoku-Tokyo in order to help for the reconstruction of Fukushima, offer platforms to produce artworks on a regular basis. The artistic tide is so high that, as the art historian Hayashi Michio observed, it is impossible for "a single critic [to] somewhat encompass it."[10] There consequently cannot be a Nagaoka or Keown for irradiated Fukushima—or as yet no one has accepted the "impossible" challenge—because the accident is so recent, and the nuclear catastrophe is still unfolding, with the number of artworks certain to increase.

Regarding the ways in which the catastrophe is represented, Hayashi has questioned the "proper" way of representing, between the voice of the victims themselves, that must be given priority, and representations in or outside Japan. In his essay "Reframing the Tragedy: Lessons from Post-3/11 Japan," he discusses "spatial, temporal, or psychological" degrees of distance and proposes that multiple social centers exist through which individuals at a further remove than the immediate victims should nevertheless be valued.[11]

Hayashi's argument is fundamental. How many images of wrecked ships sitting on top of destroyed houses and empty towns were taken in the wake of the tsunami? A similar question can also be applied to Chernobyl. How many images of the rusted Ferris wheel at Pripyat have been shot and/or filmed by artists from around the world? The ubiquitous Ferris wheel is the atomic mushroom cloud of the civilian nuclear age, with artists (and increasing numbers of tourists) sometimes going to Chernobyl and/or Fukushima as if going on a safari. In search for sensationalism, they look for ruined landscapes, abandoned dwellings or whole towns, impoverished

refugees living in shelter houses or cardboard boxes, or the body of a child washed up onshore. In retrospect, more than thirty years after the accident, Chernobyl crystallized some extreme examples of these sensationalist practices from which transpire a lack of empathy for the victims: a video game (*S.T.A.L.K.E.R.: Shadow of Chernobyl*) and a horror film, *Chernobyl Diaries* (2012)—and for the Three Mile Island nuclear reactor accident in Pennsylvania in 1979, the low-budget horror film *The Children* (1980).

Within this tsunami of representation, on the one hand, the individual works either exploit or ignore the victims. On the other hand, however, the lack of experience of the catastrophe does not mean that relevant and compassionate works cannot be created. Yet, given that the writings of many A-bomb and H-bomb *hibakusha* are still invisible today, how has the voice of the civilian nuclear age victims been expressed and mediated so far, between local, national, and international interests?

At the core of these pressing forces, here again lies an impressive diversity of responses that are also representative of the variety of contemporary artistic practices, from modernist to postmodernist, in poetry, music, architecture, photography, film, and in so many other artistic means.

Radioactive Poetry: To See the Stars Once More

In Fukushima, the voice of the irradiated inhabitants could be found at the very time the catastrophe unfolded. Just few days after the earthquake, the Fukushima poet Wagō Ryōichi progressively changed his update messages on Twitter into poetry as the radio broadcast information from the government requiring residents to remain indoors. Trapped in his house, Wagō felt like he was in a prison cell and resorted to telling the world of his condition via Twitter.[12] His poetic posts were finally published under the title *Shi no tsubute* (Pebbles of Poetry, 2011):

Radiation is falling. It is a quiet night.

What does your homeland represent to you? I will not abandon my homeland. My homeland is everything to me.

They say the radioactivity isn't enough to immediately cause abnormalities in our health. If we turn the word "immediately" around, does it become "eventually"? I am worried about my family's health.

(…)

The earth rumbled again. This time, there was a lot of shaking. I rush down the stairs bare feet, trying to get outside. That was near the place with the unidentified bodies I wrote about in my last post. But even if I rushed outside, the radiation would still be raining down.

(…)

Outside, radioactivity rains down.

(...)

There is no night without a dawn.[13]

At first, his verse sounds similar to *hibakusha* poet Tōge Sankishi's verses, especially "Landscape with River" (1951), with its images of quiet landscapes and references to threatened futures and atomized families:

(...)

Now lost in darkness, the mountains upstream sleep,
snow on their peaks.
From afar, the snow sends down on the living its foretaste
of winter cold
Dear wife! Sighing again tonight over what we will wear
to keep warm?
Clinging to the vase, withered chrysanthemums dangle;
Those happy days when we dreamed of children: they too are gone
(...)
above the city of bleached bones, leveled,
we too
are living grave markers.[14]

The two poets seem closely aligned in spite of the differences in time frame and the catastrophes that prompted their writing. One image in Tōge's poem connects to Yoneda Tomoko's post-Fukushima photograph *Chrysanthemums* (2011) from the *Cumulus* series (figures 8.2a and 8.2b); the flower eerily evokes an atomic mushroom cloud as much as it evokes death. The chrysanthemum is particularly resonant in Japan as an historic symbol of the country itself, with a stylized version of the flower depicted on the imperial seal, but most importantly as a metaphor for longevity. Yoneda "updated" the chrysanthemum's symbolism in a subtle way, by connecting the nuclear accident with the empire's blind warfare policies during World War II.

Wagō's poetry also recalls the Marshallese poetry of Kathy Jetñil-Kijiner and the Kanak poetry of Déwé Gorodé, for example, because of the attachment to the land, as well as the earlier Chernobyl poetry of Lyubov Sirota, who witnessed the accident when she was living close to the plant and its bedroom community Pripyat. As a civilian, and as victim of a technical accident, she acted on the overwhelming need to express her feelings:

It is impossible, believe me,
To overpower
Or overhaul
Our pain for the lost home.

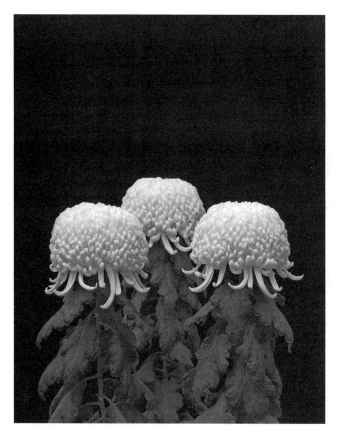

Figure 8.2a
Yoneda Tomoko, *Chrysanthemums*, from the series *Cumulus*, 2011, chromogenic print. Photo credit: © Tomoko Yoneda. Courtesy of the artist.

(…)
At night, of course, our town
Through emptied forever, comes to life.
(…)
Starts thrust down
Onto the pavement
To stand guard until morning …
(…)
We've stood over our ashes;
Now what do we take on our long journey?
The secret fear that wherever we go
We are superfluous?

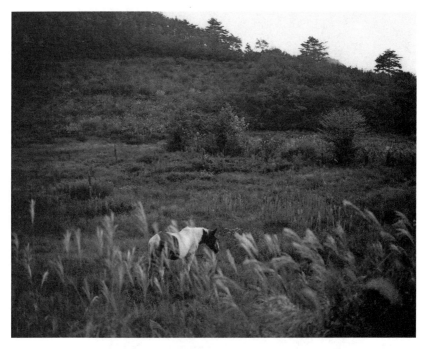

Figure 8.2b
Yoneda Tomoko, *Horse, Evacuated Village, Iitate, Fukushima,* from the series *Cumulus,*
2011, chromogenic print. Photo credit: © Tomoko Yoneda. Courtesy of the artist.

The sense of loss
That revealed the essence
Of a strange and sudden kinlessness
Showed that our calamity is not shared by those who might, one day,
Themselves face annihilation?[15]

Similarly to Shiga's photographs, the verses of Sirota and Wagō synthe-
size sorrow and beauty as they reveal anger, anxiety, despair, and hope. They
allow for recording and remembering the harshness of these moments.
Here too, the beauty of the poetry provides readers with little room for
aesthetic enjoyment because of the distressing testimonies.

Also poignant in Wagō's verses is their immediacy, a result of his posting
them on Twitter. Quite unexpectedly, Wagō's Twitter posts, Shiga's projects,
and even Sirota's books can be seen as a genuine contemporary metaphor
of the nuclear age: the good and bad of technology, its interaction with the
arts, and the impossibility of disentangling them. This fusion was famously
analyzed in the first half of the twentieth century by Walter Benjamin and

Paul Valéry and even earlier by Victor Hugo.[16] Such interlacing of the art/science compound has not ceased but instead has taken new paths—keeping in mind a difference underscored by the curator Kamiya Yukie's view of new technologies in media arts: after 3/11, as she explained, the modernist and modernizing promise of a more advanced world, which "we'd regarded as progress in this conventional sense, was not true progress at all."[17] For Kamiya, this does not mean that media arts cannot renew themselves or challenge anew a viewer's response to a previously explored topic.

Some postmodern practices directly integrated new artistic tools of communication while mediating the voice of the victims. The photographer Miyamoto Ryūji, who had photographed the 1996 earthquake in Kobe, added to a recent exhibition tsunami footage taken by witnesses—a step beyond the inclusion of testimonies (although he did that too) that Toyosaki Hiromitsu included as an element in his photo captions, and the Marukis' inclusion of their own testimonies for their Hiroshima Panels. This "content sharing" allows more reflectivity regarding the ethics involved in framing testimonies on the part of the photographer. As Hayashi puts it: "Behind this sensitive positioning of himself lie Miyamoto's self-reflective musings on his distance from the original site(s) and the limitations and possibilities of being distanced."[18]

Of course, one can continue writing poetry and prose like in the past, even without technological advances. Similarly to Tōge decades earlier, who wrote poetry with Hiroshima children, Wagō edited a book asking residents to give their testimonies and state the reasons why they do not want to abandon their hometown, titled *Furusato wo akiramenai: Fukushima, 25nin no shōgen* (We do not abandon our hometown: Fukushima, the testimonies of 25 people).[19] The project is similar to another collection of testimonies titled *To See Once More the Stars*. Instead of giving way to powerlessness, a group of scholars decided to take an action comparable to "something like that of a postal carrier. We are delivering the postcards—the textual and visual messages—that were sent through us."[20]

The title of this collection comes from the final sentence of Kenzaburō Ōe's short essay—part of the ongoing "Postcard" feature in the *New Yorker*—titled "History Repeats." Relating his thoughts about 3/11, Ōe ended his "Postcard" entry with the following hope:

When I was at an age that is commonly considered mature, I wrote a novel called "Teach Us to Outgrow Our Madness." Now, in the final stage of life, I am writing a "last novel." If I manage to outgrow this current madness, the book that I write will open with the last line of Dante's Inferno: "And then we came out to see once more the stars."[21]

The collection of "postcards" in *To See Once More the Stars* is compelling in many regards. First, it is a bilingual publication in which the non-residents and visitors affected were also given a voice. As Hayashi pointed out, referring to comments made by the philosopher Nakajima Yoshimichi, foreigners still have very little visibility, and the same goes for the LGTB community: too often the voices mediated in great majority have been those from "normalized" Japanese nuclear families. Second, the testimonies come from a wide range of persons: farmers, artists, scholars, and housewives bring a welcome richness with their diversity. The book also includes visual testimonies with the addition of pictures of works such as Kondō Takahiro's *Hotaru* (Fireflies, 2011), an installation made of glass and uranium glass, which looks like many little sugar cubes, glowing at dusk on the seaside then in a crate. Even the voices from non-professional writers impart a sense of poetry. In "Half-Life," a postcard from Sonya M. Gray, a Tlingit from Hoonah Village in Alaska, she asks:

What does it feels like when you are dying? Are your senses dull, so that you cannot taste the colors ... the burnt-smoky, the raw-leafy, the ripe-earthy? Can your soul love the salty skin? ... Do you not see familial lyrics sung upon the shore ... / Then I am indeed, dying.[22]

The many postcards convey many expressions of distress, rage, and hope. Here too, as with A-bomb literature, the definition of art must be widened. Poetry can be found anywhere, be it in the verses of a farmer or a housewife. Further on, beyond what Hayashi has called the "voices from the epicenter,"[23] many practices developed in order to help the evacuees cope with their loss of place.

Living Under Radiation: Music and Design

As the 3/11 catastrophe unfolded, rescue efforts for the victims took shape quickly since information about the accident circulated far more rapidly than for Chernobyl. The musician Ōtomo Yoshihide explained that the first thing he thought to do was actually talk to people who were there, in order to know what they really needed.[24] Once back in Fukushima city, where he had spent much of his childhood, Ōtomo realized that their difficulty was to keep going, emotionally, on a daily basis. He described the surprisingly unchanged aspect of day-to-day life in the city of Fukushima during his visit only two weeks after the catastrophe, where damages were repaired very quickly compared to the ravaged coastline and the remote power plant. Yet the residents struggled with an omnipresent feeling of despair. That reinforced his wish to organize a music festival.

In collaboration with many artists (among them was Wagō), Ōtomo launched his festivals in August 2011. The series featured local and national musicians, and everybody could bring their instruments and play. The popularity of the event was great, gathering 30,000 people onsite with 250,000 viewing on Ustream.[25]

Initially, Fukushima's punk star Endō Michirō had suggested the idea to Ōtomo, about a month after the catastrophe. Endō had founded the legendary band The Stalin, one of the precursors of Japanese punk music. He also wrote a song after the earthquake titled "Genpastu burūsu" (Nuclear Blues, 2011). Perhaps coincidentally, Endo was featured in the disturbing yet interesting film *Bakuretsu toshi* (Burst City, 1982).[26] In the film, rival gangs compete against one another in music battles and car races before protesting against the nearby construction of a nuclear power plant. Apart from the near omission of women (there is only one female character—the atom—who is sexually objectified and assaulted), *Burst City* is illustrative, given its pre-Chernobyl context, to demonstrate that the postwar "atoms for peace" sentiment was not always peacefully orchestrated. Decades later, music still crosses the path of nuclear plant–related activism. When Endō first came up with the idea of a music festival he had proposed calling it "Nuclear Power Plants, Fuck You." Ōtomo reacted to the title with skepticism but not to the idea; the organizers settled on Project FUKUSHIMA! for the August 2011 event, as a way to bring a positive association to a place with such a negative one.[27]

Politically motivated post-Fukushima art also included proactive practices such as the ones used by the Tokyoite collective Chim↑Pom. On the right lower side of Okamoto Tarō's *Ashita no shinwa* (Myth of Tomorrow, 1969), the group temporarily installed its own creation, a panel with odd-looking atomic mushrooms escaping from the damaged power plant. Okamoto's panel is an artistic landmark displayed in Tokyo's Chibuya train stations that depicts the horror of the atomic bombings. The Chim↑Pom collective appeals to many art viewers, perhaps because of its strong political message, but perhaps also because the visual pieces have a presence in contemporary museums and galleries, whereas musical performances tend to be more fleeting. The arts are still compartmentalized even in our postmodern world.

For Ōtomo, however, the political message was not central, and the townspeople came first. The immediate issue for him was not whether nuclear energy was good or bad. Instead, as he explained: "Right now, the direct damage caused by the radiation isn't so much the problem as the wounds in people's hearts, the emotional disorders."[28]

Project FUKUSHIMA!'s efforts to bring entertainment to the residents involved a truly inspiring reversal of the tools usually employed by what Guy Debord calls "the society of spectacle" by avoiding the usual mainstream kitsch spectacle but keeping the entertainment, all the while directly broadcasting information and music from the city (without being filtered via Tokyo). The project benefitted from a necessary and fruitful cooperation with scientists—for instance, the radiation expert Kimura Shinzo—since the area selected for the festival contained a lot of cesium.[29] The art/science compound is visible here too. In order to prevent visitors' skin from coming in direct contact with the radioactivity, Kimura advised covering the ground. The idea developed into the making of a huge *furoshiki*, sewn together from many smaller *furoshiki* (pieces of fabric), to cover a grassy expanse measuring six thousand square meters.[30] The crafting of the large patchwork became a collective project, with local residents (even the elderly) and musicians pitching in to help (some participants even wrote messages on their *furoshiki*).[31] Ōtomo's efforts and his ongoing Project FUKUSHIMA! is therefore an extraordinary collaborative endeavor between poetry, punk, science, and spectacle.

The JAGDA (Japan Graphic Designers Association Inc.) Handkerchiefs for Tohoku Children project (figures 8.3a–f) began with the group's swift effort to raise funds for children of the Tohoku region, Fukushima city, and other evacuated areas by selling handkerchiefs they designed in venues across the country. In its second phase, the *Yasashī Hankachi Project* ("yasashī" meaning "kind") involved exhibiting and selling handkerchiefs of the children's own design, similar to the poetry Tōge wrote with *hibakusha* children but in drawings; it gave visibility to the children's vibrant drawings and gave the children themselves a voice in the JAGDA project. The handkerchief designs exhibited at Akita Museum as part of the touring exhibition, for example, show the children's surprising optimism for the future.

Fundraising for earthquake relief has a long history. After the 1923 Great Kanto Earthquake, for instance, Yoshida Hiroshi took some of the prints he was able to salvage to the US and sold them to raise money for the victims.[32] The fundraising goal of Handkerchiefs for Tohoku Children is to help the children to realize reconstruction projects in their own schools. Children of Naraha Minami-kita elementary school, for example, chose to replace the musical instruments they had to leave behind after the evacuation because of concerns about radioactive contamination.[33]

The general optimism of the drawings in fact mirrors that of their parents, the media, and Japan's way of dealing with disasters (tsunamis and

Figure 8.3a
The exhibition at Tokyo Midtown Design Hub, JAGDA, January–February, 2013.
Courtesy of Japan Graphic Designers Associations Inc. (JAGDA).

Figure 8.3b
JAGDA member designers from Tokyo and Tohoku at the opening reception, JAGDA,
January 2013. Courtesy of Japan Graphic Designers Associations Inc. (JAGDA).

Figure 8.3c
Workshop with children who contributed drawings for the handkerchiefs (Shinchi Elementary School, Fukushima). Courtesy of Japan Graphic Designers Associations Inc. (JAGDA).

Figure 8.3d
Workshop with children who contributed drawings for the handkerchiefs (Shinchi Elementary School, Fukushima). Courtesy of Japan Graphic Designers Associations Inc. (JAGDA).

Figure 8.3e
Handkerchief design by Hitoshi Ogasawara in Iwate, JAGDA, 2012. Courtesy of Japan
Graphic Designers Associations Inc. (JAGDA).

Figure 8.3f
Handkerchief design by Takuya Abe in Miyagi, JAGDA, 2012. Courtesy of Japan
Graphic Designers Associations Inc. (JAGDA).

earthquakes are fairly frequent). In one of the postcards from *To See Once More the Stars*, Yokoyama Ai (described as a mother) wrote the poem "Donguri" (Acron, 2014):

(…)
Evacuate is an easy word to say.
But it is not easy in reality.
We discussed it as a family and as husband and wife
And we cried.
In the future,
Our children will be adults,
But I hope that
Small children will be able to collect
Many flowers, rocks, and tree branches.
With those in their hands,
When children say,
"Mommy, look at this! Look!"
I hope we can reply
"They're pretty"
Not
"No, Honey, don't touch them."
That's all I wish.[34]

Similar responses to those expressed in the form of written testimonies or collaborative design projects came from practitioners in other media. Architecture played a very special role after the nuclear accident. In fact, according to Kamiya, "Architects were the swiftest players in the wake of the earthquake."[35]

Rethinking the Limits of Nuclear "Shelters" in the Postmodern Age

Two major architectural projects—*Ark Nova* by Indian-British sculptor Anish Kapoor and the architect Isozaki Arata, and Ito Toyo's *Minna no ie*, (Home-for-All)—depart from the stereotypical image of the cold underground shelters we imagine in the Cold War era and instead provide warm and convivial cultural spaces.

Kapoor and Isozaki's *Ark Nova* (2013) is an inflatable, bubble-like, traveling concert hall made of purple-coated polyester material (figures 8.4a–f). It was designed with the intent to "bring hope through music to regions afflicted by the Great East Japan Earthquake" and to foster a "long-term rebuilding of culture and spirit."[36] The mobile bubble can welcome large audiences, with seating for about five hundred people on benches made

Figure 8.4a
Lucerne Festival Ark Nova in Fukushima 2015. Photo credit: © Yu Terayama / Lucerne Festival Ark Nova.

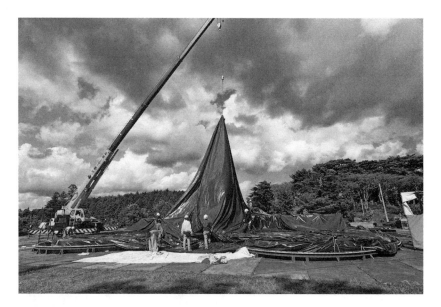

Figure 8.4b
Lucerne Festival Ark Nova in Matsushima 2013. Photo credit: © Lucerne Festival Ark Nova.

Figure 8.4c
Lucerne Festival Ark Nova in Matsushima 2013. Photo credit: © Lucerne Festival *Ark Nova*.

Figure 8.4d
Lucerne Festival Ark Nova in Sendai 2014. Photo credit: © Yu Terayama / Lucerne Festival Ark Nova.

Figure 8.4e
Lucerne Festival Ark Nova in Sendai 2014. Photo credit: © Yu Terayama / Lucerne Festival *Ark Nova*.

Figure 8.4f
Lucerne Festival Ark Nova in Fukushima, 2015. Photo Credit: © Yu Terayama / Lucerne Festival Ark Nova.

from cedar trees salvaged from devastated areas.[37] The project is notable for its involvement with local communities and its blending of materials diverse in type and meaning: modern and traditional, technologically advanced and damaged. The purple bubble has housed performances ranging from traditional Japanese Noh and Kabuki theater to classical musical programs featuring internationally renowned solo musicians as well as members of the Swiss Lucerne Festival (hosted in 2013 at Matsushima), the Sendai Philharmonic Orchestra, and even local children's orchestras. The partnership of international artists of many mediums and of all generations is a tremendous cooperative effort that, given its stated purpose to bring hope to earthquake victims, ironically parallels and thus goes against today's sprawling industrial international conglomerates—one of which, as we've seen in chapter 7, is the nuclear industry.

Isozaki's idea to conceive an architectural project inspired by ruins of a city (a project, no less, with the potential to be inflated, deflated, and relocated) is not surprising given his overall philosophy, summarized by his well-known statement: "Ruins are what our cities will be in the future, and the future cities are ruins themselves."[38] Isozaki was involved in the postwar architectural movement Metabolism, which gained prominence at the 1960 World Design Congress in Tokyo and the 1970 Expo in Osaka. Isozaki architectural designs continue to reflect the movement's sense of architecture as a biological, organic process. "Our modern cities live during a very 'short' time," according to Isozaki, "and will release energy, and will become material again."[39] The movement is usually seen as heavily influenced by Tange Kenzō's architecture, in particular his much celebrated Hiroshima Peace Memorial Museum. The bubble-like project *Ark Nova* therefore logically follows a tradition of post-calamity reconstructive architecture and art, while responding to the international industrial and corporate expansion in a reconstructive and creative fashion.

Convivial spaces have also developed in areas where the evacuees have been relocated. As part of the group of architects Kisyn no Kai, Itō Toyō came up with the idea for the *Minna no ie* (Home-for-All). The project would build gathering places for the survivors who had been relocated to temporary housing; the goal was to strengthen the communities by building communal spaces (figures 8.5a and 8.5b). Several projects were completed in different areas, some geared to help children or specific groups like fishermen.[40] The design process for a Home-for-All structure in Rikuzentaka, for example, was exhibited in the Japanese Pavilion at the 2012 Venice Biennale of Architecture and won a Golden Lion.[41] For Itō, architecture had to be rethought in order to adapt to the needs onsite and in response to

a

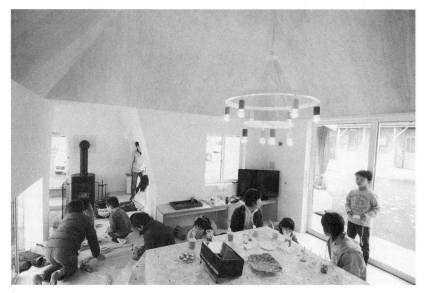

b

Figures 8.5a–b
Itō Toyō and Maki Ōnishi, "Home-for-All for Children in Higashimatsushima," 2013.
Photo credit: Itō Toyō & Associates, Architects.

nature.[42] Given the enormous number of refugees and relocated residents, architecture and architects had to act locally and not just from Tokyo.[43]

Itō's project is also a thoughtful and necessary critique of Western modernity, especially given the number of efforts in the name of modernity that have impacted non-Western societies in ways still disastrous today. The American, British, and French nuclear tests in Oceania and the uranium mining in many communities and nations, for instance, immediately come to mind. Thus Itō qualifies his architectural views as allowing for a "little bit of antimodernization."[44] He notes that we are still embedded in the twentieth-century philosophy that considers technoscience as a tool to conquer nature. In 2011, when huge retaining walls were built to protect against a tsunami, and when the power plant was said to be earthquake resistant, neither the preventative measure nor the prediction panned out. This very separation from nature was and still is clearly inadequate according to Itō. The city cannot be separated from the environment, and therefore for him, "modernist thinking has reached its limit." The temporary houses provided by the state for the refugees, for example, were designed to "provide shelter and privacy for the individual, but not to foster interaction."[45] Instead, Home-for-All's structures are based on premodern Japanese houses, with verandas opening to the landscape, and where everyone can spend time together.

In the 1920s the philosopher Watsuji Tetsurō analyzed what he believed were the limits of Western modernity—based on his extensive studies of Western and Eastern philosophies and cultures—in *Fūdo* (a work translated into English as *Climate and Culture*). *Climate and Culture* stressed the importance of the influence of climate and space onto "being" (how one is in the world) and thus culture, which is the basis for his acknowledgement but also critique of Heidegger's emphasis on space but mostly time in *Being and Time*. Heidegger focused on the importance of time (temporality, historicity, and the awareness of one's death) in the way one is in the world (or in Heidegger's terminology: *Dasien*'s "being-in-the-world"). But for Watsuji, the climatic conditions specific to a geographical area and even a country (space) influence its culture, explaining differences in cultures: a "meadow" type of climate for Europe, "desert" for Africa, "monsoon" for some parts of Asia, and Japan's "typhoon nature."

Watsuji also examined modern European capitalism, which "see[s] man as an individual; the family, too, is interpreted as a gathering of individuals to serve economic interests," as opposed to the Japanese way.[46] Watsuji observed that in the West, members of the same family are separated even within the house by doors and locks, while in Japan, he says, even if

capitalism were adopted, sliding doors and paper screens allow the family to merge, privacy being unnecessary. Watsuji defined the house as the "real essence of the Japanese way of life."[47] Some of Itō's collaborative structures show how concepts of openness and community are embodied in their design.

Relating to Watsuji's philosophy to analyze a Home-for-All is, however, limiting. He is often associated with the Kyoto School, and followed a similar controversial nationalist path than the Kyoto School and Heidegger, during World War II, one that remains an issue even in our contemporary times. Hayashi pointed out that many post-Fukushima artistic responses focused on the victims can come "dangerously close to nationalistic narcissism, exemplified by abuse of the term *kizuna* (bond)—or offering audiences more hopeful visions of the future."[48] It is true that nationalism and protectionism is a recurrent threat (and a danger in every nation). But the modern attitude of separating nature and society must be reassessed. Such a rethinking is pivotal to our postmodern societies—something underscored in the West by Bruno Latour.[49]

Oddly enough, Watsuji's *Climate and Culture* makes no direct link between what the author calls "Japan's typhoon nature" and the design of houses.[50] On the contrary, Itō's architecture aims at re-investigating the importance of nature (and without a nationalist agenda). Beyond helping the evacuees, thinking about solutions for the future is also crucial, for natural disasters will not cease. The Sendai Mediatheque (1995–2001) is a striking example of the way Itō fuses architectural and natural features, premodern and postmodern designs—a concept that Isozaki Arata had praised as a "clear and elegant solution" and that Itō had started to imagine after the 1995 earthquake in Kobe (figures 8.7a and 8.7b).[51]

The Sendai Mediatheque comprises three basic elements: tubes, plates, and glass windows. Instead of pillars, Itō used a group of bars, or "tubes," that appear to flow contiguously from floor to floor. The floors are made from panels in honeycomb-like grids. The exterior walls are made out of two layers of glass, just like a "skin."[52] The weight-bearing fluidity of the floors and tubes allowed the building to remain almost unaffected after 3/11.

Given this overview of the artists who responded after Fukushima in a variety of mediums—from Shiga, Wagō, Ōtomo and Itō—we can now examine how the accident at Fukushima (and Chernobyl before it) led some artists to ponder anew, as many had done in previous times of nuclear crisis, on the role of the arts in society.

Figures 8.6a–b
Itō Toyō and Yanagisawa Jun, "Playground-for-All in Minamisoma," 2016. Photo
credit: Itō Toyō & Associates, Architects.

Figures 8.7a–b
Itō Toyō & Associates, Architects, Sendai Mediatheque, 2001. Photo credit: Itō Toyō
& Associates, Architects.

From Nuclear Power to Saving Power: Art after Fukushima and Chernobyl

In the art of the atomic age lies the indisputable necessity of testifying to one's fate. The work of Shiga and Wagō are seminal in that they capture the events and testimonies, visually and textually. Remembrance, for the direct and indirect victims, is made possible. As Sontag vehemently stated: "Remembering *is* an ethical act."[53]

In architecture, Itō explained having contemplated the role of public architecture (since the 1995 earthquake in Kobe) in two respects: first, the vital ways in which the structure will react to the earthquake itself; and second, the social function the building must serve after the disaster. Not only was the Sendai Mediatheque building almost undisturbed after the earthquake, but it was reopen very quickly to provide the survivors with a "cultural refuge in the city."[54]

Itō's intention was to foster "meaningful" interactions between residents. He wanted not to restore the life existing before the tsunami but "to create a new social life for the next generation that will be growing up in the aftermath of the catastrophe."[55] His position is consequently not a nostalgic or romantic longing for the past.

In music, Ōtomo's idea for Project FUKUSHIMA! came from the desire to care for the residents, but also to change Fukushima's image. Some reconstruction plans had envisioned, for example, the transformation of Fukushima city into a casino-friendly zone, in order to brighten the city's gloomy reputation. As Ōtomo saw it, if Hiroshima had succeeded in turning the stigma due to devastating atomic bombings and radioactivity into an international symbol of peace, then Fukushima too could transform its negative image. The motive is understandable. In *City of Corpses*, Ōta Yōko had also previously declared: "Hiroshima, too, had its history, and it saddened me to march forward over the corpse of the past."[56] In the post-Fukushima context, the music festival's motto was, quite tellingly, "the future is in our hands."[57] Its first performances were purposely held on August 15, 2011, sixty-six years to the day after Japan lost the war.[58] Here again, military shadows are never too far removed.

For Ōtomo, cultural expressions must help us to face the reality of the events since politicians and scientists do not, but also because "right now, the science to stop what's happening in the nuclear power plant is lacking, so someone has to do something about it."[59] Consequently, the arts must play a role:

Drawing lines is not the role of music and art. Music and art make invisible lines visible and cast doubt on them. That's why they're interesting, and that's why they

have the power to motivate people with the suggestion that the lines drawn by politicians and others are not really accurate.[60]

In photography, shocked by the earthquake and accident, and also because he was born in Fukushima, Takeda Shimpei decided to make "a picture of the aftermath in the most direct manner," by using a technique called autoradiography, by collecting irradiated soil samples to capture the effects on film.[61] More than half a century after Heidegger's "The Question Concerning Technology," art still can act as the "saving force" the philosopher envisioned in his postwar / Cold War context against the technological "Enframing," but also as a "revealing." After the tsunami and the nuclear catastrophe, the technological enframing and art's "saving force" and "revealing" are undeniable. The post-Fukushima artistic practices, therefore, place themselves in line with previous artistic practices of the atomic age. Consider, for example, the urgency of writing expressed by Ōta Yōko, even if it made her sick. Think of the militant poetry by Oceanians such as Cite Morei, Henri Hiro, and Chantal Spitz.

The same can be said of artists producing works on and after Chernobyl. Lyubov Sirota was compelled to write her poetry from her displaced vantage point as an evacuee of the exclusion zone. Igor Kostin—part of the Atomic Photographers Guild (like Del Tredici and Toyosaki)—was one of the few photographers to capture images of the Chernobyl reactor on film the same day as the explosion. Kostin, like Takeda would later, dealt with radioactivity on film, although "by accident." Out of the first roll of photographs he took from the helicopter flying over the exploded reactor, only one photograph could be used. The others were blackened by radioactivity. Kostin returned to the contaminated area for years to document cleanup efforts and aftereffects of radioactivity on humans, animals, and the land (figures 8.8a–e).

In the moments after the accident at Chernobyl, Igor Kostin explained his decision to risk his health to cover the accident:

I wanted to act; I couldn't sit still. The idea of remaining at home or, worse, taking the first plane and fleeing the radiation, did not cross my mind. I had to remain in the Ukraine. The plant was a hundred and fifty kilometers from Kiev, a hundred and fifty kilometers from my building.

The workers there spoke the same language I do. They were my people, my brothers. I was one of them. I stayed.[62]

Recording and remembering are also political acts, not simply ethical choices, whether one is a "committed" or "autonomous" artist. The political/apolitical compound, like the others, does not respond to rigid categorization or polarization. Ethical acts become evident after any war,

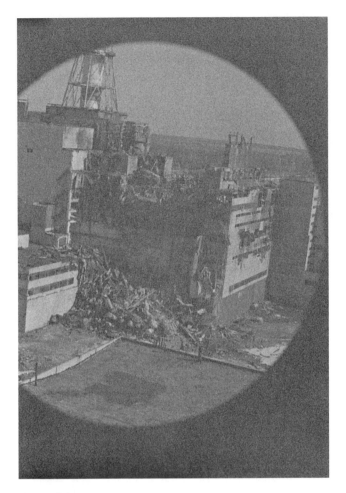

Figures 8.8a–e
Igor Kostin, *Chernobyl—The Aftermath*, 1986. Photo by Igor Kostin / Sygma, via Getty Images.

Figures 8.8a–e (continued)

Figures 8.8a–e (continued)

after large-scale accidents, after any traumatic events, as depicted by Goya, Ernst Friedrich, Robert Capa, and in the nuclear age, by Ōta Yōko, Yamahata Yōsuke, Henri Hiro, Igor Kostin, and Shiga Lieko. The role of the arts and representations of suffering are crucial in the nuclear age. For nuclear accidents, however, there is another difference between Fukushima and Chernobyl: government censorship. In an era of social networks, Twitter, Facebook, and live streaming, any attempt to hide the catastrophe at the Fukushima power plant would have been futile.

Chernobyl: Beyond the Clouds of Censorship

The fact that the Soviet Union tried to conceal the accident cannot be argued anymore. Almost ten years later, in the face of this denial, the Belarusian writer Svetlana Alexievich decided to let the inhabitants of Chernobyl speak for themselves in her book *Voices from Chernobyl* (1997).[63] Her approach is similar to that of Tōge after Hiroshima, when he wrote poetry with children; to Toyosaki, when portraying the many H-bomb and radon *hibakusha*; and finally to Wagō, when he collected testimonies from Fukushima residents. Alexievich intended to give voice to personal stories rather than create an official history, and to do so without modifying or inadvertently magnifying the memories she gathered and published in the form of monologues.

Art is thus a revealing in the Heideggerian sense. In the nuclear age, this is true also because the radioactive fallouts are sociopolitical as much as technological. In that sense, the monologues of Alexievich's witnesses are a revealing of the suffering and the circumstances of the inhabitants themselves. The first monologue comes from Lyudmilla Ignatenko, a woman whose husband, Vasily Ignatenko, was a firefighter turned liquidator at the plant who died two weeks after the accident.

I don't know what I should talk about—about death or about love? Or are they the same? Which one should I talk about?

We were newlyweds. We still walked around holding hands, even if we were just going to the store. (...)

The doctors kept telling them they'd been poisoned by gas. No one said anything about radiation. And the town was inundated right away with military vehicles, they closed off all the roads. The trolleys stopped running, and the trains. They were washing the streets with some white powder. (...) No one talked about the radiation. Only the military people wore surgical masks. (...)

He started to change—every day I met a brand-new person. The burns started to come to the surface. In his mouth, on his tongue, his cheeks—at first there were little

lesions, and then they grew. It came off in layers—as white film ... the color of his face ... his body ... blue ... red ... gray-brown. And it's all so very mine! It's impossible to describe! It's impossible to write down! And even to get over.[64]

Through the changing colors of the husband, through the white powder spread down the streets, and through the military men's surgical masks that contrast dramatically with the naked faces of the civilians, radioactivity becomes visible.

Another of the many monologues collected by Alexievich expresses the bitterness of a soldier whose wife deserted him, taking the children with her. He started to sing in the middle of his monologue—"Even one thousand gamma rays / Can't keep the Russian cock from having its days"—and then voiced more disdain toward his wife by telling a crude joke.[65] In another monologue, Anna Badaeva mused about the changes radiation has brought to the world, but she wasn't sure how to recognize it: "What's it like, radiation? Maybe they show it in the movies?" She explained that some people say radioactivity has no color, no smell, but others say it is black, like earth. But if it is invisible, she said, "then it's like God. God is everywhere, but you can't see him."[66] There also is the poignant story of Nikolai Kalugin, who had to break into his own house after the evacuation, to recover, or rather "steal," one of his belongings—a door, which he considered to be a particularly important belonging. Tradition in his family held that those who died were laid to rest on this specific door until they could be buried; his six-year-old daughter was then sick in the hospital. "Daddy, I want to live, I'm still little," he recalled her whispering in his ear. There were seven girls in the room. "Can you picture seven little girls shaved bald in one room?"[67] He laid her body down on the door in keeping with his family's ritual, sorrowful for the smallness of the coffin when it arrived, as small as a doll's box, and for the cruel fate of having to bury his own child.

The monologues in *Voices from Chernobyl* also endorse the ethical role the arts play when they act as a revealing, giving visibility to the physical as much as the emotional impact of the accident and radioactivity. Toward the end of his monologue, one soldier explains how his friends died: one got fat "like a barrel," another one skinny and black "like coal," Then he remarked, "I was in Afghanistan, too. It was easier there. They just shot you." He also remembered how the plant technician Leonid Toptunov tried to push the red button but it did not work. They buried him in a foil-insulated coffin and covered it with concrete, amid people shouting to his father: "That was your bastard son who blew it up!"[68]

Art is revealing, even retroactively. The narratives organized by Svetlana Alexievich, act like the photography of Igor Kostin—as a resistance, not

only against past governmental censorings but also against the current business strategies of nuclear corporations.

Recently the Russian nuclear industry attempted to improve its image by organizing a beauty contest in which the winner would be crowned Miss Atom. This contest, which runs yearly since 2004, is open to Russian women working or studying in the nuclear industry. A leading nuclear information portal, Nuclear.Ru, organized the contest, and in 2010, 350 contestants entered according to Nuclear.Ru, from Russia, as well as Ukraine, Belarus, and Kazakhstan.[69] In such circumstances—when attention is drawn (and energy expended) to facilitate the glorification of an industry noted for its lack of transparency—do the photographs of desolated radioactive landscapes and *hibakusha*, as taken by Igor Kostin, Robert Del Tredici, and Toyosaki Hiromitsu, stand a chance to gain visibility in public debates?

Swirling amid the glamorous aura and sheen of the beauty contest, radioactivity captures more colors: pink and purple, for instance, in the logo for the 2011 contest, which launched with the slogan "Miss Atom 2011: the colors of beauty." At the close of a welcome letter on the web portal's home page, the contest organizers stated their wish for "only bright spring colors" to be associated "with the nuclear industry worldwide," and neither should "events paint it gray and joyless." They organizers strongly believed "that the future rests on nuclear. And the future should be bright. Bright and light."[70]

If radioactivity has a color, it may well be pink, like the Miss Atom logo and the painted lily that graces Nuclear.Ru's web page, it might be blue, red, and gray-brown like the colors of Vasily Ignatenko's dying husband, or black "like coal," like the body of the soldier's friend. If radioactivity has a gender, it may well be female, like the character Betty in Michel Darry's prewar novel *The Race for Radium*. Radioactivity may well be named Betty, or Wakako, like the lone female character in Saitō Takao's manga, who was victimized in the Japanese uranium mine Ningyo-toge during the postwar uranium rush. The atom is female. Incidentally, there is no plan to crown a Mister Atom as of yet.

In terms of gender and sexuality, the atom is not always adopted as a loose metaphor or an objectifying marketing strategy. Ikeda Ai's inkjet print *Sievertian Human—Wisdom, Impression, Sentiment* (2017) (figure 8.9) underscores, for the artist, the effect of radiation in particular in woman's bodies. Women and children are more sensible to radioactivity. For Karen Barad, atoms are "'ultraqueer' critters" with "radically deconstructive ways of being" that radically question identity and binaries: the politics of her analysis are more than ever necessary to consider.[71] The organization of a

Figure 8.9
Ikeda Ai, *Sievertian Human—Wisdom, Impression, Sentiment*, 2017. Ink on paper, inkjet print. Courtesy of the artist.

Miss Atom contest shows here again that the industry is still dominated by heterosexual male CEOs—with the exception of Orano's, or at the time AREVA's, Anne Lauvergeon, or "Atomic Anne" as she was called. Lauvergeon was expelled in 2011, possibly for political reasons but definitely because of corruption. Virginia Woolf, and in her footsteps Susan Sontag, previously emphasized that war has a gender, and it is male. The nuclear industry has one too. It is (mainly) male—or rather heterosexual male.

A Russian male counterpart to Miss Atom is the title character in *Atomic Ivan* (2012). On the surface the film is a simple love story: a jilted scientist who works at a Russian nuclear power plant tries obsessively to reunite with his ex-girlfriend, also a scientist employed at the plant in something close to harassment. The film includes an amusing scene in which a play is staged on the premises of the plant (with actors dressed in monster-like mutant costumes)—perhaps a reference to or mockery of the staging of Svetlana Alexievitch's *Voices from Chernobyl* in 2006 by the French theatrical company Brut de Béton on site, in front of the infamous reactor.

Although Atomic Ivan touches on the desire to rethink monstrous mistakes of the past, it overwhelming views the nuclear industry as prestigious, exciting, and hopeful. Such an outlook is not surprising given the film's appropriation by the nuclear industry as a communication tool. The Russian company Rosatom concluded a report on its communication strategy—which comprises blogs, games and mobile applications, and regular TV documentaries on nuclear-related topics—in the following terms: "ROSATOM State Corporation lent its support to the feature film Atomic Ivan that was completed in 2012. For the first time in history a film was shot at operating Kalinin and Leningrad NPPs. The film won several prizes in 2012."[72]

How extensively Rosatom supported the film, financially or in any other capacity, is not clear. There is a tipping point, however, at which an idealistic view of an industry, such as the portrayal of a mining company in Saitō Takao's manga, has the potential be considered corporate propaganda or at least complicity. The post-catastrophe nuclear age forces us to notice the incommensurable impact of capitalism on scientific applications as much as on the arts. Although the desire of the Russian industry to live down an accident that occurred a quarter century ago is understandable from a corporate viewpoint, given the obvious economic driving force of such an initiative—its ethics remain problematic. The use or possible reappropriation of a film is one aspect, but regarding the Miss Atom contest, what is troubling is any corporate transformation of a negative image into a

positive one by attempting to humanize its technology with the patriarchal objectification of women.

The Miss Atom contest was at best a questionable effort to promote the Russian nuclear industry's bright outlook for the future, but is also problematic because it refers to the postwar contest of Miss Atomic Bomb or Miss Cue. The US military's idea to pair atomic bombs and Las Vegas showgirls in its endorsement of nuclear testing during the Cold War seems more egregious more than a half century later. Operation Cue was the code name for an aboveground test scheduled at the Nevada Nuclear Test Site on May 1, 1955. Military personnel crowned would-be starlets with a headpiece resembling an atomic cloud (figure 8.10) or at times a "mushroom cloud" bikini.

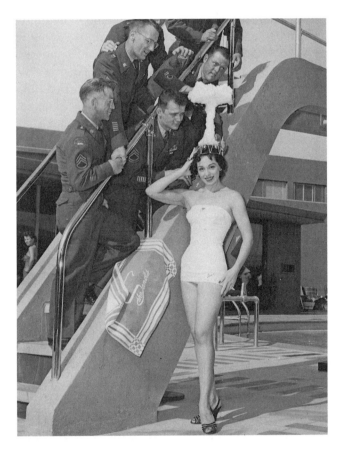

Figure 8.10
Photograph of Copa Girl Linda Lawson as Miss Cue, May 1, 1955. Courtesy of UNLV Libraries Special Collections.

Such examples show that the Cold War era military fervor for new atomic technology cannot be disentangled from the response of civilians who, whether through Cold War fears or postwar nationalism, bought in to its attempted glamorization. In the case of the Russian Miss Atom, the issue is one of an industry glorifying its own public persona for profit. Both can be seen as an affront to *hibakusha* everywhere: from the A-bomb victims who Yamahata and Tōmatsu represented in postwar photographic reportage, to the Marshallese who were contaminated and/or displaced from their homes, to the Chernobyl victims whose voices came to life because of Alexievich and via Kostin's photographs.

In Chernobyl, Kostin photographed deformed children and animals. Although Toyosaki focused on dignified portraits, avoiding representing deformities and monstrosity, Kostin documented every detail of the accident, including the most disturbing. His intent was not driven by a search for sensationalism but rather by a sense of responsibility to convey a rate and degree of birth defects and deaths so abnormally high in some areas that he felt compelled to send these pictures to President Gorbachev. His effort was made in vain.[73] Here, the exposure of deformities is a political act.

Similarly, in Tōmatsu Shōmei's photograph of the *hibakusha* woman (see figure 4.3a), her gaze is so strong behind the scars that we can hardly sustain it, and the image is all the more repulsive because we know the atomic bombings were no accident. The work of Kostin, Yamahata, and Tōmatsu leave no doubt about the terrible consequences of large-scale technological accidents and terrifying warfare. If the camera's mechanical eye is suspect for its lack of objectivity (never mind its lack of authenticity), the intentions of the photographer cannot be mistaken.

Retroactively therefore, the works of Kostin and Alexievich act as a revealing as much as a saving force in the face of Soviet censorship and the industrialist capitalist sublime. Yet the invisible harmfulness of the capitalist sublime is far more pervasive. It inevitably absorbs nuclear corporations and contaminates other vital social activities. Given this particular background, and even from a recent vantage point it seems that Fukushima escaped state censorship, we must wonder what challenges Japanese artists have faced that are comparable to or the same as Russian artists responding to Chernobyl.

Kizuna, Nationalism, and Radioactive Fukushima

A tension exists between the local, national, and the international artistic representations of the Fukushima accident. On the national level, as we

saw earlier in the chapter, Hayashi Michio underscored the issue in which the "concept of the *kizuna* (bond) … has been misused to block perception of the history that brought the nation to the present situation." While the cohesive nationalist spirit to cooperate in times of crisis can be comforting, it can as well "erase differences and dissonances among involved parties" and thus has also overshadowed other communities (foreigners and LGBTs, for example). He further insisted, regarding nationalism and the accident: "It is not impossible to discern some similarities between this structural blindness and propaganda during the fascist period in Japan, with its lack of objective logistical analysis and its promotion of *kokutai* (the unified character of the state) and *yamato* (Japanese) spirit."[74] It is true that there was an overemphasis on hope for the future, sometimes disregarding the still current cruelty of the situation. Hagio Moto's manga, *Na no hana* (Canola Flower, 2011–16), is an example of this ambivalence.[75]

Hagio usually produced romantic manga for women, sometimes portraying homosexual love and thus deals with different politics than the ones relating to nuclear tragedies. But after the nuclear accident, she published *Canola Flower*. The last edition regroups several stories that first appeared in 2011, and they convey an optimistic reading of the event, one which references the nuclear disaster in Ukraine twenty-five years earlier: Nano, a young schoolgirl disturbed by the death of her grandmother during the tsunami, has a clairvoyant dream in which she encounters a young girl from Chernobyl. Like other sick children in her area, this girl had received indirect help from Nano's grandmother, a supporter of Chernobyl's recovery efforts. The dream girl from Chernobyl has died, however, and this dream knowledge helps Nano to decide to stay in Fukushima; she will plant canola seeds to extract the radiation and purify the soil in an effort to carry on meaningful work, like her grandmother.

At first, this optimism may seem disturbing or at least sentimental, but the manga, aimed at children and young adults, attempts to help them cope with loss. Regarding optimistic practices, even Hayashi acknowledged the comforting powers of "bonding." Furthermore, at the core of the many other stories Hagio juxtaposes in the book, are the characters Madam Pluto and Count Uranus, personifications of atomic powers and radioactive waste (a somewhat slightly more gender-balanced anthropomorphic representation of the atom even if it is not perfect), who introduce some of the good and bad aspects of nuclear energy to her young readership.

On the international level, artists worldwide have persistently created images that misrepresent or trivialize Fukushima and Chernobyl victims or the events themselves; the sensationalism of such depictions are a crude

reality.[76] No medium seems to be spared. The foreign-drawn caricatures in *Charlie Hebdo* (or other journals) that showed skeletal sumo wrestlers with three legs were received in Japan with great sadness. Even the Japanese manga series *Oishinbo* (translated as The Gourmet), dedicated an issue to Fukushima's food and became controversial for depicting a character having a nosebleed. The series had been very popular since the 1980s, but the scandal was so widespread among readers that the second Fukushima issue became the mangas' last.[77] This does not mean that compelling works were not created internationally, on the contrary, but there is a tension between the necessary feeling of empathy for the plight of people living in distant places (and the desire to act upon them), and misrepresentation, orientalism and sensationalism.

In such circumstances, Ōtomo's aim to change the perception of the town is understandable. Who would want their city's inhabitants to be portrayed as monstrous radioactive mutants turned cannibals in a horror movie like *Chernobyl Diaries* (2012)? Thus the desire to overcome the radioactive stigma and nationalist agendas should not be underplayed. Sontag has convincingly demonstrated (with an analogy relating to manmade violence) how memory can be compartmentalized to avoid acknowledging that "the evil was *here*." It is easier to address the evil that comes from elsewhere rather than to recognize an evil that takes place *here*.[78] Even when it comes to representing natural disasters and nuclear civilian catastrophes, there is a politic and an ethic in representing the victims, whether they belong to a different country, ethnicity, religion, community, or not.

Adding to this is the problem of national or international agendas. To some extent, situation seems similar to Nagaoka's observation about A-bomb literature. *Hibakusha* writers had but little coverage before the Bikini Atoll tests and were also caught in Japan's nationalist agenda. He compared two views: the first came from the *hibakusha* poet Kurihara Sadako, who advocated the importance of memory and remembering to culture; the second came from the literature professor Matsumoto Hiroshi in Hiroshima, who thought culture could become a tool for propaganda, and believed that politics should be separated from culture—the modern apolitical/political compound.[79] But A-bomb literature's particular aura still does not attract readers on the international level. Kurihara, Ōta Yōko, and Hara Tamiki's voices have but little visibility.

Regarding Fukushima, and in times of globalization, when social networks and increased English proficiency among the world's population permit more artistic international cooperation, we can't predict whether the voice of Fukushima's irradiated residents will become invisible like the ones

from Hiroshima. The question, however, is whether Fukushima's voices will fill the void felt in representation of the atomic age by past censorship, at the expense of the other global *hibakusha*, A-bomb, H-bomb, and radon *hibakusha*. Will contemporary Fukushima-related artworks take center stage at the expense of A-bomb and H-bomb literature?

The works of Ōta, Hara, Jetñil-Kijiner, Spitz, Alexievich and Wagō, all bore the burden of the act of remembering; questions about the way they will be remembered are pivotal. At Chernobyl, the installation of a New Safe Confinement structure was nearly complete in April 2018 to enclose the temporary sarcophagus built immediately after the disaster around the reactor, and will further block radioactivity from leaking. But the radioactive tragedy is still unfolding in Fukushima. Will artworks continue to be produced on the topic in vast numbers, or will the industry's dark power play its magic in Japan too, given that the industry successfully cast a shadow onto the global *hibakusha* so far?

9 Censorship and the Nuclear Industry's Summertime Blues

After the nuclear accident at Fukushima, Aida Makoto created a wall-sized mixed media artwork in response to the sense of chaos and turmoil in Japan. For this piece, titled *Monument for Nothing IV* (2012), Aida superimposed nuclear-related messages, which had spread via Twitter, over a floor-to-ceiling light blue background: given our knowledge that an earthquake and tsunami were catalysts for the disaster, it evokes on the one hand an almost endless succession of geological stratums and on the other a gigantic wave—a wave of messages on Fukushima.[1]

The levels and types of media response to 3/11 were more intense than those for Chernobyl. In 1986, televised newscasts had begun to take precedence over print news. But by the time of Fukushima, the internet had overtaken older (and slower) media formats; reports and comments circulated by smartphones and ever-proliferating social networks were "going viral." Aida felt overwhelmed by the information and realized that "many Japanese just couldn't think anymore." This is the feeling he wanted the wall of Tweets to convey.[2]

One might think that the tsunami of news coverage and artworks representing the Fukushima accident escaped any censorship. On the contrary, the philosopher Kanamori Osamu has observed the nuanced ways in which the term *fūhyō higai* (harmful rumors) and *goyō gakusha* (scholar beholden to the government or who adjusts his/her judgment) were frequently used after the Fukushima accident. Kanamori explains one aspect in which "the norm of 'pure objectivity' is extremely hard to establish due to the very nature of radiation." He clarifies further by saying that although some false rumors were circulated, the overuse of the term "harmful rumors" blurred the distinction between real and fictional rumors. And yet, he continues, even if there were many different types of reactions in the scientific community, the fact that these terms contaminated the debates is revelatory of the collision between the political and scientific spheres. Kanamori

therefore asks: "Does this kind of feature reflect their historical origin, that is, the Manhattan Project? As this project had a military character, is it inevitable that the related sciences deriving from it possess an inclination to disrespect the value of human health and life?"[3]

The "harmful rumors" were a very important part of post-Fukushima Japan. They also resurfaced in Takamine Tadasu's *Japan Syndrome* (2012), a video about the dangers of nuclear reactors that directly references the American film *The China Syndrome* (1979) the latter telling the story of a near-disaster at a fictional nuclear reactor outside Los Angeles (and better explored later in the chapter). Takamine's *Japan Syndrome* is a video in which people reenact conversations about radioactivity (and of course about the "harmful rumors"). Takamine's approach, according to Kamiya, was effective because it exposed the various ways in which people responded to the problem.[4] The video was part of a solo exhibition at the Art Tower Mito in 2013 titled *Cool Japan*, which refers to the government's strategy to expand trade and cultural influence globally. The exhibition at the time also "critiqued the contradictory move taken by the government to possibly restart the halted nuclear plants despite unresolved issues."[5]

The collision between military/scientific and political power that Derrida had analyzed in the Cold War context for nuclear war is differently positioned in the context of Fukushima, however (and it lacks the military component as well).[6] Derrida's argument can be retrieved and extended for the discussion of nuclear catastrophe in this chapter just as it was in chapters 7 and 8 for uranium mining and corporate CEOs. The government-beholden scholars, who Kanamori calls the "mainstream faction," are driven by economic gains and hardly distinguishable from the corporate entrepreneurs. Kanamori narrows the target of his analysis even further, stating that the "mainstream faction" is a dominant class, benefiting from high prestige and a good salary. He sees it as self-deceiving as well, because scholars who think they act as good scientists and engineers are unaware of the issue in its most comprehensive level. Not all scientists are government-beholden scholars, but a sufficient number are, enough to be a phenomenon worth noting. Kanamori then concludes: "But isn't 'a self-deceiving false consciousness of a dominant class' almost the literal definition of 'ideology,' at least in its Marxist terminology?"[7] Thus science and ideology fuse in the realm of research; this is not a completely new phenomenon, as he also underscores.

Adding to the problem created by *goyō gakusha*, or the "mainstream faction" of scientists, is the crucial role played by the media. Despite the initial flood of 3/11 news stories, within several years the accident seemed to have

become invisible in the Japanese media—so much so that the philosopher Shin Abiko said that one has to go out of Japan to hear about Fukushima, and by now, it has disappeared from foreign media too. After Hiroshima, during the nuclearization of the Pacific and the exploitation of mines in many Native Indian lands and African nations, censorship was the nuclear-era government's dark power. We know that censorship existed at the time of Chernobyl. Is this censorship still a factor, in Japan and in other nuclear nations? Or, have exploded power plants become a once-iconic image now fallen out of fashion in the news? Was censorship at play at TMI, the first accident of the kind? And how did it unfold during Chernobyl?

Silence after Fukushima: Not at All Sexy, but "Barbaric"

By 2015, only three years after Aida's *Monument for Nothing IV*, news of the accident nearly disappeared from the Japanese press, as if its continued presence would interfere with the imminent reactivation of the nation's nuclear power plants. Surprised by the silence of the Japanese media regarding Fukushima in 2014, and by the government's obstinate decision to reboot the industry, the composer Sakamoto Ryūichi decided to reboot the concert series he had started in 2012 to raise awareness and funds. No Nukes, the title he chose for the series, featured bands such as Sakamoto's own Yellow Magic Orchestra (YMO) and Kraftwerk, who performed its notorious "Radioactivity" (1975) with updated lyrics: Fukushima was added to the series of catastrophes the group names in the song.

Aside from his role as founder of YMO, Sakamoto is also known for his participation in the British-Japanese-made film, *Senjō no Merī Kurisumasu* (*Merry Christmas Mr. Lawrence*, 1983), directed by Ōshima Nagisa. Sakamoto not only composed the soundtrack but also acted in the film, playing a commandant in a Japanese-run POW camp during World War II. The singer-songwriter David Bowie played a duty-bound but guilt-ridden Allied Forces major imprisoned in the camp. Amid the plot's continued threats of torture and execution, which become deeply embedded in the mind and alter the prisoner's will to survive, the film examines the complex relationship between authority and powerlessness: at first Sakamoto's character interprets Bowie's quiet defiance of brutality and torture as a sign of weakness. It is possible to project the film's examination of power onto a post-Fukushima context: the repeated announcements from government officials about the potential nuclear power plants' reopening were threats to the collective public mind, thus rendering powerless any hopes that the plants would remain shut down. And indeed they did not.

In the midst of Sakamoto's post-Fukushima antinuclear efforts and his No Nukes concert series the musician declared, "Keeping silent after Fukushima is barbaric."[8] That statement voices his opposition to the Japanese government's nuclear policies in the wake of 3/11. On the one hand, it challenges an assumption in Adorno's controversial postwar declaration, that "to write lyric poetry after Auschwitz is barbaric."[9]

On the other hand, Sakamoto's statement about keeping silent also brings to mind the song "Silence Is Sexy" (2000), from the experimental German band Einstürzende Neubauten, with the lyrics progressing and the song's message turning on itself: "Silence is sexy / So sexy / (…) / Silence is not sexy at all / (…) / Silence is sexy / So sexy / As sexy as death."[10] After Chernobyl, the Neubauten covered another well-known nuclear-related song, "Morning Dew" (by Bonnie Dobson, 1962)—a song itself inspired by the post-apocalyptical film *On the Beach* (1959) and recorded famously by The Grateful Dead, Jeff Beck, and Robert Plant. After Fukushima, silence is no longer sexy but "barbaric" for Sakamoto.

Sakamoto's No Nukes concerts are a logical extension of the 1979 concert with the same name, organized by MUSE (Musician United for Safety Energy), a collective of American musicians. Several months after the Three Mile Island accident, on March 28, 1979, in Middletown, Pennsylvania, MUSE mobilized recording artists such as Jackson Browne, Ry Cooder, Bruce Springsteen & the E Street Band, and Gil Scott-Heron, who sang "We Almost Lost Detroit" (1977). That song and its lyrics respond to John Fuller's book of the same name, published in 1975, which described the 1966 partial nuclear meltdown at the Fermi 1 plant, on lands leased from Detroit Edison, located south of the city:

How would we ever get over
losing our minds?
Just thirty miles from Detroit
stands a giant power station.
It ticks each night as the city sleeps
seconds from annihilation.
But no one stopped to think about the people
or how they would survive,
and we almost lost Detroit
This time.[11]

Several decades after the 1979 concert, anxieties about nuclear accidents are expressed. But on the one hand, TMI and Fukushima are not all together similar. The scale of the accident at Three Mile Island (TMI) was different from Fukushima: TMI is level 5, not 7, for instance, and there was

Figure 9.1a
Robert Del Tredici, *Lynn Ann Biesecker, fourth grade, Middletown Christian Day School, Middletown, Pennsylvania, USA, May 20, 1979,* photograph. Photo credit: Robert Del Tredici, the Atomic Photographers Guild.

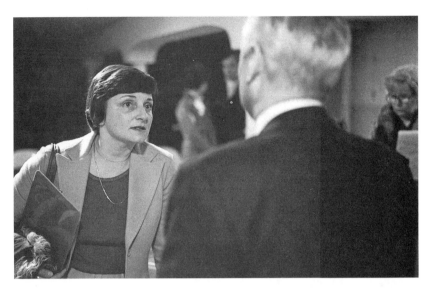

Figure 9.1b
Robert Del Tredici, *Nancy Prelesnik, Catholic nurse and Robert Arnold, vice-president of Metropolitan Edison at a public meeting in Hershey, Pennsylvania, USA, February 26, 1980*, photograph. Photo credit: Robert Del Tredici, the Atomic Photographers Guild.

no exclusion zone. In its aftermath, however, despite positive changes in overall nuclear plant operations, we will see in the next section how the dark power of the nuclear industry worked to conflate the agendas of politicians and industrialists, as well as the media, at the ultimate expense of TMI *hibakusha*, and that TMI and Fukushima have more in common than a No Nukes music festival.

For TMI, whereas there was not censorship of media coverage just as with Fukushima, the voices of the TMI residents still have but little visibility. To find these voices we can look once more to Robert Del Tredici and his photographic album *The People of Three Mile Island* (1980) (figures 9.1a and 9.1b). For this album too—as did Yamahata and the Marukis for Hiroshima, and as did Toyosaki for the Marshallese and radon *hibakusha*—Del Tredici supplemented his photographs with texts and interviews. He collected testimonies from people of different ages, genders, and occupational backgrounds. Just like the *hibakusha* poet Tōge, who elicited responses in verse from the children of Hiroshima, Del Tredici interviewed young people from the Middletown community. As one child stated after the accident: "Never again would this be the same beautiful, quiet countryside it once

was. The future of the area is still unknown."[12] Another response invoked a well-known cheerleading chant:

Two, Four, Six, Eight,
Who do we appreciate?
TMI, TMI, yaaay!
Two, Four, Six, Eight,
Who made us irradiate?
TMI, TMI, yaaay![13]

When Del Tredici visited the Middletown Elementary School, he was interested in the dreams children might have had in the wake of the near-disaster. "I had a bad dream about TMI. I thought it was TMI in our house. I thought the oven was it. It started to smoke. Everybody died in our house," said Maria H., a third grader. "I had a dream of TMI. I dreamed that some-body walked up to me and asked me to get in the thing to turn off the switch. And I said that I'd be glad to. I felt bad when the accident hap-pened," said Shirley T., also in third grade.[14]

A poignant testimony in Del Tredici's book from Nancy Prelesnik (figure 9.1b), a working wife and mother, illustrates men's biopower over women's bodies. Although she had discussed abortion in medical ethics classes while attending a Catholic nursing school, Prelesnik said, she was not prepared for what happened when she got pregnant despite using an IUD. She had only one week to make a decision:

I was used to [living in] very free and liberal states ... and I was taken aback when I realized how difficult it would be to get an abortion here. ... They would not con-sider mine a therapeutic abortion, though I may have had good cause or reason. I had been exposed to radiation.

... You are supposed to be happy through pregnancy, everything else matters. You can't think nice thoughts and you can't be without stress ... the food, the things you eat and drink. I try not to buy anything from Pennsylvania anymore. ... I would not want to be a young person looking forward to my first baby.[15]

Connected to the way male-dominated legislators and politicians regu-lated her body and the male-dominated nuclear power industry contami-nated her environment, are the feelings of shame and silencing that result from patriarchal biopower. Prelesnik explained that she felt "ostracized" for having had an abortion, and for having spoken out about it, but that an entire network of people with the same experience felt "like hostages." Her cat had developed leukemia, and after the painful experience of taking care of it during its illness she explained, "I couldn't handle having a baby that would develop leukemia or be deformed or deficient."[16] Censorship and

self-censorship are thus components present at TMI. Women and children are known to be more sensitive to radioactivity. The black strip that silences the female figure in Ikeda Ai's post-Fukushima *Sievertian Human—Wisdom, Impression, Sentiment* (2017) in figure 8.9 directly refers to the particular effect radioactivity has on woman's and children's bodies as explored in the previous chapter. Are the safety standards for radioactivity based on adult healthy men? How accessible are the tolerance levels for women, elders, children, fetuses, pets, and living beings such as insects and plants, if indeed they exist?

While there was no direct censorship of the media, the media did play a pivotal role at TMI in many ways, as did the prescient film *The China Syndrome* (1979). Released in the US only twelve days before TMI, the film was playing in theaters in and around nearby Harrisburg, the Pennsylvania state capital, some ten miles away. One line in the script "incredibly described a meltdown as having the potential to contaminate an area ... the size of the state of Pennsylvania."[17] Ten days before TMI—reflecting the timeliness of the film, and in anticipation of further public debate over atomic energy that the film was certain to spark—the *New York Times* published an article with the opinions of six experts it had commissioned to weigh in on the realism the film conveyed as well as its fictional aspects.[18] The film, however, did not (and was not meant to) give voice to the fears of schoolchildren like Maria or Shirley, or nurses like Nancy Prelesnik. But its release in theaters just a dozen days before the accident made the film so conspicuous that it overshadowed the plights of TMI residents at the time—and even today. At its core the film was meant to be a thriller in the conspiracy-theory genre, which examined the collusion of the government, the nuclear industry, and the media. An analysis of the art of the atomic age cannot but include an examination of the film's dark radiance.

Three Mile Island and the Media Stampede

The role of the media in nuclear-related matters is key to *The China Syndrome* (1979), so much so that it prompted Baudrillard in 1981 to state that the film "is a great example of the supremacy of the televised event over the nuclear event."[19] Jane Fonda and Michael Douglas co-star as (respectively) a TV news reporter and a cameraman; both characters witness and capture on film an emergency measure taken at a nuclear power plant after what looked like a very short earthquake, while conducting a routine interview. But the newsroom managers refuse to broadcast the crew's discovery. The cameraman presents the footage to experts who confirm that the incident

almost resulted in "the China syndrome," the epithet used to describe a reactor that melts through its concrete and steel containment material, and releases radioactivity into groundwater and the environment. The epithet itself invokes another expression, "digging to China" (dating to the nineteenth century in the West), which became popular in the late 1930s among children, whose endless shoveling of a hole in the ground prompted fantasies of coming out on the other side of the world.

The rest of the film depicts how the TV crew and a power plant technician (played by Jack Lemmon) pair up to shed light on the maneuvers and breach on safety standards of the corporate utility officials who operate the plant and the media barons who try to conceal the truth about the near-accident. The technician finally takes over the control room, gun in hand, and demands to be interviewed live on TV. The corporate powers-that-be distract him by setting off a false Code Red alert and sending in a SWAT team to kill him.

The plot shows the strikingly clear logic and hierarchy of the coldhearted corporate magnates portrayed in the film, who were ready to bulldoze anything that obstructed their ascension to power and their financial gain: if their treachery had not been stopped, the unsafe practices and faulty engineering at the root of the problem would have cost the lives of many workers and gravely affected residents in a potentially wide-ranging circle. In the film, a corporate hit man forces a soundman from the TV station, who is transporting the damming radiograph evidence to an official investigation, to drive off the road and down a steep cliff to his death. The film concludes with Jane Fonda's character restoring the truth (and her career) as she sheds a tear, live on primetime television. The final scene ends as Fonda's last words fade to a commercial, an effect, according to Baudrillard, that softens the truth she "exploded" in her character's role as a whistleblower. And yet, the film as a whole, he says—in an analysis I will return to later in this section—"finds its strength in filtering catastrophe, in the distillation of the nuclear specter through the omnipresent hertzian relays of information."[20]

The film can certainly be criticized for its caricatures: the cameraman's paranoia and susceptibility to suspect conspiracy theories, for instance, but most especially the industrialists, seen as road-rage murderers from one vantage point. Whatever retrospective comparison can be made between events in the film and those in real life, the partial meltdown of the TMI Unit 2 reactor occurred due to a defective valve and the mistaken judgment of an insufficiently trained technician, rather than the direct result of corporate cupidity.

These is no doubt that confusion over the near-disaster at the plant itself—considering that it had been previously advertised as accident-proof—led

to near-chaos. Some scientists had calculated the possibility of hydrogen bubbles causing a dreadfully lethal explosion (before invalidating their calculations). Then, public relations efforts with mixed and contradicting messages about safety by utility officials, nuclear experts, and state officials—all of which were filtered through the media—resulted in 140,000 people fleeing their homes. Finally, President Jimmy Carter toured the control room of the reactor on April 1, 1979, and, while being photographed with the pant legs of his suit tucked into floppy yellow safety boots, he exuded confidence that things were under control.[21] The reactor, however, was shut down within a month, and its fallout of anxiety has had a residual effect on the US nuclear power industry ever since.

In retrospect, given new federal rules and regulations imposed on the nuclear industry, as well as continued accusations that the industry was less-than-transparent, *The China Syndrome* still holds interest today. It served at the time of the TMI accident not unlike a voice of authority behind the media coverage; some reporters were assigned to the event as if the credential that qualified them most for the job was having seen the film.[22] Spencer Weart also analyzed the film's role in news coverage of TMI. He commented that hundreds of reporters "dominated" the headlines for a week, and their rhetoric adopted narratives "prepared by the antinuclear movement," and that the film was central to the reporting of the events. Some reporters even made hyperbolic references to the end of the world, Hiroshima, and Frankenstein.[23]

The film's received more than a passing mention in a 1980 report issued by Nuclear Regulatory Commission (referred to as the Rogovin Report). It stated that the "cumulative effect of the film on the public perception" of TMI, and the fact "that it sensitized readers and watchers, as well as reporters, editors, and commentators, to the implications of a nuclear accident and the possibility of a core melt, is a thesis beyond argument."[24] This resulted in a "media stampede," according to the report. TMI journalism was also judged as not always "enlightened," but as a result of its abundance "the nuclear industry was abruptly stripped of whatever mystique it had left from the old days of the Manhattan Project." In its final assessment of the media response to TMI the report stated: "Instances of inadequate research, inaccuracy, factual cornercutting, and overkill marred the performance of some of the newspeople. But the story that got out was basically pretty straight: this was a serious and avoidable accident. It could have been much worse. It could have happened in a lot of places." The report then projected that barring basic changes in the industry and its regulation, it could happen again. But the fact that it happened "in the glare of the media," might insure that such an accident would not happen in the future.[25]

The China Syndrome itself alluded, even if only in part, to the functioning of news agencies but also made grandiose claims on the power of news coverage. At the beginning of the film, the two news directors congratulate themselves for assigning a routine nuclear energy story to a woman they count on as much for her sex appeal (thus boosting ratings) as for her professional docility. Both men were confident that "in any case, she will do what we tell her!" But after the accident at the plant, the refusal of her superiors to broadcast her reportage leaves her in a dilemma, stuck between exposing the nuclear utility company's breach on safety (and as a result, saving lives) and her desire to keep her job and advance her career. Circumstances (and her work ethic) push her to rebel against the TV station's position, but in the end the film's screenwriters downplay her tough choices as ultimately unecessary: the news directors' initial refusal had been motivated by legal constraints regarding broadcasting shots of the control room, they claimed, not by any will to conceal "truth."

For Baudrillard the collusion of the media and the nuclear industry in *The China Syndrome* cannot be more clear: "The essence of the film is not in any respect the Watergate effect in the person of Jane Fonda, not in any respect TV as a means of exposing nuclear vices, but on the contrary TV as the twin orbit and twin chain reaction of the nuclear one." Furthermore, just like Sontag claimed that science fiction of the Cold War era numbs us to nuclear realities, Baudrillard points out in *The China Syndrome*, the catastrophe does not happen and is not meant to happen: "instead of stupidly exploding" it must "be disseminated, in homeopathic, molecular doses, in the continuous reservoirs of information. Therein lies the true contamination: never biological and radioactive, but, rather, a mental destructuration through a mental strategy of catastrophe."[26]

In the case of nuclear matters, the media are at once absorbed into the nuclear industry as well as functioning as one of it vital arteries, or its "twin orbit." As a real-life event in itself, TMI remains a radioactive trace in consciousness: allusions to it can be detected in the background of films such as *X-Men Origins: Wolverine* (2009) and Spielberg's *Super 8* (2011), and in many other cultural productions.[27] The involvement of the media and *The China Syndrome* in shaping TMI's legacy cannot be denied.

From TMI's Media Stampede to Chernobyl's "Fiasco Mediatique"

Censorship did not obstruct TMI's media stampede like it effectively halted press coverage in the days after Chernobyl. We've already seen in previous chapters how the impacts of censorship played out postwar and during the Cold War era. Censorship undeniably unfolded (more or less successfully)

to similar effect in and outside of Soviet Russia for the civilian applications of the technology.

In the beginning of *Chernobyl: Confession of a Reporter*, when Igor Kostin shared his memories of the actual event, he recalled how news bureaus were buzzing all over the world, and consequently it would have been impossible for President Mikhail Gorbachev to conceal the catastrophe much further. The president gave accreditation to only five Soviet media outlets. Only one of those revealed the accident three days later; even the official Soviet newspaper refrained from publishing any photograph and made one noncommittal statement: "An accident occurred at the nuclear plant in Chernobyl. One of the reactors has been damaged. The measures have been taken. A governmental commission is inquiring."[28] Gorbachev later explained that he'd received only scant if not inaccurate information about the accident from plant officials; the scenario strangely echoes complaints from the governor's office in the US about being deceived in the hours and days after Three Mile Island. Gorbachev said he'd been told that the reactor was "absolutely safe, it could even be set up on the Red Square. It would be like a samovar, like putting a kettle on the Red Square."[29] But Kostin knew that a US satellite had taken a picture of the explosion; he'd been listening clandestinely to the *Voice of America* radio broadcast to learn more about the accident: "There were hundreds, even thousands of dead. I was devastated. Neither the government, nor the scientists had mentioned a major nuclear catastrophe." His own agency, Novosti, finally published one photograph from the roll of film he had taken of the damaged reactor—the only shot whose image was not obliterated by radiation. But once he was accredited, the agency refused to send him a car to return to the site because "a journalist is replaceable, but a car … ."[30]

The Ukrainian politician, journalist, and activist Alla Yaroshinskaya, who became part of the Supreme Soviet (parliament) a few years after the accident and also was an advisor to President Boris Yeltsin, acknowledged this level of censorship when she published excerpts from many "secret" documents issued by the USSR Health Ministry. In one of them, for example, she identified three "fatal paragraphs."[31]

(4) Classify as secret all information about the accident. (8) Classify as secret all information about the results of medical treatment. (9) Classify as secret all information about the degree of radioactive injuries to the personnel taking part in the liquidation of the consequences of the accident at the Chernobyl Nuclear Power plant.[32]

When such policies were enforced, she said, they struck "fear in the people in charge of magazines, the radio, television, and the cinema." Yaroshinskaya then detailed how documentaries and films on Chernobyl, such

as Rollan Sergienko and Lyubov Sirota's *The Threshold* (1988), were held for months in dusty corners of government offices until inspectors could "dissect" them.[33] Sirota's poem "To Vasily Deomidovich Dubodel" (a Chernobyl victim) responds to such censorship and silencing efforts:

But thousands of "competent" functionaries
count our "souls" in percentages, (...).
They keep trying to write off
our ailing truths
with their sanctimonious lies.
But nothing will silence us!
even after death,
from our graves
we will appeal to your Conscience
not to transform the Earth into a Sarcophagus![34]

As Ignacio Ramonet once argued, democracy is not possible without a strong web of communication, but controlling the media does not necessarily guarantee controlling public opinion when an issue or event is clouded by suspicion.[35] Strangely, Ramonet, a media specialist in Spain and France, did not analyze the very specific ways in which the cloud of radioactive suspicion hovered over French soil after Chernobyl, instead preferring focusing on other global media frenzies such as the Monika Lewinski's scandal for example.

And yet, the debate about Chernobyl's spread of radioactivity into France, once qualified as a "fiasco mediatique" (a media fiasco),[36] has turned into a decades-long controversy involving lawyers, nuclear experts, the media, an association of victims (many suffering from diseases of the thyroid), NGOs, and the government. From the start, very little official information was available until a few journalists realized that other European countries had placed restrictions on food and were distributing iodine tablets.[37] Professor Pierre Pellerin, under the auspices of the Ministry of Health, explained that Chernobyl posed no danger to the French population. There was only one official source of information, however: the government. Two weeks later, some commentators on national TV finally announced, "We were lied to!"[38] Pellerin and the government were compelled to release the radioactive readings, but only in 2004 did an actual map of the readings became available, showing slightly higher numbers than formerly disclosed.[39] Quite predictably, a series of lawsuits ensued.[40] In France, the CRIIAD (Commission for Independent Research and Information about Radiation) was formed, in May 1986, in order to obtain independent data regarding the Chernobyl radioactive plume.[41]

Although these enquiries are still debated, relatively few visual artists in France have chosen to response to them. And, for a nation with so many power plants and such a strong film industry, nothing comparable to the star-studded *The China Syndrome* has come out of France. Neither Baudrillard nor Derrida wrote about Chernobyl, Moruroa, or France's nuclear radiance. The dearth of response reflects not so much a lack of interest as it does the presence of censorship (and self-censorship) that stems from conflicts of interest between media conglomerates and the nuclear industry, and less-than-transparent postcolonial policies concerning the mining industry, as well as the nuclear tests in French Polynesia and Algeria—scenarios cited in chapter 7 with the comments of Pierre Vermeren.[42] Typically, even in 2015, the special issue on art after Fukushima in *Art Press*, one of France's leading art magazines, had not one mention of Moruroa, let alone the mines in the lands of the Natives in Canada, and in Niger and other African nations.[43] Censorship is thus not to be found in Soviet Russia alone.

White Fluffy Cloud Covers in France

There are nuclear-related artworks in France, however, though they surface on another plane, perhaps with less visibility than in other atomic landscapes. Since 1999, the French theatrical company Brut de béton has staged a series of Svetlana Alexievich's Chernobyl monologues, in homage to the civilian and military liquidators who sacrificed their lives for the safety of other Europeans. The company, which fosters freedom of expression for the forgotten or excluded, even staged a reading in front of reactor number 4 at Chernobyl.

While the staged monologue series gives visibility to the voices of Chernobyl's victims in France, the German-French artist Jürgen Nefzger brings visibility to the nuclear power plants themselves. In 2003 Nefzger began to take pictures of power plants in France, the UK, Germany, and other parts of Europe for his photographic series *Fluffy Clouds* (2003–) (figures 9.2a–c). The series evokes the genre of pastoral landscape painting, an idealized portrayal of humankind's dominion over nature and the triumph of taming and developing of the land. Nefzger had in mind, however, a specific goal by focusing on nuclear development. The fact that very few people have actually seen a nuclear plant with their own eyes, he says, and not through the lens of the media, seems ironic given our ubiquitous references to living in the atomic age. Nefzger's intention therefore cannot be mistaken: "As the real threat has slipped into the invisible, I try to show how people are growing oblivious to the inherent threat linked to nuclear energy facilities."[44]

Figure 9.2a
Jürgen Nefzger, "Kalkar, Germany," 2005, from the series *Fluffy Clouds*. Courtesy of the artist and Galerie Françoise Paviot, Paris.

Another of the few nuclear-related artworks in France is the film *Grand Central* (2013), directed by Rebecca Zlotowski, which focuses on nuclear plant workers in a remote part of France. Its title is given in English to take advantage of a play on words involving *centrale*, which in French can also mean "power plant" and the famous train station in the heart of New York City, one of the biggest industrialized metropolises. The film's main character, Gary, is an unskilled, temporary worker sent to assist in decontaminating the plant, who finds himself at the core of a nuclear accident and a love triangle. But love, like science, is about taking risks, about power and loss of control; to play on the message in the film's trailer, no one is safe from accidents and melting hearts.

Grand Central represents multicultural France by casting Tahar Rahim—a French actor of Algerian descent—as Gary, and hiring other nationally and ethnically diverse actors who were praised by *Le Monde* for bringing an "unprecedented energy in the French cinema, that we hope will be renewable."[45] The film even includes a homosexual relationship on the periphery

Figure 9.2b
Jürgen Nefzger, "Sellafield, England," 2005, from the series *Fluffy Clouds*. Courtesy of the artist and Galerie Françoise Paviot, Paris.

Figure 9.2c
Jürgen Nefzger, "Nogent-Sur-Seine, France," 2003, from the series *Fluffy Clouds*. Courtesy of the artist and Galerie Françoise Paviot, Paris.

of the plot. Given that France conducted nuclear tests in Algeria, the scenario was promising. Yet *Grand Central* does not touch upon the Chernobyl cloud, let alone the ramifications of the French nuclear industry in other parts of the world (including Algeria). But for many outside the border of Western society's bubble, giving visibility to issues that concern the entanglement of nuclear technology and colonial legacy takes greater precedence than a story about love between a mixed-raced couple. When the film was reissued in theaters after the Fukushima accident, however, the filmmaker explained that she intended the film to say more about love than about nuclear catastrophes.[46] Her film, however, still asks relevant questions about labor regulations in the nuclear industry, just like the novel by Elisabeth Filhol that inspired it, *La Centrale* [The Power Plant, 2010]. Filhol's book directly questions the practice of employing partially trained temporary workers in a nuclear environment, as expressed in the voice of a job seeker: "Interim agencies sprout around power plants like mushrooms"; after months of hard times you let the facility (i.e., the plant, but also the easiness of getting hired) take you: you enter, the contract's signed.[47] The novel was based on an actual minor accident that happened because of undertrained temporary workers in a power plant—similar to the problem at the heart of the TMI accident.

These local realities sprouting around the nuclear facilities must be given visibility. As we've seen, however, no artistic depictions in continental France of either AREVA's (now Orano's) uranium mines in Canada, Niger, or Kazakhstan, or of the effect of the nuclear tests in French Polynesia and Algeria, rise to the surface. But for a country in which about 70–80 percent of its energy comes from nuclear power, it is surprising to see that Chernobyl's radioactive clouds and its past nuclear tests have been uninspiring. Although direct governmental control over the press dissolved in France in the late 1970s and officially in 1982 (four years before Chernobyl), France's own nuclear accidents—at Saint-Laurent-des-Eaux (Saint-Laurent) in 1969 and 1980, both graded at level 4—were kept secret for a very long time, and they still receive scant news coverage today.[48] Censorship's dark power lingers. More than radioactivity's invisibility, this is what challenges the arts, and not just in France or in the countries of the former USSR.

Summertime Blues and Thermonuclear Gardens

If, after the 3/11 earthquake and tsunami—and in the midst of the culture's obsession with social media outlets like Twitter and Facebook—hiding the Fukushima accident was not an option for Japan, finding reliable information amid the ensuing media chaos was a challenge. One of Ōtomo's

motivations for starting Project FUKUSHIMA! was to be able to broadcast information directly from the city of Fukushima itself, instead of filtered information from Tokyo. As stated earlier, after the accident, all sorts of information circulated, the media were saturated, and even experts disagreed.[49]

For Ōtomo, the media did not act as counter power and the idea to "customize" news coverage was sparked when the announcement of a spontaneous protest against the power plants, attended by about 15,000 people in Tokyo a month after the catastrophe—and broadcast via Twitter messages alone—was ignored by the mainstream Japanese media. The excuse, after the fact, was that no press release had been issued for the protest, and that such "amateur" events didn't qualify for coverage.[50] Worse, rumors started to circulate, according to Ōtomo, like the one at Fukushima about the existence of an ongoing plan at Tokyo Station that would "put badges on just the people from Fukushima."[51] That troubling report evoked a morbid analogy to the stigma Jewish people endured when forced to wear an armband with a yellow star. Another rumor purported that Fukushima women were now unmarriageable (because of radiation-caused sterility), as if Fukushima men were somehow left untouched. This brings to mind the group of *hibakusha* women called the "Hiroshima Maidens," and the fundraising efforts on their behalf around the time of the *Lucky Dragon 5* accident. Having been disfigured as schoolgirls, these women's fate was said to depend on getting reconstructive surgery in the US, otherwise they would be unable to marry. Here, too, we must wonder why young men were not included in the group?

Specters of former radioactive traumas still haunt the psyches in Japan. Rumors, about the badges for instances, were spreading in Fukushima like "wildfire," recalled Ōtomo, and "the situation was so much worse than the rumors being spread in Tokyo. I think this is very symbolic. It means that people are at a loss, and that they feel isolated and forsaken."[52] Ōtomo's decision to broadcast directly from Fukushima was thus seminal, given "the problem in Japan … that most of the media are owned by power companies, so there was no way for them to report honestly."[53] Just like Chomsky and Vltchek had noted for the West, and Vermeren for France, large corporations own most media outlets.[54] Even today, the nuclear apparatus still hold its dark power.

One typical and notorious example in Japan of media-giant censorship occurred following the Chernobyl accident when Toshiba EMI told the Japanese band RC Succession to drop two songs from its forthcoming album, *Covers*, that included covers of Elvis Presley's "Love Me Tender" and, most famously, Eddie Cochran's "Summertime Blues." The lyrics had been transformed by antinuclear and seemingly clairvoyant messages.[55] A version of

"Summertime Blues" by the group's lead singer Imawano Kiyoshirō has since become a classic of antinuclear militancy in Japan:

The hot summer is on its way
Everyone is running out to the beach
When I went for a swim at a quiet spot
Well there was a nuclear power plant
I just haven't got a clue what it's for.
Little Japan's summertime blues
Hot smoke was coming out of the top
The Tokai Earthquake is on its way
But still there are more and more of them
They keep on building nuclear power plants
I just haven't got a clue who they're for.
Little Japan's summertime blues
Well the cold winter is on its way
It looks like lots of your hair's been falling out
But they still keep saying on TV:
Japan's nuclear plants are safe.
I just haven't got a clue, there's no truth to that.
This is the last summertime blues.
(…)"[56]

Toshiba EMI's parent company, Toshiba Corporation (one of Japan's major nuclear engineering firms) had supplied, along with General Electric and Hitashi, some nuclear reactors for the Fukushima power plant. Toshiba EMI cancelled the album and refused to release the singles. But the record label Kitty released the album in 1980, and Imawano Kiyoshirō went on to perform in other bands such as The Timers, singing other antinuclear songs like "Meltdown":

My brain is melting,
my cerebrum too,
my cerebellum too, down, down, down,
meltdown,
…
… in the power of science I believed.[57]

The effect of censorship today is still a topic of debate. According to Yamamoto Akihiro in *Kaku to nihonjin* [Nuclear and the Japanese], censorship was evident but sporadic: many other musicians produced antinuclear songs, such as the Blue Hearts with "Chernobyl" (1991), Sano Motoharu with "Keikoku doori keikaku dōri" [As Warned, As Planned, 1988], and the Bakufū Slump with "Suparu" (1988), in which the group shouted the word "radioactivity" on stage.[58] ("Bakufū" means "bomb blast" or "shock

wave.") Yamamoto also recalled that some famous teenage magazines such as *Takara-jima* [Treasure Island] spread antinuclear messages by interviewing celebrities like Sakamoto's YMO (who later organized the No Nukes festival in Tokyo), which gave space for reflection to a lot of young people.

On the other hand, Manabe Noriko explained that the Blue Hearts released their album independently after pressure from their own label, Meldac, which is a sub-label of Nippon Crown and is partly owned by Mitsubishi Electric (another nuclear company). Manabe lists other blatant instances of self-censorship on the part of radio broadcasters, sometimes underscoring the odd ways in which censorship failed: after the problem with his album *Covers*, for instance, Imawano performed songs about free speech during live programs in summer 1988 (to free himself from the label companies), but those songs were later released by Toshiba EMI, leaving Imawano to assume that the executives had probably not bothered to listen to them.[59]

This censorship therefore echoes the pre- and postwar censorship we've seen in previous chapters—although without the intervention of the militaries. In the US, the difficulty to exhibit Hiroshima-related photographs is still present to date, as I explored in part II. Another example of thwarted efforts to exhibit occurred with the American artist Sheila Pinkel's *Thermonuclear Gardens* (1982–1991), a project she planned to show in federal buildings. As part of her work she wanted to research the military-industrial complex and military contractors, but she explained how little information she could find from government or media sources.[60] More instances than these few most likely exist, waiting to be given visibility.

As we've seen regarding military applications of nuclear technology, the recurrent issue of state or military censorship has clear goals. To paraphrase Sontag again: if governments had their way, war photography and poetry would elicit support for the sacrifices soldiers make in war but not portray war's cruelty and reality.[61] In the twenty-first century, freedom of expression regarding the military (as much as the civilian) use of nuclear technology is still being negotiated in many parts of the world. In such circumstances, it is therefore understandable that more artists venture into committed/political practices and attempt to find for themselves in Chernobyl and Fukushima ways to respond to the nuclear age.

The Nuclear Taxonomy: Of Mice and Men

Beginning in the late 1980s, the Swiss artist Cornelia Hesse-Honegger decided to see for herself the effect of radioactivity on living beings that

no one had cared to study: bugs. She collected and drew samples of insects, first where Chernobyl's radioactive cloud had traveled in Sweden and Switzerland (in Ticino next to the Italian border), then in Chernobyl, next at the Sellafield and Krümmel sites (Germany), then in TMI, and finally in Fukushima at two faulty plants. Her radioactive terrain is wide (figures 9.3a–c).

As a result of her travels Hesse-Honegger made an unequivocal assessment: all locations host deformed if not sterile bugs. The drawings of the victimized bugs themselves serve as an indirect statement suggesting that there are still voices not fully heard that must receive equal attention, in addition to the ones already underscored. In her writings, Hesse-Honegger recalls some scientists underplaying the impact of radioactivity on insects, if not outright suppressing the information (at least in the late 1980s).[62] But in the opening statement for the artist's catalog, *The Future's Mirror* (2000), Inge Schmitz-Feuerhake, a professor of experimental physics at Bremen University, declares: "More than 60 years after American geneticist Herman J. Muller had shown that ionizing radiation induces malformations, there are still many experts … who will deny such effect are possible."[63] The art/science compound is here again undeniable, although it exists in an unstable binary where the separation between the two fields is not clear-cut. The recent research of the scientist Timothy Mousseau on birds and bugs in Chernobyl and Fukushima strangely echoes Hesse-Honegger's nuclear taxonomy in drawings.

The work in both science and art is crucial. Against a 2006 International Atomic Energy Agency (IAEA) report on Chernobyl, in which their thorough investigation was said reveal that wildlife were thriving twenty years after the accident, Mousseau, along with many other colleagues in Russia and Japan worked to give visibility to radioactivity's impact on Chernobyl and Fukushima's wildlife. He explained that some species became locally extinct in some areas due to the radioactive levels while others developed a resistance, but only to low-dose radiation.[64] On the other hand, the IAEA acknowledged a disastrous effect of radioactivity on animals and plants too, which they defined as an "environmental stress." But, they went on to explain, "when the stress is subsequently reduced and sufficient time passes, recovery occurs and the ecosystem again regains stability."[65] Art, like science, can be a revealing, bringing attention to "voiceless" wildlife through necessary efforts made in these respective fields.

Some documentaries with pristine and aesthetically pleasing images describe Chernobyl and the exclusion zone as a "post-nuclear Eden," where nature "reclaimed the land, reversing the effects of hundreds of human developments," an odd statement suggesting that humans are not animals

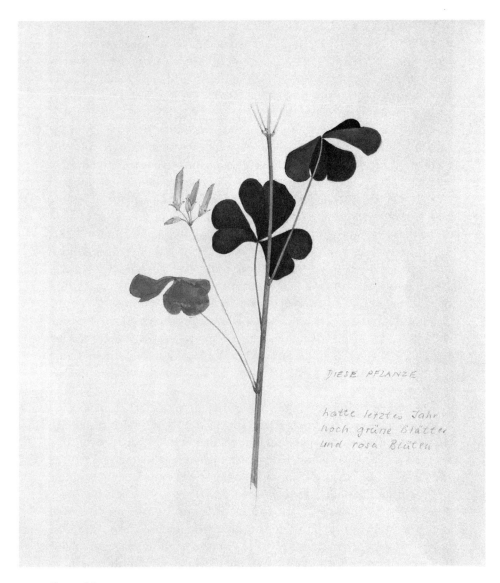

Figure 9.3a
Cornelia Hesse-Honegger, *Clover Turned Red with Yellow Flowers Instead of Pink Flowers Like the Year before Chernobyl, from Gysinge, Sweden.* Color sketch, Gysinge, 1987.
© 2017 by Pro Litteris, Zurich & JASPAR, Tokyo C1466.

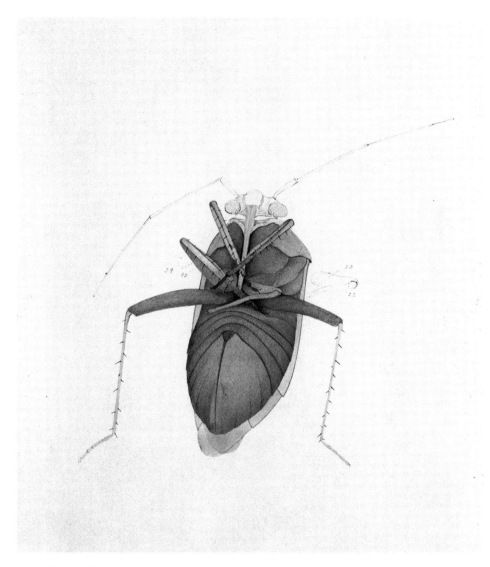

Figure 9.3b
Cornelia Hesse-Honegger, *Soft Bug from Pripyat, Ukraine, 1990*. Watercolor, Kiew, 1990. © 2017 by ProLitteris, Zurich & JASPAR, Tokyo C1466.

Figure 9.3c
Cornelia Hesse-Honegger, *Two Leafhoppers from Shinobu Spa Near Fukushima City.*
Double feeler on the left leafhopper and the right one is too small with a distur-
bance on the thorax. Watercolor, Zurich, 2017. © 2017 by Pro Litteris, Zurich &
JASPAR, Tokyo C1466.

and "naturally" part of nature, and that deserted radioactive lands are "better" than inhabited ones.[66] That said, the impact of human activities on the planet cannot and should not be undermined.

It precisely here that the notion of a "nuclear anthropocene," as explained by Peter C. van Wyck and also by Ele Carpenter, is relevant. Van Wyck observed that the word "Anthropocene" entered the Oxford English Dictionary in 2014, between "anthropism" and "anthropocentrality." Van Wyck puts the term, which is the name given to our current geological era (marking the period in which humans have had an environmental impact on Earth) into context: "The vast and incommensurable conflation of timescale that leads from Pleistocene to Holocene to Anthropocene reaches a point of parochial compression with the current proposal that the Anthropocene, or let's just call it the late or post-Holocene, commences with nuclear practices."[67]

The empirical work of Hesse-Honegger and Mousseau reveal different conclusions regarding the "nuclear anthropocene" than the IAEA and the "post-nuclear Eden" documentaries. This anthropocene was also made visible by the photographs of the direct aftermath of the accident by Kostin, and by Del Tredici (figure 9.4), the latter showing reindeer carcasses in a meat-locker in Swedish Lapland. The meat from these carcasses is too radioactive for human consumption; the reindeer ate moss contaminated by fallout from the Chernobyl cloud, which raised the radiation level as high as 16,000 becquerels per kilo (300 becquerels per kilo is the maximum allowed in Sweden). Slaughterhouse workers refer to the carcasses as "the becquerel reindeer."[68]

In Japan, Homma Takashi, framed the radioactive mushrooms collected in the forest of Fukushima, making another subtle analogy between atomic mushroom clouds and post-Fukushima radioactive mushrooms (figures 9.5a–d).

In one of the monologues collected by Alexievich, Anna Badaeva spoke about her garden, filled with so many dead moles; her son notices that the May bugs and maggots had not come out, and the bees not left their nest for several days: "The radio wasn't saying anything, ... but the bees knew."[69]

Art's Revealing and Science's Saving Power

In post-Fukushima Japan too, caught between a past media tsunami and the silence that followed, it is not surprising that artists, scientists, and even journalists look for their own data and create their own version of the events. *Ichiefu* (1F, 2014), by Tatsuta Kazuto, is a unique work that sets

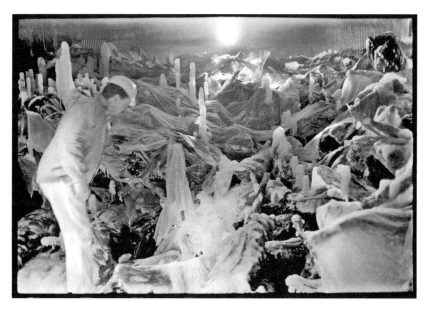

Figure 9.4
Robert Del Tredici, *The Becquerel Reindeer, Harads Same-produktor, Harads, Lapland, Sweden,* December 3, 1986, photograph. Photo credit: Robert Del Tredici, the Atomic Photographers Guild.

out to portray the government's lack of transparency about power plant operations.[70] The Japanese manga artist signed on as a temporary worker at a plant to see the situation for himself, but he chose to use the pen name Tatsuta Kazuto to publish his work. The anonymity allows him to re-enroll with the contracting company for as long as the work is available. *Ichiefu* depicts the harshness of the job even in the smallest details, explaining for example how difficult it is to scratch his nose in the heat of the summer when sweating under his protective suit, and the inconvenience of not being able to remove his mask, for evident safety reasons. In another part of the book he tells how he and his co-workers almost died in a car accident when a bull unexpectedly crossed the road while they were heading back to the plant, giving perspective to the fragility of life and easiness for an accident to occur even in daily life; a large number of cattle, herds and pets were left behind after the evacuation. The author's aim, however, was not to tell "the truth" about Fukushima, but to tell *his* truth: the daily life of a worker.

The manga's complete lack of female characters is actually a function of the real working life Tatsuta depicts. We've already seen several

Figures 9.5a–e
Homma Takashi, from the series *Mushrooms of the Forest*, 2011. Type C print. © Takashi Homma.

atomic-themed fictions of pre-Hiroshima and the Cold War where the female character was the metaphor for the atom. Even if accidental on the part of the author, the absence of women in *Ichiefu* highlights the still-patriarchal atomic world of male CEOs, engineers, and workers. Whether it was his purpose or not, Tatsuta does not depict anything but life inside the plant, so nothing about local opinions or the world outside is given enough visibility, such as antinuclear protests and the associations formed by mothers and housewives to educate and support each other, whether about food safety or anxiety. Because Tatsuta focuses on the workers almost exclusively, his manga series, published in three volumes so far and numbering hundreds of pages, includes less than a dozen vignettes in which a female figure appears.

Figures 9.5a–e (continued)

In the two volumes of her manga *Luminous: Child of Light*, Erika Kobayashi retraces the history of radioactivity and key developments of the atomic age using an inclusive approach—from Marie Curie to Fuller's Radium Dance, to the Radium Girls, Rutherford, Szilard, Fermi, Hiroshima, Bikini, and Fukushima. In that sense, and even without discussing the power plant, she makes visible another truth about the atomic age: the predominant gender imbalance in the use of the technology. Tatsuta and Kobayashi use their mangas to depict reality though through different lenses—and they wind up revealing the same truth.

Given the particularity and detail revealed by Tatsuta's drawings—and keeping in mind that Hesse-Honegger's work met with criticism for not depicting "reality"—one can understand why some have been suspicious about the information communicated in his manga. Tatsuta's brief depiction of the role of the *yakuza* (Japanese mafia) in the cleaning of the plant

Figures 9.5a–e (continued)

directly rebuffs claims of the journalist Suzuki Tomohiko, first made while he was working for NHK, Japan's major public broadcasting organization. In a similar fashion to Tatsuta's anonymous employment, Suzuki went undercover with a camera in the Fukushima power plant to investigate the role played by the *yakuza* in day-to-day cleanup operations. In his subsequent book he explains that his investigation felt like a calling: he liked the song "London Calling" (1979) by British punk band The Clash, he said, and it was now Fukushima calling.[71] The following excerpt from the "London Calling" lyrics takes a fatalistic approach to a nuclear doomsday:

The ice age is coming, the sun is zooming in
Engines stop running, the wheat is growin' thin
A nuclear era, but I have no fear
Cause London is drowning, and I, I live by the river.[72]

Figure 9.5a–9.5e (continued)

The book is an incriminating view of how the companies involved managed the crisis and how the *yakuza*, long-rumored to be tied to the industry, were involved. As the philosopher Kanamori Osamu observed regarding scientific reports after the accident: pure objectivity is hard to attain, but it is not impossible to get close to it. Some *yakuza* or former *yakuza* may have come to their job the "regular" way, recruited by the Tokyo Electric and Power Company (TEPCO). Tatsuta refrains from making links between the nuclear industry and organized crime, although his stance is far from being pro-nuclear despite some surprisingly naïve comments. For example, when

a character thinks that anti-nuclear groups must be happy that the cleaning of the plant will take a long time, otherwise they would fall short of anti-nuclear arguments. Suzuki's coverage, on the other hand, is sensationalist, and concerns itself just as much with unsafe conditions as with shady contract dealings. It is certain however that from the standpoint of philosophical debates, and even after the advent of absolute scientific truth, truth as a philosophical question is still being discussed today and is very much in the public mind.

After the accident, some practitioners in the sciences too went in search of truth by making personal decisions with public impacts. Right after the accident, Kimura Shinzō decided to quit his job for the National Institute of Occupational Safety and Health, as a therapist who treated radiation workers, because his boss prevented him from going to Fukushima.[73] Yet he wanted to take measurements for himself. Kimura, who helped Ōtomo Yoshihide to safely organize Festival FUKUSHIMA!, had done some research on the health of Chernobyl's victims. With the help of the NHK, Kimura produced a unique map of radioactivity published in *Hottosupotto* [Hot Spot].[74] The book divulges that radioactivity was detected on the campus of Hiroshima University (840 kilometers from Fukushima) in collected samples of tree leaves. Kimura also worked in collaboration with Takasuji Toshihiro of Nagasaki University, who detected radioactivity in Nagasaki that had come from Fukushima.[75]

As the nuclear industry in Chernobyl had done earlier, the Japanese nuclear companies running Fukushima created their own clouds of suspicions, even in the midst of the information tsunami. And, similar to the ways in which uranium mining had tried to conceal the radioactive damages in open-pit and underground sites, the failure of the industry to acknowledge the wounds they caused is both the source of its power and of its demise. Here too, Adrienne Rich's poem "Power" (see chapter 7) is more than ever relevant, especially this line referring to Marie Curie: "her wounds came from the same source of her power." In the rubble of this more recent nuclear wound, Fukushima, what remains to acknowledge is why the nuclear industry as a whole seems not to learn from their past mistakes.

The Capitalism Sublime

In "The Sublime and the Avant-Garde," the philosopher Jean-François Lyotard addressed the fundamental tasks "of bearing pictorial or otherwise expressive witness to the inexpressible." When connecting Barnett

Newman's essay on the sublime to the sixteenth-century analysis of the feeling of the sublime in Burke and Kant, Lyotard discussed how the concept of the sublime became associated with "contradictory feeling—pleasure and pain, joy and anxiety, exaltation and depression" as modern concepts in esthetics took shape; then he declared how "the sublime may well be the single artistic sensibility to characterize the Modern." For Lyotard, the fact that art exists, "now and here … where there might have been nothing at all, … is sublime."[76] As he carried his examination further, he also stated that in the arts, the sublime is now experienced in a capitalist economy by speculating on art rather than in art itself; art is a market, and not all artists are free from the "taste" of the public or from their intermediaries in the system of galleries and institutions. Here is another meeting point between art and science.

In the nuclear age, the impact of capitalism on the application of nuclear technology is undeniably incommensurable. The nuclear lobby is perhaps one of the strongest, especially given ongoing debates about climate change. The economical stakes are indeed stunning for the nuclear industry. On the one hand, the industry must overcome harsh criticism and challenges from competing alternative technologies. In the online business section of the *New York Times* in 2014, a video titled "Lessons from Fukushima" featured members of the industry explaining how they updated safety measures but, most importantly, how they were forced to shut down several reactors for two main reasons: the unpopularity of the industry, and the impossibility to compete with cheaper electricity provided by natural gas.[77] On the other hand however, the investments and contracts generated by the industry are absolutely great. The French nuclear giant AREVA (Orano), for example, signed a contract in 2015 with Brazil worth about 75 million euros.[78] But the numbers are far more astonishing than that: although in the 1960s the electricity generated by nuclear power was described as "too cheap to be metered,"[79] by 2015, AREVA announced a loss of 4.8 billion euros,[80] and EDF (Électricité de France) estimated that the necessary renovation and safety updates of the entire national nuclear plants (strangely called in French the "nuclear park") required an investment of about 55–70 billion euros.[81] In addition, and in order to avoid oil dependency, France had already invested about 17 billion euros before the Soviet accident into the "nuclear solution," all the while extracting wealth in Niger with unfair neocolonial deals.[82] All of these examples illustrate how markets and speculation shape the atomic-capitalist sublime. Economic gains and energy resources are also what fuels wars, and the nuclear industry was not spared by the contamination of the Western capitalist logic.

The numbers are sublime and dazzling, from the infinitely large to the infinitely small: after Fukushima, the writer and philosopher Hiroki Azuma wonders if the true costs of nuclear "accidents" can be built into the industry budget. In "Thoughts from the 20km Evacuation Zone" he explains that nuclear energy is said to be cheap, but its cost does not include the compensation that should be made to those children who had to leave their *randoseru* (school bags) behind and carry instead the scars left in their hearts.[83]

The capitalist sublime has been pervasive enough to contaminate the judicial system. As the economics professor Fumikazu Yoshida has stressed: the "Polluter Pays Principle" was bypassed to allow the use of public funds and to avoid TEPCO's bankruptcy.[84] Furthermore, as thermal power generation became progressively cheaper, using more money for safety of nuclear power would make generating it more expansive. The capitalist sublime hits indiscriminately. It had already absorbed environmental, moral, and ethical concerns for most energy industries and corporations: we know of the dreadful oil spillages and of chemical pollutions, accidents, and explosions. The nuclear industry is no exception—the difference being the dissemination, as well as the long-lingering and immensely powerful effect, of radioactivity.

In light of the many reports regarding the TMI and Chernobyl accidents, and their similarities detailing industry cause and effect, it seems, as Kenzaburō Ōe stated in his *New Yorker* "postcard," that history repeats. Inevitably, nuclear corporate greed was portrayed in the arts. If the fictional aspects of *The China Syndrome* negate the value of the film's overall realism of the industry for some viewers, there is the specific case of the unsolved death of Karen Silkwood in 1974 (before TMI) and brought to screen in 1983 (before Chernobyl).

The Capitalist Sublime's Half-Life

Capitalism is the atomic sublime. It contaminated the nuclear industry and surfaces in the notorious case of Karen Silkwood. Silkwood, a nuclear worker, union activist, and whistleblower, died abruptly in 1974 in unclear circumstances. Meryl Streep played the title role in the film *Silkwood* (1983) to great acclaim for her sensitive portrayal of the woman who was alternately characterized by the media as a hotheaded militant or an antinuclear hero. Kurt Russell and Cher played supporting roles.

In real life, Karen Silkwood worked at a nuclear facility in Oklahoma, the Cimarron Fuel Fabrication Site. She tried actively to expose the nuclear

company's safety transgressions and violations by handing over to the press the materials she surreptitiously gathered to corroborate her allegations, but died in a suspicious car accident while on her way to deliver the damaging information to a *New York Times* journalist in 1974—a scenario that echoes the fate of the soundman in *The China Syndrome*. Not all of her documents were recovered, but whether or not she had them with her at that time was not clear—truth is not always accessible. At the time of her death she was twenty-eight years old and a mother of three. Her father filed and partially won a lawsuit (on behalf of her children) against the nuclear corporation Kerr-McGee, although not for the car accident but for planting plutonium in her apartment. The trial lasted ten weeks and was said to be "the longest in Oklahoma history."[85] The spiked plutonium also suggests the possible intent of corporate officials to cause health problems that would drive her out of the plant.

Kerr-McGee was a large corporation mainly involved in oil and natural gas exploitation, and is now part of the Anadarko Petroleum Corporation. The company still attracts international criticism, for example in 2001, for its "illegal, unethical and politically controversial plundering of hydrocarbons"[86] in the Moroccan occupied parts of Western Sahara—a territory formally colonized by Spain then France.[87] Here too, the atomic connections of the compounds I've explored in these pages—East/West and art/science, for example—are clear.

Although Gil Scott-Heron performed his song "We Almost Lost Detroit" for the 1979 No Nukes concert, his song had been released in 1977. Scott-Heron acknowledged Fuller's book of the same name for inspiring the song, as I mentioned earlier in the chapter, but also credited the case of Karen Silkwood. These lyrics from the song refer to her:

How would we get over losing our minds?
The sheriff of Monroe County had,
Sure enough disasters on his mind,
And what would Karen Silkwood say
If she was still alive?
That when it comes to people's safety
Money wins out every time
And we almost lost Detroit
This time, this time.[88]

Suspicions that the industry was to blame for her death were also expressed in "Are You Karen Silkwood?" (1979), a song recorded by the band Walls to Roses:

(...)
Are you Karen Silkwood?
We've heard about you.
Talking to the outside—Dumb thing to do.
People lose confidence,
We might close down.
Little girl, the stakes are high—
We don't fool around.

Are you Karen Silkwood?
Come back to bed.
This thing is too big for us;
It's gone to your head.
You've got your mission,
I've got my doubts.
I never asked to this—
Babe, I think I want out.
(...)[89]

Each stanza of the song portrays Silkwood's predicament from an differ-ent point of view, with one stanza seemingly voiced by threatening plant officials and another by her boyfriend, who clearly felt overwhelmed by her whistleblowing efforts (see the two stanzas above). Another stanza comes from the investigator who helped confirm her suspicions, and another, finally, from the coroner at the accident scene. The song was part of the album *Songs of Changing Men*, which aimed at celebrating gay culture, rein-forcing a positive vision of masculinity, and opposing violence against women.

The film, directed by Mike Nichols with a screenplay by Nora Ephron and Alice Arlen, provides a compelling look at the importance of gender in the Silkwood case. Corporate insatiability is clearly portrayed in the film, but the act of individual resistance taken against a powerful male-dominated industry by a twenty-eight-year-old woman is outstanding. Although cor-porate officials apply patriarchal pressure to Silkwood, a co-worker harasses her, and a less-than-supportive boyfriend (played by Kurt Russell) deserts her, her character comes across with the complexity of Silkwood in real life, even though the effort to discredit her by the company and other institu-tions that insinuated she was sexually promiscuous was not sufficiently explored.

Whereas the revealing power of the media is idealized, as it was in *The China Syndrome*, *Silkwood* is nevertheless an early depiction of corporate cover-up and the suppression of information in a patriarchal world. In

terms of gender, power imbalance and corporate greed in the workplace, we still see the pattern repeat in history.

The gender power imbalance in today's nuclear industry harks back to the time of the Radium Girls, some being in high school when they were hired, as young as sixteen, striving for financial independence or to help their families subsist. Women had just won the right to vote (nationally established in the US in 1920). The gender binary in *Silkwood* is all the more salient with its unequivocal parallels to Carole Langer's documentary *Radium City*, which depicted the strikes conducted in vain by some of the female workers at Luminous Processes factory where the Radium Girls were employed: they sought a pay raise of a few dollars after the war, paltry compared to the wealth of its president Joseph Kelly. In retrospect Langer reveals that the Argonne National Laboratory, which tested the surviving Radium Girls, started as a postwar $68 million research project.

The capitalist sublime in the atomic age is thus nothing new. Finally, looking at the art of the atomic age brings us to question the purpose of art itself—always a necessary act in challenging times.

The Art of the Atomic Age Today

When considering the role artistic responses to the nuclear age have played in the world, it can be argued on the one hand that antinuclear militancy has no effect: from the Radium Girls to Fukushima, the nuclear industry has sustained its dark power across countries and continents in spite of the arts. In addition—from an environmental point of view, and within specific art forms such as rock concerts—the production, maintenance, and consumption of artworks consumes energy and generates waste, therefore contributing to one aspect of the current problem. In that sense, Adorno's postwar analysis of the two aesthetical categories, the "committed" and "autonomous" categories, or political/apolitical, is still relevant today.[90] Furthermore, it can be argued, as Spencer Weart has already subtly underscored, that a "nuclear fear" has been imprinted on our minds. As an example he offers the storm of news reporting that covered the accident at TMI, prompting (in his estimation) about 200,000 residents to temporarily evacuate, but, as he reminds us, the "quarter of a million people" (roughly the same number) who were evacuated in Ontario because of leaked deadly chlorine gas generated only a "few columns in the newspapers."[91]

Thomas Gerusky, director of the Bureau of Radiation Protection in the Department of Environmental Resources—and one of the voices portrayed by Del Tredici—explained: no matter how accurate and up to date the information he gave in public meetings after TMI, there always was a cloud of

suspicion and skepticism floating around. He gave the example of dentists who told people to evacuate the area all the while ignoring that they themselves take excessive dental X-rays of their patients.[92] It is also true that the world's energy needs are great, and that nuclear power plants were likewise a great idea: the small atom has the power to expend lots of energy.

But on the other hand in a somewhat different formulation, the secrecy and cover-ups around nuclear activities themselves generate militant responses: to paraphrase Sontag again, remembering is an ethical act. Military and civilian nuclear activities are denying the wounds they inflict—such is the source of their demise. Art is just one way to mediate the testimonies, feelings, and points of view regarding the almost infinite radioactive wounds. Most importantly, the industry is far from running out of resources even only a couple of years after Fukushima—a consideration worth noting here again. And yet Fukushima and the fate of the evacuees have almost disappeared from minds and newsrooms. Keeping silent would thus be "barbaric."

Although it can be argued that the problem will take decades to solve and that reporting daily on the topic with no new information is useless, it can also be argued that the post-Fukushima government very adroitly diverted the attention away from the catastrophe: In 2013, historical East Asian wounds were reopened when the Japanese prime minister, Abe Shinzō, visited the controversial nationalist Yasukuni Shrine that memorializes the country's war dead, but which also enshrines several convicted war criminals. Old disputes resurfaced, about the Comfort Women (the euphemistic term for the women who were forced into prostitution for Japanese military brothels), and about the Senkaku Islands (alternately called Senkaku, or Diaoyu, or Tiaoyutai depending if one is from Japan, China, or Taiwan). Notably, the Islands are believed to hold energy resources. The message was clear: giving up the nuclear agenda meant reviving colonial disputes to access the energy resources on the islands.

In August 2015, the Sendai nuclear power plant was restarted, and by November 2015, East Asian leaders shook hands in reconciliation. Japan's planned sales of reactors in India and Kazakhstan could also go forward. Although Abe stopped visiting the Yasukuni Shrine to protect those relationships, members of his cabinet did not (but gradually stopped). Abe's post-Fukushima nuclear politics, together with the change in the constitution allowing Japanese soldiers to participate in US wars, thus follow the neoliberal policies of the US.[93]

The "intra-action" (to use Karen Barad's concept here too) between nuclear activities and colonial heritage reactivated controversies that had once rendered the East Asia region unstable, and the government embedded

in the minds of the public the impossibility of resolving the disputes or drilling for resources elsewhere (i.e., on the islands). That made it possible to reinstall the power plants on the Japanese sociopolitical landscape—all the while diverting the attention away from Japan's own energy treasure, a near-endless resource: geothermal power generated from active volcanoes.[94]

To return to the arts, a time of crisis always brings critical thinking about their capacity and purpose. After 3/11, Kamiya Yukie emphasized that artists have always asked the overwhelming question, "What can *art* do?" And yet, she explained, concerning Fukushima, it took several years for some artists to "chew on and digest this question."[95] When it comes to artists depicting the nuclear age, the definition and framework of art has been renegotiated to include a types of voices since Hiroshima, through testimonial styles of A-bomb literature, the militancy of H-bomb art, and the patchwork style of uranium-related atomized works.

In the atomic age, however, art is also dual. It can be a revealing, a saving power, but, it can also be an enframing in the Heideggerian sense. At the end, finally, the many catastrophes are not "the unthinkable" and radioactivity is not "limiting" the current responses in arts. But the challenge is elsewhere: in what will be remembered in the future. To paraphrase Adorno once again, the abundance of real suffering tolerates no forgetting. But whom do we wish to remember? After 9/11, Sontag stated:

The "barbarian" is another person's "just doing what everybody else is doing." ... The children of Hiroshima and Nagasaki were no less innocent than the young African-American men (and a few women) who were butchered and hanged from trees in small-town America. More than one hundred thousand civilians, three-fourths of them women, were massacred in the RAF firebombing of Dresden on the night of February 13, 1945; seventy-two thousand civilians were incinerated in seconds by the American bomb dropped on Hiroshima. The roll call could be much longer. Again, whom do we wish to blame? Which atrocities from the incurable past do we think we are obliged to revisit?"[96]

We live in a world where nuclear weapons still exist and where some political leaders still threaten to use them, and where land, bodies, and minds have been irradiated—in America, Oceania, Africa, Europe, Asia, and East Asia—a world in which uranium is still being mined in unfair trades and where nuclear accidents still exist. Given that world: What do we wish to remember? There is no perfect society and there are so many radioactive wounds. Will the dark radiance of A-bomb literature and H-bomb art be left in the dark corners of history, overshadowed by other wounds from Chernobyl and Fukushima? Will the many uranium-generated wounds of colonial and neocolonial times be left invisible? Will the voices from TMI, Chernobyl, and Fukushima prevail—or will they become invisible too?

Toward a Conclusion: More Artistic Hotspots

At the onset of the atomic age in the early 1900s, radioluminescent costumes and the Radium Dance of Loïe Fuller played off tales of radium bandits and few atomic or radium bombs: the performing arts and fiction were the first artistic genres to respond to Marie Curie's discovery of a new chemical element, and from them came alternate messages of promise and danger. Now, after the accident at the Fukushima Daiichi plant in 2011, we have more than a century of artworks to examine in response to nuclear power. Although many of them have gone unrecognized, they have the power to reveal the dark radiance of—and give visibility to—the global *hibakusha*. Examining the atomic age, together with the art created in response to it, allows us to see beyond, or find new resonance in, the tropes we have come to associate with it.

Photographs of gigantic mushroom clouds billowing from the Pacific Ocean, for instance, and shots of a razed Hiroshima city, barren of all life, cannot help but evoke the military use of the atom. We now know that politico-military powers controlled the way we visualize the bomb by carefully orchestrating these images—either during their production or, later, through censorship or even by directly producing declassified images for public consumption. Especially in the West, such images emphasized the combined lethal beauty and power of the "fabulously visual" atomic age. Looking at these images we feel the reverberations of the bomb as predicted by Orwell and Derrida: because of it, "power will be concentrated in still fewer hands,"[1] as Orwell stated, and as a result of it, for Derrida, that power has "never been so terribly accumulated, concentrated, entrusted as in a dice game to so few hands."[2]

Censorship and self-censorship of atomic voices linger, whether the source of suppression be politico-military or corporate in nature, and the media facilitate the messages: as Baudrillard sees it, the media serve as the "twin orbit and twin chain reaction" of the nuclear industry.[3] But given

the ways in which the media can oversaturate our minds—from a stampede of reporters at Three Mile Island, to live TV coverage of a power plant exploding in Fukushima, to social media networks running a relay of real, fake, or rumored news—it is possible to perceive the multitude of images we see and sound-bites we hear as nothing more than white noise emanating from flat blue screens.

The arts of the atomic age help us see what the politico-military, media, or corporate images do not help visualize: invisible radioactivity materializes in many visible colors through the artistic filter. We see the iridescent-green smiles of the Radium Girls and brown camel-hair brushes they moistened in their mouths. We imagine the ashen, burned bodies of bombed Hiroshima described by Ōta Yōko and Hara Tamiki, and see the ones of Nagasaki in the black and white photographs of Yamahata Yōsuke. In many A-bomb testimonies we see the white of the maggots and the white of the bones resurfacing on Hiroshima's parade ground. Radioactivity reveals the pristine colors of the atomized Oceanian atolls, that were the "emerald garlands" described by Chantal Spitz. Radioactivity is black like the hair falling from the scalp of Kathy Jetñil-Kijiner's six-year-old niece Bianca, who died of cancer. It is red like the jellyfish babies and stillbirths Jetñil-Kijiner described, and it starkly contrasts with the white-albino Western race, and with the "white lies" Burroughs described in white-voiced nuclear denials. It is army-green, like the uniform of Major Gavin in Alfred Coppel's *Dark December*. Radioactivity takes on the color of resistance—in the words of Henri Hiro, Déwé Gorodé, and Boubou Hama; in the sculptures of Gustav Metzger; in the recipes of the group Women Strike for Peace, and the songs of Iron Maiden—and places it against the blue, white, and red of US, French, and British flags. Radioactivity is yellow, like the yellowcake processed in the uranium mines where atomized "nuclear" families portrayed by Toyosaki and Del Tredici developed cancers. In another sense, the nuclear age is tainted by the dying liquidators at Chernobyl and the testimonies they provided to Alexievich; it is likewise colored by the questionable practices of using Las Vegas showgirls to tout H-bomb testing in Nevada, and using the gender stereotyping in the Miss Atom beauty contests to plug the nuclear industry's focus on the growing need for affordable energy. Finally, radioactivity is purple, like the concert hall Isozaki and Kapoor designed, and it is multicolored, like the handkerchiefs designed by relocated children and exhibited by JAGDA.

Looking at the arts of the atomic age, especially at the aspect of it is deemed "unthinkable," requires that we look at the fundamental essence of art itself, and include in our definition of art and artistic responses (at least

for this discussion) a broad range of cultural production. We must consider the ontological duality of every human endeavor, whether that endeavor is artistic or scientific. Art and science as well have positive and negative forces—or saving, revealing, and enframing forces (in phenomenological terms).

Art is not solely the "saving force" Heidegger had envisioned during the Cold War, but art (at large, including the popular arts) still is a "revealing" of particular truth or phenomena. While military- and media-generated images saturated our consciousness, they left a void that was soon filled with sublime imageries: radioactive monsters, Godzilla, Martian invasions, and the swimsuit bikini designed by Louis Réard. These images are pervasive and enduring. Consider that the fantasized characters of SpongeBob SquarePants and Moana invade our minds and obscure the Oceanian *hibakusha*. Such creations are intended as entertainment and not purposefully meant to numb our radioactive memories. And yet these images are, to paraphrase Susan Sontag again, revelatory of the incapacity and powerlessness to respond to the nuclear age. On the other hand there exist relevant and revelatory works even in science fiction and comics: in science fiction there is Alexander Bogdanov's novel *The Red Star* and Ray Bradbury's short story "There Will Come Soft Rain," and in comics the manga *Barefoot Gen*, by Nakazawa Keiji.

For Heidegger, art can be saving power only if it reflects on the way he had questioned technology. Thus art (and not just technology) can also be an "Enframing" (even if Heidegger does not expressly write it). The corporate hand on the arts (and in particular the hand of the nuclear industry), has the potential to enframe. For example, although the vibrant paintings by Pilbara-based Aboriginal artists that Rio Tinto sponsored, such as Clifton Mack, and Allery Sandy, help the promotion of Aboriginal culture, the sponsoring does not give light to the impact of decades-long history of uranium mining in Australia. The company also calls attention to its lack of support for the Namibian communities where it extract great wealth of uranium. In contrast, the design group JAGDA, a collaborative with no nuclear ties, invited Fukushima-area schoolchildren into its ranks to help produce handkerchiefs, the profits from which will benefit the children themselves.

The problem for the arts of the atomic age is therefore not one of medium of representation. Looking at the artistic responses to the atomic age instead requires that we turn to ethics as the branch of knowledge with the potential to connect the many other branches (artistic or scientific) as they continue to advance and develop—from the arts to the sciences, with all the disciplines and cross-disciplines in between. Our ethical engagement

in the future depends on acknowledging past and present nuclear wounds. This condition is absolute.

Concerning artistic responses and ethics, however, we must ask questions that address the politics of representation: Who gets to tell? Who should bear the burden? What trauma should be remembered? How should this be done? There are conflicting forces at work regarding empathy for those in distant places—the risk of orientalist depictions, for instance, and the ultimate urgency to remember the plights of the victims—since, as Sontag stated, remembering is an ethical act. Ontologically, the politics of representation must be reinvestigated: in both the arts and the sciences, as long as the patriarchal and racist ways in which nature and people have been treated remains dominant and unquestioned, sublime narratives and images will continue to proliferate.

This reinvestigation has become ever more vital. We cannot help but notice that aside from early twentieth-century artistic depictions, such as the radium dances and radium-powered vessels, that the art of the atomic age is unarguably an art of suffering. Even at the time of the Curies, plots in radium literature were already tainted by toxic uses of radioactivity.

In the humanities an epistemological shift occurred, displacing the philosophical discussions of Greek atomism and its perceptions of the laws of nature of material reality, and discussion of determinism and free will that had continued until the early twentieth century. Marie Curie's dreams of radioactive medicine seemed all but forgotten. Is it possible to see apolitical practices move forward in such circumstances? Since the dominant modern Western view of nature and people must be readdressed, is it not time for the modernist separation between political and apolitical work to be reassessed as well?

On the one hand, in these chapters we have seen how political works in response to nuclear traumas can give visibility to the voices of global *hibakusha*, and many more such works may well be directed in response to nuclear traumas other than the ones I have explored in this book: the impact of Soviet and Chinese tests and mining, for instance, as well as the nuclear programs, mining, and Pacific tests of the UK. On the other hand, apolitical atomic works exist that should not be disregarded and which need to be discussed. In fact, I believe, such works hold a clue to our current crisis. Therefore, as a way of concluding my study on the arts of the atomic age, I have chosen to acknowledge several more hotspots, even though (and perhaps because) they seem distant and different from one another.

Each of the four hotspot blurs the political/apolitical divide: first, the art created in relation to nuclear traumas that still have little visibility

(such as traumas relating to nuclear depleted uranium weapons); second, art produced in the scientific setting of the particle laboratory; third, the involvement of artists in the storage and disposal of radioactive material; and fourth, the art that references nuclear medicine, before finally concluding with a discussion of the whole of the arts of the atomic age.

Depleted Uranium, the Iraq War, and the War on Terror

Given the continued use of atomic weapons after the Cold War and their persistence today, especially in the form of depleted uranium (DU), it might seem that political artworks are ineffective tools for change, and that apolitical works are irrelevant or unjustified representations of the nuclear age. In fact, the invisibility of artworks confronting the use of depleted uranium during the Persian Gulf War is striking, for reasons that I explore in the following pages.

George Gessert is one of the few artists to write on the topic. In "Notes on Uranium Weapons and Kitsch," Gessert addresses the ways in which forms of entertainment and kitsch allow entire societies to deflect or disregard a problem. Similar to the way that Sontag characterizes science fiction films of the Cold War era, Gessert comments that kitsch produced in Nazi Germany and Stalin's USSR "inoculated [the public] against empathy and prepared the way for atrocities." But now, there is Freddy Kruger and Disney movies, says Gessert, and "kitsch can be light or dark." He contends that our collective attention has been successfully diverted from DU and nuclear realities.[4] Therefore, unsurprisingly, extremely few works focus on DU.

Gessert is primarily known for biotech artworks that concern the relationship between plant breeding and aesthetics. But several years before Chernobyl he produced *Sky* (1985), a unique artist's book in which he proposed ways of transforming military sites, nuclear materials, and even weapons into works of art. One of the most thoughtful pieces in the book, *God of the Butterflies* (1985), reveals a consciousness of (and compassion for) nonhuman beings: Gessert imagined a strain of bacteria that would "swiftly eliminate" the human species without harming the others species; the bacteria would be kept in storage and released only "if unlimited nuclear war became extremely likely."[5] He illustrated this concept with a blank page.

Another work on DU is the film titled *Sky* (2015), by the French director Fabienne Berthaud. The film is not at all based on Gessert's book, although DU figures in the plot. In this love story, a French woman named Romy abandons her violent husband while on vacation in the US and, in an attempt to find a way to support herself, takes off for Las Vegas, where

she meets and soon falls in love with Diego, a US Gulf War veteran dying of cancer. "My body is sick, Romy," he tells her, "I was poisoned … by the amount of uranium I got. … It's pay off for the DU. … When it hits the target you breathe it in, and it gets in your blood, your lungs. … You fell for a guy who's gonna die."[6] When Romy gets pregnant the couple argues about whether she should have an abortion because of possible deformities to the fetus or illnesses the child could later develop. But just like the film *Grand Central* and the anime *In This Corner of the World* by Kōno Fumiyo set near Hiroshima, *Sky* is more about love than it is about nuclear matters; the Gulf War is mentioned only in passing, as alluded to in the dialog quoted above.

Now that fighting the "Gulf War Syndrome" has become a way of life for many US veterans affected by depleted uranium—the term has made its way into the lexicon alongside "shell shock" and "PTSD"—we must wonder what the effects have been on the other side of the missiles, and how many more *hibakusha* voices still need to be heard. In 2014, *Time* magazine published a 2012 photo essay about postwar Iraq featuring the work of the German photographer Christian Werner. Most of the twenty-four photos, taken in or near hospitals and cemeteries in Basra, Fallujah and Baghdad, show the effects that DU-based munitions have had on children—infants with cerebral tumors, children with leukemia and with limb or eye deformities, and stillborn babies. Others focus on the family members mourning children who don't survive.[7]

What Achille Mbembe calls the "the military-technological revolution" has undeniably "multiplied the capacity for destruction in unprecedented ways."[8] Mbembe gives the example of DU but also mentions other modes of destruction such as toxic spillages affecting ground and water or damages to energy infrastructures, therefore targeting a population's offspring in order to weaken future rebellions: many women were advised to have an abortion during the Kosovo campaign and to avoid pregnancy for two years. Thus it seems as if producing apolitical artworks (or none at all) in such a context would be "barbaric," to invoke the Japanese musician Sakamoto Ryūichi, who used the word to refer to keeping silent after Fukushima. There are still so many nuclear wounds to be healed and addressed.

After the use of depleted uranium, the radioactive landscape becomes even more atomized—stretching from the post-9/11 context, when the quest for Iraqi weapons of mass destruction that never existed led to the war on terror. In war matters, even after the Jewish and Japanese holocausts, the amount of suffering that emanates from everyday news reports is still unsurprisingly surprising. Regarding the 2003 invasion of Iraq, images of Abu Ghraib have rightly invaded our minds, and the art in response to the

torture committed there has left a bigger imprint—see, for example, the series of paintings by Fernando Botero—than the use of depleted uranium (or the use of lies on nuclear weapons) has.

The group of artists Rosalyn Deutsche selected to profile in *Hiroshima after Iraq* have produced pieces relating to the two Gulf Wars while at the same time juxtaposing their own reinvestigations of Hiroshima. One work in particular, Silvia Kolbowski's twenty-two-minute film *After Hiroshima mon amour* (2005–2008), brings to the surface the seeming impossibility of an end to the Iraq conflict by referencing Resnais's film, which itself concerned the persistence of memory regarding Hiroshima.[9] One reason for the lack of response to the Iraq War, to paraphrase what curator Kamiya Yukie said in the context of Fukushima, may be that such events take time to "chew." Deutsche's book came out in 2010. Seven years later, the film *Shock and Awe* (premiered in 2017) finally investigated the lies regarding the alleged making of nuclear weapons in Iraq, George W. Bush used to justify his decision to invade.

A song on the topic by David Bowie, "New Killer Star" (2003) took far less time to surface. Bowie, who lived close to ground zero, was deeply moved by the events of 9/11 to write lyrics that conveyed the impact of the attacks on New Yorkers. The invasion of Iraq started in March 2003, and by September 16, Bowie had released his album *Reality*. "New Killer Star" was the first track, with the following opening lyrics:

See the great white scar
Over Battery Park
Then a flare glides over
But I won't look at that scar
Oh, my nuclear baby
Oh, my idiot trance
All my idiot questions
Let's face the music and dance
(...)
All the corners of the buildings
Who but we remember these?[10]

The song has no obvious political message; the music video made of the song depicts power plants and astronauts rather than nuclear warheads. Oddly, "New Killer Star" received little attention, which one music critic attributes to the fact that Bowie's prolific output in the year leading up to the release caused the public anticipation for something new to dwindle. But the government's use of the attacks to justify military involvement in the Middle East was definitely on post-9/11 minds in artistic and

intellectual circles. The critical and cultural appraisal of Michael Moore's *Fahrenheit 9/11* (2004), which grossed the highest box-office earnings for a documentary, received a *Palme d'Or* and a lasting standing ovation at the Cannes Film Festival, is evidence enough.

There seems to be no escape from the irradiation of politics: the scattered hotspots of nuclear-related artworks appeared at the start of the Obama presidency in spite of the administration's hopeful promises for "change we can believe in." *Radiation Burn* (2010) (figures 10.1a–c), a public intervention by the Critical Art Ensemble (CAE), gives visibility to the radiological dispersion device (RDD), or "dirty bomb," and what the collective calls the weapon's "mythic narrative that is perfect for scaring an uninformed population. CAE would call it a jewel in the crown of fear second only to nuclear attack."[11] Because the mythologies surrounding the device remained even after Barack Obama was elected, the collective felt compelled to do something about it. In times of terrorism, and against the fear of it instilled by the US government, the group tried to demonstrate how unlikely it would be for non-state actors to produce and use such bombs, and how much less lethal they are than what the government claims. In this public performance, with the help of pyrotechnics professionals, CAE detonated a mock dirty bomb in a park in the German city Halle. Then, as members of CAE, dressed in hazmat suits and carrying radiation monitors, taped off the "contaminated" areas with yellow "caution" tape, an actual nuclear scientist informed the public about the ineffectiveness of the dirty bombs and the unlikeliness of such an attack; by invoking the scientist's authority, CAE aimed to counteract the scare tactics used by any nation's imperialist agenda.

Although the number of works in response the two Gulf Wars is small in comparison to other wars and events of the atomic age, few art-focused programs emerges. Christian Weber's 2012 photo-reportage in fact covers the two Gulf Wars. And Alan Ingram, from the Department of Geography at the University of London, for examples has launched an academic research project (supported by a British Academy fellowship) to explore the artworks created by UK or Iraqi artists and/or on the 2003 invasion and subsequent occupation of Iraq.[12]

The small number of artistic responses to the use of DU or (or to the lies on the potential making of nuclear weapons) in Iraq gathered here may be explained by several facts: they may have little visibility, it can take time to acknowledge the past, and our attention was diverted elsewhere, first to Fukushima and now, at the time of this writing, to North Korea. Nuclear negotiations occupy minds all over the globe given the Trump

a

b

Figures 10.1a–c

Critical Art Ensemble, *Radiation Burn*, 2010, Werkleitz Festival, Halle, Germany, photographic documentation of a public performance/intervention. Photo credit: Critical Art Ensemble.

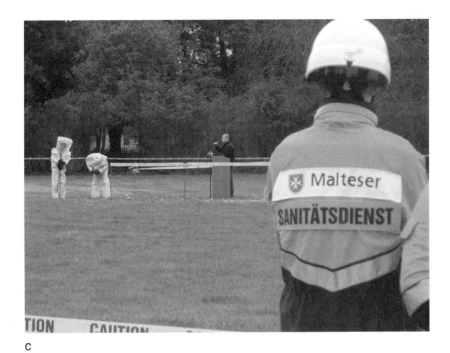

c

Figures 10.1a–c (continued)

administration's potential provocations. An already acclaimed literary response to Trump himself comes from Mark Doten, whose "Trump Sky Alpha" (2017) appeared in the journal *Granta* as a preview of the author's forthcoming novel in 2019. The title refers to an ultra-luxurious aircraft that the president pilots twice a week from the White House to New York to Mar-a-Lago—with the cheapest seat going for fifty thousand dollars. While manning the controls during each flight, he simultaneously streams an address to the nation via YouTube. This presidential routine continues until something he says plunges the world into a nuclear war, and his advisers must find a "safer" way to broadcast his messages:

Under the extraordinary circumstances unfolding around the world, the nuclear attacks, the hundreds or thousands of ongoing conflicts, the millions or tens of millions already dead, Trump would absolutely not be permitted to fly Trump Sky Alpha. *Mr President, we can get you into a bunker with full communication equipment and you can give your address there, you just can't do it in a goddamn plastic blimp at the start of World War III.*[13]

In the midst of such obviously political satires and political artworks, however, an unbroken, apolitical artistic chain reaction of response has continued within nuclear laboratories. What do these works contribute to our understanding as the nuclear era continues to unfold? And are there relevant responses to the atomic age?

Particles of Art: The Fermilab Art Gallery

In his book *Information Arts: Intersections of Art, Science, and Technology*, Stephen Wilson includes a section on atomic physics, in which he names a handful of artists, such as Brixey, the Canadian group InterAccess, John Duncan and Anthea Maton, who directly engage either with scientists or scientific devices.[14] Yet, there exist more artistic interactions between science and technology in particle laboratories if one considers a wider modernist context: some artists are simply inspired by the science and technology they are exposed to, and represent them in "traditional" ways, without actually using scientific devices or new technologies and apparatuses in their practice (the latter being the topic of Wilson's book).

What CP Snow called "two cultures" (science and the humanities) thrive side-by-side at Fermilab, established in 1967 as National Accelerator Laboratory in Illinois, not far from Chicago, and renamed for Enrico Fermi upon completion in 1974. Robert R. Wilson, a key physicist of the Manhattan Project—and whose idealistic voice John Adams depicted in *Doctor Atomic*—became the first director of the lab in 1967. As Wilson stated: "I have always felt that science, technology, and art are importantly connected. ... Aesthetics is partly a matter of communication, and with so many people involved, I felt that everyone would appreciate a good design and would keep their designs equally clean and understood."[15] He also made sure that an artist would be on the premises full-time: Angela Gonzales, the eleventh employee he hired, designed all the graphics, logo and chose the color schemes.[16]

Wilson was "a confident amateur sculptor" who went to Rome for inspiration, as Fermilab's third director, John Peoples, recalled.[17] Wilson felt personally responsible for making sure that the building did not resemble stereotypical concrete-block science facilities—not an easy task given pressure from big construction companies and resistance from scientists who objected to including artists in the project. Wilson's architectural inspiration for Fermilab came from Chartres Cathedral and the Beauvais Cathedral in France, and from the Ford Foundation building in New York.[18] The building itself is grand, with an entrance hall (named for Wilson) that celebrates

the international cooperation of particle scientists. Glass windows in the inner and outer walls create a sense of open space that works as an antidote to Wilson's belief that ideas get lost in communication.

Fermilab's apolitical mission and collaborative spirit are reflected in the curatorial decisions that bring visual and performing arts to the site. An auditorium for the performing arts was installed the 1970s because the physicist Arthur Roberts had an interest in music.[19] The art/science interaction is thus historical and continues today. The gallery and onstage programming feature international artists, ranging from Russian ballet troupes to the Croatian watercolorist Ana Zanic, and the Ukrainian band DakhaBrakha (described as a "folkdrone Bjorkpunk quartet" known for its "mournful accordion and apocalyptic cello").[20]

The science premises hosted their first artist-in-residence program in 2014–15 with Lindsey Olson. Her *Art and the Quantum World* exhibit included artist's books that were inspired by medieval illuminated manuscripts (figures 10.2 and 10.3). According to Olson: "Ancient manuscripts were used to transmit the most important information of their day. My books illustrate the deep and fundamental connection between particle physics research and the origins of the universe."[21] Olson also worked with scientists and numerous staff members onsite to create a series inspired by what goes on inside a particle accelerator; these ink drawings depict the way in which magnetic forces propel the particles in packets (or pulses) around a storage ring (figures 10.4a–c).

Just like quantum theories had inspired Dalì, and crystallography had fascinated the British designers of the Festival Pattern Group during the Cold War, artists today have taken an interest in particles, but their works are not widely known. In 2006, Gyorgy Darvas and Tamas Frakas, who produced artworks based on quark particles, have commented on the problem: "No textbooks that make visible these basic properties by means of art are currently available." But they contend that such artistic visualizations can help getting close to "mysterious" physical objects such as quarks, and leave physicists better able to discover new secrets about them.[22] There exist, however, other reasons that make such practice relevant.

Arts at CERN

CERN (European Organization for Nuclear Research) also has a similar art program. Located near Geneva, CERN is a world populated by quarks, gluons, hadrons, black holes, and antimatter. How not to be inspired?

Figure 10.2
Lindsay Olson, *Solar Neutrinos*, 2015, ink, acrylic, collage on paper. Photo credit: Reidar Hahn for Fermilab. Courtesy of the artist.

Established artists in several genres have referred to or depicted the type of work conducted at CERN, or have made the site itself a part of their work. *Angels & Demons* (2009) is one example. The film, based on the novel by Dan Brown, stars Tom Hanks (in the same role he played another Brown-inspired blockbuster, *The Da Vinci Code*), as Robert Langdon, a Harvard scholar. Langdon finds evidence that antimatter has been stolen from a secret CERN laboratory, and he joins a CERN scientist to track it down before the criminals use it to destroy the Vatican.

In music, Nick Cave & the Bad Seeds released the song "Higgs Boson Blues" (2013), from the album *Push the Sky Away*. The band's beautiful musical arrangements are accompanied by admittedly cryptic lyrics: as the song begins the protagonist is heading toward Geneva and CERN, home of the Large Hadron Collider where the Higgs boson is being investigated.

Figure 10.3
Lindsay Olson, *Beam Line*, 2015, Ink, acrylic, collage on paper. Photo credit: Reidar Hahn for Fermilab. Courtesy of the artist.

(...)
Have you ever heard about the Higgs Boson Blues?
I'm going down to Geneva, baby
(...)
Driving my car
Flame trees on fire
Sitting and singing
The Higgs Boson Blues
I'm tired, I'm looking for a spot to drop
All clocks have stopped in Memphis now
And the Lorraine Motel is hot
it's hot, it's hot, that why we call it the Hot Spot (...)[23]

The lyrics also combine resonant references to Lucifer and Robert Johnson (the iconic blues guitar player who, as legend would have it, sold his soul to the devil in exchange for his musical prowess) and the Lorraine

Figure 10.4a
Lindsay Olson, *Riding the Ring a*, 2015, ink, acrylic, collage on paper. Photo credit:
Reidar Hahn for Fermilab. Courtesy of the artist.

Motel where Martin Luther King was assassinated, before strangely devolv-
ing into densely rhymed stanzas about the Disney character Hannah Mon-
tana and Miley Cyrus—thus fusing not only different universes and time
frames, but also different cultural figures, even the most distant.

In addition to being inspirational, CERN is also a hotspot for contem-
porary artists. Since 2011 the facilities have hosted a series of residencies
for artists (ranging from a three-month stay in the Collide program to a
one-month stay in the Accelerate program, geared to those whose have
never before spent time in a laboratory). The programs were initiated and
designed by CERN's former art director Ariane Koek, an international cul-
tural strategist and curator, as meeting points between the two cultures.[24]

One example of CERN residency resulted in *Horizons irrésolus* (Unresolved
Horizons, 2016) (figures 10.5a–d) by the Swiss artists Rudy Decelière and
Vincent Hänni, in collaboration with the physicist Robert Kieffer and the

Figure 10.4b
Lindsay Olson, *Riding the Ring b*, 2015, ink, acrylic, collage on paper. Photo credit: Reidar Hahn for Fermilab. Courtesy of the artist.

cosmologist Diego Blas and produced by the association POWA. The work is an immersive sound piece, including 888 micro-synthesizers and speakers. Each of the sound modules holds the same code and receives, analyzes, and emits varied information and sounds to and from its three neighbors. There is a beautiful connection between the modules as heard individually, like a single voice, and heard as a whole, like the unified sound of a crowd. As the artists explain it, the effect is similar to the wholeness of the wind that blows into the leaves, and when what becomes audible is not one leaf but the wind that blows into the leaves.[25]

In *Meeting the Universe Halfway*, Karen Barad points out how in quantum mechanics it is impossible to separate the phenomenon observed from the tools that are used, because the particles act in different ways according to the tools used (hence the principle of uncertainty). Instead of "interactions," she sees "intra-actions."[26] *Horizons irrésolus* therefore renders audible

Figure 10.4c
Lindsay Olson, *Riding the Ring c*, 2015, ink, acrylic, collage on paper. Photo credit: Reidar Hahn for Fermilab. Courtesy of the artist.

this quantum inseparability. In turn, it is another powerful metaphor of art and science's intra-actions.

At first, such works may look irrelevant in the face of so many nuclear traumas. But the arts, and the nature of art itself, have always engaged with nature, the cosmos, and the atoms, from the ancient Greek and Indian atomists, to the Japanese *Kojiki*, and to the Romantics in the West. Programs like the ones at Fermilab and CERN, therefore, carry on this artistic tradition. Before them, other scientific facilities also welcomed artists: NASA began its artist-in-residence program in the 1960s, and over the years has commissioned and collected works by Robert Rauschenberg, Andy Warhol, Annie Leibovitz, and Nam June Paik.[27]

Paik has long acknowledged that new technologies would become inextricably involved in artistic creation. In 1984 he stated in "Art and Satellite" that we are "already knee-deep in the post industrial age" and that the two-way satellite will inspire artists as they learn "how to give a conversational

a

b

Figures 10.5a–d
Vincent Hänni, Rudy Decelière, Robert Kieffer, and Diego Blas, *Horizons irrésolus*
CERN (nos. 1 to 4), 2016. Medium: digital. Photo credit: © Rudy Decelière. Courtesy
of *Horizons irrésolus* CERN (Hänni, Decelière, Kieffer, Blas).

c

d

Figures 10.5a–d (continued)

structure to the art; how to master differences in time."[28] Paik was part of
the neo-Dada movement Fluxus, and its multinational breadth somewhat
matches the international cooperation of scientists and artists at CERN and
Fermilab. The works produced there (and other similar context such as the
Canadian TRIUMF) are therefore inscribed in this millenary tradition, but
with the direct involvement of scientists.

The practices, however, are all the more interesting for the history of
their emergence. CERN was first imagined in 1949, in the aftermath of
World War II and the atomic bomb, by scientists such as Lew Kowarski and
Niels Bohr; the idea was further developed in 1950 via a UNESCO General
Conference, which led to its founding in 1954. Just like Fermilab, CERN
was the peaceful response to decades of antagonizing wars—in which art
played a damning role through propaganda. Not only are these CERN pro-
grams historically remarkable, but they also foster an enduring and grow-
ing international collaboration: while CERN started with twelve founding
member states, now scientists from over a hundred countries are collabo-
rating. It is precisely this cross-generational and border-free teamwork that
makes CERN and similar laboratories stand out.

In fact, in an ideal world where the use and threat of nuclear weaponry
would have ceased and alternative energies flourished, such art/science
teamwork in itself would be the best work of the atomic age. Of course
the world is not ideal: rivalries continue and war is still pursued. In addi-
tion, some artists or institutions use the atom and nuclear technology as a
topic to quickly respond to the growing public awareness of it since Fuku-
shima but with superficial approaches, without any intellectual, political
and scientific effort and knowledge of the topic, whether their approach
is political or apolitical. But this is a problem of ethic of the content of the
work more than of systems of representation. Modern political/apolitical
responses, as we continue to see, remain hard to separate, in particular for
the next artistic hotspot: the art representing radioactive waste.

The Embarrassing Question of Radioactive Waste and Art

Radioactive waste is one of the biggest problems facing current and future
generations. And again we see how most artworks that take up the topic
don't fit neatly into either the political or apolitical category. The docu-
mentary *Into Eternity* states the dilemma of nuclear waste in a very clear
and concise way: modern humankind is fifty thousand years old, and the
pyramids are five thousand years old, but radioactive waste will last *one
hundred thousand years* and nothing built by humans has lasted a tenth of

this time. How can these wastes be safely buried—knowing that there cannot be safety without danger? How should artists respond to this problem?

In their respective philosophical essays on Fukushima, Jean-Luc Nancy and Nishitani Osamu both advocated the urgent need to look and think at the present situation for future generations. Nishitani, for example, explained that since the time nuclear technology was used as a technic of destruction, and since the time its "peaceful use" was exploited, and even given that "sciences and technics accomplished important progresses, they were powerless to process nuclear waste."[29] The problem in fact embodies one of the failures of Western modernity, to have integrated the idea of perpetual progress and advancement of science to the point of having gambled on the future generations and on the future progress of science to deal with the problem.

In the arts, the American artist James Acord devoted a large part of his life to the nuclear age and in particular to nuclear waste disposal. An example of his projects involved the building of a series of granite sculptures containing the plutonium from several nuclear warheads. The monuments would be strung across the Aleutian Islands and into Siberia, thus incorporating the material in a sort of reliquary for the atomic age.[30] But Acord died before he could finish the piece.

Acord also created a five-foot high sculpture titled *Monstrance for a Grey Horse* (figure 10.6b). He envisioned the work as a monument to be placed at the edge of a nuclear waste dump to signal the contamination of the place for people in the future (when language will have changed after thousands of years). In the center of the granite sculpture (granite can last for thirty thousand years) he wanted to insert live nuclear material but given the difficulty in accessing the material, he resorted to using crushed red Fiesta tableware, which was manufactured in the 1930s with uranium in its glaze.[31]

The artist's persistence can best be characterized by the fact that for fifteen years he lived in the dormitories of the Hanford Nuclear Reservation in Richmond, Washington, where the plutonium for bombs used at the Trinity Site and in Nagasaki were manufactured; the site now holds the distinction of being the most contaminated location in the US (figure 10.6a). Acord was the only private individual in the world licensed to own and handle radioactive material.

The American artist Taryn Simon created another compelling work, *Black Square XVII* (2015), as a reinvestigation of Kazimir Malevich's iconic *Black Square* (1915), a work often referred to by critics and art historians as the "zero point of painting." Simon filled her black square with vitrified

Figure 10.6a
James Acord in front of Hanford's Fast Flux Test Facility, 1993. © Arthur S. Aubry.

nuclear waste and stored it in "a concrete reinforced steel container, with a holding chamber surrounded by clay-rich soil, at the Radon Nuclear Waste Disposal Plant in Sergiev Posad, located 72 km northeast of Moscow."[32] Within the black square is a letter she wrote to the future; it will be read when the artwork is deemed safe for exhibition at the Garage Museum of Contemporary Art in Moscow—that is, approximately in the year 3015, a thousand years after its making.

As unbelievable as it may seem, the idea to build such works as Acord's *Monstrance* and Simon's *Black Square* was already considered in a 1993 report issued by a committee at Sandia National Laboratories, whose facilities deal with both civilian and military nuclear devices but belong to the US Department of Energy. The committee had hoped to find an efficient way to devise markers that would prevent future societies quite different than our own from inadvertently intruding on (or purposefully vandalizing) the repositories at the Waste Isolation Pilot Plant (WIPP). The team of experts from diverse fields included "an astronomer (who searches for extra-terrestrial intelligence)" and "an archaeologist (who is at home with cultures that differ in both time and space from our own)," together with a designer and a linguist.[33]

Figure 10.6b
James Acord, *Monstrance for a Grey Horse*, 1991. Medium; 35 mm slide. © James Acord.

In assessing an appropriate application for the markers, it was thought that "art usually has no function, it exists only to be experienced. If people of the future view the WIPP Marker as a piece of art, they are less likely to try to interpret it as conveying a particular message rather than as some elaborate 'artistic statement.'"[34] The report also concluded that a marker should keep people away from an area, and thus a marker incorporating art would not be effective because art is intended to draw people to it. The committee's comment applied to "ugly" art as well; the report cited

Picasso's *Guernica* as an example of an ugly artwork that nevertheless compelled attention. In a final comment, the committee stated how "great art is hard to commission," and warned that one downside of holding a competition would be having to settle for a less-than-ideal design.[35] The committee thereby concluded this section of its report by stating that artists can be solicited to contribute ideas, but those in charge of selecting a design should not be obligated to consider them.

In spite of all this, however, the report offered "artistic" solutions: one was a logo poorly caricaturing Munch's *The Scream* (1893), another was to make a marker of black-dyed concrete or granite that would be "incredibly hot from sun absorption."[36] According to the report, the warning message should be nonlinguistic but should communicate clearly to whomever would find it:

(...) *Sending this message was important to us.*
We considered ourselves to be a powerful culture.
This place is not a place of honor ... no
highly esteemed deed is commemorated here
... nothing valued is here. (...)
The danger is unleashed only if you substantially disturb this place physically.
This place is best shunned and left uninhabited.[37]

If the US government was skeptical about the power of art to send a nuclear warning, artists seemed welcome to play a role in France. The French National Agency for Nuclear Waste (ANDRA) launched an open call for artists in 2015 in order to "imagine the memory of depository centers of radioactive waste for future generations."[38] ANDRA explained that the project was a "rare opportunity to conceive an artistic gesture usable for a pluri-millenary period."[39] The 2016 laureate, for example, was *Foret* (Forest) by Nicolas Grun and Pierre Laurent, an installation project conceived with eighty pillars that would gradually sink into the ground over a period of three hundred years, and at the same time eighty trees would grow behind them—the point being that the pillars would have completely sunk once the waste had become safe.[40]

There is a long history in France that values the way artistic mediums and scientific devices intra-act, especially since the World Fairs of the nineteenth century (as noted in chapter 2, however, those fairs also gave voice to colonialist or orientalist views). ANDRA's open call is but the latest instance of upholding that positive intra-action (that seems, at first glance, to avoid the colonialist narratives of past world fairs). For now it is too early to tell if the role of artists as designers of nuclear graveyards will lead to the

enframing underscored for nuclear corporations such as AREVA and Rio Tinto. Such artworks are difficult to categorize. But the heritage of Western colonization is still present. The repository in the Marshall Island called "the dome" in Runit, in which is buried about 111,000 cubic yards of radioactive debris from the US tests, has no warning sign, no barrier, and no indication of the dangerousness of the place (some of the material buried there has a half-life of 24,000 years). As Enewetak's senator Jack Ading put it: "If they [the US government] can spend billions of dollars on wars like Iraq, I'm sure they can spend $10,000 for a fence. It's a small island." Here too, Toyosaki's notion of "environmental racism" comes to mind again. Jetñil-Kijiner gives visibility to the dome in her poem "Anointed" (2018). In addition, one wonders where the waste and debris of the French tests in the Pacific are buried, and if ANDRA takes care of them, and if art will be commissioned to signal the danger of the nuclear tomb.

Even in the case of nuclear waste, the military/civilian and East/West compounds are at stake. As a whole, when looking at the art of the nuclear age, we see less focus on the admittedly few positive aspects of the technology (for evident reasons), yet there are some.

About Nuclear Medicine: Atom Heart Mother

Nuclear medicine was the one scientific application that the Curies had hoped would thrive. In the arts, as we have seen, representations of the atom's role in medicine are rare if rather eclectic. Marie Corelli's *The Secret Power* and Arthur Benjamin Reeve's *The Deadly Tube* both included the use of radium (to better or worse effect) as a cure. The Jáchymov Hospital (located close to the Czechoslovakian uranium mine) was also the setting for the 1937 Pathé short film *Mining for Radium* mentioned in chapter 1. Marie Curie herself became the focus instead, with biographical films such as Mervyn LeRoy's *Madame Curie* (1943) and *Les palmes de M. Schutz* (The Palms of Mister Schutz, 1997), based on the theatrical play by Jean-Noel Fenwich.

Another work that was "inspired" by nuclear medicine is Pink Floyd's album *Atom Heart Mother* (1970). The first track, "Atom Heart Mother Suite," had been tentatively titled "The Amazing Pudding" during the times when the band performed it in concert.[41] But then a producer suggested a more elaborate arrangement, and the band decided to find a "real" title for the song. One of the band members was reading the *Evening Standard* when the discussion came up, and he stopped at an article about a fifty-six-year-old woman in the UK who had been fitted with a nuclear-powered pacemaker.

The title "Atom Heart Mother" popped into the mind of one of the Pink Floyd members. Despite the mild protests of band members, he retorted "why not."[42] The album as a whole, however, with its cover featuring a speckled cow standing alone in a pasture, offers no musical rendering or reflection concerning nuclear science or medicine.

Among the few traces of nuclear medicine that appear in responses from the visual arts, one is a photograph from Patrick Nagatani's Nuclear Enchantment series: *Radiation Therapy Room* (1989) shows a man about to be treated for cancer of the parotid gland in a green room. The man lies on the table, ready for treatment, with white netting—perhaps the most unsettling aspect of the photo—covering his face.

Another potentially unsettling example never came to be: the festival Ars Electronica canceled a performance because a group of artists had planned to crush a test tube containing the urine of a cancer patient. According to the pair of artists, who go by the name of Tako (Ive Tabar and Vasja Kokelj): "The project topicalizes the widespread application of radioactive isotopes, which is still a huge taboo despite their everyday use in medicine, electronics, construction, and agriculture, and is often abused to the detriment of ordinary people under the guise of exclusive dominant experts."[43]

But the bulk of practices relating to nuclear medicine come from art therapy workshops for cancer patients and from fundraising events, such as "Art Bra Austin," for which bras are designed and sold. The bras are also modeled by cancer survivors.[44] Such practices, however, exist at the margin of what is typically considered art, and they are seldom exhibited in museums and galleries. What is striking therefore is the scarce number of artworks focusing on nuclear medicine per se: it is as if Marie Curie's aspirations for the use of radioactivity were diverted. But being nostalgic of nineteenth century France would be forgetting that this was also the time of the country's colonial expansions, and this context matters.

Art and Color: A Radioactive Legacy

In the arts of the atomic age, as we have seen, radioactivity is not invisible but varicolored; the arts in response to the atomic age are diverse in form and content, and in great majority they represent suffering.

Times of crisis lead to pondering the relevance and purpose of human activities (of the arts and sciences, in the case of the atomic age). After World War II, Adorno and Horkheimer, Claude Levi-Strauss, and more recently Bruno Latour already underscored the urgent necessity to reconsider European Enlightenment, Western civilization, and Western modernity. In the

arts, what must be questioned is less the modernist emphasis on the separation between political and apolitical art than the possibility for the arts to be an enframing. Much has been written about art as propaganda and the problem of censorship (versus freedom of speech) and rightly so. But there exists another form of enframing that must equally be considered.

Today, some nuclear corporations directly commission artists or are art patrons. The practices also existed during the Cold War, when they produced comics and cartoons (Walt Disney's *Our Friend the Atom* is one paradigmatic example). At the same time, these nuclear corporations mine great wealth in non-Western nations even today in neocolonial ways. These practices are in fact deeply rooted in the development of Western modernity: the best advanced artistic and scientific objects were already exhibited together in world's fairs since the mid-nineteenth century. And they were exhibited in contrast to colonized and non-Western cultures (objects and people), represented as inferior and belonging to the past. The superiority of the West together with the divide (Occident/Orient), these very fallacies, were thus staged through the use of artistic and scientific objects (as explored in chapter 2 and 7).

Current practices, therefore, bear the invisible imprint of the tie between modernity and colonialism and how artworks and scientific applications got entangled with it. When Polynesian artist Henri Hiro is exhibited at the Quai Branly Museum in Paris (which exhibits "indigenous" art) and not at the Pompidou Center like his contemporary Yves Klein is; when art is commissioned for a waste repository within Western borders but not for a Western repository in the Pacific, when contemporary artist Allery Sandy, for example, only reaches the White Cube because she is exhibited in Aboriginal shows and was sponsored by the nuclear company Rio Tinto and not simply because she is a "contemporary artist," then art reveals this imprint.

To paraphrase Adrienne Rich here again in her poem "Power" from *The Dream of a Common Language*, on how Marie Curie denied her wounds, denying our wounds is the source of our demise. But the arts lack neither resources nor energy: in our globalized world, the multitude of societies can communicate on a common plane: the artistic language.

After Said's Orientalism, therefore, the urgent necessity is to continue being aware of the issue of Orientalist depiction of "the other," but also to succeed in avoiding a segregation of the artistic production (of different cultures and times). This therefore also means transgressing the modern forgetting of the past. Western "modern" societies are focused on the new and the future, but reassessing past mistakes is vital. For example, inquiring about and giving visibility to the traumas caused by early uranium mining

(when safety levels weren't consistent) in terms of heath, environmental effect, resource stealing, and cultural appreciation is pivotal because some consequences are still developing today.

For the art of the atomic age, considering the past would allow for testimonies of the global and historical *hibakusha* to gain visibility. What matters most for the arts of the atomic age is visibility and the ethics of representation: How to convey the grim relevance of the nuclear testimonies to a wider audience? How to give visibility to the varicolored voices (be they human, animal, or vegetal)?

As long as radioactive landscapes proliferate, there will be artworks created in response to them and to the suffering of their inhabitants; the nuances of colors, feelings, and opinions approach the infinite. In 1986, the Italian art historian Manlio Brusatin argued that colors lie at the perfect intersection between art and science, between representation and scientific disciplines such as optics and physics, and that, consequently, in a history of colors we cannot distinguish art from science. After Fukushima, we cannot but notice the persistence of the "intra-actions," to use Barad's term. Kitsch entertainment, as well as censorship and self-censored media, have numbed us to the industry's true colors and deadened our senses to the radioactive dangers. They have prevented us from looking behind the pictorial tropes.

But when it comes to the relevance or purpose of the arts taken in our atomic age, we can turn back to Alfred Coppel's *Dark December* as we look toward the future and remember what Major Gavin said to Lorry, the woman with keloid scars he saved from rapists in their post-apocalyptic hell: "Who can each of us call to account for what's happened? We are all responsible. We mustn't ever forget that. Or it will all happen again."[45] Isn't it one of the roles of art and the humanities to keep the nuclear memory radioactive and alive?

Notes

Introduction

1. Jacques Derrida, "No Apocalypse, Not Now," *Diacritics* 14, no. 2 (Summer 1984): 22, 23.

2. Nishitani Osamu, "Où est notre avenir?" [Where Is Our Future?], *Ebisu-Etudes Japonaises* 47 (Spring–Summer 2012): 60. The article is a revised version of Nishitani Osamu, "'Mirai' wa doko ni aru no ka," *Gendai Shisō* 39 (2011): 34–37. Note that for all Japanese names in the text and notes I use the traditional order (family name preceding given name).

3. Catherine Jolivette, ed., *British Art in the Nuclear Age* (Burlington, VT: Ashgate, 2014), 14.

4. George Orwell, "You and the Atomic Bomb," *Tribune* (October 19, 1945), http://orwell.ru/library/articles/ABomb/english/e_abomb (accessed February 8, 2018).

5. Lynn Gamwell, *Exploring the Invisible: Art, Science and the Spiritual* (Princeton, NJ: Princeton University Press, 2002); James Acord, Carey Young, and Mark Aerial Waller, *Atomic Book* (London: The Arts Catalyst, 1998); Jolivette, ed., *British Art in the Nuclear Age*, 14.

6. John O'Brian, ed., *Camera Atomica* (Toronto: Art Gallery of Ontario and Black Dog Publishing, 2015); Ele Carpenter, ed., *The Nuclear Culture Textbook* (London: Black Dog Publishing, 2016).

7. Yamamoto Akihiro, *Kaku to nihonjin—Hiroshima, Gojira, Fukushima* [Nuclear and the Japanese—Hiroshima, Godzilla, Fukushima] (Tokyo: Chūōkōron-Shinsha, 2015).

8. Toyosaki Hiromitsu, *Atomikku eiji* [Atomic Age] (Tokyo: Tsukiji Shokan, 1995) and Toyosaki Hiromitsu, "Hidden and Forgotten Hibakusha: Nuclear Legacy," in John O'Brian, ed., *Camera Atomica*.

9. Karen Barad, *Meeting the Universe Halfway: Quantum Physics and the Entanglement of Matter and Meaning* (Durham, NC: Duke University Press, 2007).

10. Maurice Blanchot, "War and Literature," chap. 12 in *Friendship*, trans. Elizabeth Rottenberg (Stanford, CA: Stanford University Press, 1997), 110. First published in 1971.

Chapter 1

1. David Dowling, *Fictions of Nuclear Disaster* (Iowa City: University of Iowa Press, 1987) and Paul Brians, *Nuclear Holocaust: Atomic War in Fiction, 1895–1984* (Kent, OH: Kent State University Press, 1987), https://brians.wsu.edu/2016/11/16/nuclear-holocausts-atomic-war-in-fiction/(accessed February 8, 2018). See also P. D. Smith, *Doomsday Men: The Real Dr. Strangelove and the Dream of the Superpower* (New York: St. Martin's Press, 2007).

2. Nakao Maika, "The Image of the Atomic Bomb in Japan before Hiroshima," *Historia Scientiarum* 19, no. 2 (2009): 123–124. According to Nakao, radium *onsen* were popular during the Taisho era (1912–1928). In fact both radium and radon *onsen* are still in use today, and not just in Japan.

3. *Piff! Paff! Pouf!, A Musical Cocktail*, lyrics by William Jerome, music by Jean Schwartz, book by Stanislaus Stange (New York: Shapiro, Remick & Company, 1904). The show, produced at the New York Casino, opened on April 2, 1904, under the direction of F. C. Whitney.

4. Gerald Bordman, *American Musical Theater: A Chronicle*, rev. ed. (New York: Oxford University Press, 2010 [1978]), 234; *New York Times* quoted in "The Radium Dance," https://www.orau.org/ptp/collection/miscellaneous/radiumdance.htm (accessed January 30, 2018).

5. Ann Cooper Albright, *Traces of Light: Absence and Presence in the Work of Loïe Fuller* (Middletown, CT: Wesleyan University Press, 2007), 193.

6. Deborah Jowitt, *Time and the Dancing Image* (Oakland: University of California Press, 1989).

7. Albright, *Traces of Light,* 193.

8. "Loie Fuller Introduces New Radium Dance," *Los Angeles Herald*, Sunday supplement, May 1, 1904, 10.

9. Albright, *Traces of Light,* 193.

10. "Loie Fuller Introduces New Radium Dance," 10.

11. Frank N. Magill, ed., *The 20th Century A-GI: Dictionary of World Biography, Volume 7* (London: Routledge, 1999), 1263.

12. Albright, *Traces of Light*, 192.

13. In the patent description for the United States Patent Office, Fuller explains for example how she improved her costume for the "Serpentine Dance" by using curved sticks as props, so that the folds of the fabric would "assume variegated and fanciful waves of great beauty and grace," together with some white or colored light effects. She obtained several patents for the costume, one in France on April 1893 (serial no. 227,107), one in England the following month (no. 10,296) and in the United States on the April 17, 1894, in New York (no. 518,347), and under her given name, Marie Louise Fuller.

14. She therefore offered an original version compared to the ones recorded with different dancers by the Lumière Brothers, Georges Méliès, and Edison Studio (owned by Thomas Edison).

15. Albright, *Traces of Light*, 193.

16. Stephanie Strasnick, "Pierre Huyghe Brings Spiders, Quails and (Hopefully) Rats to Lower East Side Gallery," *Artnews*, March 18, 2014, http://www.artnews.com/2014/03/18/pierre-huyghe-brings-spiders-quails-rats-to-lower-east-side-gallery (accessed March 2015).

17. Erika Kobayashi, *Hikari no kodomo* [Luminous: Child of the Light] vol. 1 (Tokyo: Little More, 2013).

18. William Rose, *The Radium Book*, illustrated by Harry Hohnhorst (Cleveland, OH: Rose Publishing Company, 1905).

19. Lucretius, *The Nature of Things* (London: Penguin Classics, 2007), 38–39. In a 2018 publication, Thomas Nail explains that Lucretius never used the word "atom" itself in Latin while it was available to him, instead preferring "matter" or "things" in a flow of matter. Thomas Nail, *Lucretius I, An Ontology of Motion* (Edinburgh: Edinburgh University Press, 2018).

20. Lucretius, *The Nature of Things*, 8.

21. Ibid, 42.

22. Ibid, 46. According to Thomas Nail, Lucretius did not used the term *libre voluntas* (free will) but simply *voluntas* (will).

23. Ibid, 7, 9.

24. Richard Dehan (Clotilde Graves), "Lady Clanbervan's Baby," in *Off Sandy Hook and Other Stories* (New York: Frederick A. Stokes Company, 1915), 267, 275.

25. Arthur Benjamin Reeve, *The Deadly Tube* (Worcestershire, UK: Read Books Ltd, 2013), 5.

26. Ibid, 21

27. Ibid., 22, 25

28. Ibid., 21, 22.

29. Claudia Clark, *Radium Girls: Women and Industrial Health Reform, 1910–1935* (Chapel Hill: The University of North Carolina Press, 1997), 33. Clark mentions the Radium Luminous Material Corporation, which became the U.S. Radium Corporation and the Radium Dial Company, a branch of the Standard Chemical Company. They were first located in Orange, New Jersey. See also Ross Mullner, *Deadly Glow: The Radium Dial Worker Tragedy* (Washington, DC: American Public Health Association, 1999). The clock factory Bayard in Normandy, France, used radioluminescent materials until 1989 and was decommissioned at the cost of two millions of euros. See Richard Plumet, "Fermée depuis plus de 20 ans, l'usine des célèbres réveils Bayard sera enfin détruite" [Closed for 10 years, the notorious factory of Bayard alarm clocks will finally be destroyed], *France 3 Régions*, April 25, 2013, http://france3-regions.francetvinfo.fr/normandie/2013/04/25/fermee-depuis -plus-de-20-ans-l-usine-des-celebres-reveils-bayard-sera-enfin-detruite-240829.html (accessed April 2017). The article does not mention any impact on the workers.

30. Clark, *Radium Girls*, 113; "Radium Victims Win $50,000 and Pensions in Suit Settlement," *New York Times*, June 5, 1928. The federal judge William Clark explained that the issue was "an extremely serious social question in a human way."

31. See "Award Disappoints One Radium Victim," *New York Times*, June 6, 1928. The Illinois case was also far more complicated due to Catherine Donohue's health, and it lasted several months. For scans of much of the press coverage, see Len Grossman, "The Case of the Living Dead Women," 2009–2012, http://www.lgrossman .com/pics/radium/index.html (accessed February 16, 2017).

32. Frederick Griffin, "Society of the Living Dead," *The Star Weekly*, April 23, 1938; Arthur J. Snider, "Some of 'Doomed' Women in Radium Poisoning Survive," *Boston Evening Globe*, June 29, 1953.

33. Marie Curie, quoted in Robert R. Johnson, *Romancing the Atom: Nuclear Infatuation from the Radium Girls to Fukushima* (Santa Barbara, CA: Praeger, 2012), 12–13, bracketed text in original.

34. Rudolf Brunngraber, *Radium: Roman eines Elements* [Radium: A Novel] (New York: Random House, 1937) for the English version.

35. Clark, *Radium Girls*, 108.

36. See Frank Nugent, "The Screen in Review," *New York Times*, November 26, 1937; Charles Taylor, "New DVDs to Warm Your Toes: 'Nothing Sacred,'" *New York Times*, October 30, 2011.

37. Carole Langer (dir.), *Radium City*, documentary film, Carole Langer Productions, 1987; Janet Maslin, "Film Festival; a View of the Radium Dial Horror," *New York Times*, September 25, 1987.

38. Atomic Energy Commission, *Epidemiological Follow-up of the New Jersey Radium Cases*, final report, NYO-2181-5-1 (July 1968). A part of the research was also devoted to the Lindsay Light Company thorium cases (1931–1950); research continued with the purchase of the facility by Kerr McGee and the use of the site as a radioactive dump, but the Radium Girls were definitely the most important group study.

39. Argonne National Laboratory, Environmental Research Division, annual report, Center for Human Radiobiology (April 1985), iii. See also Robley D. Evans, "Radium and Mesothorium Poisoning and Dosimetry and Instrumentation Techniques in Applied Radioactivity," Massachusetts Institute of Technology, Annual Progress Reports of 1968 and 1970.

40. "They told me the day before I was admitted that they were going to drill the bones in my ear before they could get to it and I would have never let them do it, as I haven't felt good since. And I had social security + blue cross + they told me it wouldn't cost anything and today they sent me this bill. ... I have spent enough money for all the pills beside paying my own doctor that Argonne should at least take care of this as I have been through enough + am still not feeling good." Charlotte Purcell, letter to Argonne National Laboratory, July 17, 1974, National Archives at Chicago.

41. Reeve, *The Deadly Tube*, 21.

42. Pathologies for the woman known as "Case 05–215" included but were not limited to: cancer of the right eyelid, arthritis, late psychotic symptoms, cataracts and glaucoma, amputation at the left mid-tight (section of the thigh) and traces of pitting edema on the right leg, an ovarian cyst removed, all teeth removed, but, as the report concluded: she was a "well developed, well nourished elderly, and garrulous women who is lying comfortably in bed." In Robley D. Evans and Robert J. Kolenkov, "Radium and Mesothorium Poisoning and Dosimetry and Instrumentation Techniques in Applied Radioactivity," Annual Progress Report, Massachusetts Institute of Technology, 952–5, May 1968, 523.

43. "Case 03–666," Looney Margaret, Argonne National Laboratory intra-lab memo, CHR Records (April 16, 1973), National Archives at Chicago.

44. Ann Nocenti, Mark Texeira, John Royle, Philip Moy, *Wolverine: Evilution* (New York: Marvel Comics, September 1994); Kurt Vonnegut, *Jailbird*, New York: Random House, 151; Shelley Stout, *Radium Halos: A Novel about the Radium Dial Painters* (Create Space Independent Publishing Platform, 2009); D. W. Gregory, Radium Girls (Woodstock, IL, 2000); Melanie Marnich, *These Shining Lives* (New York: Dramatists Play Service, Inc., 2010), see also Michael Billington, "These Shining Lives—Review," *The Guardian*, May 16, 2013, https://www.theguardian.com/stage/2013/may/16/these-shining-lives-review (accessed February 16, 2017); Eleanor Swanson, "Radium Girls," *The Missouri Review* 25, no. 1 (Spring 2002): 27, and Eleanor Swanson, *A*

Thousand Bonds: Marie Curie and the Discovery of Radium (Waco, Texas: National Federation of State Poetry Societies Press, 2003).

45. Clark, *Radium Girls*, 108.

46. Paul d'Ivoi, *Le radium qui tue* [The Radium that Kills] (Paris: Tallandier, 1948), 10, 11. First published as *La course au radium* [The Race for the Radium] in *Le Journal des Voyages*, October 1908–July 1909.

47. Henry de Graffigny, *La cavern au radium* [The Radium Cave] (Paris: J. Ferenczi & Fils, 1927).

48. Michel Darry, *La course au radium* [The Race for the Radium] (Paris: J. Ferenczi & Fils, 1936).

49. Maurice Leblanc, *The Secret of Sarek* (New York: A. L. Burt, 1920), 364.

50. Agatha Christie, *The Big Four* (London: Harper, 2002 [1927]), 84. "Radium Thieves" is the title of the novel's fourth chapter.

51. Albert Dorrington, *The Radium Terrors* (Amsterdam: Fredonia Books, 2002 [1911]), 51.

52. Ibid., 132.

53. Ibid., 236, 290.

54. Alexander Bogdanov, *Red Star: The First Bolshevik Utopia* (Bloomington: Indiana University Press, 1984 [1908]), ix. (The novel was republished several times before being staged in 1920 by the Proletcult, a Soviet organization intended to sponsor proletarian culture.) Bogdanov includes numerous descriptions of Martian civilization being more advanced than Earthling societies. One notable example of a proto-feminist attitude is Bogdanov's portrayal of equality between men and women, resulting in body shape and muscular mass of each gender being indistinguishable from the other because "it is evidently the enslavement of women in the home and the feverish struggle for survival on the part of the men which ultimately account for the physical discrepancies between them," 76.

55. Ibid., 37, 28.

56. See Annette R. Federico, *Idol of Suburbia: Marie Corelli and Late-Victorian Literary Culture* (Charlottesville: University Press of Virginia, 2000) and Teresa Ransom, *The Mysterious Miss Marie Corelli: Queen of Victorian Bestsellers* (New York: Sutton Publishing, 1999).

57. Marie Corelli, *The Secret Power* (Rochester, NY: Scholar's Choice, 2015), 16. First published in 1921.

58. Ibid., 85.

59. Ibid., 266, 261, 263.

60. Marie Corelli, *The Mighty Atom* (London: Hutchinson and Co., 1896), 140, 142.

61. Ibid., 145.

62. Ibid., 149.

63. Albert Einstein, December 1926, quoted in Arlen J. Hansen, "The Dice of God: Einstein, Heisenberg, and Robert Coover," *NOVEL: A Forum on Fiction* 10, no. 1 (Autumn 1976): 50.

64. Albert Einstein and Leopold Infeld, *The Evolution of Physics, From Early Concepts to Relativity and Quanta* (New York, Clarion Books, 1938). Werner Heisenberg, "La découverte de Planck et les problèmes philosophiques de la physique classique" [Planck's Discovery and the Philosophical Problems of Classical Physics], in *L'homme et l'atome* [Man and the Atom], Rencontre Internationales de Genève (Neuchatel: Editions de la Baconnière, 1958).

65. Dowling, *Fictions of Nuclear Disaster*, 2.

66. Brians, *Nuclear Holocaust*, chap. 1.

67. Marie Curie, *La radiologie et la guerre* [Radiology and War] (Paris: Librairie Felix Alcan, 1921), 3, 11.

68. Ibid., 132, 138. Curie's hopes were also turned toward a stronger national use of radium therapy; she pointed out that the United States and the United Kingdom had various institutes while France only had the recent joint efforts of the University of Paris and the Pasteur Institute (with the newly created Radium Institute).

69. Such argument was for example the underlining message of *War and Medicine*, an exhibition displayed at London's Wellcome Trust Gallery in 2008. It displayed pictures of the disastrous casualties of war, past and contemporary artworks, and medical experiments in psychology or reconstructive surgery. See *War and Medicine*, The Wellcome Collection (London: Black Dog Publishing, 2008).

70. Curie, *La radiologie et la guerre*, 140, 142.

71. Robert Cromie, *The Crack of Doom* (London: Digby Long, and Co., 1895), 3, http://www.gutenberg.org/files/26563/26563-h/26563-h.htm (accessed February 6, 2018).

72. Ibid., 116.

73. Ibid., 15–17.

74. Ibid., 203–203.

75. Anatole France, *L'Île des pingouins* (Penguin Island, 1908). Unpaged English translation https://archive.org/stream/penguinisland00fran/penguinisland00fran _djvu.txt(accessed February 6, 2018).

76. Ibid.

77. Richard Rhodes, *The Making of the Atomic Bomb* (New York, NY: Simon & Schuster Paperbacks, 1986), 44.

78. Upton Sinclair, *The Millennium, A Comedy of the Year 2000* (Newcastle-on-Tyne: Northumberland Press Limited, 1929), 48, 35, 36, 54. Sinclair wrote *The Millennium* after a fire whipped through the experimental cooperative community he had founded in Englewood, New Jersey, six months after it opened. According to Paul Brians, the work was originally an unproduced and unpublished play written in 1907, which the author then published as a novel 1924.

79. Karel Čapek, *The Absolute at Large* (Lincoln: University of Nebraska Press, 2005 [1922]), 8. Čapek was the first to use the word "robot" to describe an artificial human in his novel *RUR: Rossum's Universal Robots* (1920).

80. Ibid., 158.

81. Nakao, "The Image of the Atomic Bomb in Japan before Hiroshima," 128.

82. See *Cine-journal* 346, no. 42 (April, 1, 1916) and "Les effluves funestes—Camille de Morlhon," Fondation Jérôme Seydoux Pathé, http://filmographie.fondation-jeromeseydoux-pathe.com/17464-effluves-funestes-les (accessed March 2017).

83. See Arthur B. Evans, "The Verne School in France: Paul d'Ivoi's *Voyages Excentriques*," *Scientific Studies* 36 (2009): 220.

84. Olaf Stapledon, *Last and First Men* (London: Orion Books, 2004), 27, 28, 272. First published in 1930.

85. Nakao, "The Image of the Atomic Bomb in Japan before Hiroshima," 124.

Chapter 2

1. Amira K. Bennison, *The Great Caliphs: The Golden Age of the 'Abbasid Empire* (New Haven: Yale University Press, 2010).

2. Even though great scholars like Avicenna were mostly preoccupied by the problem of transmutation and alchemy (in addition to medicine), the translation movement that started in Baghdad was precursory and unique in that it translated into one single language, Arabic, research mainly produced in India and Greece.

3. Paul Strathern, *Mendeleyev's Dream: The Quest of the Elements* (London: Penguin Books, 2001), 39. First published in 2000.

4. Albert Einstein, "Letter to President Roosevelt," August 2, 1939, http://www.atomicheritage.org/key-documents/einstein-szilard-letter(accessed February 14, 2018).

5. Ibid.

6. Spencer R. Weart, *Nuclear Fear: A History of Images* (Cambridge, MA: Harvard University Press).

7. Weart, *Nuclear Fear*, 103, 104. See also William L. Laurence, "Eyewitness Account of Atomic Bomb over Nagasaki," War Department, Bureau of Public Relations, press release, September 9, 1945, available at http://www.atomicarchive.com/Docs/Hiroshima/Nagasaki.shtml(accessed February 14, 2018).

8. Leonard Engel and Emanuel S. Pillar, *The World Aflame: The Russian-American War of 1950*, quoted in Patrick B. Sharp, *Savage Perils: Racial Frontiers and Nuclear Apocalypse in American Culture* (Norman: University of Oklahoma Press, 2007), 167.

9. Lisa Yoneyama, *Hiroshima Traces: Time, Space, and the Dialectics of Memory* (Berkley: University of California Press, 1999).

10. John Hersey, *Hiroshima* (London: Penguin, 1985). First published in 1946. Robert Jay Lifton and Greg Mitchell explained how the book was criticized for being reductive, since the scale of the bombing and death toll are not included, and for the editing imposed on Hersey (to include the reason why the bomb was dropped); see Robert Jay Lifton and Greg Mitchell, *Hiroshima in America: Fifty Years of Denial* (New York: Grosset/Putman, 1995), 86.

11. John Dower, "Foreword to the 1995 Edition," in Michihiko Hachiya, *Hiroshima Diary* (Chapel Hill: University of North Carolina Press, 1995).

12. On Soviet Russia's nuclear weapons program, see Toyosaki Hiromitsu, *Atomikku eji* [Atomic Age] (1995); Nadav Kander, *Dust* (Berlin: Hatje Cantz, 2014); and Julian Charrière, *Polygon* (Berlin: The Green Box, 2015). See also Oleg Bukharin, "The Future of Russia's Plutonium Cities," *International Security* 21, no. 4 (Spring 1997).

13. Algeria is even more invisible, but documentary films give the victims some visibility: see Larbi Benchiha's *Vent de sable, le Sahara des essais nucléaires* (Wind of Sand, the Sahara of Nuclear Tests, 2008), and *L'Algérie, De Gaulle et la bombe* (Algeria, De Gaulle and the Bomb, 2010). In writings, there is the work of the chemist Louis Bulidon, who was a witness of an accident that occurred during the test named "Beryl," and the nuclear physicist Raymond Sene, who wrote another nuclear testimony: Louis Bulidon and Raymond Sene, *Les irradiés de Béryl: l'essai nucléaire français non contrôlé* (The Irradiated from Beryl: The Uncontrolled French Test) (Paris: Thaddee, 2011). Regarding China, Toyosaki Hiromitsu also underscored, albeit in a few lines, the effect of the program on few residents in Tibet in Hiromitsu Toyosaki, *Atomikku eji* [Atomic Age], ibid.

14. Michelle Keown, *Pacific Islands Writings: The Postcolonial Literature of Aotearoa / New Zealand and Oceania* (Oxford: Oxford University Press, 2009), first published in 2007.

15. Katy Jetñil-Kijiner, *Iep Jāltok, Poems from a Marshallese Daughter* (Tucson: University of Arizona Press, 2017).

16. Chantal T. Spitz, *Island of Shattered Dreams*, trans. Jean Anderson (Wellington, New Zealand: Huia, 2007), 13. First published as *L'Île des rêves ecrasés* [Island of Shattered Dreams] (Papeete: Les éditions de la plage, 1991).

17. Teresia K. Teaiwa, "Bikini and Other S/Pacific N/Oceans," *The Contemporary Pacific* 6. no. 1 (Spring 1994): 87, 95.

18. Michel Darry, *La course au radium* [The Race for the Radium] (Paris: J. Ferenczi & Fils, 1936).

19. John Vidal, "Uranium Workers Dying after Time at Namibia Mine, Report Warns," *Guardian*, April 15, 2014, http://www.theguardian.com/environment/2014/apr/15/uranium-workers-dying-cancer-rio-tinto-namibia-mine (accessed February 2015).

20. AREVA (France) has 34% of the capital, SOPAMIN (Niger) 31%, OURD (Overseas Uranium Resources Development Company Ltd, Japan) holds 25%, and ENUSA (Empresa Nacional des Uranio S. A., Spain) 10%. Since the renaming of AREVA to Orano, the information can be found in "Annual Activity Report" (2016), available on the company's website at http://www.orano.group/assets/img/finances/PDF/pdf-Publications-financiaires-informations-reglementees/EN/2016_PUBLICATIONS/2016_Annual_Activity_Report.pdf (accessed April 2018).

21. Rio Tinto's official webpage, "Culture," http://www.riotinto.com/ironore/culture-9614.aspx (accessed March 20, 2015). The URL is no longer active but the information was transferred to another web page at http://desertriversea.com.au/the-supporters/rio-tinto (accessed February 2018).

22. Stefano Carboni, "A Message from the Art Gallery of Western Australia," *Colors of Our Country*, Rio Tinto (Perth, Australia: Indigenous Art Code Exhibition catalogue, 2015).

23. "Colours of Our Country," Rio Tinto, http://www.riotinto.com/media/media-releases-237_23090.aspx(accessed February 12, 2018).

24. "Building Community Capacity through Education," Rio Tinto, http://www.riotinto.com/ourcommitment/features-2932_5384.aspx (accessed March 20, 2015).

25. Bretchen Kohrs and Patrick Kafka, "Study on Low-Level Radiation of Rio Tinto's Rössing Uranium Mine Workers, EJOLT & Earthlife Namibia Report," 2014, http://www.criirad.org/mines-uranium/namibie/riotinto-rossing-workers-EARTHLIFE-LARRI-EJOLT.pdf (accessed March 2015). The study only covers 44 of the 16,000 miners, yet it is alarming to learn that medical details for all of workers are not accessible for study. The reports indeed concluded: "It is of utmost importance that the Ministry of Health and Social Services gets unrestricted access to the medical reports of all workers employed by Rössing Uranium in order to get an overall picture of the worker's conditions" (pp. 29–30). For a mine that has been in operation

since 1976, the fact that no attention was given to this problem and that health information is not transparent is incomprehensible.

26. Edward Said, *Orientalism* (New York: Penguin Books, 1978).

27. The poet encouraged the French workers to perform this task of "universal" breadth, which must be undertaken for the good of entire planet, a planet in which he described the Chinese as being "perfidious" and the Indians "half-naked." Bornier also praised the initiative of this canal for the good it will bestow upon those to whom "Christ was still unknown." Quoted in Said, *Orientalism*, 90. See also Henri de Bornier, *L'Isthme de Suez*, (Paris: Imperial Institute of France, 1861).

28. Abigail Solomon-Godeau, "Going Native: Paul Gauguin and the Invention of Primitivist Modernism," in *The Expanding Discourse: Feminism and Art History*, ed. Norma Broude and Mary Garrard (New York: Icon Editions, 1992), first published in *Art in American* 77 (July, 1989): 323. Such display was strikingly criticized at the time by Egyptian scholars; see Egyptian scholar quoted by Timothy Mitchell, "Orientalism and the Exhibition Order," *Colonialism and Culture* (Ann Arbor: University of Michigan Press, 1992).

29. Holly Edwards, "The Magic City," in *Noble Dreams Wicked Pleasures, Orientalism in America 1870–1930*, exhibition catalogue (Princeton, NJ: Princeton University Press, 2000, in association with Sterling and Francine Clark Art Institute, Williamston, MA), 192, 193.

30. "Radium at the Fair," San Francisco Call 96, no. 36 (1904): 8. See also Luis A. Campos, Radium and the Secret of Life (Chicago: University of Chicago Press, 2015), 50.

31. On the topic see Nisitani Osamu, *Ebisu-Etudes Japonaises* 47 (Spring–Summer 2012), and Jean-Luc Nancy, *L'Équivalence des catastrophes: (Après Fukushima)* [The Equivalence of Catastrophes: (After Fukushima)] (Paris: Galilée, 2012).

32. "We may believe that the changes in the foundations of modern science are an indication of profound transformations in the fundamentals of our existence, which on their part certainly have their effects in all areas of human experience. From this point of view it may be valuable for the artist to consider what changes occurred during the last decade in the scientific view of nature." Werner Heisenberg, "The Representation of Nature in Contemporary Physics," *Daedalus* 87, no. 3, Symbolism in Religion and Literature, Summer (1958), from *Die Kunste im Technischen Zeitaler*, published on behalf of the Bavarian Academy of Fine Arts (Munich: R. Oldenbourg publisher, 1956), 95.

33. Werner Heisenberg, "La découverte de Planck et les problèmes philosophiques de la physique classique" [Planck's Discovery and the Philosophical Problems of Classical Physics], in *L'homme et l'atome* [Man and the Atom], Rencontre Internationales de Genève, (Neuchatel: Editions de la Baconnière, 1958), 54.

34. Leo Szilard quoted by Richard Rhodes, *The Making of the Atomic Bomb*, 24, 14.

35. C. P. Snow, "The Two Cultures," in *Leonardo* 23, no. 2/3, quoted in *New Foundations: Classroom Lessons in Art/Science/Technology for the 1990s*, ed. Sonia Landy Sheridan (Elmsford, NY: Pergamon Press, 1990), 171, 172.

36. C. P. Snow, "The Two Cultures: A Second Look," in C. P. Snow, *The Two Cultures* (Cambridge, UK: Cambridge University Press, 1998), 60.

37. Literary critic F.R. Leavis was strongly opposed to Snow in what is now known as "the Snow-Leavis controversy." See F. R. Leavis, *Two Cultures?: The Significance of C. P. Snow* (Cambridge, UK: Cambridge University Press, 2013). The lecture was initially delivered in 1962. See also Roger Kimball, "'The Two Cultures' Today," *The New Criterion* (February 1994).

38. Tristan Sauvage, recalling the conference given for the occasion of a group exhibition at Amici della Francia in May 1952, *Arte Nucleare,* Galleria Schwartz (Milan: Grafiche Gaiani Milano, 1962), 30.

39. Stephen Petersen, "Explosive Propositions: Artists React to the Atomic Age," in *Science in Context* 17, no. 4 (2004), 579–609.

40. Helen Megaw, quoted in *From Atoms to Patterns: Crystal Structure Designs from the 1951 Festival of Britain: The Story of the Festival Pattern Group*, Lesley Jackson (London: Richard Dennis Publications, Wellcome Trust Gallery, April 14–August 10, 2008), exhibition catalogue, 5, and Marcus Brumwell, quoted in ibid.

41. Ann Coxon, "From Atoms to Patterns," *Frieze* 117, September 2008, http://www.frieze.com/issue/review/from_atoms_to_patterns/ (accessed March 20, 2015).

42. Catherine Jolivette, "Representations of Atomic Power at the Festival of Britain," in *British Art in the Nuclear Age*, 112.

43. See the exhibition catalogue *Doisneau chez les Joliot-Curie, Un photographe au Pays des Physiciens* [Doisneau at the Joliot-Curie's: A Photographer in the Physicians' land] (Sommières: Romain Pages Editions, 2005), Musée des arts et métiers/Cnam.

44. Martin Heidegger, *"Science and Reflection"* (lecture, August 1954) in preparation of "The Question Concerning Technology" for the conference "The Arts in the Technological Age" held in Munich, in Martin Heidegger, *The Question Concerning Technology and Other Essays* (New York: Harper Torchbooks, 1982), 169.

45. See, for example, Heidegger, "The Question Concerning Technology"; Martin Heidegger, "What Are Poets For?," *Poetry, Language, Thought* (New York: HarperCollins, 1971).

46. Martin Heidegger, "The Question Concerning Technology," *The Question Concerning Technology and Other Essays*, 19, 14, 15, 28.

47. Theodor Adorno, "Commitment," *New Left Review*, I, no. 87–88 (1974): 75.

48. Clement Greenberg, "Modernist Painting," Charles Harrison and Paul Wood, eds., *Art in Theory 1900–1990* (London: Blackwell, 1992), 754–760. Jean-Paul Sartre's view, which emphasized the crucial role of the prose writer as politically committed, appeared in *Qu'est-ce que la littérature?* (What Is Literature, 1947).

49. Susan Sontag, *Regarding the Pain of Others* (New York: Picador, 2003), 101.

50. Bert Winther, "The Rejection of Isamu Noguchi's Hiroshima Cenotaph: A Japanese American Artist in Occupied Japan," *Art Journal* (Winter, 1994): 26.

51. Alice Kain, "*Nuclear Energy*, Henry Moore (1898–1996)," University of Chicago Arts webpage, n.d., https://arts.uchicago.edu/public-art-campus/browse-work/nuclear-energy (accessed February 18, 2018).

52. Ibid.

53. Henry Moore, quoted by David Katzive, "Henry Moore's Nuclear Energy: the Genesis of a Monument," *Art Journal* 32 (1973): 286, additional quote from Katzive, 288.

54. "45 items in second round acquisitions: Atom Piece jewel of the crown," *Mainichi Shimbun*, April 7, 1987, quoted in Kamiya Yukie, *Simon Starling: Project for a Masquerade (Hiroshima)* (Hiroshima, Japan: The Hiroshima City Museum of Contemporary Art, Hiroshima, 2011), exhibition catalogue, 125.

55. Kamiya Yukie, "An Introduction to Atom Piece: Simon Starling, Henry Moore and Hiroshima." In *Simon Starling: Project for a Masquerade (Hiroshima)*, 128.

56. Henry Moore quoted in *Henry Moore—Sculpture and Environment* (New York: Harry Abrams, 1976), 462.

57. *Chūgoku Shimbun*, newspaper article quoted by Kamiya Yukie, "An Introduction to Atom Piece: Simon Starling, Henry Moore and Hiroshima," 125–130.

58. In 2014, Robert Burstow resumed at least two points of views: on the one hand, he recalled that Iain A. Boal underscored Moore's deliberate decision to undermine his commissioners' triumphalism by renaming the *work Nuclear Energy* instead of the initial title *Atom Piece*—the word *piece* being too close to *peace*. While on the other hand, Burstow also showed that Moore's intentions were analyzed as ambivalent because of the cathedral-like footing of the sculpture, see Robert Burstow, "Geometries of Hopes and Fear: The Iconography of Atomic Science and Nuclear Anxiety in the Modern Sculpture of World War and Cold War Britain," in *British Art in the Nuclear Age*, ed. Catherine Jolivette (Farnham, UK: Ashgate, 2014), 63.

59. Natasha Degen, "Simon Starling," *Frieze* 137 (March 2011), http://www.frieze.com/issue/review/simon-starling (accessed May 2013).

60. Kamiya Yukie, "An Introduction to Atom Piece: Simon Starling, Henry Moore and Hiroshima," 126.

61. "Blair Backs Nuclear Power Plans," *BBC News*, May 16, 2006, http://news.bbc
.co.uk/2/hi/uk_news/politics/4987196.stm (accessed March 2015).

62. The Wellcome Trust Gallery choice of "autonomous" curatorial practices is also
motivated by the fact that it belongs to the science charity and founding body the
Wellcome Trust. The trust's mission is to improve "health by supporting bright
minds in science, the humanities and social sciences, and public engagement." It is
therefore logical that its gallery exhibits "autonomous" artworks within "autono-
mous" curations which serves the Trust's promotion of science. http://www
.wellcome.ac.uk/About-us/index.htm (accessed March 2015).

63. Arts at CERN's official website http://arts.web.cern.ch (accessed March, 2015).

64. *"Our 90 Years: 1923-2013,"* Exhibition press release, (Tokyo: Museum of Con-
temporary Art Tokyo, February 15–May 11, 2014), 1.

65. Jean-Luc Nancy, *The Equivalence of Catastrophes*, 13.

66. Voltaire, "Poème sur le désastre de Lisbonne [Poem to the Lisbon Disaster],"
Toleration and Other Essays, rev. ed. (New York: The Knickerbocker Press, 1912), 262.
First published in 1755.

67. Theodor Adorno, *Negative Dialectics* (New York: Routledge, 1966), 361.

68. Nancy, *The Equivalence of Catastrophes*, 11.

69. Shima Atsuhiko, "A Guide to Tetsumi Kudo Part 11: *Cultivation by Radioactivity
and Kudo's First Return to Japan in Eight Years,"* in *Your Portrait: A Tetsumi Kudo
Retrospective* (Osaka: Daikim Foundation for Contemporary Arts, Osaka and The
National Museum of Art, 2013), exhibition catalogue, 176. The exhibition toured at
the National Museum of Arts, Osaka, The National Museum of Modern Art, Tokyo,
and the Aomori Museum of Art from 2013 to 2014.

70. Ibid.

Chapter 3

1. Ōta Yōko, *Zanshū tenten* [Residues of Squalor], in Kyoko and Mark Selden, eds.,
The Atomic Bomb, Voices from Hiroshima and Nagasaki (London: Routledge, 2005), 57.
First published in Japanese in 1954.

2. Ibid.

3. See Robert Jay Lifton, *Death in Life: Survivors of Hiroshima* (Chapel Hill, NC: Uni-
versity of North Carolina Press, 1991. For Ōta's writings see the anthological volume
of *Nihon no genbaku bungaku vol. 2, Ōta Yōko* [Japanese A-bomb Literature vol. 2, Ōta
Yōko] (Tokyo: Holp Publishing, 1983), and the four volumes of *Ōta Yōko Shū* [Ōta
Yōko Collection] (Tokyo: Nihon Tosho Center, 2001), first printed in 1984.

4. Nagaoka Hiroyoshi, "Futatsu no shi—haha Tomi to musume Yōko to" [Two Deaths—Mum Tomi and Daughter Yōko, 1982], in *Japanese A-bomb Literature vol. 2, Ōta Yōko*, 349–353.

5. Nagaoka, "Genbaku bungaku shi" [History of A-bomb Literature], 1973, in *Nihon no genbaku kiroku* [Japanese A-bomb Records] 16 (Tokyo: Nihon Tosho Center, 1991), 76.

6. Kenzaburō Ōe, *Hiroshima noto* [Hiroshima Notes, 1965]. In English, see Ōe, *Hiroshima Notes* (New York: Grove Press, 1997).

7. Mutsu Katsutoshi, "Kaeranu tamashii" [A Soul Never to Come Home], from *Gembaku taikenki* (Personal Accounts of the Atomic Bomb), in John Whittier Treat, "Atomic Bomb Literature and the Documentary Fallacy," *Journal of Japanese Studies* 14, no. 1 (Winter 1988): 41–42. This article is also a chapter in John Whittier Treat, *Writing Ground Zero: Japanese Literature and the Atomic Bomb* (Chicago: University of Chicago Press, 1995). See also Osada Arata, ed., *Genbaku no ko—Hiroshima no shōnen shōjo no uttae* [A-bomb Children—The Voice of Boys and Girls of Hiroshima] (Tokyo: Iwanami, 1990). First published in 1951.

8. Treat, "Atomic Bomb Literature and the Documentary Fallacy," 40.

9. Nagai Takashi, *Nagasaki no kane* [The Bells of Nagasaki] (New York: Kodansha International, 1994), 19, 34–35. First published in 1949.

10. John W. Dower, "Foreword to the 1995 Edition," in Hachiya Michihiko, *Hiroshima Diary: The Journal of a Japanese Physician, August 6–September 30, 1945*, trans. Warner Wells, MD (Chapel Hill: University of North Carolina Press, 1995), vii. First published in English in 1955.

11. See Nagaoka, "Two Deaths." Junko Fumitsuki's work is titled *Ōta Yōko san no shi* [The Death of Ōta Yōko, 1964]. She had met Ōta three months prior to her death.

12. The American psychiatrist Robert Jay Lifton quotes and refers to Ōta and briefly mentions Hara and Tōge, as well as a few other A-bomb works (see Lifton, *Death in Life*). The journalist Richard Rhodes also included direct testimonies and quoted Ōta, but the voices of the victims feel at times dehumanized within the mostly anonymous testimonies. Richard Rhodes's *The Making of the Atomic Bomb* (New York: Simon & Schuster Paperbacks, 1986). In both books Ōta is referred to only as "a writer" or "a female writer," yet both books remain a valuable source of information.

13. Maurice Blanchot, "War and Literature," chapter 12 in *Friendship*, trans. Elizabeth Rottenberg (Stanford, CA: Stanford University Press, 1997), 110. First published in 1971.

14. Kazashi Nobuo, *Tetsugaku no 21 seiki: Hiroshima kara no daiippo* [Philosophy of the 21st Century, First Steps from Hiroshima] (Hiroshima: Hiroshima Peace Culture Center, 1999), 8.

15. Ibid.

16. Treat, "Atomic Bomb Literature and the Documentary Fallacy," 43.

17. Theodor Adorno, "Cultural Criticism and Society" and "Commitment," in *Can One Live after Auschwitz? A Philosophical Reader*, ed. Rolf Tiedemann (Palo Alto, CA: Stanford University Press, 2003), 162 and 251–252. Adorno wrote "Cultural Criticism and Society" in 1949; it first appeared in print 1951. "Commitment" was written in the early 1960s but appeared posthumously, first in *New Left Review* I, no. 87–88 (1974).

18. Rolf Tiedermann, "Introduction," in *Can One Live after Auschwitz?*, ibid, xvi–xvii.

19. Ōta Yōko, *City of Corpses*, in Richard H. Minear ed., trans., *Hiroshima: Three Witnesses* (Princeton, NJ: Princeton University Press, 1990), 179, 218.

20. Hara Tamiki, *Summer Flowers*, in Richard H. Minear ed., trans., *Hiroshima: Three Witnesses*, 58.

21. Ōta, *City of Corpses*, 188, 189.

22. Ibid., 180.

23. Ibid., 199.

24. Ibid.

25. Ōta, *Residues of Squalor*, 71–72.

26. Hayashi Kyōko, *Futari no bohyō* [Two Grave Markers], in Selden and Selden, *The Atomic Bomb, Voices from Hiroshima and Nagasaki*, 24.

27. Ibid., 25.

28. Maruki Iri and Maruki Toshi, *The Hiroshima Panels / Hiroshima no zu* (Tokyo: Niji Shobou, 1959), pages unnumbered.

29. John W. Dower and John Junkerman, eds., *The Hiroshima Murals, The Art of Iri Maruki and Toshi Maruki* (Tokyo, New York, San Francisco: Kodansha International, Ltd., 1985).

30. Nagaoka, "History of A-bomb Literature," 270. Regarding the atrocities of the Japanese Empire, the Marukis said it was important to talk about it and discussed it in the context of mind control.

31. John Whittier Treat, "Hiroshima and the Place of the Narrator," *Journal of Asian Studies* 48, no. 1 (February 1989): 36.

32. Ōta, *City of Corpses*, 182.

33. Hara, *Summer Flowers*, 45.

34. Ibid., 46.

35. Ibid., 49. See also Treat, "Atomic Bomb Literature and the Documentary Fallacy," 49.

36. Hara, *Summer Flowers*.

37. Nagai, *The Bells of Nagasaki*, p. 37.

38. Ōta, *City of Corpses*, 188.

39. Hara, *Summer Flowers*, 52; Nagai, *The Bells of Nagasaki*, 22; Hachiya, *Hiroshima Diary*, 101.

40. Hachiya, *Hiroshima Diary*, 100.

41. Iguchi Motosaburō (or Gensaburō, there are many readings possible for the same kanjis), "Kyō ten" ["Bad Luck" or "Evil Point," 1945], in Nagaoka, "History of A-bomb literature," 78–79.

42. Ota, *City of Corpses*, 205

43. Nagai, *The Bells of Nagasaki*, 21, 48, 51.

44. Ibid., 73.

45. Susan Lindee, *Suffering Made Real: The American Science and the Survivors at Hiroshima* (Chicago: University of Chicago Press, 1997), 17. First published in 1994.

46. Adorno, "Commitment," 244.

47. Comment made in relation to Gunter Anders's philosophical writings on the bomb. Nagaoka, "History of A-bomb Literature," 124.

48. Blanchot, *Friendship*, 109.

49. Lynn Gamwell, *Exploring the Invisible: Art, Science, and the Spiritual* (Princeton, NJ: Princeton University Press, 2002), 265.

50. Barnett Newman, "A New Sense of Fate," in John Philip O'Neill, *Barnett Newman: Selected Writings and Interviews* (Berkeley: University of California Press, 1990), 169. First written in 1948.

51. Jackson Pollock, "Interview with William Wright" (1950), in Kristine Stiles and Peter Selz, eds., *Theories and Documents of Contemporary Art, A Sourcebook of Artists' Writings* (Berkeley: University of California Press, 2012), 24.

52. Brooke Kamin Rapaport, *Vital Forms: American Art and Design in the Atomic Age, 1940–1960* (Brooklyn, NY: Brooklyn Museum of Art and Harry N. Abrams, 2001), exhibition catalog.

53. Enrico Baj, from letter written in 1960, in *Arte Nucleare*, Galleria Schwartz (Milan: Grafiche Gaiani Milano, 1962), 19, 21.

54. *Baj et Dangelo, peintures nucléaires* [Baj and Dangelo, Nuclearist Paintings], exhibition catalog, Apollo Gallery, Brussels, March 4–17, 1952.

55. As Timothy J. Garvey roughly listed: "One untitled composition on Plexiglas, for example, features clusters of line and ball combinations that foreshadow the atomic cluster design of George Nelson's famous Ball wall clock from 1947. Others showed splitting circular forms surrounded by textured haloes evoking the emanation of energy." See Timothy J. Garvey, "László Moholy-Nagy and Atomic Ambivalence in Postwar Chicago," *American Art* (Fall 2000): 24.

56. "Chicago's Part," and Carey Orr, "End of Warfare, or End of Civilization" (cartoon), *Chicago Daily News* (August 9, 1945), both quoted in Timothy J. Garvey, "László Moholy-Nagy and Atomic Ambivalence in Postwar Chicago," 23–38, 23.

57. Garvey, "László Moholy-Nagy and Atomic Ambivalence in Postwar Chicago," 26.

58. See Henry DeWolf Smyth, *Atomic Energy for Military Purposes; The Official Report on the Development of the Atomic Bomb under the Auspices of the United States Government, 1940–1945*, published in 1945.

59. László Moholy-Nagy, "The Function of Art," in Richard Kostelanetz, ed., *Esthetics Contemporary* (New York: Prometheus Books, 1989), 65, 66–67. Reprinted from *Vision in Motion* (Chicago: Theobald, 1947).

60. Salvador Dalí, "Anti-Matter Manifesto," exhibition leaflet, Carstairs Gallery, New York, December 1958–January 1959; archives of the National Library of France.

61. Hara, *Summer Flowers*, 51.

62. Ibid., 58.

63. Ibid.

64. Ibid., 89. "One day countless white sea gulls were moving about in the middle of that impressionist painting: schoolgirls on a labor detail. They had alighted atop the brightly gleaming rubble; white blouses bathed in the bright rays of the sun, each had opened her lunchbox."

65. Dower and Junkerman, *The Hiroshima Murals*, 25.

66. Ibid., 15.

67. *1945 nen +/– 5nen* [Year 1945 +/– 5 Years] (Hiroshima: The Hiroshima City Museum of Contemporary Art, 2016), May 21, 2016–July 3, 2016, exhibition catalogue.

68. Nobuko Tsukui, "Women Writers on the Experience of World War II: The Atomic Bomb and the Holocaust," *Journal of the College of Humanities* 2 (Kasugai: Chubu University, 1999).

69. Ōta, *City of Corpses*, 147.

70. Ibid., 149, 147.

71. See Nagaoka, "Two Deaths." Ōta suffered from numerous physical ailments and went from hospital to hospital before her death.

72. Ibid. See also Ōta Yōko, *Hachijussai* [Eighty Years Old] (Tokyo: Kodansha, 1961) and Ōta Yōko, "Haha no shi" [Mother's Death], *Asahi Journal* (February 3, 1959).

73. Minear, *Hiroshima: Three Witnesses*, 34.

74. "Genbaku hisaiji no nōto" [Notes from an A-bomb Victim], http://home .hiroshima-u.ac.jp/bngkkn/database/HARA/tamiki-note.html; Minear, *Hiroshima: Three Witnesses*, 30.

75. Minear, *Hiroshima: Three Witnesses*, 30. Hara had been arrested as a communist militant, and after the shock of that ordeal he suffered another blow: the prostitute he had paid a great deal of money to live with him walked out on him after only a month.

76. Nagaoka, "History of A-bomb Literature," 82. According to Nagaoka, Hara committed suicide in protest—after hearing a radio announcement about the Korean War and Truman's statement on the possible use of nuclear weapons in that war—as well as in despair that his experience would be repeated. On the other hand, Minear also acknowledges that Hara was always suicidal, in particular after the death of his wife see Minear, *Hiroshima: Three Witnesses*, 35.

77. Tōge had always been sick during his childhood. Having been diagnosed with tuberculosis, he felt his life was condemned but realized he was wrongfully diagnosed just before the bombings. He had bronchiectasis, not tuberculosis. See Minear, *Hiroshima: Three Witnesses*, 279.

78. Minear, *Hiroshima, Three Witnesses*, 289.

79. Tōge Sankichi, "Prelude," from "Poems of the Atomic Bomb," in Minear, *Hiroshima: Three Witnesses*, 305.

80. Maruki Iri, interview by John Junkerman, in Dower and Junkerman, *The Hiroshima Murals*, 125, 11.

81. Ibid, 125.

82. Nakazawa Keiji, *Barefoot Gen, Vol. 1: A Cartoon Story of Hiroshima* (San Francisco: Last Gasp, 2004), first published in 1973. Keiji Nakazawa, *Kuroi ame ni utarete* [Struck by Black Rain] (Tokyo: Dino Box, 2005).

83. See *Genbaku to inochi, Mangakatachi no senso* [Life and the A-bomb, Manga Artists and War] (Tokyo: Kin no Hoshi Publications, 2015). See also Yamamoto Akihiro, *Kaku to nihonjin—Hiroshima, Gojira, Fukushima* [Nuclear and the Japanese—Hiroshima, Godzilla, Fukushima], which focuses on manga, films and popular culture.

84. Treat, *Writing Ground Zero*, 105.

85. See "Record of Hiroshima: Images of the Atomic Bombing," Hiroshima Peace Media Center, available at http://www.hiroshimapeacemedia.jp/?gallery=201106 13141546676_en (accessed March 2016).

Chapter 4

1. Igarashi Yoshikuni explained that Americans spread DDT by plane twenty-four hours before landing in Japan, and that DTT was also spread at schools and major stations in ways that novelist Nosaka Akiyuki (usually known for *Graves of the Fireflies*) also remembered: "When powered with DDT on my head, it stuck to my skin forever since I could rarely take a bath. My skin looked like it was infected with ringworm. It was particularly awful when powder was injected into my pants with a dispenser which looked like a horse's penis. With the taste of diluted starch syrup, I felt glad the war was over. But, with DDT, I really understood Japan's defeat." Nosaka Akiyuki, quoted in Igarashi Yoshikuni, *Bodies of Memories, Narratives of War in Postwar Japanese Culture, 1945–1970* (Princeton and Oxford: Princeton University Press, 2000), 67.

2. Ōta Yōko, *Zanshū tenten* [Residues of Squalor], in Kyoko and Mark Selden, eds., *The Atomic Bomb, Voices from Hiroshima and Nagasaki* (London: Routledge, 2005), 58. First published in Japan in 1954.

3. Ibid., 59.

4. Ibid., 61.

5. "Civil Censorship Detachment," document dated September 21, 1945, reproduced on webpage of the Gordon W. Prange Collection, Hornbake Library North, University of Maryland, https://www.lib.umd.edu/prange/about-us/civil-censorship-detachment.

6. Jay Rubin, "From Wholesomeness to Decadence: The Censorship of Literature Under the Allied Occupation," *Journal of Japanese Studies* 11, no. 1 (Winter 1985): 85.

7. Ōta, *City of Corpses*, 149–150.

8. *Nihon no genbaku bungaku* [Japanese A-bomb Literature] (Tokyo: Holp Shuppan, 1983).

9. Nam Jun Paik's commemorative work was exhibited for the exhibition *Hiroshima—Hiroshima—Hiroshima* (the title uses three different alphabets: kanji, katakana, and romaji), May 3–August 20, 1989. See *Hiroshima—Hiroshima—Hiroshima, Commissioned Work "Theme Hiroshima,"* exhibition catalog, Hiroshima City Museum of Contemporary Art (Kyoto: Nissha Printing Co., Ltd, 1989). The works of Willem de Kooning, Kusama Yayoi, and Yves Klein were exhibited in *Hiroshima no gendai bijutsu* (Contemporary Art of "Hiroshima"), June 6–September 25, 2016, Hiroshima City Museum of Contemporary Art, information available at https://www.hiroshima-moca.jp/en/exhibition/collection2016-2/.

10. See synopsis at "NHK Drama Special 2015—Ichiban Densa ga Hashitta," https://jdramas.wordpress.com/2015/08/10/nhk-drama-special-2015-ichiban-densha-ga-hashitta/ (accessed September 2017)

11. Richard Holledge, "'The Sensory War 1914-2014' at Manchester Art Gallery," *Artnews* (February 24, 2014), http://www.artnews.com/2015/02/24/the-sensory-war-1914-2014-at-manchesteart-gallery (accessed September 2017). See also Ian Youngs, "Hiroshima Survivors' Art to Go on Show," *BBC News* (September 18, 2014), http://www.bbc.com/news/entertainment-arts-29235538 (accessed September 2017).

12. Saito Hiro, "Reiterated Commemoration: Hiroshima as National Trauma," *Social Theory* 24, no. 4 (December 2006).

13. Rubin, "From Wholesomeness to Decadence: The Censorship of Literature Under the Allied Occupation," 71, 76.

14. Some examples related by Rubin include one place where the expression "hairy foreigner" was changed to "westerner." Other remarkably odd instances were when a remark about MacArthur that was judged "contemptuous" was deleted, and when the suggestion of the GIs' relations with prostitutes and/or fraternization with Japanese women (depicted by characters who were holding hands) was removed. On the other hand, in *Aki kaze* [Autumn Wind] by Ishizaka Yōjirō, a character refuses to shave his beard unless, as he stated, "I have to order from MacArthur's GHQ." The passage was however left intact. Ibid., 92.

15. Rubin, "From Wholesomeness to Decadence: The Censorship of Literature Under the Allied Occupation," 89.

16. John W. Dower and John Junkerman, eds., *The Hiroshima Murals, The Art of Iri Maruki and Toshi Maruki* (Tokyo, New York, San Francisco: Kodansha International, Ltd., 1985), 15.

17. William Johnston, "Introduction," in Nagai Takashi, *Nagasaki no kane* [The Bells of Nagasaki] (New York: Kodansha International, 1994), vi. First published in 1949.

18. *The Bells of Nagasaki* was finally published in 1949, along with the essay titled "Manira no higeki" (The Tragedy of Manila).

19. See Robert J. Lifton and Greg Mitchell, *Hiroshima in America: Fifty Years of Denial* (New York: Grosset/Putman, 1995), 56.

20. Richard H. Minear explained how Hara attempted to publish the first part of his triptych in *Kindai bungaku* (Modern literature), but the journal was instructed not to publish it (however it did publish the less-graphic third part of the triptych, in 1949). Hara then opted for *Mita bungaku* (Mita literature) established by Keiō University because it had no prepublication censorship but faced few inconsistent post-censorship problems. For a detailed account of *Summer Flowers* pre- and post-censorship, see Richard H. Minear, ed., trans., *Hiroshima: Three Witnesses* (Princeton, NJ: Princeton University Press, 1990), 36.

21. Shōda Shinoe, *Miminari* [Tinnitus] (Tokyo: Heibonsha, 1962), 10, cited by Nobuko Tsukui, "Women Writers on the Experience of World War II: The Atomic Bomb and the Holocaust," *Journal of the College of Humanities* 2 (Sept. 1999), 4.

22. See Rubin, "From Wholesomeness to Decadence: The Censorship of Literature Under the Allied Occupation." See also Naoko Shimazu, "Popular Representation of the Past: The Case of Post-war Japan," *Journal of Contemporary History* 38, no. 1 (January 2003): 101–116.

23. Ōta, "Sanjō" [Mountain Top], May 1955, in Minear, *Hiroshima: Three Witnesses*, 141.

24. Tōge Sankichi, "August 6, 1950," in Minear, *Hiroshima: Three Witnesses*, 347–349.

25. Saito, "Reiterated Commemoration: Hiroshima as National Trauma," 362.

26. Some photographs were published by *Asahi shimbun* before the enforcement of the Press Code, and after the code with two albums in 1952 (some of the pictures were also published in the US the same year) and 1959, in addition to Yamahada's "Genbaku satsuei memo" [Notes on A-bomb Photography].

27. Rupert Jenkins, ed., *Nagasaki Journey, The Photographs of Yosuke Yamahata, August 10, 1945* (San Francisco: Pomegranate Artbooks, 1995), 116.

28. Yamahata Yōsuke, "Genbaku satsuei memo" [Notes on A-bomb Photography], in *Genbaku no Nagasaki: Kiroku no shashin* [Nagasaki's A-bomb: A Photographic Record] (Tokyo: Gakufū Shoin, 1959), 23; see also Yamahata Yōsuke, *Nihon no shashinka 23* [Yamahata Yōsuke, Japanese Photographer 23] (Tokyo: Iwanami, 1998).

29. Yamahata, *Nagasaki's A-bomb* (pages with photographs are not numbered).

30. Nagaoka Hiroyoshi, "Genbaku bungaku shi" [History of A-bomb Literature"], 1973, in *Nihon no genbaku kiroku* [Japanese A-bomb Records] 16 (Tokyo: Nihon

Tosho Center, 1991) 124. See also: Domon Ken, *Hiroshima* (Tokyo: Kenkohsya, 1958); Fukushima Kikujirō, *Pikadon: aru genbaku hisaisha no kiroku* [Record of an A-bomb Victim] (Tokyo: Tokyo Chunichi Newspaper, 1961).

31. Susan Sontag, *Regarding the Pain of Others* (New York: Picador, 2003), 24, 25.

32. Yamahata, "Notes on A-bomb Photography," 24.

33. Saito, "Reiterated Commemoration: Hiroshima as National Trauma," 364.

34. *Hiroshima: sensō to toshi* (Hiroshima: War and City) (Tokyo: Iwanami, 1952).

35. Saito, "Reiterated Commemoration: Hiroshima as National Trauma," 365. See also "The Devastation of Hiroshima: A Record in Photographs—Human Beings," Hiroshima Peace Media Center, http://www.hiroshimapeacemedia.jp/mediacenter/article.php?story=20080527000925257_en (accessed September 15, 2016).

36. Sontag, *Regarding the Pain of Others*, 48.

37. "When Atom Bomb Struck—Uncensored," *Life* (September 29, 1952), 19–25.

38. Ibid., 22.

39. Sontag, *Regarding the Pain of Others*, 46.

40. Jenkins, *Nagasaki Journey, The Photographs of Yosuke Yamahata, August 10, 1945*, 116.

41. For example, the Hiroshima Panels were exhibited in 2015 at the University Museum in Washington. See "Japanese Art on Hiroshima and Nagasaki Atomic Bombings Exhibited in Washington," Associated Press (June 13, 2015), https://www.yahoo.com/news/japanese-art-atomic-bombings-exhibited-washington-000651477.html?ref=gs (accessed September 2016).

42. Erin Barnett and Philomena Mariani, "Introduction," in *Hiroshima: Ground Zero 1945*, International Center of Photography exhibition catalog, (New York: Steil, 2011), 5.

43. Willis E. Hartshorn, "Director Foreword," in *Hiroshima: Ground Zero 1945*, 4.

44. Ibid.

45. *Shashin-shū genbaku wo mitsumeru: 1945-Nen Hiroshima Nagasaki* [Staring at the Collection of Photographs: 1945, Hiroshima and Nagasaki] (Tokyo: Iwanami, 1981).

46. *Hiroshima: sensō to toshi* [Hiroshima: War and City], (Tokyo: Iwanami, 1952). The publication includes close-ups of corpses (certainly taken at the morgue); pieces of flesh; pictures of victims suffering from radiation sickness (women and children with hair loss) and some bearing pronounced keloid scars on their faces and bodies; and, finally, a few of healthy orphans and the reconstruction of the city.

47. "Letters to the Editor," *Life* (October 20, 1952), 7, quoted in Barnett and Mariani, "Introduction," in *Hiroshima: Ground Zero 1945*.

48. Saito also discusses why Hiroshima took so long to be subsumed in the Japanese national identity: the reluctance of the Japanese government to recognize the *hibakusha* after the Press Code was lifted in 1952; the imperial family did not attend the August 6 memorial until 1954; the state effectively and officially "nationalized" memories of the bombing only in 1957, when the *hibakusha* were finally provided medical care in a unanimous ruling by the Diet; and non-Japanese victims of the A-bomb were not publically acknowledged until 1990. As Saito explained, the mayor of Hiroshima attempted very early on to urge Tokyo politicians to plead of universal peace, but postwar reconstruction had become a priority. Saito argues that the accident with the fishing boat Lucky Dragon 5 was a catalyst for the entire country to accept the Hiroshima bombings as part of the country's collective trauma. See Saito, "Reiterated Commemoration: Hiroshima as National Trauma," 368.

49. Hayashi, *Futari no bohyō* [Two Grave Markers], in Selden and Selden, *The Atomic Bomb, Voices from Hiroshima and Nagasaki*, 37.

Chapter 5

1. "Scenes from *Doctor Atomic*," *New York Times* (October 14, 2008), https://www.youtube.com/watch?v=9Rze1UizJyw (accessed September 2016).

2. Spencer R. Weart, *The Rise of Nuclear Fear* (Cambridge, MA: Harvard University Press, 2012), 292. The book is an updated version of *Nuclear Fear, A History of Images* (Cambridge, MA: Harvard University Press, 1988).

3. John Adams, "Doctor Atomic and His Gadget," talk delivered at Yale University, October 29, 2009, 53, http://tannerlectures.utah.edu/_documents/a-to-z/a/Adams_09.pdf (accessed March 7, 2018).

4. John Adams, quoted by Spencer Weart, *The Rise of Nuclear Fear*, 292.

5. Adams, "Doctor Atomic and His Gadget," 54.

6. John Adams, *Doctor Atomic*, libretto available at http://spielzeit13-14.staatstheater.karlsruhe.de/media/libretto/Doctor%20Atomic%20amerik_deutsch.pdf (accessed March 7, 2018).

7. Ibid.

8. Kurt Vonnegut, *Cat's Cradle* (London: Penguin Modern Classics, 2008). First published in 1963.

9. Nagano Fumika, "Surviving the Perpetual Winter: The Role of Little Boy in Vonnegut's *Cat's Cradle*," in Harold Bloom, ed. *Kurt Vonnegut* (New York: Bloom's Literary Criticism, 2009), 127–142.

10. Weart, *The Rise of Nuclear Fear*, 291.

11. Adams, "Doctor Atomic and His Gadget," 54.

12. R. R. Wilson, "The Conscience of a Physicist," *Bulletin of Atomic Scientists* 26, no. 6 (1970): 30–34.

13. Rukeyser writes in uncompromising verse regarding gender differences: "Whoever despises the clitoris despises the penis / Whoever despises the penis despises the cunt / Whoever despises the cunt despises the life of the child. / Resurrection music, silence, and surf." Muriel Rukeyser, *The Speed of Darkness*, (New York: Random House, 1968).

14. Alex Ross, "Countdown," *New Yorker*, October 3, 2005.

15. On female scientists and radioactivity see Marelene F. Rayner-Canham and Geoffrey Rayner-Canham, *A Devotion to Their Science: Pioneer Women of Radioactivity* (Montreal: McGill-Queen's University Press, 1997). See also Annette Lykknes, Lise Kvittingen, and Anne Kristine Borresen, "Appreciated Aboard, Depreciated at Home: Ellen Gleditsch (1879–1968)," *Isis* 95, no. 4 (December 2004).

16. Ruth H. Howes and Caroline L. Herzenberg, *Their Day in the Sun: Women of the Manhattan Project* (Philadelphia, PA: Temple University Press, 1999), 32. The book lists many other women in several fields, including technicians and civilians, and the many women whose research indirectly contributed to the research for the bomb.

17. Ibid., 36

18. Denise Kiernan, *The Girls of Atomic City, The Untold Story of the Women who Helped Win World War II* (New York: Simon & Schuster, 2013), 34.

19. Ibid., 69.

20. Ibid., 44–45.

21. Ibid., 157.

22. Adams, *Doctor Atomic*, libretto.

23. Karen Barad, *Meeting the Universe Halfway* (Durham, NC: Duke University Press), 4, 8–11.

24. Niels Bohr, from Niels Bohr Archives, quoted by Karen Barad in *Meeting the Universe Halfway*, 10.

25. Jacques Derrida, "No Apocalypse Not Now," *Diacritics* 14, no. 2 (Summer 1984), 22.

26. Dougal McNeill, *The Many Lives of Galileo: Brecht, Theater and Translation's Political Unconscious*, Stage and Screen Studies (Book 7), (Bern: Peter Lang Academic, 2005), 36. See also Weart, *The Rise of Nuclear Fear*, 292.

27. Bertolt Brecht, quoted by Robert D. Hostetter in "Drama of the Nuclear Age, Resources and Responsibilities in Theater Education," *Performing Arts Journal* 11, no. 2 (1988): 86.

28. Bertolt Brecht, quoted by McNeil in *The Many Lives of Galileo*, 39. On the changes see also "History of Changes of Brecht's Galileo," Internet Archive, http://web.archive.org/web/20061214065712/http://www.nmsu.edu/~honors/galileo/gchanges.html.

29. Bertolt Brecht, *Life of Galileo* (London: Methuen Publishing, 1994), 110.

30. Theodor Adorno, "Commitment," 247. On Brecht see also Walter Benjamin, "What is Epic Theater," *Illuminations*, ed. Hannah Arendt (New York: Schocken Books, 1969), 150. First published in 1955.

31. Hara Tamiki, *Summer Flowers*, in Richard H. Minear ed., trans., *Hiroshima: Three Witnesses* (Princeton, NJ: Princeton University Press, 1990), 106.

32. Nagaoka, "History of A-bomb Literature," in *Nihon no genbaku kiroku* [Japanese A-bomb Records] 16 (Tokyo: Nihon Tosho Center, 1991), 120.

33. See David G. Goodman, trans., *After Apocalypse: Four Japanese Plays of Hiroshima and Nagasaki* (Ithaca, NY: Cornell University East Asia Program, 1994), first published in 1986. See also Nagaoka, "History of A-bomb Literature," 118.

34. Igarashi Yoshikuni, *Bodies of Memories, Narratives of War in Postwar Japanese Culture, 1945–1970* (Princeton and Oxford: Princeton University Press, 2000), 58. In literature, Ōta Yōko addressed the sadness of the prostitution problem as well as its link to American, English, French, Chinese, and Australian troops in the city of occupied Hiroshima in her novel *Human Tatters*. Tomatsu Shomei too photographed prostitutes in *Chewing Gum and Chocolate*. Many films of the period too, such as *Akasen chitai* (Street of Shame, 1956) by Mizoguchi Kenji, also portrayed this terrible reality, far from any idealized view of prostitution.

35. John Whittier Treat, *Writing Ground Zero: Japanese Literature and the Atomic Bomb* (Chicago: University of Chicago Press, 1995), 309.

36. Benjamin, "What Is Epic Theater," 150.

37. Goodman, *After Apocalypse*, 273.

38. Ibid., 274, 281.

39. Treat, *Writing Ground Zero,* 62

40. Goodman, *After Apocalypse*, 317

41. Ibid., 310.

42. "Hero in Handcuffs, *Newsweek*, April 1, 1957.

43. Fernand Gigon, *Formula for Death, E=mc2* (The Atom Bombs and After) (London: Allan Wingate Publishers, 1958). See also Fernand Gigon, *Apocalypse de l'atome* (Atom Apocalypse) (Paris: Mondiales Editions, 1958).

44. Marie Luise Kaschnitz, "Hiroshima," from *Neue Gedichte* (1957), in *Selected Later Poems of Marie Luise Kaschnitz*, trans. Lisel Mueller (Princeton, NJ: Princeton University Press, 1980), 3. On Western poetry and songs on Hiroshima, see Brian Murdoch, *Fighting Songs and Warring Words: Popular Lyrics of Two World Wars* (London and New York: Routledge, 1990). On Japanese songs and poetry, see *Nihon no genbaku bungaku, Shika* [Japan's A-bomb Literature, Poetry], vol. 13 (Tokyo: Holp Publishing, 1983).

45. John Wain, "Song about Major Eatherly," 1958, quoted by William Bradford Huie in *The Hiroshima Pilot* (New York: Pocket Book, 1964), 8–9. On the problem relating to fictional works seen as historical documentary see Alison Lee, *Realism and Power, Postmodern British Fiction*, Routledge Revivals (New York: Routledge, 1990).

46. See Mark di Suvero, *Eatherly's Lamp*, multimedia; audio file artist's statement, https://www.moma.org/explore/multimedia/audios/28/audios-special-exhibitions-all (accessed September 2016). The work is part of the MoMA collection.

47. Günter Anders, *Burning Conscience: The Case of the Hiroshima Pilot* (New York: Monthly Review Press, 1962). First published in 1961.

48. "Girls of Hiroshima to Claude Eatherly" (letter 8, July 24, 1959), in Anders, *Burning Conscience*, 25–26.

49. Nagaoka, "History of A-bomb Literature," 124.

50. Huie, *The Hiroshima Pilot*.

51. See George P. Elliot, "The Eatherly Case," *Commentary*, August 1, 1968, https://www.commentarymagazine.com/articles/burning-conscience-by-claude-eatherly-and-gunther-anders-the-hiroshima-pilot-by-william-bradford-huie-dark-star-by-ronnie-dugger/ (accessed March 9, 2018).

52. Huie, *The Hiroshima Pilot*, 1.

53. Anders, *Burning Conscience*, 108.

54. Huie, *The Hiroshima Pilot*, 126.

55. Ibid., 86. Huie's statement on the health of the Bikini military personnel could not be further from the truth for reasons explored in the next chapter.

56. Ibid., 247. Huie quoted an unreferenced *Newsweek* bio-note describing him as a writer "refugee" doing odd jobs such as carpentry, and that he had published books in Europe and a biography for a "major philosophical tract."

57. Anders also underscored that the transcription of the letters Huie quoted were inaccurate, and that he had started to reply point by point but thought the needs of the world were more pressing than the authors' quarrel. Gunther Anders, "Introduction" (1982), in *Hiroshima est partout* [Hiroshima Is Everywhere], (Paris: Seuil, 2008), 50 (my translation). Original title *Hiroshima ist uberall* (Munich: Beck, 1995).

58. Ronnie Dugger, *Dark Star, Hiroshima Reconsidered in the Life of Claude Eatherly of Lincoln Park, Texas* (Cleveland: World Publishing Company, 1967), 44.

59. Ibid, 182

60. Miguel Brieva, *Bienvenido al mundo* [Welcome to the World] (Madrid: Reservoir Books, 2007).

61. Marc Durin-Valois, *La derniere nuit de Claude Eatherly* [Claude Eatherly's Last Night] (Paris: Plon, 2012).

62. In *Genbaku to inochi, Mangakatachi no sensō* [Life and the A-bomb, Manga Artists and War] (Tokyo: Kin no Hoshi Publications, 2015).

63. The case of the RAF observer of the bombing of Nagasaki who said in his 1961 memoir, "with such utter devastation before our very eyes, how imperative to do something to see that it should never happen again," triggered no turmoil. See Leonard Cheshire, *The Face of Victory* (1961), quoted by Jerome Klinkowitz in *Pacific Skies: American Flyers in World War II* (Jackson: University Press of Mississippi, 2004), 234. Similarly, the suicide of navigator Paul Bregman in 1985 (around the fortieth anniversary of the atomic bombings) barely made the news. Ronnie Dugger also quote several statements from military men in *Dark Star* that caused no outrage comparable to the Huie-Anders controversy.

64. Alfred Coppel, *Dark December* (Greenwich: Fawcett Publications, Inc., 1960), 16.

65. Lisa Yoneyama, *Hiroshima Traces: Time, Space, and the Dialectics of Memory* (Berkley: University of California Press, 1999).

66. Sata Ineko, "The Colorless Paintings," in Kenzaburō Ōe, ed., *Fires from the Ashes, Short Stories about Hiroshima and Nagasaki* (London: Readers International, 1985), 125.

67. Coppel, *Dark December*, 45.

Chapter 6

1. See Yamamoto Akihiro, *Nuclear and the Japanese—Hiroshima, Godzilla, Fukushima* (Tokyo: Chūōkōron-Shinsha, 2015), 179.

2. See Saito Hiro, "Reiterated Commemoration: Hiroshima as National Trauma," *Social Theory* 24, no. 4 (December 2006), 368.

3. In the film, the Polynesians would have become accustomed to radioactivity, drinking a red, blood-like mixture. No one, especially no scientist, in the film tries to help decontaminate the island or study the mixture rendering the islanders immune to radioactivity.

4. Epeli Hau'ofa, "The Ocean in Us," *The Contemporary Pacific* 10, no. 2 (Fall 1998), 396.

5. Andre Vltchek, *Oceania, Neocolonialism, Nuke and Bones* (Auckland: Atuanui Press Ltd, 2013).

6. Ibid., 19, 37.

7. Hau'ofa, "The Ocean in Us," 392.

8. Noam Chomsky, "Foreword," in Andre Vltchek, *Oceania, Neocolonialism, Nuke and Bones*, 7.

9. Elizabeth M. DeLoughrey in "The Myth of Isolates: Ecosystem Ecologies in the Nuclear Pacific," in Pramod K. Nayar, *Postcolonial Studies: An Anthology* (Oxford: John Wiley & Sons Ltd, 2016).

10. Hau'ofa, "The Ocean in Us," 392, 395–396.

11. Isaac Soaladaob, quoted by Vltchek, *Oceania, Neocolonialism, Nuke and Bones*, 30–31.

12. Michelle Keown, *Pacific Islands Writings: The Postcolonial Literature of Aotearoa / New Zealand and Oceania*, (Oxford: Oxford University Press, 2009), first published in 2007.

13. Michael Light, *100 Suns, 1945–1962* (New York: Alfred A. Knopf, 2003), inside front cover.

14. "Revolutions Per Minute" (The Art Record), 2 vinyl LPs, Ronald Feldman Fine Arts, Inc. (New York: The Charing Hill Company Ltd., 1982).

15. "Bikini: With documentary photographs, abstract paintings, and meteorological charts, Ralston Crawford here depicts the new scale of destruction," *Fortune* Magazine (December 1946).

16. Nagaoka Hiroyoshi, "History of A-bomb Literature," in *Nihon no genbaku kiroku* [Japanese A-bomb Records] 16 (Tokyo: Nihon Tosho Center, 1991), 114, 117 and 120.

17. Ralph E. Lapp, *The Voyage of the Lucky Dragon* (New York: Harper & Brothers, 1958).

18. Frances Kathryn Pohl, *Ben Shahn* (Petaluma, CA: Pomegranate, 1993), 27.

19. Richard Hudson and Ben Shahn, *Kuboyama and the Sage of the Lucky Dragon* (New York: Thomas Yoseloff Ltd, 1965), 48–50. For the children's book: *Koko go ie da—ben shān no daigo fukuryū maru* (Here Is the House—Ben Shahn's Lucky Dragon) (Tokyo: Shueisha, 2006).

20. Ōta Yōko, "Noirōze no kokufuku" (Conquering Neurosis, 1958), in Richard H. Minear ed., trans., *Hiroshima: Three Witnesses* (Princeton, NJ: Princeton University Press, 1990), 128–129.

21. Sadako Kurihara, *Bikini, Be with Hiroshima and Nagasaki*, in Lequita Vance-Watkins and Mariko Aratani, trans., *White Flash, Black Rain: Women of Japan Relieve the Bomb* (Minneapolis, MN: Milkweed Editions, 1995), 16–17.

22. Toyosaki Hiromitsu, *Kaku yo ogoru nakare* [Nuclear Despair] (Tokyo: Kodansha, 1982); Toyosaki, *Māsharu shotō kaku no seiki* (Marshall Islands, Nuclear Century: 1914–2004, 2005). Unfortunately, I came across these two mammoth volumes while completing my book and unfortunately, I cannot include any analysis of the works here.

23. Kathy Jetñil-Kijiner, "History Project," in *Iep Jāltok, Poems from a Marshallese Daughter* (Tucson: University of Arizona Press, 2017), 14.

24. Ibid., 20.

25. Ibid., 20–21.

26. Jetñil-Kijiner, "Bursts of Bianca," in *Iep Jāltok, Poems from a Marshallese Daughter*, 40.

27. Jetñil-Kijiner, "Fishbone Hair," in *Iep Jāltok, Poems from a Marshallese Daughter*, 25.

28. Giff Johnson, *Don't Ever Whisper: Darlene Keju, Pacific Health Pioneer, Champion for Nuclear Survivors* (N/A: Giff Johnson, 2013).

29. Darlene Keju-Johnson, "Nuclear Bomb Testing on Human Guinea Pigs," in *Women on War: An International Anthology of Writings from Antiquity to the Present*, Daniela Gioseffi, ed. (New York: Feminist Press at the City University of New York, 2003), 251.

30. Ibid., 249.

31. President Truman in Robert Stone, *Radio Bikini* (1988), documentary.

32. Jetñil-Kijiner, "Ettolok Ilikin Lometo," in *Iep Jāltok, Poems from a Marshallese Daughter*, 10.

33. Johnson, *Don't Ever Whisper*, 71.

34. "No te parau tia, no te parau mau, no te tiamaraa, 8th Nuclear Free and Independent Pacific Conference," Arue, Tahiti (1999) (Suva, Fiji Islands: Pacific Concerns Resource Centre, 2000).

35. DeLoughrey, "The Myth of Isolates."

36. Toyosaki, *Nuclear Despair*, 183.

37. John G. Fuller, *The Day We Bombed Utah: American's Most Lethal Secret* (New York and Scarborough: Nal Books, 1984), 2, 6.

38. Vltchek, *Oceania: Neocolonialism, Nukes and Bones*, ibid., 86–89.

39. Jacques Derrida, "No Apocalypse, Not Now," *Diacritics* 14, no. 2 (Summer 1984), 23.

40. Hau'ofa, "The Ocean in Us," 397. Hau'ofa stated: "Ours is the only region in the world where certain kinds of experiments and exploitation can be undertaken by powerful nations with minimum political repercussions to themselves."

41. Keown, *Pacific Islands Writings*, 93.

42. Cite Morei, "Belau Be Brave," in *Te Rau Maire [the Fern Leaf]: Poems and Stories of the Pacific*, Marjorie Tuainekore Crocombe, Ron Crocombe, Kauraka Kauraka, and Makiuti Tongia, eds. (Rarotonga: 6th Festival of Pacific Arts, 1992), 4.

43. Vltchek, *Oceania: Neocolonialism, Nukes and Bones*, 32.

44. Elizabeth M. DeLoughrey, "Solar Metaphors: 'No Ordinary Sun,'" *Ke Mate Ka Ora: A New Zealand Journal of Poetry and Poetics* 6 (September 2008): 51.

45. Hone Tuwhare, "No Ordinary Sun," first published in *Northland Magazine* (May 1958), in Hone Tuwhare, *No Ordinary Sun* (Auckland: Longman Paul Ltd, 1973), 23.

46. Tuwhare, quoted in Elizabeth DeLoughrey, "Solar Metaphors," 52.

47. Keown, *Pacific Islands Writings*, 93.

48. In *Oceania, Imagining the Pacific*, exhibition leaflet, City Gallery Wellington, New Zealand, August 6– November 6, 2011. The Greenpeace *Rainbow Warrior* was the target of a state-sponsored bombing by a branch of French intelligence service in the port of Auckland, before the ship had been scheduled to sail to an event protesting a nuclear test planned in Moruroa.

49. Brett Graham in Anne-Marie White, "An International Indigene, Engaging with Brett Graham," *Art New Zealand* 147 (Spring 2013): 42.

50. Michelle Keown, "Our Sea of Island": Migration and *Mtissage* in Contemporary Polynesian Writing," *International Journal of Francophone Studies* 11, no. 4 (2008): 13.

51. Henri Hiro, "Tauraa" in Marjorie Tuainekore Crocombe, ed. "Te Mau Aamu Maohi/Poesie Tahitienne/Tahitian Poetry, Hubert Brémond/Henri Hiro/Charles Manutahi," *Mana, A South Pacific Journal of language and Literature* 7, no. 1 (1982): 59.

52. Henri Hiro, "'Oihanu e", Ibid., 41.

53. Ibid., 41–42.

54. Keown, *Pacific Islands Writing*, 97.

55. Chantal T. Spitz, *Island of Shattered Dreams*, trans. Jean Anderson (Wellington, New Zealand: Huia, 2007), 168. [First published as *L'Île des rêves ecrasés* [Island of Shattered Dreams] (Papeete: Les éditions de la plage, 1991).

56. Ibid., 23.

57. Ibid., 14.

58. Keown, *Pacific Islands Writing*, 98.

59. Dina El Dessouky, "Activating Voice, Body and Place," in DeLoughrey and Handley, eds., *Postcolonial Ecologies: Literature of the Environment*, 260.

60. Rai Chaze, *Vai: La rivière au ciel sans nuage* [Vai: The River with Sky without Cloud] (Tahiti: Api Tahiti, 2014), 43. First published in 1990.

61. Ibid., 38–39.

62. El Dessouky, "Activating Voice, Body and Place," 261.

63. Chaze, *Vai: La rivière au ciel sans nuage*, 43.

64. Déwé Gorodé, *Sharing as Custom Provides: Selected Poems of Déwé Gorodé*, trans. Raylene Ramsay and Deborah Walker (Canberra: Pandanus Books, 2004), 19.

65. Ibid., 42–43,

66. Peter Brown, "Introduction," in Gorodé, *Sharing as Custom Provides*, xxxix.

67. Gorodé, *Sharing as Custom Provides*, 6, 8.

68. "La grenouille et la bombe" (The Frog and the Bomb), Jean-Paul Sartre, ed., *Les Temps Modernes* 224 (January 1956).

69. Jean-Paul Sartre, "La libération de Paris: une semaine d'apocalypse," *Clarté*: 9 (August 24, 1945), 1. See Carole Jacobi, "'A Kind of Cold War Feeling' in British art,

1945–1952," in Catherine Jolivette, ed., *British Art in the Nuclear Age* (Burlington, VT: Ashgate, 2014), 26.

70. Chantal Spitz in Bruno Barrillot, Marie-Hélène Villierme, and Arnaud Hudelot., eds., *Témoins de la bombe* [Witnesses of the Bomb] (Papeete: Éditions Univers Polynésiens, 2013), 83.

71. Twelve veterans have been awarded remuneration in 2017 (which is only 2% of the requests in spite of the 2010 Morin Law for irradiated victims). See "Essais nucléaires: 12 vétérans irradiés obtiennent le droit a une indémisation (Nuclear Tests: 12 irradiated veterans obtained rights to compensation), *Le Monde*, March 15, 2017.

72. Marguerite Duraille (Patrick Rambaud), *Mururoa mon amour* (Paris: Jean-Claude Lattes Editions, 1996).

73. Bengt and Marie-Thérèse Danielsson, *Moruroa mon amour* (Paris: Stock, 1974). See also Bengt and Marie-Thérèse Danielsson, *Moruroa, notre bombe colonial* (Moruroa, Our Colonial Bomb) (Paris: L'Harmattan, 1993).

74. In his review of *Moruroa mon amour*, anthropologist Jean Guiart contended that the book was inconsistent; that the authors were not grateful enough for the compensation they received after their daughter died of cancer; that they gave too much ink to the separatists' demands; and that Tahiti would not survive as it is without France given the US presence. See Jean Guiart, "Danielsson, Marie-Thérèse et Bengt, *Moruroa mon amour*," *Journal de la Societe des océanistes* 30, no. 45 (1974).

75. See Jean-Marc Regnault, *Pouvana'a et De Gaulle, la candeur et la grandeur* (Pouvana'a and De Gaulle, the Ingenuousness and the Grandeur) (Papeete: Tahiti Editions, 2016).

76. The debates about whether Pouvanaa's eviction was due to the French military nuclear program or not are in vain: the Algerian FLN (National Liberation Front) was established in 1954 when the American nuclear tests were well underway. Even if the first nuclear tests were operated in the Algerian desert in the early 1960s, as part of the Evian Accords granting independence to the Algerians, it is clear that losing more colonies and potential remote test sites would have been detrimental to the nascent French nuclear program.

77. See Bernard Dumortier, *Atolls de l'atome, Mururoa & Fangataufa* (Atolls of the Atom, Mururoa & Fangataufa) (Rennes: Marine Editions, 2004). The book is of quasi-military propaganda, detailing the French military might and arsenal, evidently downplaying the effect on the environment and population, also downplaying the Rainbow Warrior accident.

78. Christine Bonnet and Jean-Marie Desbordes, *Aux enfants de la bombe* (To the Children of the Bomb), 2013. The documentary was awarded a prize from FIFO (International Festival of Oceanian Documentary Films). In writings, see Barrillot, Villierme, and Hudelot. eds., *Témoins de la bombe* [Witnesses of the Bomb].

79. Brain, Malle, and Cassavetes quoted in Spencer Weart, *The Rise of Nuclear Fear*, 288.

80. Kristen Iversen, *Full Body Burden: Growing Up in the Shadow of Rocky Flats* (New York: Broadway Books, 2013), 5–6.

81. Ibid., 157.

82. Mary Clarke, Esther Lewin, and Jay Rivkin, *Peace of Resistance* (Los Angeles: The Ward Ritchie Press, 1970).

83. Ibid., n.p.

84. See Amy Swerdlon, *Women Strike for Peace, Traditional Motherhood and Radical Politics in the 1960s* (Chicago: University of Chicago Press, 1993); Dennis Hevesi, "Dagmar Wilson, Anti-Nuclear Leader, Dies at 94," *New York Times*, January 23, 2011, and Elaine Woo, "Dagmar Wilson Dies at 94; Organizer of Women's Disarmament Protesters," *Los Angeles Times*, January 30, 2011.

85. John Dower, "War, Peace, and Beauty," in *The Hiroshima Murals*, 17. On postwar Japanese antinuclear movements and women's role, see Masakatsu Yamazaki, "Nuclear Energy in Postwar Japan and Anti-nuclear movements in the 1950s," *Historia Scientiarum* 19, no. 2 (2009).

86. "The Women of Greenham," *Greenham Song Book*, accessed April 5, 2017, https://womensliberationmusicarchive.files.wordpress.com/2010/10/yourgreenham _song_book.pdf. On the Greenham Common see also Beeban Kidron, "The Women of Greenham Common Taught a Generation How to Protest," *The Guardian*, September 2, 2013.

87. Ibid.

88. David Cortright, *Peace: A History of Movements and Ideas* (Cambridge: Cambridge University Press, 2008); "19-Year Greenham Common Campaign to End," *The Guardian*, September 5, 2000.

89. Achille Mbembe, "Necropolitics," *Public Culture* 15, no. 1 (2003): 17, 30.

90. Virginia Woolf, *Three Guineas* (Eastford, CT: Martino Fine Books, 2013), 6–7. First published in 1938.

91. Susan Sontag, *Regarding the Pain of Others* (New York: Picador, 2003), 3.

92. William S. Burroughs, "Astronaut's Return," in *Exterminator!* (London: Penguin Classics, 2008), 23, 24. First published in 1973.

93. Ibid., 24.

94. Gustav Metzger, Manifesto Auto-Destructive Art (1960), in Gustav Metzger: AutoDestructive Art, http://radicalart.info/destruction/metzger.html (accessed April 2017).

95. Martyl Langsdorf, in "The Doomsday Clock: The Symbolic Public Warning System," History Channel documentary (2016). See also Kennette Benedict, "Martyl Langsdorf (1917–2013)," The Bulletin.org, April 9, 2013, http://thebulletin.org/sites/default/files/Martyl%20Annual%20Report.pdf (accessed April 2017).

96. "Timeline," Bulletin of Atomic Scientists , 2018, https://thebulletin.org/timeline (accessed March 16, 2018).

97. Iron Maiden, "2 Minutes to Midnight," *Powerslave*, EMI, Capitol Records (1984).

98. Barry McQuire, "Eve of Destruction," *Eve of Destruction* Dunhill (1965); Sex Pistols, "God Save the Queen," *Never Mind the Bollocks, Here's the Sex Pistols*, Virgin, A&M (1977); The Specials, "Man at C&A," *More Specials*, Horizon Studios (1980); The Sun Ra Arkestra, "Nuclear War," *Nuclear War*, Music-Box (1984).

99. Iron Maiden, "Brighter Than a Thousand Suns," *A Matter of Life and Death*, EMI, Sanctuary (2006).

100. Nagaoka, "History of A-bomb Literature," 122.

101. Shohono Naomi, "A-bomb related research activities and Antinuclear movements of Japanese scientists," originally delivered at the First Conference of IPPNW (International Physicians for Prevention of Nuclear War) help March 20–25, 1981 at Airlie House near Washington DC, available at http://ir.lib.hiroshima-u.ac.jp/ja/list/HU_journals/AN00213938/4/--/item/15122.

102. Frédéric Joliot-Curie, *Cinq années de lutte pour la paix* [Five Years of Struggle for Peace] (Paris: Éditions "Défense de la paix," 1954), 57. See also Frédéric Joliot-Curie, *Textes Choisis* [Selected Texts] (Paris: Éditions Sociales, 1959).

103. See Herbert Lottman, *The Left Bank; Writers, Artists, and Politics from the Popular Front to the Cold War* (Chicago: University of Chicago Press, 1982), 272.

104. "It is not too late, even now; /it is not too late to muster your true strength. / If the scene seared onto your retinas that day pierced your heart/ so that tears drip unceasingly from the wound; / … it is not too late … to take those hands that now hand limp/ and grasp them firmly/ between your won palms, raw and red:/ no, / it is not too late, even now." In Minear, trans., *Hiroshima: Three Witnesses*, 357.

105. Boris Vian, *La java des bombes atomiques* [The Java Dance of Atomic Bombs, 1968], full English translation available at https://muzikum.eu/en/127-7140-155430/boris-vian-la-java-des-bombes-atomiques-english-translation.html (accessed March 19, 2017).

106. Ibid.

107. Yves Klein, "'Explosions Bleues,' Lettre à la Conférence internationale de la détection des explosions atomiques," July 1958, first published in *Stich* (1994), 147–148 and in *Le dépassement de la problématique de l'art et autres écrits* (Paris: École

Nationale Supérieure des Beaux-Arts, 2003), 60–61. English translation use here by Klaus Ottman, https://walkerart.org/magazine/yvesklein-texts-from-20-days-of-klein -on-twitter (accessed March 18, 2018).

108. Ibid.

109. Édouard Launet, *Sorbonne Plage* [Sorbonne Beach] (Paris: Stock, 2016), 148.

110. Tony Atkinson, "The Moruroa Pacific Peace Flotilla," in *Below the Surface: Words and Images in Protest at French Testing on Moruroa*, Ambury Hall, ed. (Auckland: Random House New Zealand, 1995), xiii.

111. Morty Sklar, *Nuke-rebuke: Writers & Artists Against Nuclear Energy & Weapons* (Iowa City, IA: The Spirit that Moves Us Press, 1984).

112. Christine Hauder, "U.S. Nuclear Weapons Tests Come to Youtube," *New York Times*, March 17, 2017.

113. Toyosaki, *Nuclear Age*, 273.

114. Toyosaki, *Kaku yo ogoru nakare* [Nuclear Despair], 200.

115. Chris Bell, "The Movie So Toxic It Killed John Wayne: The Tragedy of *The Conqueror*," *The Telegraph*, January, 17, 2017, http://www.telegraph.co.uk/films/0/movie -toxic-killed-john-wayne-tragedy-conqueror/ (accessed October 2017).

116. Karen G. Jackovich and Mark Sennet, "The Children of John Wayne, Susan Hayward and Dick Powell Fear That Fallout Killed Their Parents," *People* (November 10, 1980), http://www.people.com/people/archive/article/0,,20077825,00.html (accessed March 2016).

Chapter 7

1. Paul Brians, "Nuclear War in Science Fiction, 1945–1959," *Science Fiction Studies* 11, no. 3 (November 1984): 258.

2. Susan Sontag, "The Imagination of Disaster," *Commentary* (October 1, 1965): 47.

3. Ibid, 42, 44.

4. Ibid., 48.

5. David Dowling, *Fictions of Nuclear Disaster* (Iowa City: University of Iowa Press, 1987), 16.

6. See chapter 5 in Paul Brians, *Nuclear Holocausts: Atomic War in Fiction* (Kent, OH: Kent State University Press, 1987); Brians, "Nuclear War in Science Fiction, 1945– 1959," 258.

7. Dwight D. Eisenhower, Speech before the General Assembly of the United Nations on Peaceful Uses of Atomic Energy, New York City, December 8, 1953.

8. George Orwell, "You and the Atomic Bomb," *Tribune* (October 19, 1945), http://orwell.ru/library/articles/ABomb/english/e_abomb (accessed February 8, 2018).

9. Olaf Stapledon, *Last and First Men* (London: Orion Books, 2004), 99. First published in 1930.

10. Jiri Kasparek, "Soviet Russia and Czechoslovakia' Uranium," *The Russian Review* 11, no. 2 (April 1952).

11. Christian Deubner, "The Expansion of West German Capital and the Founding of Euratom," *International Organization* 33, no. 2 (Spring 1979).

12. Cheikh Anta Diop, *Les fondements économiques et culturels d'un État Fédéral d'Afrique Noire* (1987) [in French]. Published in English as Cheikh Anta Diop, *Black Africa: The Economic and Cultural Basis for a Federated State* (Chicago: Chicago Review Press, 1987), x. First published in 1960.

13. Ibid.

14. Gabrielle Hecht, "Africa and the Nuclear World: Labor, Occupational Health, and the Transnational Production of Uranium," *Comparative Studies in Society and History* 51, no. 4 (2009): 897.

15. Jim Harding, *Canada's Deadly Secret: Saskatchewan Uranium and the Global Nuclear System* (Nova Scotia: Fernwood Publishing, 2007); Peter C. van Wyck, *Highway of the Atom* (Montreal and Kingston: McGill-Queen's University Press, 2010); Traci Brynne Voyles, *Wastelanding: Legacies of Uranium Mining in Navajo Country* (Minneapolis: University of Minnesota Press, 2015).

16. Spencer Weart, *The Rise of Nuclear Fear* (Cambridge, MA: Harvard University Press), 199.

17. Leonard Engel and Emanuel S. Pillar, *The World Aflame: The Russian-American War of 1950* (New York: Dial Press, 1947), 34–35.

18. Brians, "Nuclear War in Science Fiction, 1945–1959," 259–260.

19. Helen Clarkson, *The Last Day: A Novel of the Day After Tomorrow* (New York: Torquil Book, 1959), http://www.pages.drexel.edu/~ina22/301/NOVEL-Last_Day2.htm (accessed March 23, 2018).

20. Ibid.

21. Ibid.

22. Ibid.

23. Ibid.

24. Dowling, *Fictions of Nuclear Disaster*, 221.

25. Will F. Jenkins, *The Murder of the U.S.A* (Rockville, MD: Wildside Press, 2016), 4, 5, 10. First published in 1946.

26. Patrick B. Sharp, *Savage Perils: Racial Frontiers and Nuclear Apocalypse in American Culture* (Norman: University of Oklahoma Press, 2007), 164.

27. Brians, "Nuclear War in Science Fiction, 1945–1959," 253.

28. Ibid., 254.

29. John W. Campbell Jr. quoted in Paul Boyer, *By the Bomb's Early Light, American Thought and Culture at the Dawn of the Atomic Age* (New York: Pantheon Books, 1985), 115, 116.

30. Boyer, *By the Bomb's Early Light*, 116.

31. Dowling, *Fictions of Nuclear Disaster*, 221.

32. Brians, "Nuclear War in Science Fiction, 1945–1959," 254.

33. Ibid.," 256.

34. Dickie Thompson, "Thirteen Women," Cinephonic Music Co. of London and Darby Music Co., New York (1954); recorded as "Thirteen Women and One Man," by Bill Haley and His Comets, Decca Records (1955).

35. Brians, *Nuclear Holocausts: Atomic War in Fiction*, 256.

36. Stapledon, *Last and First Men*, 107, 108, 109.

37. Brians refers for example to Piers Anthony's *Var the Stick* (1972) and Dean Ing's *Pulling Through* (1983), in Brians, *Nuclear Holocausts*, chapter 4.

38. Stapledon, *Last and First Men*, 101.

39. Gore Vidal, *Kalki* (New York: Penguin Book, 1998). First published in 1978.

40. Ibid., 217.

41. Judith Merril, *Shadow on the Hearth* (New York: Doubleday, 1950).

42. Brians, "Nuclear War in Science Fiction, 1945–1959," 255.

43. Ibid.

44. Ray Bradbury, "There Will Come Soft Rains," in *The Martian Chronicles* (London: HarperCollins, 2008), 284-286. First published in 1951.

45. Ibid., 226. Sara Teasdale's poem was first published in *Harper's* in 1918 as a response to the end of World War I and with the hope that the so-called Great War would be the last.

46. Jon Towlson, "Rehabilitating Daddy, or How Disaster Movies Say It's OK to Trust Authority," *Paracinema* 16 (June 2012): 12.

47. Alfred Coppel, *Dark December* (Greenwich: Fawcett Publications, Inc., 1960), 20.

48. Leonard Rifas, *Paha-Sapha, The Black Hills* (1979), Energy Comics #1 (Educomics, January, 1980): 21, see https://archive.org/stream/TestUploadForJeffKaplan/Energy Comics01#page/n0/mode/2up

49. The Commodores, "Uranium," Dot Records (1955).

50. Warren Smith, "Uranium Rock" (1958), also on the album *Sun Rockabillys—Put Your Cat Clothes On*, Phillips (1973).

51. Bernard Benally, quoted in Robert Del Tredici, *At Work in The Fields of The Bomb* (New York: Harper & Row Publishers, 1987), 168–169.

52. Ibid., 169.

53. Marsha Weisiger, "Happy Cly and the Unhappy History of Uranium Mining on the Navajo Reservation," *Environmental History, Environmental History* 17, no. 1 (2012): 146–159, 154. See also the 2000 documentary *The Return of Navajo Boy* by Jeff Spitz.

54. Voyles, *Wastelanding*, 23, 201. The Navajos were considered to be hostile and savage, once even depicted as kidnapping the "Christ Child."

55. Ibid., 34.

56. This was partly due to what some scholars called the "Gillette syndrome." With a boom economy and rapid wealth also comes economic insecurities. For mining jobs, their temporary nature and the rapid social changes result in a lack of cohesion and lagging accommodation infrastructures. Ibid., 188.

57. Weisiger, "Happy Cly and the Unhappy History of Uranium Mining on the Navajo Reservation," 151.

58. Toyosaki Hiromitsu, *Atomikku eiji* [Atomic Age] (Tokyo: Tsukiji Shokan, 1995), 143.

59. Weisiger, "Happy Cly and the Unhappy History of Uranium Mining on the Navajo Reservation," 148.

60. Weisiger, quoting the Kerr McGee film *A Navajo Journey*, directed by C. J. Colby, 1952, in "Happy Cly and the Unhappy History of Uranium Mining on the Navajo Reservation," 152–153.

61. Jean Baudrillard, *Simulacra and Simulation*, trans. Sheila Faria Glaser (Ann Arbor: The University of Michigan Press, 1994), 96. First published in 1981.

62. "The Downwind People: A Thousand Americans Sue for Damage Brought by Atomic Fallout," *Life* (June 1980). See also Sarah Alisabeth Fox, *Downwind: A People's*

History of the Nuclear West (Lincoln: The Board of Regents of the University of Nebraska, 2014).

63. For an online gallery view of Busee's photos see the Prince Wales Northwest Territory Heritage Centre, https://www.pwnhc.ca (accessed March 27, 2918); Van Wyck, *Highway of the Atom*, 15.

64. Shelley Sopher and John Piper, *Nuclear Dragons Attack!* (self-published, 1978). A description of the comic is available at http://comixjoint.com/nucleardragonsattack.html (accessed March 2016).

65. *Uranium*, 1990, documentary film directed by Magnus Isacsson, https://www.nfb.ca/film/uranium/ (accessed March 27, 2018).

66. Harding, *Canada's Deadly Secret*. For the controversy on tailings see the sections "Yellowcake Tailings and Public Health" and "Tailings Spills in New Mexico," 49–51.

67. The Cigar Lake mines, for example, became a "joint venture" between Cameco, a Canadian corporation (37–50%), the Japanese Idemitsu Uranium (8%) and Tepco (5%), and finally the French AREVA (37%). Harding, *Canada's Deadly Secret*, 69–70. Harding states 37% for Cameco unlike the company's website, which announces an ownership of 50%, see "Cameco Signs MOU to Improve Cigar Lake Project Economics," *Cameco* website (October 4, 2011), https://www.cameco.com/media/news/cameco-signs-mou-to-improve-cigar-lake-project-economics (accessed March 2016).

68. Michael Hardt and Antonio Negri, *Empire* (Cambridge and London: Harvard University Press, 2000), 40.

69. Del Tredici, *At Work in The Fields of The Bomb*, 136.

70. Julie Salverson, *Lines of Flight, An Atomic Memoir* (Hamilton, ON: Wolsak and Wynn, 2016).

71. Harding, *Canada's Deadly Secret*, 20.

72. *The Romance of Canadian Radium*, Eldorado Gold Mines, Limited, (Toronto, ON, circa 1930), n/a, http://www.andra.fr/dvd_radium/pdfs/The%20Romance%20of%20Canadian%20Radium.pdf (accessed March 25, 2017).

73. Alexander Bogdanov, *Red Star: The First Bolshevik Utopia* (Bloomington: Indiana University Press, 1984 [1908]), 113.

74. André Salifou, *Biographie politique de Diori Hamani, premier president de la republique du Niger* [Biography of Diori Hamani, The Republic of Niger's First President] (Paris: Karthala Editions, 2010), 245. Mining towns such as Saint-Laurent and Fessenheim would receive about 300 million West African francs (about US$49.5 million) per year. In English, see also Guy Martin, "Uranium: A Case-Study in Franco-African Relations," *The Journal of Modern African Studies* 27, no. 4 (December 1989).

75. Achille Mbembe, "Necropolitics," *Public Culture* 15, no. 1 (2003): 32.

76. *L'escroquerie nucléaire, 70 ans de rayonement atomique de la France* [The Nuclear Swindle: France's 70 Years of Atomic Radiance], *Charlie Hebdo* (August 2012), 47.

77. AREVA, http://www.new.areva.com (accessed August, 2009) (accessed February, 2016).

78. Assia Djebar, Speech at L' Académie française, June 22, 2006, http://www.lefigaro.fr/pdf/AssiaDjebar.pdf (accessed March 25, 2017).

79. See Jeremy Keenan, "Uranium Goes Critical in Niger: Tuareg Rebellions Threaten Sahelian Conflagration," *Review of African Political Economy* 117 (2008), 453.

80. The Clash, "Stop the World," Campaign for Nuclear Disarmament, CBS Records (1980). See also Marcus Gray, *The Clash: Return of the Last Gang in Town* (London: Helter Skelter, 2001), 354.

81. Greenpeace conducted a research onsite and concluded conditions to be unacceptable for locals and workers, http://www.greenpeace.org/international/en/news/features/AREVAS-dirty-little-secrets060510/ (accessed October, 2011). From personal sources I learned that, even if AREVA (now Orano) constructed a hospital for its workers, it only is open to current workers, not retired ones. The retirement age is however very young, which forbids any treatment of eventual cancer due to radiation. At the time of my inquiries (summer 2009), I have been told that, as an example, a former mine worker had died of cancer at age 30, leaving a family behind. See also "Uranium mining in Niger: AREVA responds," Aljazeera (January 23, 2014), http://www.aljazeera.com/programmes/orphans-of-the-sahara/2014/01/uranium-mining-niger-areva-responds-2014121101952629572.html (accessed March 2016). In documentary form see Idrissou Mora-Kpai, *Arlit, deuxieme Paris* [Arlit, Second Paris], 2005. The French NGO CRIIRAD (Commission for Independent Research and Information about Radiation) paired with the Nigerien NGO AGHIRIN'MAN to give awareness on how to deal with the many environmental problems. See http://www.criirad.org/actualites/dossiers2005/niger/somniger.html.

82. Hecht, "Africa and the Nuclear World: Labor, Occupational Health, and the Transnational Production of Uranium," 905, 904, 912.

83. Phillipe Brunet, *La nature dans tous ses états: uranium, nucléaire et radioactivié en Limousin* [Nature in all its States: Uranium, Nuclear Technology and Radioactivity in Limousin] (Limoge: Limousin University Press, 2004). See also the TV documentary "Uranium: le sancalde de la France contaminée" [Uranium: The Scandal of Contaminated France], directed by Romain Icard and Emmanuel Amara, 2008, France 3 channel.

84. M. Gauthier, *Quand Marcoule sera conté*, typescript. The play was performed in Bagnols, France, on May 11, 12, and 18, 1957; see Gabrielle Hecht, "Peasants, Engineers, and Atomic Cathedrals: Narrating Modernization in Postwar Provincial

France," *French Historical Studies* 20, no. 3 (1997): 398. See also Gabrielle Hecht and Michel Callon, *The Radiance of France: Nuclear Power and National Identity After World War II* (Cambridge, MA: MIT Press, 2009). The French version of the book was edited and updated in 2014.

85. Leonard Rifas, "Cartooning and Nuclear Power: From Industry Advertising to Activist Uprising and Beyond," *PS: Political Science and Politics* 40, no. 2 (April 2007): 255.

86. General Electric Company, *Adventures Inside the Atoms* (1948): 14, https:// archive.org/details/GeneralElectricCompanyAdventuresInsideTheAtom1948 (accessed March 26, 2018).

87. Rifas, "Cartooning and Nuclear Power," 255.

88. Heinz Haber, *The Walt Disney Story of Our Friend the Atom* (New York: Simon and Schuster, 1956).

89. The coalition "Art Not Oil and BP or not BP" opposes BP's £7.5 million contribution to the National Portrait Gallery, the Royal Shakespeare Company, the British Museum, and many other art institutions. See Angela Freeman, "News from the Field, BP Sponsorship Sparks Controversy," *Afterimage* (August 11, 2016).

90. The patronage operates a similar neocolonial double standard regarding the African mines themselves, even though the company advertises that its donating funds for schools, education and hospitals in Niger. Yet a nationalization of the resources would be far more resourceful for the country. "AREVA and Niger, a Sustainable Partnership," http://niger.areva.com/niger/liblocal/docs/GB_AREVA%20 and%20Niger.pdf (accessed March 30, 2018).

91. Olivier Mathieu, "Le Musee national Boubou-Hama, toute une histoire" [The Boubou-Hama Museum, An Entire Story], *Jeune Afrique* (September 22, 2016), , http://www.jeuneafrique.com/mag/356017/societe/musee-national-boubou-hama -toute-histoire/ (accessed March 25, 2017). See also AREVA's brochure at http://niger .areva.com/niger/liblocal/docs/72p_Livre_Musee.pdf [French language] (accessed April 2018).

92. Olivier Wantz from AREVA stated: "With this new pavilion, we can see the face of a uranium industry building on its past, deeply anchored in the present and looking towards the future. I am glad that younger visitors to the Boubou Hama National Museum can, with this new Pavilion, discover the passion of our industry, the opportunities that it offers and the quality of the industrial partnership, historic, robust and long-lasting, between Niger and AREVA. They will perhaps be able to take away with them a desire to become the miners of tomorrow and go on building the future of the mining industry in Niger and throughout the world." In "Inauguration of the Uranium Pavilion at the National Museum, A Symbol of the Long-Standing Partnership Between AREVA and the State of Niger," press release, AREVA (May 30,

2016), http://niger.areva.com/EN/niger-814/inauguration-of-the-uranium-pavilion -at-the-national-museum-a-symbol-of-the-longstanding-partnership-between-areva -and-the-state-of-niger.html(accessed April 6, 2018).

93. AREVA, Rapport de croissance responsable 2010, http://www.areva.com/ finance/liblocal/docs/2010/RAPPORT%20DE%20CROISSANCE%202010-FR.pdf, 29 (accessed April 17, 2017). See also Michel Serres's profile on Bloomberg's website at https://www.bloomberg.com/research/stocks/private/person.asp?personId=3019 0199&privcapId=20994927&previousCapId=553785&previousTitle=Bpifrance%20 Investissement (accessed April 2018).

94. CEA Saclay, "Partnership Art and Science," press release CEA, June 27, 2014, see also the artist's website, http://ateliercst.hypotheses.org/1457.

95. As the website of IRSN exhibition explains, the exhibition was "devoted to radioprotection, that is, to all the means aiming at protecting the workers, the population and the environment from the potentially noxious effect of X-rays and radioactivity." Exhibition statement, http://www.vous-avez-dit-radioprotection.fr/ (accessed September, 2009). The exhibition was organized in 2008 by the Pavillion des Sciences of CCSTI (Centre de culture scientifique technique et industrielle) of Franche-Comté, in collaboration with IRSN (Institut de radioprotection et de sûreté nucléaire), Musée Curie, Röntgen Musem, and Deutsches Museum in Munich (my translation).

96. "Did You Say Radiation Protection?" (n/a), http://www.vous-avez-dit-radio-protection.fr/ArtTour.pdf. One of the two artists, Piet.sO, explained however not being able to express themselves freely, while also understanding that the exhibition was not pro- or anti-nuclear. "Art et science: Vrais ou faux jumeaux du savoir?" available at http://www.irsn.fr/FR/connaissances/Nucleaire_et_societe/expertise -pluraliste/debats/Pages/4-art-et-science.aspx?dId=b2ac4afe-ab25-4376-a1ec-e633d8 cee49f&dwId=e1445010-b6d4-4b73-91ad-122400d00e3c#.VuOnLMcbba4 (accessed March 2016).

97. On the Japanese uranium mine see Hiroaki Koide and Yoshihira Doi, *Ningyōtōge uran kōgai saiban* [Ningyo-toge's Uranium Pollution Trials] (Tokyo: Hihyosya, 2001).

98. Soon Hoon Bae, press release, www.nppap.or.kr (accessed January 2011, but no longer available); For more information see http://www.e-flux.com/shows/view/ 8515 (accessed October 2011). I would like to thank my former student SooHye Baik for the research work and translation she did for me.

99. "AREVA, KEPCO Sign Partnership to Develop Imouraren Mine, Plan to Extend Cooperation," February 4, 2010, http://www.areva.com/EN/news-8192/areva-kepco -sign-partnership-to-develop-imouraren-mine-plan-to-extend-cooperation.html (accessed March 2016). See also Oh Hae-Young, "KEPCO Signs an Uranium Mining Partnership with Areva SA," *Korea IT Times*, February 9, 2010, http://www.korea

ittimes.com/story/7260/kepco-signs-uranium-mining-partnership-areva-sa (accessed March 2016).

100. Roland Barthes, "Martiens" [The Martians] in *Mythologies* (Paris: Seuil, 1957), 41, 42.

101. Sontag, "The Imagination of Disaster," 42.

102. Jacques Derrida, "No Apocalypse, Not Now," *Diacritics* 14, no. 2 (Summer 1984): 28.

103. William S. Burroughs, "Astronaut's Return," in *Exterminator* (New York: Penguin, 1979), 24–25. First published 1960.

104. Toyosaki, *Atomikku eji* [Atomic Age], 143–144.

105. On the Indian mines, see Vasundhara Sirnate, "Students versus the State: The Politics of Uranium Mining in Meghalaya," *Economic and Political Weekly* XLIV, no. 47 (2009): 19. The mining company's reaction to the accusation was that the many diseases are "not due to radiation but attributed to malnutrition, malaria and unhygienic living conditions etc.," Uranium Corporation of India Limited, accessed March 2016, http://www.ucil.gov.in/myth.html. On the Indian nuclear program, see Hecht, "Africa and the Nuclear World: Labor, Occupational Health, and the Transnational Production of Uranium," 18. See also n/a, "Atomic Energy: Dormant Indo-Soviet Collaboration," *Economic and Political Weekly* 8, no. 48 (1973).

106. Gabrielle Hecht, *Being Nuclear: Africans and the Global Uranium Trade* (Cambridge, MA: MIT Press and Wits University Press, 2012).

107. Noam Chomsky and Andre Vltchek, *On Western Terrorism: From Hiroshima to Drone Warfare* (London: Pluto Press, 2013).

108. Vermeren, *Le choc des décolonisations*, 45-48.

109. "Artist Opportunity: Uranium Mining Exhibition," Flagstaff Arts Council, http://flagartscouncil.org/2016/01/artist-opportunity-uranium-mining-exhibition (accessed April 7, 2017).

110. "Nuclear Futures Partnership Initiative," *Nuclear Futures* website, http://nuclearfutures.org/about (accessed April 17, 2017).

111. "Immersive Projection Installations," *Nuclear Futures* website, http://nuclearfutures.org/immersive-projection-installation-exposing-the-legacies-of-the-atomic-age (accessed April 17, 2017).

112. Adrienne Rich, "Power," *The Dream of a Common Language: Poems 1974–1977* (New York: W. W. Norton & Company, 2013), 3.

113. Adrienne Rich, quoted in "Interview by Cat Richardson," 2011, National Book Foundation, http://www.nationalbook.org/nba2011_p_rich_interv.html#.Wt9R5y -ZPwc (accessed April 23, 2018).

Chapter 8

1. Susan Sontag, *Regarding the Pain of Others* (New York: Picador, 2003), 81.

2. Shiga Leiko, *Rasen kaigan—notebook* [Spiral Coast notebook] (Tokyo: AKAAKA Art Publishing, 2013).

3. Sontag, *Regarding the Pain of Others*, 78.

4. Jean-Luc Nancy in *L'Équivalence des catastrophes: (Après Fukushima)* [The Equivalence of Catastrophes: (After Fukushima)] (Paris: Galilée, 2012), 11.

5. Nishitani Osamu, quoted by Nancy in *The Equivalence of Catastrophes*, 35.

6. Ōtomo Yoshihide, "The Role of Culture: After the Earthquake and Man-Made Disasters in Fukushima," trans. Mia Isozaki (lecture, Tokyo University of the Arts, April 28, 2011) http://www.japanimprov.com/yotomo/fukushima/lecture.html (accessed April 4, 2018).

7. Ōe also further stated: "The Japanese should not be thinking of nuclear energy in terms of industrial productivity; they should not draw from the tragedy of Hiroshima a "recipe" for growth. Like earthquakes, tsunamis, and other natural calamities, the experience of Hiroshima should be etched into human memory: it was even more dramatic a catastrophe than those natural disasters precisely because it was man-made." In Ōe Kenzaburō, "History Repeats," *New Yorker*, March 28, 2011, http://www.newyorker.com/magazine/2011/03/28/history-repeats (accessed March 29, 2011).

8. Matsubayashi Yōju and Mori Tatsuya, directors, *311*, documentary film (2011). For an analysis see Hayashi Michio, "Reframing the Tragedy: Lessons from Post-3/11 Japan," in *In the Wake, Japanese Photographers Respond to 3/11* (Boston: Museum of Fine Arts, 2015).

9. Nishio Baku, "Contesting the Fear of Nuclear Disasters," in *To See Once More the Stars, Living in a Post-Fukushima World*, ed. Naitō Daisuke, Ryan Sayre, Heather Swanson, and Takahashi Satsuki (Santa Cruz, CA: New Pacific Press, 2014), 122.

10. Hayashi, "Reframing the Tragedy," 166.

11. Ibid.

12. Wagō Ryōichi, *Furusato wo akiramenai: Fukushima, 25nin no shōgen* [We do not abandon our hometown: Fukushima, the testimonies of 25 people], (Tokyo: Shichosha Publishing, 2012), 2.

13. Wagō Ryōichi, "Shi no tsubute" [Pebbles of Poetry], *Gendaishi techo* [Handbook of Contemporary Poetry] (Tokyo: Shichosha Publishing, 2011), 37. Translation available at http://www.shichosha.co.jp/gendaishitecho/item_406.html.

14. Tōge Sankichi, "Landscape with River," from *Poems of the Atomic Bomb*, in Richard H. Minear ed., trans., *Hiroshima: Three Witnesses* (Princeton, NJ: Princeton University Press, 1990), 343.

15. Lyubov [Liubov] Sirota, "To Pripyat," in *The Chernobyl Poems* (1995), English translation available at https://brians.wsu.edu/2016/12/05/chernobyl-poems.

16. See Walter Benjamin, *The Work of Art in the Age of Mechanical Reproduction*, rev. ed. (New York: Prism Key Press, 2012). Later in the 1920s Valéry saw in the live broadcasting of music a "new intimacy of Music and Physics," Paul Valéry, "La Conquête de l'ubiquité [The Conquest of Ubiquity]," *Œuvres*, tome II, *Pièces sur l'art* rev. ed. (Paris: Gallimard, 1960), 1283–1287. According to Victor Hugo, books have a supreme quality of merging literature and the technology of reproduction, thereby succeeding in enhancing education: "if something is greater than God seen from the sun, it is God seen in Homer." Victor Hugo, "L'art et la science [Art and Science]," Extract of *William Shakespeare*, rev. ed. (Arles: Actes Sud, 1985), 10, first published in 1928.

17. Kamiya Yukie, Takatani Shiro, and Miwa Masahiro, "Accelerating Technology / Introspective Art," in *16th Japan Media Arts Festival* (Tokyo: Japan Media Arts Festival Secretariat, 2013), 254.

18. Hayashi, "Reframing the Tragedy," 171.

19. Wagō, *We Do Not Abandon Our Hometown*, 2.

20. Naitō et al., *To See Once More the Stars*, vii.

21. Ōe, "History Repeats."

22. Sonya M. Gray, "Half-life," in Naitō et al., *To See Once More the Stars*, 4.

23. Hayashi, "Reframing the Tragedy," 166.

24. Ōtomo Yoshihide, "Living under Radiation—The Role of the Arts after 3.11 Fukushima (presented at East Asian Studies, New York University, November 16, 2011). See also Isobe Ryo, ed., *Purojekuto Fukushima!* (Project Fukushima!) (Tokyo: DOMMUNE Books, 2011).

25. Ōtomo, "Living under Radiation."

26. Ishii Sōgo, director, *Bakuretsu toshi* [Burst City] (Dynamite Productions, 1982).

27. Ōtomo Yoshihide, "Project FUKUSHIMA! Activity Report," http://www.japan improv.com/yotomo/fukushima/oneyearlater.html (accessed April 2, 2018).

28. Ōtomo, "The Role of Culture."

29. Kimura Shinzō researched the accidents in Chernobyl and Fukushima. The importance of his research will be detailed later the chapter.

30. A *furoshiki* is a piece of tissue used in Japan to wrap objects such as lunch boxes.

31. Ōtomo, "Living under Radiation."

32. See "Our 90 Years: 1923–2013," exhibition press release (Tokyo: Museum of Contemporary Art, 2013), 1.

33. JAGDA webpage, "The JAGDA Handkerchiefs for Tohoku Children Part 2," http://www.jagda.or.jp/information/jagda/1757 (accessed March 31, 2018).

34. Yokoyama Ai, "Donguri" (Acron), in Naitō et al., *To See Once More the Stars*, 1–3.

35. Kamiya Yukie, "Collective Acts in the Aftermath, Art in Post-Earthquake Japan," *Flash Art International* (November-December 2013), https://www.flashartonline .com/article/collective-acts-in-theaftermath/ (accessed December 2015).

36. "Lucerne Festival *Ark Nova* 2013 in Matsushima," press release, March 5, 2013, 2, 3. There is the evident Christian reference to Noah's Ark, but the project also recalls the concept of "sacred guest" of the Japanese folklorist Orikuchi Shinobu, which is the concept that "*marebito* from foreign lands brought religions and festivals and revitalized society as a result."

37. "World's First Inflatable Concert Hall Goes Up in Japan's Disaster Area," *Japan Times*, (September 26, 2013, http://www.japantimes.co.jp/news/2013/09/26/ national/worlds-first-inflatable-concert-hall-goes-up-in-japans-disaster-area/#.VFwn G1OUdyo (accessed December 2013).

38. Isozaki Arata, *kūkan e* [Toward Space] (Tokyo: Bijutsushuppansha, 1971), 50.

39. Ibid.

40. See the Home-for-All website at http://www.home-for-all.org (accessed August 2017).

41. *Itō Toyō, NA kenchikuka shirīzu* [Itō Toyō, NA Architect series] (Tokyo: Nikkei BP Sha, 2013).

42. Ōnishi Wakato, "Post-Disaster Architecture: Ito Proposes a Design for 'Everyone,'" *The Asahi Shimbun*, March 17, 2012, http://ajw.asahi.com/article/cool_japan/ style/AJ201203170011 (accessed March, 2015).

43. Itō, in *Itō Toyō, NA kenchikuka shirīzu*, 17–18.

44. "The Building After: Julian Rose Talks with Toyo Ito," *Artforum*, September 2013, 342–347, http://artforum.com/inprint/issue=201307&id=42634&pagenum=0. (accessed April 4, 2018).

45. Ibid.

46. Watsuji Tetsurō, *Climate and Culture* (Tokyo: The Hokuseido Press, 1971), 144.

47. Watsuji sees the house in Japan as of "unique and important significance of, if you like, the community of all communities." Ibid., 144.

48. Hayashi, "Reframing the Tragedy," 169.

49. Bruno Latour, *Nous n'avons jamais été modernes* [We have never been modern] (Paris: La Découverte, 1991).

50. Watsuji, *Climate and Culture*, 133.

51. *Itō Toyō, NA kenchikuka shirīzu*, 174.

52. Ibid, 174, 172.

53. Sontag, *Regarding the Pain of Others*, 115.

54. The Building After: Julian Rose Talks with Toyo Ito."

55. Ibid.

56. Ōta Yōko, *City of Corpses*, in Minear, *Hiroshima, Three Witnesses*, 226.

57. Project FUKUSHIMA! official website, http://www.pj-fukushima.jp (accessed March 2013).

58. Ōtomo, "The Role of Culture."

59. Ibid.

60. Yoshihide Ōtomo, "Project FUKUSHIMA! Activity Report [One year later: looking back at last year's activity - looking ahead to plans for 2012]," trans. Cathy Fishman, 2012, http://www.japanimprov.com/yotomo/fukushima/oneyearlater.html (accessed May 19, 2013).

61. Takeda Shimpei, quoted in *In the Wake, Japanese Photographers Respond to 3/11* (Boston: Museum of Fine Arts, 2015), 89.

62. Igor Kostin, *Chernobyl: Confessions of a Reporter* (New York: Umbrage Edition, 2006), 10.

63. Svetlana Alexievich, *Voices from Chernobyl: The Oral History of a Nuclear Disaster*, trans. Keith Gessen rev. ed. (London: Picador, 2006), first published in 1997.

64. Ibid., 5–12.

65. Ibid., 47.

66. Alexievich, *Voices from Chernobyl*, 49, 52.

67. Ibid., 33.

68. Ibid., 49.

69. Most of the direct information has disappeared from the internet, such as the official website of the contest. Only few photographs and a partial Wikipedia page remain, and this link from the web portal, Nuclear. Ru, "International Beauty Contest—Miss Atom 2011," https://web.archive.org/web/20131115022302/http://miss2011.nuclear.ru/en/ (accessed April 5, 2018). I would also like to thank Lyailya Nurgaliyeva for helping me finding information about the contest. See Clarissa Ward, "Nuclear Beauties Wanted for Russian Competition, Miss Atom Takes Off Her Chemical Protection Suit," ABC News (February 17, 2009), https://web.archive.org/web/20100609142538/http://abcnews.go.com/Technology/Story?id=6889182&page=1 (accessed April 8, 2017), and "Miss Atom, 12 Photos," Fishki.net (2009), http://fishki.net/21007-konkurs-krasoty-miss-atom-12-foto.html (accessed April 8, 2017). And according to this Russian-language website, the competition continues (as of 2017).

70. Nuclear. Ru, "International Beauty Contest—Miss Atom 2011," ibid.

71. Karen Barad, "Nature's Queer Performativity," *Kvinder, Kon & Forskning* 1, no. 2 (2012): 25.

72. Public Annual Report 2012, State Atomic Energy Corporation ROSATOM, 89, http://www.rosatom.ru/upload/iblock/18d/18d4f67e3c1a6a44e3715945cbe0fe27.pdf.

73. Kostin, *Chernobyl*, 160.

74. Hayashi, "Reframing the Tragedy," 177.

75. Hagio Moto, *Na no hana* [Canola Flower] (Tokyo: Shogagukan, 2016).

76. The misrepresentation of Fukushima and Chernobyl is a crucial point: In 2011, Vice released a video of the photographs by the Canadian photographer Donald Weber. Weber took photographs of Chernobyl, then of the evacuation zone in Fukushima. The video shows Weber taking pictures of a corpse in Fukushima. There was no direct death from radioactivity after the accident but the video was nevertheless called "Photographing the Nuclear Disaster in Fukushima." This relates also to Hayashi's analysis of the representation of the dead after the tsunami, as well as to the questions of sensationalism and orientalism: pertaining to who can represent the victims and how. See "Photographing the Nuclear Disaster in Fukushima," *Vice*, Picture Perfect (2011), https://www.youtube.com/watch?v=bi3OA1tNFfo (accessed August, 2015).

77. See Kariya Tetsu and Hanasaki Akira, *Oishinbo: Fukushima no shinjitsu* [The Gourmet, Fukushima's Truth] vol. 1 (Tokyo: Kokagukan, 2013). See also "Outrage derails manga series 'Oishinbo' for Fukushima nuclear crisis depiction," *Japan Times*, May 18, 2014, http://www.japantimes.co.jp/news/2014/05/18/national/outrage

-derails-manga-series-oishinbo-fukushima-nuclear-crisis-depiction/ (accessed April 20, 2017).

78. Sontag, *Regarding the Pain of Others*, 88. Sontag makes this argument in relation to slavery in the US. When her book *Regarding the Pain of Others* was published in 2003, almost a century and a half after the abolition of slavery, there were still no museums in the United States dedicated solely and comprehensively to slavery—beginning with the slave trade in Africa (rather than just a specific feature of slavery, like the Underground Railroad for instance)—despite the existence of several museums dedicated to the Holocaust (along with countless Holocaust memorials) in the US. Similar analogies can me made in Europe, given that the UK and France participated in the slave trade. For Americans, Sontag said, slavery was "a memory judged too dangerous to social stability to activate and create." In 2011 there was no museum in the US, UK, or France. In 2007, the International Slavery Museum opened in Liverpool, and in 2014, the Whitney Plantation opened in New Orleans. France inaugurated a memorial in Nantes (France) in 2012, politely named Memorial of the Abolition of Slavery.

79. Nagaoka Hiroyoshi, "The History of A-bomb Literature," in *Nihon no genbaku kiroku* [Japanese A-bomb Records] 16 (Tokyo: Nihon Tosho Center, 1991), 111.

Chapter 9

1. *Aida Makoto: Monument for Nothing* (Tokyo: Mori Art Museum, November 17, 2012–March 31, 2013).

2. Aida Makoto, quoted in *Aida Makoto: Monument for Nothing*, exhibition press release (Tokyo: Mori Art Museum, November 17–March 31, 2013).

3. Kanamori Osamu, "The Biopolitics of Contemporary Japanese Society," in *La réception et la résistance—la vie selon les sciences occidentales et le Japon—Actes du colloque de Tokyo, 2014*, Collection de monographies des études japonaises internationals (Tokyo: Hosei University Press, 2014), 146, 147, 148.

4. Kamiya Yukie, "Collective Acts in the Aftermath, Art in Post-Earthquake Japan," *Flash Art International* (November-December 2013), http://www.flashartonline.com/article/collective-acts-in-theaftermath/ (accessed December 2015).

5. Ibid. See also "Tadasu Takamine's Cool Japan," Art agenda (2013), http://www.art-agenda.com/shows/tadasu-takamine-at-contemporary-art-center-art-tower-mito (accessed April 7, 2017).

6. Jacques Derrida, "No Apocalypse, Not Now," *Diacritics* 14, no. 2 (Summer 1984).

7. Kanamori, "The Biopolitics of Contemporary Japanese Society," 148.

8. Sakamoto Ryuichi, in Roger Pulvers, "Ryuichi Sakamoto Reminds Japanese What's the Score on Nuclear Blame," *Japan Times*, July 1, 2012, http://www .japantimes.co.jp/opinion/2012/07/01/commentary/ryuichi-sakamoto-reminds -japanese-whats-the-score-on-nuclear-blame/ (accessed February 28, 2015).

9. Adorno, "Commitment," *New Left Review*, I, no. 87–88 (1974), 84.

10. Blixa Bargeld, Andrew Chudy, and Alexander Hacke, "Silence Is Sexy," Royalty Network, Inc., 2000.

11. Gil Scott-Heron, "We Almost Lost Detroit," *Bridges*, Artista Records, 1977.

12. Laura Bretz (then a junior high school student), in Robert Del Tredici, *The People of Three Mile Island* (San Francisco: Sierra Club Books, 1980), 101.

13. "Children's Chant," in Del Tredici, *The People of Three Mile Island*, 102.

14. Maria H. and Shirley T., quoted in Del Tredici, *The People of Three Mile Island*, 101.

15. Nancy Prelesnik, quoted in Del Tredici, *The People of Three Mile Island*, 54.

16. Ibid.

17. Dick Thornburgh, "Three Miles Island," remarks made at the National Press Club, Washington, DC, March 28, 1989, https://www.justice.gov/sites/default/files/ ag/legacy/2011/08/23/03-28-1989.pdf (accessed April 8, 2018).

18. David Burnham, "Nuclear Experts Weigh Debate 'The China Syndrome,'" *New York Times*, March 18, 1979, https://www.nytimes.com/1979/03/18/archives/ nuclear-experts-debate-the-china-syndrome-but-does-it-satisfy-the.html?_r=0 (accessed April 8, 2018).

19. Jean Baudrillard, *Simulacra and Simulation*, trans. Sheila Faria Glaser (Ann Arbor: The University of Michigan Press, 1994), 53. First published in 1981.

20. Ibid., 56–57.

21. See Chana Gazit, *Meltdown at Three Mile Island*, directed by Margaret Drain and Chana Gazit, February 22, 1999, USA, aired as part of the PBS series *The American Experience*; and the testimony of Thomas Gerusky, director of the Bureau of Radiation Protection in the Department of Environmental Resources, in Del Tredici, *The People of Three Mile Island*, 96.

22. Gazit, *Meltdown at Three Mile Island*.

23. Spencer R. Weart, *The Rise of Nuclear Fear* (Cambridge, MA: Harvard University Press, 2012), 225. See also Philip Louis Cantelon and Robert Chadwell Williams, *Crisis Contained: The Department of Energy at Three Mile Island* (Carbondale: Southern Illinois University Press, 1982).

24. The Rogovin Report stipulated that about 400 journalists came to give an account of the accident, also due to the fact that the plant was reachable by major news centers such that New York and Chicago. Nuclear Regulatory Commission, Special Inquiry Group, *Three Mile Island: A Report to the Commissioners and to the Public*, directed by Mitchell Rogovin (Washington, DC: Government Printing Office, 1980), 4.

25. Ibid., 4–5.

26. Baudrillard, *Simulacra and Simulation,* 57.

27. See Grace Halden, *Three Mile Island, The Meltdown Crisis and Nuclear Power in American Popular Culture* (New York: Routledge, 2017).

28. Quoted in Igor Kostin, *Chernobyl: Confessions of a Reporter* (New York: Umbrage Edition, 2006), 10.

29. Mikhail Gorbachev, in *The Battle of Chernobyl*, documentary film, directed by Thomas Johnson, Discovery Channel, 2006.

30. Kostin, *Chernobyl*, 9.

31. Alla Yaroshinskaya, *Chernobyl: Crime without Punishment,* rev. ed. (Piscataway, NJ: Transaction Publishers, 2011), 46.

32. Ibid.

33. Ibid., 46, 47.

34. Lyubov [Liubov] Sirota, "To Vasily Doemidovich Dubodel," in *The Chernobyl Poems* (1995), English translation available at https://brians.wsu.edu/2016/12/05/chernobyl-poems (accessed November, 2017).

35. Ignacio Ramonet, *La tyrannie de la communication* [Tyranny of Communication] (Paris: Folio, 2001).

36. Bernard Lerouge, *Tchernobyl, un 'nuage' passe …: Les faits et les controversies* [Chernobyl, a Cloud Passes by: The Facts and the Controversies] (Paris: L'Harmattan, 2009), 8.

37. France had a weather forecast that has become infamous for showing how an anticyclone had stopped the radioactive cloud at the French border—the meteorologist later said she regretted the broadcast. See "Tchernobyl: le mensonge français" (Chernobyl: the French Lie), broadcast by *C dans l'air*, France, Channel 5, April 25, 2005.

38. Archived footage of the TV program *Midi 2*, report by Jacques Violet, broadcast on Antenne 2, May 11, 1986, INA archives.

39. Laure Noualhat, "Des vérités long temps chachées" [Some Long Hidden Truths], *Libération*, May 29, 2006, http://www.liberation.fr/evenement/2006/05/29/des-verites-longtemps-cachees_40842 (accessed May 17th, 2015).

40. An association of persons affected by thyroid cancer (AFMT) sued the government and Professor Pellerin, but the case was later dismissed because "even with the current advancement of science, it is impossible to establish a causal link between the observed pathologies and the radioactive fallout of Chernobyl. Bulletin of the Cour de cassation [Court of cassation or final court appeal], http://www.legifrance.gouv.fr/affichJuriJudi.do?oldAction=rechJuriJudi&idTexte=JURITEXT000026668750&fastReqId=240639787&fastPos=1 (accessed May 17, 2015). See also Cyrille Vanlerberghe, "Affaire de Tchernobyl: professeur Pellerin innocent," *Le Figaro*, November 20, 2012, http://www.lefigaro.fr/flash-actu/2012/11/20/97001-20121120FILWWW00613-tchernobyl-le-pr-pellerin-innocente.php (accessed May 17, 2015).

41. See the CRIIRAD webpage for information about its formation and its mission, http://www.criirad.org/english/presentation.html (English language).

42. Pierre Vermeren, *The Shock of Decolonization* (Paris: Odile Jacob, 2015).

43. See *Art Press* 423 (June 2015).

44. Jürgen Nefzger, artist statement, http://www.juergennefzger.com/work_fluffy.html#1 (accessed August 2015). See also *Jürgen Nefzger, Fluffy Clouds* (Ostfildern: Hatje Cantz Verlag, 2010).

45. Thomas Sotinel, "'Grand central': fission amourseuse à l'ombre de la centrale" ["Grand Central": Love Fission in the Shade of a Power Plant], *Le Monde*, May 20, 2013 (revised in August 27, 2013), http://www.lemonde.fr/festival-de-cannes-2013/article/2013/05/20/grand-central-fission-amoureuse-a-l-ombre-de-la-centrale_3378246_1832090.html (accessed February 2016).

46. Franck Nouchi, "Rebecca Zlotowski: 'Mon film est politique, il n'est pas militant'" [My Film Is Political, It Isn't Militant], *Le Monde*, August 28, 2013, http://www.lemonde.fr/culture/article/2013/08/26/rebecca-zlotowski-mon-film-est-politique-il-n-est-pas-militant_3466687_3246.html, (accessed February 2016).

47. Elisabeth Filhol, *La Centrale* [The Power Plant] (Paris: Folio, 2010), 24. [My translation]

48. On the topic, see Jean-Michel Décugis, Christophe Labbé, and Olivia Recasens, "Le jour où la France a frôlé le pire" [The Day France Came Close to the Worst] *Le Point*, March 22, 2011, http://www.lepoint.fr/societe/le-jour-ou-la-france-a-frole-le-pire-22-03-2011-1316269_23.php; Jean-Baptiste Renaud, "Nucléaire: La politique du mensonge?" [Nuclear: The Politic of Lie?], *Spécial Investigation*, Cannal + Channel, May 4, 2015.

49. Ōtomo recalled how Professor Yamashita Shunichi of Nagasaki University, who had been researching the effect of radioactivity in Chernobyl, claimed that there was absolutely no risk after the accident at the Japanese plant. Ironically, he gave his conference in the village Iitate, in Fukushima Prefecture, on April 11, 2011, which was later declared a "systematic evacuation area." All of the residents were forced to evacuate. Ōtomo Yoshihide, "Project FUKUSHIMA! Activity Report," http://www .japanimprov.com/yotomo/fukushima/oneyearlater.html (accessed April 2, 2018). See also Ōtomo Yoshihide, "The Role of Culture: After the Earthquake and Man-Made Disasters in Fukushima," trans. Mia Isozaki (lecture, Tokyo University of the Arts, April 28, 2011) http://www.japanimprov.com/yotomo/fukushima/lecture .html(accessed April 4, 2018).

50. Ōtomo, "Project FUKUSHIMA! Activity Report."

51. Ōtomo, "The Role of Culture."

52. Ibid.

53. Ōtomo, "Living under Radiation—The Role of the Arts after 3.11 Fukushima (presented at East Asian Studies, New York University, November 16, 2011).

54. Noam Chomsky and Andre Vltchek, *On Western Terrorism: From Hiroshima to Drone Warfare* (London: Pluto Press, 2013); Vermeren, *The Shock of Decolonization.*

55. See Yamamoto Akihiro, *Nuclear and the Japanese—Hiroshima, Godzilla, Fukushima* (Tokyo: Chūōkōron-Shinsha, 2015), 189. See also Manabe Noriko, *The Revolution Will Not Be Televised: Protest Music after Fukushima* (New York: Oxford University Press, 2015), 76.

56. RC Succession, "Summertime Blues" (1988), recorded at Toshiba EMI, 1988.

57. The Timers, "Meruto daun" [Meltdown], performed in 1989 and finally released in the album *MUSIC from the POWER HOUSE* under the band name "Kiyoshirō Imawano & 2 3's," Universal Music LLC, 1993.

58. Yamamoto, *Nuclear and the Japanese*, 190.

59. Manabe, *The Revolution Will Not Be Televised*, 78.

60. Sheila Pinkel, *"Thermonuclear Gardens*: Information Artworks about the U.S. Military-Industrial Complex," *Leonardo* 34, no. 4 (2001). See also the artist's website at http://sheilapinkel.com/Social_Art/Thermonuclear_Gardens/img5.html (accessed April 11, 2018).

61. Sontag, *Regarding the Pain of Others*, 48.

62. Hesse-Honegger explained that following her request in a published article for a reliable scientific study, a zoologist, Dr. J. Jenny, collected more than 10,000 fire-bugs but only published incomplete information. Another of the zoologist's paper's

was also "maliciously interpreted by the press to show that my work was without any scientific value." Cornelia Hesse-Honegger, *The Future's Mirror* (Newcastle upon Tyne: Locus +, 2000), n.p.

63. Inge Schmitz-Feuerhake, "Foreword: The Necessity of Research Beside the Mainstream," in Hesse-Honegger, *The Future's Mirror*, n.p.

64. Ismael Galván et al., "Chronic Exposure to Low-Dose Radiation at Chernobyl Favors Adaptation to Oxidative Stress in Birds," *Functional Ecology* 28, no. 6 (2014): 1387–1403. About the impact of the accident on bugs in Fukushima, see also Hiyama Atsuki et al., "The Biological Impacts of the Fukushima Nuclear Accident on the Pale Grass Blue Butterfly," *BMC Evolutionary Biology* 13 (August 2013), original published in *Scientific Reports* (August 9, 2012).

65. "Environmental Consequence of the Chernobyl Accident and their Remediation: Twenty Years of Experience, Report of the Chernobyl Forum Expert Group 'Environment," Raiological Assessment Reports Series, International Atomic Energy Agency, Vienna, First published in 2003 but revised in 2006, 135, http://www-pub.iaea.org/mtcd/publications/pdf/pub1239_web.pdf (accessed September 2015).

66. "Radioactive Wolves," *Nature*, PBS, first broadcast October 19, 2011, http://www.pbs.org/wnet/nature/radioactive-wolves-introduction/7108/ (accessed March 2015).

67. Peter C. van Wyck, "The Anthropocene's Signature," in Ele Carpenter, ed., *The Nuclear Culture Source Book* (London: Black Dog Publishing, 2016), 24.

68. Kostin, *Chernobyl*, plate 105.

69. Anna Badaeva, quoted in Alexievich, *Voices from Chernobyl: The Oral History of a Nuclear Disaster*, trans. Keith Gessen, rev. ed. (London: Picador, 2006), first published in 1997, 53.

70. Tatsuta Kazuto, *Ichiefu, Fukushima Daiichi Genshiryoku Hatsudensho Rōdōki* [1F, Fukushima Daiichi Nuclear Power Plant Labor Chronicle] (Tokyo: Kodansha, 2014).

71. Suzuki Tomohiko, *Yakuza to Genpatsu Fukushima Daiichi Sennyūki* [Yakuza and Nuclear Plants, Chronicle of an infiltration] (Tokyo: Bungeishunjū, 2011).

72. The Clash, *London Calling*, CBS Records, 1979.

73. "Radiation Expert Takes on Red Tape in Disaster Zone," *Japan Times*, April 5, 2012, http://www.japantimes.co.jp/news/2012/04/05/national/radiation-expert-takes-on-red-tape-in-disaster-zone/ (accessed March 2013).

74. Kimura Shinzō, *Hottosupotto: nettowāku de tsukuru hoshano osen chizu* [Hot Spot: A Network Makes a Map of Radioactive Pollution], NHK ETV (Tokyo: Kodansha, 2012).

75. Takatsuji Toshihiro, Yuan Jun, and Zeng Zifeng, "Radioactivity of the aerosol collected in Nagasaki City due to the Fukushima Daiichi Nuclear Power Plant Accident," *IPSHU English Research Report Series* 28, March 2012, Hiroshima Peace Center for Scientific Research, 85.

76. Jean-François Lyotard, "The Sublime and the Avant-garde," *Artforum* 22, no. 8 (April 1984): 455.

77. Carrie Halperin, "Lessons from Fukushima," *New York Times*, March 10, 2014, http://www.nytimes.com/video/business/100000002757247/lessons-from -fukushima.html (accessed May 8, 2015).

78. AREVA webpage, "Brazil: AREVA Awarded a 75 Million Euro Contract for the ANGRA 3 Project7," January 5, 2015, http://www.areva.com/EN/news-10430/ brazil-areva-awarded-a-75-million-euro-contract-for-the-angra-3-project.html (accessed May 8, 2015).

79. Gazit, *Meltdown at Three Mile Island*.

80. Jean-Michel Bezat, "Philippe Varin a menacé de démissionner d'Areva [Philippe Varin threated to resign from Areva]," *Le monde*, May 7, 2015, http://www.lemonde .fr/economie/article/2015/05/07/philippe-varin-a-menace-de-demissionner-d -areva_4629456_3234.html (accessed May 8, 2015). The article also relates how the pension of AREVA's president, Philippe Varin, was reduced to 299,000 euros (tax exempt) from 664,000 euros.

81. "La rénovation des centrales nucléaires, plus chère que prévu? [Renovation of nuclear power plants, more expensive than expected?]," *Le monde*, July 17, 2013, http://www.lemonde.fr/planete/article/2013/07/11/la-renovation-des-centrales -nucleaires-plus-chere-que-prevu_3446387_3244.html (accessed May 8, 2015).

82. These are figures for the construction costs (including labor) from the first generation of French nuclear plants starting in 1963 until 1986 (second generation), *Les coûts de la filière électro nucléaire [The costs of the nuclear power sector]*, Thematic public report, Cour des comptes, January 2012.

83. Hiroki Azuma, "Genpatsu 20km ken de kangaeru [Thoughts from the 20km Evacuation Zone]," *Asahi Shimbun*, April 26, 2011, 20.

84. Fumikazu Yoshida, "The Fukushima Nuclear Disaster: One of the World's worst cases of Pollution," in *Fukushima: A Political Economic Analysis of a Nuclear Disaster*, Miranda Schreurs et al., eds. (Sapporo: Hokkaido University Press, 2013), 25.

85. George J. Annas, "The Case of Karen Silkwood," *Public Health and the Law* 74, no. 5 (1984): 516–518, http://ajph.aphapublications.org/doi/pdf/10.2105/AJPH .74.5.516; James O. Windell, *Looking Back in Crime: What Happened on This Date in Criminal Justice History?* (Boca Raton, FL: CRC Press, 2015), 43; Richard Rashke, *The*

Killing of Karen Silkwood: The Story Behind the Kerr-McGee Plutonium Case (Boston: Houghton Mifflin Company, 1981).

86. Richard Knight, "Occupied Western Sahara: Campaign to End Kerr-McGee's Involvement," *Review of African Political Economy* 32, no. 103 (March, 2005): 154. See also http://richardknight.homestead.com/files/kerr-mcgeeinwesternsahara3-05.pdf (accessedApril13,2018).

87. *Afrol News*, "Divestments from Kerr-McGee over Western Sahara Engagement," http://www.afrol.com/articles/15084 (accessed August 2015); Per Liljas, "There's a New Terrorist Threat Emerging in Western Sahara, and the World Isn't Paying Attention," *Time*, August 8, 2014, http://time.com/3085464/theres-a-new-terror-threat -emerging-in-western-sahara-and-the-world-isnt-paying-attention/ (accessed August 2015).

88. Gil Scott-Heron, "We Almost Lost Detroit."

89. Walls to Rose, "Are You Karen Silkwood?," *Songs of Changing Men*, Folkways Records (1979).

90. Adorno, "Commitment," 84.

91. Weart, *The Rise of Nuclear Fear*, 225, 226.

92. Thomas Gerusky, in Robert Del Tredici, *The People of Three Mile Island,* 97.

93. See Christophe Thouny, "Planetary Atmospheres of Fukushima: Introduction," in *Planetary Atmospheres and Urban Society After Fukushima*, Christophe Thouny, ed., (Singapore: Palgrave Macmillan, 2017).

94. There is an endless source of energy in Japan, even if there is still no entirely sustainable or perfect way of producing energy globally to date. I have often been told that relying more on volcanoes in Japan would disturb the tourism developed around the *onsen* (public bath) and hot springs, and would also ruin the landscape. Another possible source of energy is, however, the cold ocean and other bodies of water: the center of Stockholm uses water from the Baltic Sea, Cornell University uses water from Cayuga Lake, a few buildings in Toronto use water from Lake Ontario, and an hotel in Bora Bora (French Polynesia) also uses the cold water for air conditioning. See Blandine Antoine and Elodie Renaud, *Le tour du monde des énergies* [World Tour of Energies] (Paris: Jean-Claude Lattès, 2008), 176.

95. Kamiya, "Collective Acts in the Aftermath."

96. Sontag, *Regarding the Pain of Others*, 913.

Toward a Conclusion

1. George Orwell, "You and the Atomic Bomb," *Tribune*, October 19, 1945, http://orwell.ru/library/articles/ABomb/english/e_abomb (accessed February 8, 2018).

2. Jacques Derrida, "No Apocalypse, Not Now," *Diacritics* 14, no. 2 (Summer 1984): 22.

3. Jean Baudrillard, *Simulacra and Simulation,* trans. Sheila Faria Glaser (Ann Arbor: University of Michigan Press, 1994), 56. First published in 1981.

4. George Gessert, "Notes on Uranium Weapons and Kitsch," *Northwest Review* 42 (2003): 6.

5. George Gessert, "Notes toward a Radioactive Art," *Leonardo* 25, no. 1 (1992): 40.

6. Dialog of Diego (played by Norman Reedus), in *Sky* by Fabienne Berthaud, Pandora Film, 2016. This English-language film is a French-German production shot in the US, and most of the dialog is in English.

7. See Andrew Katz, "Christian Werner in Post-War Iraq: A Photographer Investigates a Health Crisis," *Time*, May 12, 2014, http://time.com/3809264/iraq-health-crisis/ (accessed September 2017).

8. Achille Mbembe, "Necropolitics," *Public Culture*15, no. 1 (2003): 30.

9. Rosalyn Deutsche, *Hiroshima after Iraq, Three Studies in Art and War* (New York: Columbia University Press, 2010). See also David Houston Jones, "The Inadequate Archive: Ethical Remaking in Silvia Kolbowski's *After Hiroshima mon amour,*" *French Cultural Studies* 24, no. 4 (2013): 417–429, which considers as well the influence of Derrida's notion of the archive's potential to both record and erase.

10. Andy Greene, "20 Insanely Great David Bowie Songs Only Hardcore Fans Know," *Rolling Stone*, August 11, 2014, http://www.rollingstone.com/music/lists/20-insanely-great-david-bowie-songs-only-hardcore-fans-know-20140811/new-killer-star-20140811 (accessed March 2017).

11. Critical Art Ensemble, *Disturbances* (London: Four Corners Books, 2012), 92.

12. Alan Ingram, "About," webpage on *Art & War: Responses to Iraq*, n.d., https://responsestoiraq.wordpress.com/about/ (accessed April 15, 2018).

13. Mark Doten, "Trump Sky Alpha," *Granta* (April 25, 2017), available at https://granta.com/trump-sky-alpha/ (accessed August 2017).

14. Stephen Wilson, *Information Arts: Intersections of Art, Science, and Technology* (Cambridge, MA: MIT Press, 2002).

15. Robert Wilson, "Starting Fermilab," Fermi National Accelerator Laboratory (1987), accessed April 12, 2017, https://history.fnal.gov/GoldenBooks/gb_wilson2.html.

16. Georgia Schwender, Fermilab's gallery director, interview with author at Fermilab, 2016. See also Joanna S. Ploeger, *The Boundaries of the New Frontier: Rhetoric and Communication at Fermi National Accelerator Laboratory* (Columbia: University of South Carolina Press, 2009).

17. John Peoples (third director of Fermilab), interview with author, 2016. I am grateful to Georgia Schwender for arranging/attending the meeting and Anne Mary Teichert for attending too.

18. Ibid.

19. Ibid.

20. Fermilab Research Alliance LLC, "Fermilab Arts & Lecture Series 2016–17," 6.

21. Lindsay Olson in "Fermilab Artist in Residence 2014–15," http://www.fnal.gov/pub/Art_Gallery/artist_in_residence/Lindsay_Olson/ (accessed April 12, 2017).

22. Gyorgy Darvas and Tamas Frakas, "An Artist's Works through the Eyes of a Physicist: Graphic Illustration of Particle Symmetries," *Leonardo* 39, no. 1 (2006): 51.

23. Nick Cave & the Bad Seeds, "Higgs Boson Blues," *Push the Sky Away*, Bad Seed Ltd (2013).

24. See Art at CERN's website, http://arts.cern/home (accessed April 15, 2018).

25. Rudy Decelière and Vincent Hänni, conversation with the author, Geneva, Switzerland, May 5, 2016.

26. Karen Barad, *Meeting the Universe Halfway: Quantum Physics and the Entanglement of Matter and Meaning* (Durham, NC: Duke University Press, 2007).

27. See James D. Dean and Bertram Ulrich, *NASA/ART, 50 Years of Exploration*, exhibition catalog, Smithsonian Institution, NASA (New York: Abrams, 2008).

28. Nam June Paik, "Art and Satellite," (1984), republished in Kristine Stiles and Peter Slez, *Theories and Documents of Contemporary Art: A Sourcebook of Artists' Writings* (Berkeley: University of California Press, 2012), 497.

29. Nishitani Osamu, "Où est notre avenir?," (Where is our future?), *Ebisu-Etudes Japonaises* 47 (Spring–Summer 2012): 64; Jean-Luc Nancy, *L'équivalence des catastrophes: (Après Fukushima)* [The Equivalence of Catastrophes: (After Fukushima)] (Paris: Galilée, 2012).

30. "James Acord: Atomic Artist," *Nuclear News* 45, no. 12 (November 2002). See also James Flint, "Looking for Acord," *The Observer* (1998); James Accord, Carey Young, and Mark Aerial Waller, *Atomic Book* (London: The Arts Catalyst, 1998); and

Philip Schuyler, "Moving to Richland-I," *New Yorker*, October 14, 1991 [part I of two-part profile of Acord].

31. "Southwestern Acquires Unusual Sculpture," Southwestern University, news webpage, https://www.southwestern.edu/live/news/5453-southwestern-acquires-unusual-sculpture (accessed April 16, 2018).

32. In Ele Carpenter, ed., *The Nuclear Culture Source Book* (London: Black Dog Publishing, 2016), 111.

33. "Expert Judgment on Markers to Deter Inadvertent Human Intrusion into the Waste Isolation Pilot Plant," Sandia National Laboratories report SAND92–1382, UC-721 (1993), F-11, http://prod.sandia.gov/techlib/access-control.cgi/1992/921382.pdf (accessed April 17, 2018).

34. Ibid., G-85.

35. Ibid.

36. Ibid., F-70.

37. Ibid., F-49–50.

38. "Art et mémoire" [Art and Memory], ANDRA, December 2016, https://www.andra.fr/pages/fr/menu1/les-solutions-de-gestion/se-souvenir/art-et-memoire-7334.html (accessed April 2017).

39. "Appel à projets artistiques ANDRA 2015" [Call for Artistic Projects ANDRA 2015], ANDRA, https://www.andra.fr/download/site-principal/document/appel-a-projets-artistique---8.pdf (accessed April 2017).

40. "Appel à projets artis tiques ANDRA 2016" [Call for Artistic Projects ANDRA 2015], ANDRA, https://www.andra.fr/download/site-principal/document/2016_1erprix-appelprojets_memoire.pdf (accessed April 2017).

41. Mark Blake, *Comfortably Numb: The Inside Story of Pink Floyd* (Cambridge, MA: Da Capo Press, 2008), 151.

42. Ibid., 152.

43. Tako, "Invisible Touch," in *Ecology of the Techno Mind* (Zavod: Kapelica Gallery, 2008), 61.

44. See Art Bra Austin's official website, http://artbraaustin.org (accessed April 15, 2017).

45. Alfred Coppel, *Dark December* (Greenwich: Fawcett Publications, Inc., 1960), 141.

Selected Bibliography

Adorno, Theodor. *Can One Live after Auschwitz? A Philosophical Reader.* Ed. Rolf Tiedemann. Stanford, CA: Stanford University Press, 2003.

Adorno, Theodor. "Commitment." *New Left Review* I (87–88) (1974): 75–89.

Aida, Makoto. *Monument for Nothing.* Tokyo: Mori Art Museum, 2012.

Albright, Ann Cooper. *Traces of Light: Absence and Presence in the Work of Loïe Fuller.* Middletown, CT: Wesleyan University Press, 2007.

Alexievich, Svetlana. *Voices from Chernobyl: The Oral History of a Nuclear Disaster.* Trans. Keith Gessen. London: Picador, 2006. First published in 1997.

Annas, George J. "The Case of Karen Silkwood." *Public Health and the Law* 74 (5) (1984): 516–518, http://ajph.aphapublications.org/doi/pdf/10.2105/AJPH.74.5.516.

Anders, Günther. *Burning Conscience: The Case of the Hiroshima Pilot.* New York: Monthly Review Press, 1962. First published in 1961.

Anders, Günther. *Hiroshima est partout.* [Hiroshima is Everywhere] Paris: Seuil, 2008.

Antoine, Blandine, and Elodie Renaud. *Le tour du monde des énergies.* [World Tour of Energies] Paris: Jean-Claude Lattès, 2008.

Arte Nucleare, Galleria Schwartz. Milan: Grafiche Gaiani Milano, 1962.

"Atomic Energy: Dormant Indo-Soviet Collaboration." *Economic and Political Weekly* 8 (48) (1973).

Barad, Karen. *Meeting the Universe Halfway: Quantum Physics and the Entanglement of Matter and Meaning.* Durham, NC: Duke University Press, 2007.

Barad, Karen. "Nature's Queer Performativity." *Kvinder, Kon & Forskning* 1 (2) (2012): 25–53.

Barrillot, B., M.-H. Villierme, and A. Hudelot, eds. *Témoins de la bombe.* [Witnesses of the Bomb] Papeete: Éditions Univers Polynésiens, 2013.

Baudrillard, Jean. *Simulacra and Simulation*. Trans. Sheila Faria Glaser. Ann Arbor: The University of Michigan Press, 1994. First published in 1981.

Barthes, Roland. *Mythologies*. Paris: Seuil, 1957.

Benjamin, Walter. *The Work of Art in the Age of Mechanical Reproduction*, rev. ed. New York: Prism Key Press, 2012.

Benjamin, Walter. "What Is Epic Theater." In *Illuminations*, ed. Hannah Arendt. New York: Schocken Books, 1969. First published in 1955.

Bennison, Amira K. *The Great Caliphs: The Golden Age of the 'Abbasid Empire*. New Haven: Yale University Press, 2010.

Blake, Mark. *Comfortably Numb: The Inside Story of Pink Floyd*. Cambridge, MA: Da Capo Press, 2008.

Blanchot, Maurice. *Friendship*. Trans. Elizabeth Rottenberg. Stanford, CA: Stanford University Press, 1997. First published in 1971.

Bogdanov, Alexander. *Red Star: The First Bolshevik Utopia*. Bloomington: Indiana University Press. First published in 1908.

Bordman, Gerald. *American Musical Theatre: A Chronicle,* rev. ed. New York: Oxford University Press, 2010. First published in 1978.

Bradbury, Ray. *The Martian Chronicles*. London: HarperCollins, 2008. First published in 1951.

Brians, Paul. *Nuclear Holocaust: Atomic War in Fiction, 1895–1984*. Kent, OH: Kent State University Press, 1987. https://brians.wsu.edu/2016/11/16/nuclear-holocausts -atomic-war-in-fiction/.

Brians, Paul. "Nuclear War in Science Fiction, 1945–1959." *Science Fiction Studies* 11 (3) (November 1984): 253–263.

Brunet, Phillipe. *La nature dans tous ses états: uranium, nucléaire et radioactivié en Limousin* [Nature in All Its States: Uranium, Nuclear Technology and Radioactivity in Limousin]. Limoge: Limousin University Press, 2004.

Brunngraber, Rudolf. *Radium: A Novel*. New York: Random House, 1937.

Boyer, Paul. *By the Bomb's Early Light, American Thought and Culture at the Dawn of the Atomic Age*. New York: Pantheon Books, 1985.

Brecht, Bertolt. *Life of Galileo*. London: Methuen Publishing, 1994.

Brieva, Miguel. *Bienvenido al mundo*. [Welcome to the World] Madrid: Reservoir Books, 2007.

"The Building After: Julian Rose Talks with Toyo Ito." *Artforum* (September 2013): 342–347. http://artforum.com/inprint/issue=201307&id=42634&pagenum=0.

Bukharin, Oleg. "The Future of Russia's Plutonium Cities." *International Security* 21 (4) (Spring 1997): 126–158.

Bulidon, Louis, and Raymond Sene. *Les irradiés de Béryl: L'essai nucléaire français non contrôlé.* [The Irradiated from Beryl: The Uncontrolled French Test] Paris: Thaddee, 2011.

Burroughs, William S. *Exterminator!* London: Penguin Classics, 2008. First published in 1973.

Campos, Luis A. *Radium and the Secret of Life.* Chicago: The University of Chicago Press, 2015.

Cantelon, Philip Louis, and Robert Chadwell Williams. *Crisis Contained: The Department of Energy at Three Mile Island.* Carbondale: Southern Illinois University Press, 1982.

Čapek, Karel. *The Absolute at Large.* Lincoln: University of Nebraska Press, 2005. First published in 1922.

Carpenter, Ele, ed. *The Nuclear Culture Textbook.* London: Black Dog Publishing, 2016.

Charrière, Julian. *Polygon.* Berlin: The Green Box, 2015.

Chomsky, Noam, and Andre Vltchek. *On Western Terrorism: From Hiroshima to Drone Warfare.* London: Pluto Press, 2013.

Christie, Agatha. *The Big Four.* London: Harper, 2002. First published in 1927.

Clark, Claudia. *Radium Girls: Women and Industrial Health Reform, 1910–1935.* Chapel Hill: The University of North Carolina Press, 1997.

Clarke, Mary, Esther Lewin, and Jay Rivkin. *Peace of Resistance.* Los Angeles: The Ward Ritchie Press, 1970.

Clarkson, Helen. *The Last Day: A Novel of the Day After Tomorrow.* New York: Torquil Book, 1959. http://www.pages.drexel.edu/~ina22/301/NOVEL-Last_Day2.htm.

Cortright, David. *Peace: A History of Movements and Ideas.* Cambridge: Cambridge University Press, 2008.

Cromie, Robert. *The Crack of Doom.* London: Digby Long, and Co., 1895. http://www.gutenberg.org/files/26563/26563-h/26563-h.htm.

Coppel, Alfred. *Dark December.* Greenwich: Fawcett Publications, Inc, 1960.

Corelli, Marie. *The Secret Power.* Rochester, NY: Scholar's Choice, 2015. First published in 1921.

Corelli, Marie. *The Mighty Atom.* London: Hutchinson and Co., 1896. http://webapp1 .dlib.indiana.edu/vwwp/view?docId=VAB7104&doc.view=print.

Critical Art Ensemble. *Disturbances*. London: Four Corners Books, 2012.

Crocombe, Marjorie Tuainekore, Ron Crocombe, Kauraka Kauraka, and Makiuti Tongia, eds. *Te Rau Maire [the Fern Leaf]: Poems and Stories of the Pacific*, (Rarotonga: 6th Festival of Pacific Arts, 1992).

Crocombe, Marjorie Tuainekore, ed. "Te Mau Aamu Maohi/Poesie Tahitienne/ Tahitian Poetry. Hubert Brémond/Henri Hiro/Charles Manutahi," *Mana, A South Pacific Journal of language and Literature* 7 (1) (1982).

Curie, Marie. *La Radiologie et la Guerre*. [Radiology and War] Paris: Librairie Felix Alcan, 1921.

Danielsson, Marie-Thérèse, and Bengt Danielsson. *Moruroa mon amour*. Paris: Stock, 1974.

Danielsson, Marie-Thérèse, and Bengt Danielsson. *Moruroa, notre bombe colonial* [Moruroa, Our Colonial Bomb]. Paris: L'Harmattan, 1993.

Darry, Michel. *La course au radium*. [The Race for the Radium] Paris: J. Ferenczi & Fils, 1936.

Darvas, Gyorgy, and Tamas Frakas. "An Artist's Works through the Eyes of a Physicist: Graphic Illustration of Particle Symmetries." *Leonardo* 39 (1) (2006): 51–57.

Deamer, David. *Deleuze, Japanese Cinema, and the Atom Bomb: The Spectre of Impossibility*. New York, London: Bloomsbury, 2014.

de Graffigny, Henry. *La cavern au radium* [The Radium Cave]. Paris: J. Ferenczi & Fils, 1927.

DeLoughrey, Elizabeth M., "Solar Metaphors: 'No Ordinary Sun.'" *Ka Mate Ka Ora: a New Zealand Journal of Poetry and Poetics* 6 (September 2008).

DeLoughrey, Elizabeth M. *"The Myth of Isolates: Ecosystem Ecologies in the Nuclear Pacific." In Postcolonial Studies: An Anthology*. Ed. *Pramod K. Nayar*. Oxford: John Wiley & Sons Ltd, 2016.

DeLoughrey, E. M., and G. B. Handley, eds. *Postcolonial Ecologies: Literature of the Environment*. New York: Oxford University Press, 2011.

Del Tredici, Robert. *At Work in the Fields of The Bomb*. New York: Harper & Row Publishers, 1987.

Del Tredici, Robert. *The People of Three Mile Island*. San Francisco: Sierra Club Books, 1980.

Derrida, Jacques. "No Apocalypse, Not Now." *Diacritics* 14 (2) (Summer 1984): 20–31.

Deubner, Christian. "The Expansion of West German Capital and the Founding of Euratom." *International Organization* 33 (2) (Spring 1979): 203–228.

Deutsche, Rosalyn. *Hiroshima after Iraq, Three Studies in Art and War.* New York: Columbia University Press, 2010.

Diop, Cheikh Anta. *Black Africa: The Economic and Cultural Basis for a Federated State.* Chicago: Chicago Review Press, 1987. First published in 1960.

d'Ivoi, Paul. *Le Radium qui tue* [The Radium that Kills]. Paris: Tallandier, 1948.

Doisneau chez les Joliot-Curie, Un photographe au Pays des Physiciens [Doisneau at the Joliot-Curie's: A Photographer in the Physicians' land]. Sommières: Romain Pages Editions, 2005.

Domon, Ken. *Hiroshima.* Tokyo: Kenkohsya, 1958.

Dorrington, Albert. *The Radium Terrors.* Amsterdam: Fredonia Books, 2002. First published in 1911.

Doten, Mark. "Trump Sky Alpha." *Granta* (April 25, 2017). https://granta.com/trump-sky-alpha/.

Dower, J. W., and J. Junkerman, eds. *The Hiroshima Murals, The Art of Iri Maruki and Toshi Maruki.* Tokyo: Kodansha International, Ltd, 1985.

Dowling, David. *Fictions of Nuclear Disaster.* Iowa City: University of Iowa Press, 1987.

Dumortier, Bernard. *Atolls de l'atome, Mururoa & Fangataufa* [Atolls of the Atom, Mururoa & Fangataufa]. Rennes: Marine Editions, 2004.

Duraille, Marguerite *[Patrick Rambaud]. Mururoa mon amour.* Paris: Jean-Claude Lattes Editions, 1996.

Durin-Valois, Marc. *La derniere nuit de Claude Eatherly.* [Claude Eatherly's Last Night] Paris: Plon, 2012.

Edwards, Matthew. *The Atomic Bomb in Japanese Cinema.* Jefferson, NC: McFarland and Company, Inc, 2015.

Evans, Arthur B. "The Verne School in France: Paul d'Ivoi's *Voyages Excentriques.*" *Scientific Studies* 36 (2009): 217–234.

Evans, Robley D., and Robert J. Kolenkov. "Radium and Mesothorium Poisoning and Dosimetry and Instrumentation Techniques in Applied Radioactivity." *Annual Progress Report, MIT* 952–5 (May 1968).

Federico, Annette R. *Idol of Suburbia: Marie Corelli and Late-Victorian Literary Culture.* Charlottesville: University Press of Virginia, 2000.

Filhol, Elisabeth. *La Centrale* [The Power Plant]. Paris: Folio, 2010.

Fox, Sarah Alisabeth. *Downwind: A People's History of the Nuclear West*. Lincoln: The Board of Regents of the University of Nebraska, 2014.

France, Anatole. *L'Île des pingouins* [Penguin Island]. 1908. English translation https://archive.org/stream/penguinisland00fran/penguinisland00fran_djvu.txt.

Fukushima, Kikujirō. *Pikadon: Aru genbaku hisaisha no kiroku* [Record of an A-bomb victim]. Tokyo: Tokyo Chunichi Newspaper, 1961.

Fuller, John G. *The Day We Bombed Utah: American's Most Lethal Secret*. New York, Scarborough: Nal Books, 1984.

Gamwell, Lynn. *Exploring the Invisible: Art, Science and the Spiritual*. Princeton, Oxford: Princeton University Press, 2002.

Galván, Ismael, Andrea Bonisoli-Alquati, Shanna Jenkinson, Ghanem Ghanem, Wakamatsu Kazumasa, Timothy A. Mousseau, and Anders P. Møller. "Chronic Exposure to Low-Dose Radiation at Chernobyl Favors Adaptation to Oxidative Stress in Birds." *Functional Ecology* 28 (2014): 1387–1403.

Garvey, Timothy J. "László Moholy-Nagy and Atomic Ambivalence in Postwar Chicago." *American Art* (Fall 2000): 22–39.

Genbaku to inochi, Mangakatachi no senso [Life and the A-bomb, Manga Artists and War]. Tokyo: Kin no Hoshi Publications, 2015.

Gessert, George. "Notes on Uranium Weapons and Kitsch." *Northwest Report* 42 (2003): 6–11.

Gessert, George. "Notes toward a Radioactive Art." *Leonardo* 25 (1) (1992): 37–41.

Gigon, Fernand. *Apocalypse de l'atome*. [Atom Apocalypse] Paris: Mondiales Editions, 1958.

Gigon, Fernand. *Formula for Death, E=mc² (The Atom Bombs and After)*. London: Allan Wingate Publishers, 1958.

Gioseffi, D., ed. *Women on War: An International Anthology of Writings from Antiquity to the Present*. New York: Feminist Press at the City University of New York, 2003.

Goodman David, G., ed. *After Apocalypse: Four Japanese Plays of Hiroshima and Nagasaki*. Ithaca, NY: Cornell University East Asia Program, 1994. First published in 1986.

Gorodé, Déwé. *Sharing as Custom Provides: Selected Poems of Dewe Gorode*. Trans. Raylene Ramsay and Deborah Walker. Canberra: Pandanus Books, 2004.

Greenberg, Clement. Modernist Painting. In *Art in Theory 1900–2000*. Ed. Charles Harrison and Paul Wood. London: Blackwell, 2003.

Guiart, Jean. "Danielsson, Marie-Thérèse et Bengt, *Moruroa mon amour*." *Journal de la Société des Oceanistes* 30 (45) (1974): 317–322.

Haber, Heinz. *The Walt Disney Story of Our Friend the Atom*. New York: Simon & Schuster, 1956.

Hachiya, Michihiko. *Hiroshima Diary: The Journal of a Japanese Physician, August 6–September 30, 1945*. Trans. Warner Wells, MD. Chapel Hill: The University of North Carolina Press, 1995. First published in 1955 for the English translation.

Hagio, Moto. *Na no hana* [Canola Flower]. Tokyo: Shogagukan, 2016.

Halden, Grace. *Three Mile Island, the Meltdown Crisis and Nuclear Power in American Popular Culture*. New York: Routledge, 2017.

Hall, A., ed. *Below the Surface: Words and Images in Protest at French Testing on Moruroa*. Auckland: Random House New Zealand, 1995.

Hansen, Arlen J. "The Dice of God: Einstein, Heisenberg, and Robert Coover." *NOVEL: A Forum on Fiction* 10 (1) (Autumn 1976): 49–58.

Harding, Jim. *Canada's Deadly Secret: Saskatchewan Uranium and the Global Nuclear System*. Nova Scotia: Fernwood Publishing, 2007.

Hardt, Michael, and Antonio Negri. *Empire*. Cambridge, MA: Harvard University Press, 2000.

Hau'ofa, Epeli. "The Ocean in Us." *Contemporary Pacific* 10 (2) (Fall 1998): 391–410.

Hecht, Gabrielle. "Africa and the Nuclear World: Labor, Occupational Health, and the Transnational Production of Uranium." *Comparative Studies in Society and History* 51 (4) (2009).

Hecht, Gabrielle. *Being Nuclear: Africans and the Global Uranium Trade*. Cambridge, MA: MIT Press and Wits University Press, 2012.

Hecht, Gabrielle. "Peasants, Engineers, and Atomic Cathedrals: Narrating Modernization in Postwar Provincial France." *French Historical Studies* 20 (3) (1997): 381–418.

Hecht, Gabrielle, and Michel Callon. *The Radiance of France: Nuclear Power and National Identity after World War II*. Cambridge, MA: MIT Press, 2009.

Hersey, John. *Hiroshima*. London: Penguin, 1985. First published in 1946.

Heidegger, Martin. *Poetry, Language, Thought*. New York: HarperCollins, 1971.

Heidegger, Martin. *The Question Concerning Technology and Other Essays*. New York: Garland Pub, 1977.

Heidegger, Martin. *Being and Time*. Oxford: Blackwell, 2004. First published in 1927.

Heisenberg, Werner. "The Representation of Nature in Contemporary Physics." *Daedelus* 87 (3) (Summer 1958): 95–108.

Heisenberg, Werner. "La découverte de Planck et les problèmes philosophiques de la physique classique" [Planck's Discovery and the Philosophical Problems of Classical Physics]. In *L'homme et l'atome (Man and the Atom), Rencontre Internationales de Genève*. Neuchatel: Editions de la Baconnière, 1958.

Hesse-Honegger, Cornelia. *The Future's Mirror*. Newcastle upon Tyne: Locus, 2000.

Hiroshima: Sensō to toshi [Hiroshima: War and City]. Tokyo: Iwanami, 1952.

Isozaki, Arata. *Kūkan e* [Towards Space]. Tokyo: Bijutsushuppansha, 1971.

Hiyama, Atsuki, Nohara Chiyo, Kinjo Seira, Taira Wataru, Gima Shinichi, Tanahara Akira, and Joji M. Otaki. "The Biological Impacts of the Fukushima Nuclear Accident on the Pale Grass Blue Butterfly." *Scientific Reports* (August 9, 2012): 1–10.

Hostetter, Robert D. "Drama of the Nuclear Age, Resources and Responsibilities in Theater Education." *Performing Arts Journal* 11 (2) (1988): 85–95.

Hudson, Richard, and Ben Shahn, *Kuboyama and the Sage of the* Lucky Dragon. New York and London: Thomas Yoseloff Ltd, 1965.

Huie, William Bradford. *The Hiroshima Pilot*. New York: Pocket Book, 1964.

Isobe, R., ed. *Purojekuto Fukushima!* [Project Fukushima!]. Tokyo: DOMMUNE Books, 2011.

Itō Toyō, NA kenchikuka shirīzu [Itō Toyō, NA Architect series]. Tokyo: Nikkei BP Sha, 2013.

Iversen, Kristen. *Full Body Burden: Growing Up in the Shadow of Rocky Flats*. New York: Broadway Books, 2013.

Jenkins, R., ed. *Nagasaki Journey, The Photographs of Yosuke Yamahata, August 10, 1945*. San Francisco: Pomegranate Artbooks, 1995.

Jenkins, Will F. *The Murder of the U.S.A.* Rockville, MD: Wildside Press, 2016. First published in 1946.

Jetñil-Kijiner, Kathy. *Iep Jāltok, Poems from a Marshallese Daughter*. Tucson: The University of Arizona Press, 2017.

Johnson, Robert R. *Romancing the Atom: Nuclear Infatuation from the Radium Girls to Fukushima*. Santa Barbara, CA.: Praeger Pub, 2012.

Joliot-Curie, Frédéric. *Cinq années de lutte pour la paix* [Five Years of Struggle for Peace]. Paris: Éditions "Défense de la paix," 1954.

Joliot-Curie, Frédéric. *Textes choisis.* [Selected Texts] Paris: Éditions Sociales, 1959.

Jolivette, Catherine, ed. *British Art in the Nuclear Age*. Surrey: Ashgate, 2014.

Jowitt, Deborah. *Time and the Dancing Image*. Oakland: University of California Press, 1989.

Jürgen Nefzger, Fluffy Clouds. Ostfildern: Hatje Cantz Verlag, 2010.

Kamiya, Yukie, "Collective Acts in the Aftermath, Art in Post-Earthquake Japan." *Flash Art International* (November–December 2013). http://www.flashartonline.com/article/collective-acts-in-the-aftermath.

Kamiya, Yukie, Takatani Shiro, and Miwa Masahiro. *"Accelerating Technology / Introspective Art," in 16th Japan Media Arts Festival*. Tokyo: Japan Media Arts Festival Secretariat, 2013.

Kanamori, Osamu. The Biopolitics of Contemporary Japanese Society. In *La réception et la résistance—la vie selon les sciences occidentales et le Japon—Actes du colloque de Tokyo, 2014. Collection de monographies des études japonaises internationals*. Tokyo: Hosei University Press, 2014.

Kander, Nadav. *Dust*. Berlin: Hatje Cantz, 2014.

Kariya, Tetsu, and Hanasaki Akira. *Oishinbo: Fukushima no shinjitsu* [The Gourmet, Fukushima's Truth], vol. 1. Tokyo: Kokagukan, 2013.

Kaschnitz, Marie Luise. *Selected Later Poems of Marie Luise Kaschnitz*. Trans. Lisel Mueller. Princeton, NJ: Princeton University Press, 1980.

Kasparek, Jiri. "Soviet Russia and Czechoslovakia's Uranium." *Russian Review* 11 (2) (April 1952): 97–105.

Katzive, David. "Henry Moore's Nuclear Energy: The Genesis of a Monument." *Art Journal* 32 (1973): 284–288.

Kazashi, Nobuo. *Tetsugaku no 21 seiki: Hiroshima kara no daiippo* [Philosophy of the 21st century, First Steps from Hiroshima]. Hiroshima: Hiroshima Peace Culture Center, 1999.

Kazuto, Tatsuta. *Ichiefu, Fukushima Daiichi Genshiryoku Hatsudensho Rōdōki* [1F, Fukushima Daiichi Nuclear Power Plant Labor Chronicle]. Tokyo: Kodansha, 2014.

Keenan, Jeremy. "Uranium Goes Critical in Niger: Tuareg Rebellions Threaten Sahelian Conflagration." *Review of African Political Economy* 117 (2008): 449–466.

Keown, Michelle. *Pacific Islands Writings: The Postcolonial Literature of Aotearoa/New Zealand and Oceania*. Oxford: Oxford University Press, 2009. First published in 2007.

Keown, Michelle. ""Our Sea of Island": Migration and Metissage in Contemporary Polynesian Writing." *International Journal of Francophone Studies* 11 (4) (2008): 503–522.

Kiernan, Denise. *The Girls of Atomic City, The Untold Story of the Women Who Helped Win World War II*. New York: Simon & Schuster, 2013.

Kimball, Roger. "'The Two Cultures' Today." *New Criterion* (February 1994).

Kimura, Shinzō. *Hottosupotto: nettowāku de tsukuru hoshano osen chizu* [Hot Spot: A Network Makes a Map of Radioactive Pollution] NHK ETV. Tokyo: Kodansha, 2012.

Klein, Yves. 'Explosions Bleues', Lettre à la Conférence internationale de la détection des explosions atomiques, July 1958. In *Le dépassement de la problématique de l'art et autres écrits*. Paris: École Nationale Supérieure des Beaux-Arts, 2003.

Klinkowitz, Jerome. *Pacific Skies: American Flyers in World War II*. Jackson: University Press of Mississippi, 2004.

Knight, Richard. "Occupied Western Sahara: Campaign to End Kerr-McGee's Involvement." *Review of African Political Economy* 32 (103) (March 2005): 154–156.

Kobayashi, Erika. *Hikari no kodomo* [Luminous: Child of the Light], vol. 1. Tokyo: Little More, 2013.

Koide, Hiroaki, and Doi Yoshihira. *Ningyōtōge uran kōgai saiban* [Ningyo-toge's Uranium Pollution Trials]. Tokyo: Hihyosya, 2001.

Koko go ie da—ben shyān no daigo fukuryū maru [Here Is the House—Ben Shahn's *Lucky Dragon*] Tokyo: Shueisha, 2006.

Kostin, Igor. *Chernobyl: Confessions of a Reporter*. New York: Umbrage Edition, 2006.

Launet, Édouard. *Sorbonne Plage* [Sorbonne Beach]. Paris: Stock, 2016.

Lapp, Ralph E. *The Voyage of the Lucky Dragon*. New York: Harper & Brothers, 1958.

Latour, Bruno. *Nous n'avons jamais été modernes* [We Have Never Been Modern]. Paris: La Découverte, 1991.

Leavis, F. R. *Two Cultures?: The Significance of C. P. Snow*. Cambridge: Cambridge University Press, 2013.

Lee, Alison. *Realism and Power, Postmodern British Fiction, Routledge Revivals*. New York: Routledge, 1990.

Lerouge, Bernard, *Tchernobyl, un 'nuage' passe...: Les faits et les* controverses [Chernobyl, a Cloud Passes By: The Facts and the Controversies]. Paris: L'Harmattan, 2009.

Lifton, Robert Jay. *Death in Life: Survivors of Hiroshima*. Chapel Hill: University of North Carolina Press, 1991. First published in (1968).

Lifton, Robert Jay, and Greg Mitchell. *Hiroshima in America: Fifty Years of Denial*. New York: Grosset/Putman, 1995.

Lindee, Susan. *Suffering Made Real: The American Science and the Survivors at Hiroshima*. Chicago: University of Chicago Press, 1997.

Lottman, Herbert. *The Left Bank; Writers, Artists, and Politics from the Popular Front to the Cold War*. Chicago: University of Chicago Press, 1982.

Lucretius. *The Nature of Things*. London: Penguin Classic, 2007.

Lykknes, Annette, Lise Kvittingen, and Anne Kristine Borresen. "Appreciated Aboard, Depreciated at Home: Ellen Gleditsch (1879–1968)." *Isis* 95 (4) (December 2004): 576–609.

Lyotard, Jean-François. "The Sublime and the Avant-garde." *Artforum* 22 (8) (April 1984): 36–43.

Manabe, Noriko. *The Revolution Will Not Be Televised: Protest Music After Fukushima*. New York: Oxford University Press, 2015.

Marnich, Melanie. *These Shining Lives*. New York: Dramatists Play Service, Inc, 2010.

Martin, Guy. "Uranium: A Case-Study in Franco-African Relations." *Journal of Modern African Studies* 27 (4) (December 1989): 625–640.

Maruki, Iri and Maruki Toshi. *The Hiroshima Panels / Hiroshima no zu*. Tokyo: Niji Shobou, 1959.

Mbembe, Achille. "Necropolitics." *Public Culture* 15 (1) (2003): 11–40.

McNeil, Dougal. *The Many Lives of Galileo: Brecht, Theatre and Translation's Political Unconscious, Stage and Screen Studies (Book 7)*. Bern: Peter Lang Academic, 2005.

Minear, Richard H., ed., trans. *Hiroshima, Three Witnesses*. Princeton, NJ: Princeton University Press, 1990.

Mitchell, Timothy. "Orientalism and the Exhibition Order." In *Colonialism and Culture*. Ann Arbor: The University of Michigan Press, 1992.

Moholy-Nagy, László. "The Function of Art." In *Esthetics Contemporary*. Ed. Richard Kostelanetz. New York: Prometheus Books, 1989. Reprinted from *Vision in Motion*. Chicago: Theobald, 1947.

Mullner, Ross. *Deadly Glow: The Radium Dial Worker Tragedy*. Washington, DC: American Public Health Association, 1999.

Murdoch, Brian. *Fighting Songs and Warring Words: Popular Lyrics of Two World Wars*. London: Routledge, 1990.

Nagai, Takashi. *Nagasaki no kane* [The Bells of Nagasaki]. New York: Kodansha International, 1994. First published in 1949.

Nagaoka, Hiroyoshi. "Genbaku bungaku shi" [History of A-bomb Literature, 1973]. In *Nihon no genbaku kiroku (Japanese A-bomb Records) 16*. Tokyo: Nihon Tosho Center, 1991.

Nagaoka, Hiroyoshi. "Futatsu no shi—haha Tomi to musume Yōko to" [Two Deaths—Mother Tomi and Daughter Yōko, 1982]. In vol. 2, "Ōta Yōko," of *Japanese A-bomb Literature*. Tokyo: Nihon Tosho Center, 2001. First published in 1984.

Nail, Thomas, and I. Lucretius. *An Ontology of Motion*. Edinburgh: Edinburgh University Press, 2018.

Naitō, D., R. Sayre, H. Swanson, and S. Takahashi, eds. *To See Once More the Stars, Living in a Post-Fukushima World*. Santa Cruz, CA: New Pacific Press, 2014.

Nakao, Maika. "The Image of the Atomic Bomb in Japan before Hiroshima." *Historia Scientiarum* 19 (2) (2009): 119–131.

Nakazawa, Keiji. *Barefoot Gen, Vol. 1: A Cartoon Story of Hiroshima*. San Francisco: Last Gasp, 2004. First published in 1973.

Nakazawa, Keiji. *Kuroi ame ni utarete* [Struck by Black Rain]. Tokyo: Dino Box, 2005.

Nancy, Jean-Luc. *l'équivalence des catastrophes: (Après Fukushima)* [The Equivalence of Catastrophes: (After Fukushima)]. Paris: Galilée, 2012.

Newman, Barnett. "A New Sense of Fate" (1948). In *John Philip O'Neill, Barnett Newman: Selected Writings and Interviews*. Berkeley: University of California Press, 1990.

Nihon no genbaku bungaku, vol. 2 "Ōta Yōko" [Japanese A-bomb Literature, vol. 2, "Ōta Yōko"]. Tokyo: Holp Publishing, 1983.

Nihon no genbaku bungaku, Shika. [Japan's A-bomb Literature, Poetry], vol. 13. Tokyo: Holp Publishing, 1983.

Nishitani, Osamu. "Où est notre avenir?" [Where Is Our Future?], *Ebisu-Etudes Japonaises* 47 (Spring–Summer 2012): 59–68. The article is a revised version of Nishitani Osamu, "'Mirai' wa doko ni aru no ka," *Gendai Shisō* 39 (2011): 34–37.

Nobuko, Tsukui, "Women Writers on the Experience of World War II: The Atomic Bomb and the Holocaust." *Journal of the College of Humanities* 2 (Kasugai: Chubu University, 1999): 35–51.

Nocenti, Ann, Mark Texeira, John Royle, and Philip Moy, *Wolverine: Evilution*. New York: Marvel Comics. 1994.

Noualhat, Laure. "Des vérités long temps chachées." *Libération* (May 29, 2006). http://www.liberation.fr/evenement/2006/05/29/des-verites-longtemps-cachees_40842.

Nuclear Regulatory Commission, Special Inquiry Group. *Three Mile Island: A Report to the Commissioners and to the Public, directed by Mitchell Rogovin*. Washington, DC: Government Printing Office, 1980.

O'Brian, John, ed. *Camera Atomica*. Toronto: Art Gallery of Ontario and Black Dog Publishing, 2015.

Ōe, Kenzaburō. *Hiroshima Notes*. New York: Grove Press, 1997.

Ōe, Kenzaburō. "History Repeats." *New Yorker* (March 28, 2011). http://www.new yorker.com/magazine/2011/03/28/history-repeats.

Osada, Arata, ed. *Genbaku no ko—Hiroshima no shōnen shōjo no uttae* [A-bomb Children—the Voice of Boys and Girls of Hiroshima]. Tokyo: Iwanami, 1990. First published in 1951.

Ōta Yōko Shū [Ōta Yōko Collection]. Tokyo: Nihon Tosho Center, 2001. First printed in 1984.

Ōta, Yōko. *Hachijusai [80 years]*. Tokyo: Kodansha, 1961.

Paik, Nam June. "Art and Satellite" (1984). In *Theories and Documents of Contemporary Art: A Sourcebook of Artists' Writings*. Ed. Kristine Stiles and Peter Slez,. Berkeley: University of California Press, 2012.

Petersen, Stephen. Explosive Propositions: Artists React to the Atomic Age. *Science in Context 14 (5) (2004):* 579–609.

Pinkel, Sheila. "*Thermonuclear Gardens*: Information Artworks about the U.S. Military-Industrial Complex." *Leonardo* 34 (4) (2001): 319–326.

Ploeger, Joanna S. *The Boundaries of the New Frontier: Rhetoric and Communication at Fermi National Accelerator Laboratory*. Columbia: The University of South Carolina Press, 2009.

Ramonet, Ignacio. *La tyrannie de la communication* [Tyranny of communication]. Paris: Folio, 2001.

Ransom, Teresa. *The Mysterious Miss Marie Corelli: Queen of Victorian Bestsellers*. New York: Sutton Publishing, 1999.

Rashke, Richard. *The Killing of Karen Silkwood: The Story Behind the Kerr-McGee Plutonium Case*. Boston: Houghton Mifflin Company, 1981.

Rayner-Canham, Marelene F., and Geoffrey Rayner-Canham. *A Devotion to Their Science: Pioneer Women of Radioactivity*. Montreal: McGill-Queen's University Press, 1997.

Reeve, Arthur Benjamin. *The Deadly Tube*. Worcestershire: Read Books Ltd, 2013.

Regnault, Jean-Marc. *Pouvana'a et De Gaulle, la candeur et la grandeur* [Pouvana'a and De Gaulle, the ingenuousness and the grandeur]. Papeete: Tahiti Editions, 2016.

Rhodes, Richard. *The Making of the Atomic Bomb*. New York: Simon & Schuster Paperbacks, 1986.

Rich, Adrienne. *The Dream of a Common Language: Poems 1974–1977*. New York: W. W. Norton & Company, 2013.

Rifas, Leonard. "Cartooning and Nuclear Power: From Industry Advertising to Activist Uprising and Beyond." *PS, Political Science & Politics* 40 (2) (April 2007): 255–260.

Rose, William. *The Radium Book*. Cleveland: Rose Publishing Company, 1905.

Rubin, Jay. "From Wholesomeness to Decadence: The Censorship of Literature Under the Allied Occupation." *Journal of Japanese Studies* 11 (1) (Winter 1985): 71–103.

Rukeyser, Muriel. *The Speed of Darkness*. New York: Random House, 1968.

Said, Edward. *Orientalism*. London: Penguin Books, 1977.

Saito, Hiro. "Reiterated Commemoration: Hiroshima as National Trauma." *Sociological Theory* 24 (4) (December 2006): 353–376.

Salifou, André. *Biographie politique de Diori Hamani, premier president de la republique du Niger*. [Biography of Diori Hamani, The Republic of Niger's first president] Paris: Karthala Editions, 2010.

Salverson, Julie. *Lines of Flight: An Atomic Memoir*. Hamilton, ON: Wolsak and Wynn, 2016.

Sartre, Jean-Paul, ed. "La Grenouille et la bombe" [The frog and the bomb]. *Les Temps Modernes* 224 (January 1956).

Sartre, Jean-Paul, ed. "La libération de Paris: une semaine d'apocalypse," *Clarté* 9 (August 24, 1945).

Schreurs, M., F. Yoshida, K. Suzuki, F. Tamba, and M. Yokemoto, eds. *Fukushima: A Political Economic Analysis of a Nuclear Disaster*. Sapporo: Hokkaido University Press, 2013.

Selden, Kyoko and Mark Selden, eds. *The Atomic Bomb, Voices from Hiroshima and Nagasaki*. London: Routledge, 2005.

Sharp, Patrick B. *Savage Perils: Racial Frontiers and Nuclear Apocalypse in American Culture*. Norman: University of Oklahoma Press, 2007.

Shiga, Lieko. *Rasen Kaigan notebook* [Spiral Coast notebook], Tokyo: AKAAKA Art Publishing, 2013.

Shimazu, Naoko. Popular Representation of the Past: The Case of Post-War Japan. *Journal of Contemporary History 38 (1)* 2003: 101–116.

Shashin-shū genbaku wo mitsumeru: 1945–Nen Hiroshima Nagasaki [Staring at the Collection of Photographs: 1945, Hiroshima and Nagasaki]. Tokyo: Iwanami, 1981.

Sinclair, Upton. *The Millennium: A Comedy of the Year 2000*. New York: Seven Stories Press, 2000.

Sirnate, Vasundhara. "Students versus the State: The Politics of Uranium Mining in Meghalaya." *Economic and Political Weekly* XLIV (47) (2009): 18–23.

Sirota, Lyubov [Liubov]. *The Chernobyl Poems* (1995). English translation https://brians.wsu.edu/2016/12/05/chernobyl-poems.

Sklar, Morty. *Nuke-rebuke: Writers & Artists Against Nuclear Energy & Weapons*. Iowa City, IA: The Spirit that Moves Us Press, 1984.

Smith, P. D. *Doomsday Men: The Real Dr. Strangelove and the Dream of the Superpower*. New York: St. Martin's Press, 2007.

Snow, C. P. *The Two Cultures*. Cambridge: Cambridge University Press, 1998.

Solomon-Godeau, Abigail. "Going Native: Paul Gauguin and the Invention of Primitivist Modernism." In *The Expanding Discourse: Feminism and Art History*, ed. Norma Broude and Mary Garrard. New York: IconEditions, 1992. First published in 1989.

Sontag, Susan. "The Imagination of Disaster." *Commentary* (October 1, 1965).

Sontag, Susan. *Regarding the Pain of Others*. New York: Picador, 2003.

Sopher, Shelley, and John Piper. *Nuclear Dragons Attack!* Self-published, 1978.

Spitz, Chantal T. *L'Île des rêves ecrasés* [The island of shattered dreams]. Papeete: Les éditions de la plage, 1991.

Stapledon, Olaf. *Last and First Men*. London: Orion Books, 2004. First published in 1930.

Stiles, K., and P. Selz, eds. *Theories and Documents of Contemporary Art, A Sourcebook of Artists' Writings*. Berkeley: University of California Press, 2012.

Strathern, Paul. *Mendeleyev's Dream: The Quest of the Elements*. London: Penguin Books, 2001. First published in 2000.

Suzuki, Tomohiko. *Yakuza to Genpatsu Fukushima Daiichi Sennyūki* [Yakuza and nuclear plants, chronicle of an infiltration]. Tokyo: Bungeishunjū, 2011.

Swanson, Eleanor. "Radium Girls." *Missouri Review* 25 (1) (Spring 2002): 27–33.

Swanson, Eleanor. *A Thousand Bonds: Marie Curie and the Discovery of Radium*. Waco, Texas: National Federation of State Poetry Societies Press, 2003.

Swerdlon, Amy. *Women Strike for Peace, Traditional Motherhood and Radical Politics in the 1960s*. Chicago: University of Chicago Press, 1993.

Takatsuji, Toshihiro, Yuan Jun, and Zeng Zifeng. "Radioactivity of the Aerosol Collected in Nagasaki City Due to the Fukushima Daiichi Nuclear Power Plant Acci-

dent." Hiroshima Peace Center for Scientific Research, *IPSHU English Research Report Series* 28 (March 2012): 79–86.

Teaiwa, Teresia K. "Bikini and Other S/Pacific N/Oceans." *Contemporary Pacific* 6 (1) (Spring 1994): 87–109.

Thouny, C., ed. *Planetary Atmospheres and Urban Society After Fukushima*. Singapore: Palgrave Macmillan, 2017.

Towlson, Jon. "Rehabilitating Daddy, or How Disaster Movies Say It's OK to Trust Authority." *Paracinema* 16 (June 2012): 10–12.

Toyosaki, Hiromitsu. *Atomikku eiji* [Atomic age]. Tokyo: Tsukiji Shokan, 1995.

Toyosaki, Hiromitsu. *Kaku yo ogoru nakare* [Nuclear despair]. Tokyo: Kodansha, 1982.

Toyosaki, Hiromitsu. *Māsharu shotō kaku no seiki*, 1914–2004. Marshall Islands: Nuclear Century, 2005.

Treat, John Whittier. "Atomic Bomb Literature and the Documentary Fallacy." *Journal of Japanese Studies* 14 (1) (Winter 1988): 27–57.

Treat, John Whittier. "Hiroshima and the Place of the Narrator." *Journal of Asian Studies* 48 (1) (February 1989): 29–49.

Treat, John Whittier. *Writing Ground Zero: Japanese Literature and the Atomic Bomb*. Chicago: University of Chicago Press, 1995.

Tsukui, Nobuko. "Women Writers on the Experience of World War II: The Atomic Bomb and the Holocaust." *Journal of the College of Humanities* 2 (September 1999): 35–51.

Tuwhare, Hone. *No Ordinary Sun*. Auckland: Longman Paul Ltd, 1973.

Valéry, Paul. "La Conquête de l'ubiquité [The Conquest of Ubiquity]." *Œuvres*, tome II, *Pièces sur l'art*, rev. ed. Paris: Gallimard, 1960.

Vance-Watkins, Lequita, and Mariko Aratani. *White Flash, Black Rain: Women of Japan Relieve the Bomb*. Minneapolis, MN: Milkweed Editions, 1995.

van Wyck, Peter C. *Highway of the Atom*. Montreal: McGill-Queen's University Press, 2010.

Vermeren, Pierre. *Le choc des décolonisations: De la guerre d'Algérie aux printemps arabes*. [The shock of decolonization: from the Algerian War to the Arab Spring] Paris: Odile Jacob, 2015.

Vidal, Gore. *Kalki*. New York: Penguin Book, 1998. First published in 1978.

Vltchek, Andre. *Oceania, Neocolonialism, Nuke and Bones*. Auckland: Atuanui Press Ltd, 2013.

Vonnegut, Kurt. *Cat's Cradle*. London: Penguin Modern Classics, 2008. First published in 1963.

Voyles, Traci Brynne. *Wastelanding: Legacies of Uranium Mining in Navajo Country*. Minneapolis: University of Minnesota Press, 2015.

Wagō, Ryōichi. *Furusato wo akiramenai: Fukushima, 25nin no shōgen* [We do not abandon our hometown: Fukushima, the testimonies of 25 people]. Tokyo: Shinchosha Publishing, 2012.

Wagō, Ryōichi. "Shi no tsubute" [Pebbles of poetry]. *Gendaishi Techo (Handbook of Contemporary Poetry)* (Tokyo: Shichosha Publishing, 2011). Translation available at http://www.shichosha.co.jp/gendaishitecho/item_406.html.

War and Medicine, The Wellcome Collection. London: Black Dog Publishing, 2008.

Watsuji, Tetsurō. *Climate and Culture*. Tokyo: The Hokuseido Press, 1971.

Weart, Spencer R. *The Rise of Nuclear Fear*. Cambridge, MA: Harvard University Press, 2012.

Weisiger, Marsha. "Happy Cly and the Unhappy History of Uranium Mining on the Navajo Reservation." *Environmental History* 17 (2012): 147–159.

Wilson, Stephen. *Information Arts: Intersections of Art, Science, and Technology*. Cambridge, MA: MIT Press, 2002.

Wilson, R. R. "The Conscience of a Physicist." *Bulletin of the Atomic Scientists* 26 (6) (1970)" 30–34.

Windell, James O. *Looking Back in Crime: What Happened on This Date in Criminal Justice History?* Boca Raton, FL: CRC Press, 2015.

Winther, Bert. "The Rejection of Isamu Noguchi's Hiroshima Cenotaph: A Japanese American Artist in Occupied Japan." *Art Journal* (Winter 1994): 23–27.

White, Anne-Marie. "An International Indigene, Engaging with Brett Graham." *Art New Zealand* 147 (Spring 2013): 36–45.

Woolf, Virginia. *Three Guineas*. Eastford, CT: Martino Fine Books, 2013. First published in 1938.

Yamahata, Yōsuke. *Genbaku no Nagasaki: Kiroku no shashin*. [Nagasaki's A-bomb: A Photographic Record] Tokyo: Gakufū Shoin, 1959.

Yamahata, Yōsuke. *Yamahata Yōsuke: Nihon no shashinka 23*. [Yamahata Yōsuke, Japanese Photographer 23] Tokyo: Iwanami, 1998.

Yamamoto, Akihiro. *Kaku to nihonjin—Hiroshima, Gojira, Fukushima*. [Nuclear and the Japanese—Hiroshima, Godzilla, Fukushima] Tokyo: Chūōkōron-Shinsha, 2015.

Yamazaki, Masakatsu. "Nuclear Energy in Postwar Japan and Anti-nuclear Movements in the 1950s." *Historia Scientiarum* 19 (2) (2009): 132–145.

Yaroshinskaya, Alla. *Chernobyl: Crime without Punishment*, rev. ed. Piscataway, NJ: Transaction Publishers, 2011.

Yoneyama, Lisa. *Hiroshima Traces: Time, Space, and the Dialectics of Memory*. Berkeley: University of California Press, 1999.

Yoshikuni, Igarashi. *Bodies of Memories, Narratives of War in Postwar Japanese Culture, 1945–1970*. Princeton, NJ: Princeton University Press, 2000.

Your Portrait: A Tetsumi Kudo Retrospective. Osaka: The National Museum of Art and Daikin Foundation for Contemporary Arts, 2013.

Index